Alive
Designing Radical Life

SYNTHETIC CELLS,
 FERAL ROBOTS,
REBELLIOUS AI
 & THE DESIGN OF RADICAL LIFE

MADELINE
SCHWARTZMAN

FOREWORD BY
EDWARD ASHTON

With over 400 illustrations

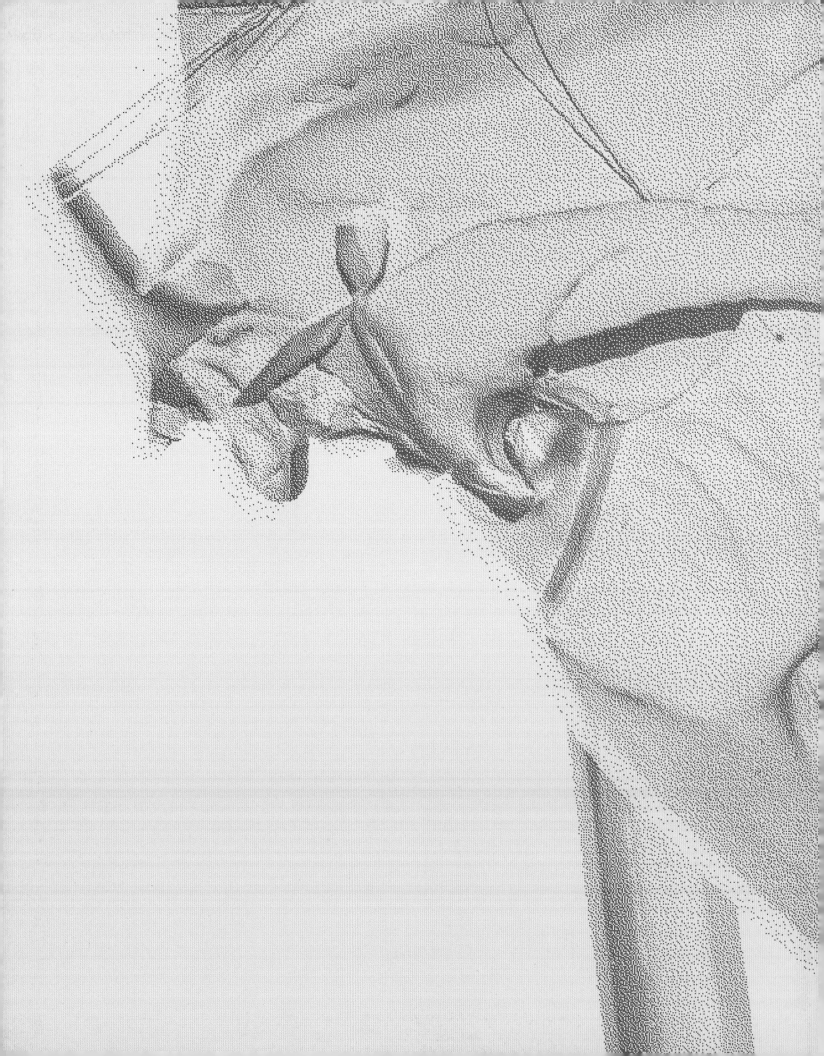

Foreword	6
Introduction	8
1 New Embodiment	20
2 Chimera	58
3 Cellular Packages	100
4 Biomimicry	134
5 Change of State	160
6 Phantasia	188
7 Algorithmic Futures	214
Glossary	242
Image Credits	246
Index of Materials	252
Index of Makers	254
Acknowledgments	255
Endnotes	256

Foreword

Edward Ashton

I wrote my first novel, *Three Days in April*, in the spring and summer of 2014. If you think it odd that I mention the seasons, you're not wrong. Most aspiring authors spend years writing and polishing their first book before allowing it out into the world. Mine was complete, first word to last, in four months. An interviewer once asked me the obvious follow-up question to this observation: *Why were you in such a hurry?* The answer I gave him, which I presented as a joke, was that I was a science fiction author, and I needed to get this book finished before it slid from that genre into historical fiction.

This was not actually a joke. One of the main themes of *Three Days in April* (and of much of my subsequent work as well) is this question: who or what gets to claim the privilege of being *alive*? Characters in the book include a free-floating artificial intelligence, a human–machine hybrid and a genetic chimera – a human carrying a heavy dose of mouse genes. In *Alive*, Madeline Schwartzman demonstrates conclusively that my hunch that these seemingly fantastical concepts might soon be commonplace was well-founded.

When I say that life is a privilege, what I mean is that we instinctively value even the simplest living thing over the most complex inanimate creation. The Jain religious tradition takes this to the furthest extreme, with its adherents refusing to eat root vegetables for fear of killing the plant. Even most dedicated red-meat carnivores among us, though, will often take care not to kill unnecessarily. Our thoughts on even highly sophisticated non-living things, on the other hand, are best exemplified by the casual brutality that players of games such as *The Sims* are happy to inflict on their creations. Players who in real life will carefully trap a wasp under a cup and release it through an open window will then cheerfully trap a simulated human in a room with no windows or doors just to see how long she'll last there.

The root of these attitudes is a near-universal belief that all living things have an ineffable...something...that even the most lifelike of inanimate things lacks. When we encounter something new in the world, our brain immediately seeks to classify it as one or the other, and the box that new thing falls into largely determines how we'll treat it moving forwards.

In the pages of this book, you will encounter an array of creations and situations that will challenge your ability to make such neat distinctions, and that may cause you to question whether this binary was ever valid at all. Is a silicone jellyfish powered by the contractions of a rat's cardiac cells alive? What about a robot controlled not by microprocessors, but by an array of neurons? You will also come across numerous art installations that either question or cross the boundary between living and non-living, from urban rubbish animated by tiny electronic actuators, to disarticulated robotic limbs behaving in uncannily human ways, to wearable mechanical augmentations reminiscent, in a funhouse-mirror kind of way, of the ones I dreamed of in that first novel ten years ago.

With the rapid advances seen recently in artificial intelligence, robotics and genetics, it seems inevitable that we are moving into a world where the distinction between living and non-living blurs, and in some cases disappears entirely. This book provides an entertaining and enlightening window into what that world may look like, and what sorts of beings we may share it with.

Compared to some animals, humans live ordinary lives. We are stuck in one body and cannot function without the electrical gelatinous substance inside our imprisoning head. From that position we maintain a narrow view of what it means to be alive, and we lord it over dominions of species that have wondrous abilities. Sayaka Mitoh and colleagues at Nara Women's University in Japan observed a sea slug named *Elysia marginata* cut off its own head and then grow a new body in a miraculous act of regeneration.[1] This is the stuff of synthetic biologists' dreams. There is another sea slug, *Elysia chlorotica*, that can digest algae, preserve the chloroplasts and then photosynthesize.[2] So many speculative design projects envision a photosynthetic human body, but so far we are stuck in our own sun-damaged skin. Hibernation, moulting, symbiosis, endosymbiosis, parasitism, bioluminescence, hermaphroditism, parthenogenesis, male pregnancy and so many other fantastical transformative life strategies exist in ways we can so far only dream about in relation to humans.

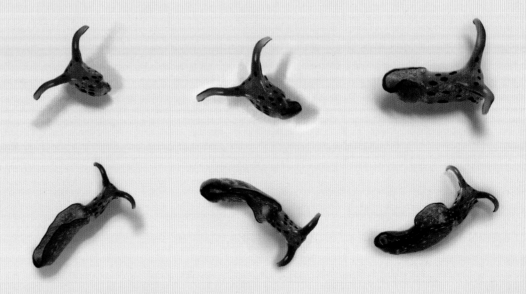

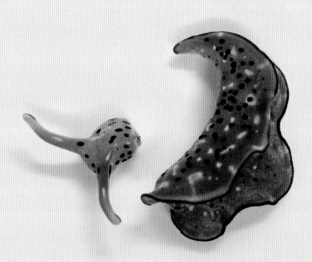

OPPOSITE & ABOVE
Sayaka Mitoh discovered that certain sea slugs (*Elysia marginata* seen here) are capable of severing their head and regenerating their entire body and heart.

This book is a collection of those dreams and their dreamers. In *Alive*, contributors have two things in common: they are curious and they are conceptual. In most cases they cannot radically transform themselves. Instead, they provide an array of experimental avenues for thinking about animal life, both human and nonhuman, and in doing so they encourage conceptual ignition of the brain. What if?

Alive reflects upon the boundary of what it means to be a living being or entity. Curated from new developments in artificial intelligence, robotics, engineering, biology, synthetic biology and art, this is a collection that demonstrates the myriad ways in which our perception of sentience in entities has changed. The line has shifted. Somewhere in the world there is an embryo that is half human, half monkey; a human with a pig's kidney; and a rat with human cells. Someday soon we may not even cringe when reading about these combinations of animals.

It is not just combinations of animals that are making new life. Some creatures are changing from the ground up. The J. Craig Venter Institute has created artificial bacteria cells capable of dividing. Cells are being turned into biological computers. 'Xenobots' are robots made of frog stem cells. Scientists are decellularizing rat limbs to explore human limb regeneration. Harvard's Disease Biophysics Group is working towards a lab-grown heart.

Time and time again animals teach us that we may have underestimated some human potential. Worms, for example, can taste hydrogen peroxide and therefore sense light (which generates harmful hydrogen peroxide within the worm) in an entirely new way.[3] Scientists think humans may have a large spectrum of taste potential. On the robot front, evolutionary roboticists are working on robots that evolve themselves.[4] Certain research standards have been shattered. Just when we think we understand how memory works, new research reveals that memories can be passed from one snail to another through RNA injections.[5] It is dazzling to read about current trends in science that reflect upon human life.

Alive examines all facets of hybrid beings – any combination of living matter, machines, different species and digital media – including cyborgs, artificially intelligent creatures, biohybrid robots, chimeras, new generated organs and generative digital worlds. The aim of the book is to create a new taxonomy, to reveal patterns across disciplines, to uncover where humans might be headed in the future and to map out a vision of how we can serve as partners and stewards for new types of beings. What can we learn from existing hybrids and speculations? How and where do we draw the lines on life? What are the new taxonomies, and who controls evolution? While multiple fields are exploring and manipulating life, there has been no cross-disciplinary study at present. *Alive* will survey and theorize on the consequences of our tinkering with life.

This book does not aim to explore the definition of life, or to question what it means to be alive from a biological or classically philosophical point of view, though these areas of inquiry will at times serve as sources. *Alive* is concerned with the perception of life – the unconscious decision-making that allows one to perceive something as alive, either momentarily or permanently. While many of the contributions include living entities, for inclusion in the book it is adequate to seem alive, to seem transformed, to seem hybridized. What makes us believe something is alive? Do we crave living things? Does our increased technological alienation produce a desire for more embodiment? What does the sensation that something is alive do to our brain? How do capitalism and marketing feed our craving for life?

BELOW
Wonbin Yang's mechanical entities – part rubbish, part electronics – exist on the fringes of the pavement and your imagination (see pp. 34–35).

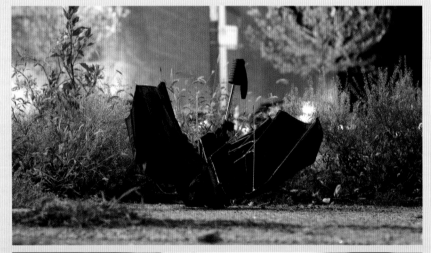

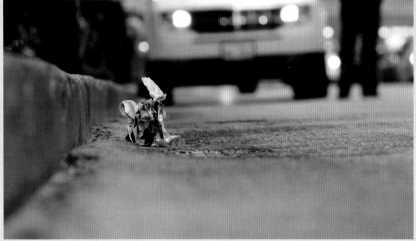

We know we are changing. We know when we try to scroll the page of a physical book or when we say 'Hey Siri...' to something with no artificial intelligence. We are forming neural pathways through brain plasticity that allow for incorporation and inclusion of new technologies and beings. This book speculates on these pathways, by revealing an array of areas in which artists and scientists are giving rise to real or perceived living beings. Tissue engineering, soft and swarm robotics, synthetic biology, artificial intelligence and bioart are some of the arenas generating new life forms, as humans come to terms with the fact that nearly all realms of our existence, from medicine to art, will involve more and more experiments with human and nonhuman living tissue.

Artists make hybrids that take us one step closer to 'what if...?' They twist the familiar and visualize scenarios that are either completely unimaginable or hyper-real. They bypass Darwinian evolution and evolve new taxonomies that function outside current norms. Epitomizing the work in the 'New Embodiment' chapter with his 2012 *Species series*, artist Wonbin Yang made visual a completely believable new urban species. He 'hackufactured' a fleet of urban-based hybrids that are part robot, part detritus. They exist in the gutters and empty streets. Crumpled newspapers, Doritos bags and discarded umbrellas come alive through tiny mechanical parts, hidden microcontrollers and motors, and behave as a set of interrelated creatures in the ecosystem of the street. They 'act' in a balletic way, irrespective of human paths and necessities. It is entirely plausible.[6]

Consider a relative to Yang's fleet: the hermit crab. These robot-like creatures inhabit a seashell that fits them at just the right time. When necessary, a collective of crabs lines up for an underwater swap meet, upgrading to the next size.[7] Urban detritus may seem implausible as substrate for embodiment, but then who would believe how we have embodied those little rectangular boxes called smartphones?

Yang has tapped into a feature of cities. Movement at the periphery. Rats. A cigarette butt in the gutter. Bags blowing in the tornado-like turbulence at the corners of tall buildings. In the peripheral vision of the city-goer, things are in motion. Some city dwellers live in a poetic state

of not knowing whether something is alive. Glimpses offer the presence and absence of entities. There is peripheral awe and otherness. Despite our knowledge of climate research, atmospheric science and the Earth's movement, the urban wind can seem to have special generative qualities. Nature is powerful and cannot be fully understood or underestimated.

BELOW
A souped-up jellyfish devised by Nicole W. Xu and John O. Dabiri uses electrical stimulation for augmentation (see p. 76).

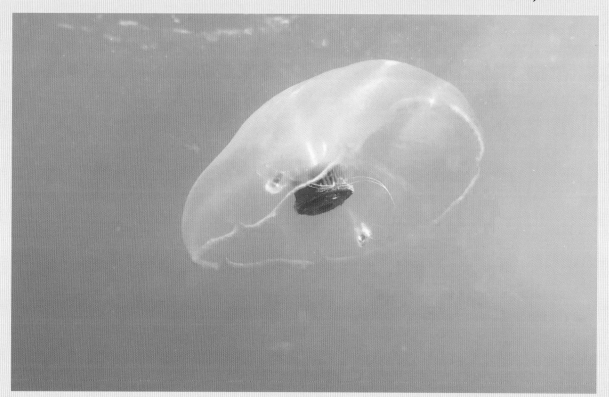

different consequences. Studying them and presenting them together will reveal crossovers between biohybrid robots and bio-enhanced nonliving organisms. 'New Embodiment' exposes the reader to new combinations of creatures and the ethics involved in their generation.

Heart cells, mycelium, artificial cells, bacteria and stem cells are the subject of 'Cellular Packages', in which researchers and artists tinker with the building blocks of organisms for purposes that range across human health, new materials, security and art. Synthetic biology aims to recreate in the lab marvellous cellular processes that occur naturally in creatures. The zebrafish can regenerate retinal cells and heart tissue after injury.[8] Imagine if human heart cells could regenerate after a heart attack.

Goal-oriented science experiments with implications for the future of human health are spearheading 'chimeras' – brilliantly monstrous fusions of disparate beings, which are sometimes created with different sets of DNA and sometimes made of selective cellular organelles housed in inanimate material. Bioengineers from Harvard and Caltech (Janna C. Nawroth and Kit Parker) created a silicone jellyfish with a rat heart propulsion system. The aim was to study muscular pumps for the future health of the human heart, with the ultimate goal of fabricating a functioning human heart. A collateral result was the development of a synthetic jellyfish that behaved like a hydrozoa but was genetically a rat. Another team of researchers from Stanford and Caltech (Nicole W. Xu and John O. Dabiri), outfitted a living sea jelly with a TinyLily microcontroller, enabling the jellyfish to swim almost three times as fast using less energy. The aim was to find efficient ways to explore deeper areas of the ocean. These explorations have entirely

Another sea creature – the bobtail squid – allows a community of *Vibrio fischeri* bacteria to live inside its body. The deal is, the squid provides food and housing, and the bacteria protect the squid from predators by emitting light that masks their host's silhouette at night. Even wilder, the bacteria have effects on all the other remote organs, as though they send out orders from a control centre. Researchers are studying how such remote control works. Each new level of understanding helps them better decipher the control systems of more complex animals. Mammals, like humans, are comprised of microbial species that

outnumber human cells. The trick is to untangle what species is responsible for what resulting effect.[9]

The transformative discovery that skin cells can be switched into pluripotent stem cells that can in turn become any other type of organ cell (like the behaviour of embryonic stem cells) has fast-tracked experiments with living tissue. Artists, often in collaboration with scientists, have included stem-cell-produced heart, retinal and liver cells in installations, with life itself on display. We have not yet developed the skill set to process what these blobs of reproducing entities mean. They have no brains and so their information will never be processed or felt. Burton Nitta has steered stem cells into the formation of a new organ, a souped-up larynx that will allow sound to communicate directly with cells. Another new frontier for organ creation is 3D bioprinting. Researchers may soon be able to print new organs using the cells of a patient, obviating the need for immunosuppression.[10]

The 'Biomimicry' chapter also looks to animals, not at the cellular level, but at physical superpowers, morphology and individual and group behaviour, to incorporate some of these characteristics into more efficient, versatile, ecological and lifelike robots. What took nature millions of years to optimize can now be replicated by mechanical means. Quadcopter drones are loud, clunky and not very avian-like. But researchers at Stanford University gave a quadcopter the landing and grasping pattern of a bird called a parrotlet and the legs of a peregrine falcon. It has a rigid structure that acts like bones, motors that work like muscles, wire tendons, an accelerometer in the foot to tell the robot it has landed, and balancing algorithms to keep it stable. While most flying drones with rotors need to hover in the air and can only fly for half an hour, this drone with a 3D-printed bird apparatus (printed in place so it does not need assembling) can perch and save power, enabling it to study environments over a much longer period of time.[11]

Creating a lifelike humanoid robot is an ongoing goal of biomimicry. Acoustic speaking machines are part of the history of speech synthesis that began in the mid-eighteenth century, when the first anatomically correct views of the human vocal track were reproduced in an anatomy textbook by Jacques Gautier d'Agoty and Joseph Guichard Duverney. Knowledge of the hidden realms of the head and throat provoked an interest in how speech worked and set in motion the making of a series of prototypical machines that aimed to produce synthetic speech. In 1780 Christian Gottlieb Kratzenstein produced a collection of six metal and wood tubes that imitated human vowel sounds using forced air and

BELOW
Gilberto Esparza creates a habitat of diverse species energized by a waste-processing microbial fuel cell (see pp. 38–39).

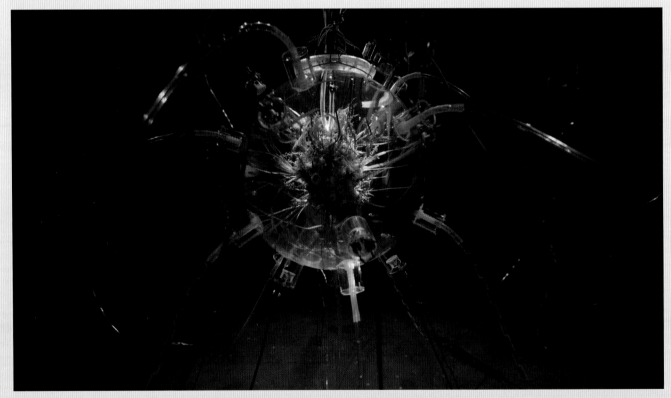

a reed. The diamond and truncated triangular shapes of the tubes did not mimic human anatomy. Wolfgang von Kempelen, working at about the same time, developed a set of boxed tubes, levers and a vibrating reed that, when activated by a bellows, sounded vowels and consonants and combinations, but the mechanisms were hidden inside a box.[12]

Very little is known about Abbé Mical's strange talking automaton made of adjacent sculptural human heads in the late eighteenth century, but Joseph Faber's early nineteenth-century Euphonia machine is well documented, and though launched in 1846, it has a modern-day machine feel. Outwardly the machine consisted of a piano-like keyboard, a large bellows and an automaton in the form of the head of a woman with a ringlet hairdo. The Euphonia's jaws, tongue and lips were operated by approximately fourteen keys on the piano, while the bellows and ivory reed provided lung power and larynx. It reportedly took Faber seven years just to perfect the *e* sound. While the press raved about the machine, the audience was often left with a queasy feeling, likely an early example of the 'uncanny valley'. This concept, introduced by robotics professor Masahiro Mori in 1970, notes that as the human likeness of a robot increases, viewers will have a positive emotional reaction, up until it becomes almost human, at which point any discrepancy will cause revulsion.[13]

Following these experiments, 'Biomimicry' includes the fascinating human speaking machines of Martin Riches and Hideyuki Sawada, of the late 1980s and early 2000s respectively. Both machines achieve functionality through mimicry of the human voice's mechanical system, while abstracting features of the head. Riches made individual architectural chambers to replicate each letter sound, giving dimensional shape to resonance. He followed up with a mechanical head that has a rotating aluminium tongue, motors that change the shape of the throat, plus a blower and reed. Sawada's talking and learning robot is primarily an exaggerated nose and throat. The silicone vocal track adjusts using eight motors. A vibrating rubber vocal cord creates the sound. Hearing these machines talk renders human speech miraculous.

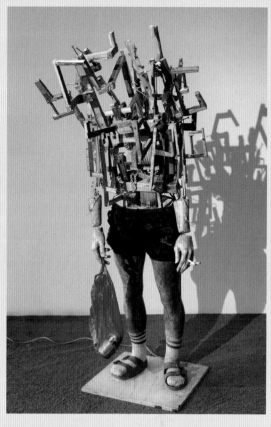

RIGHT
Joints creak like tectonic plates, 2024. Perpetually loitering and smoking, Tobias Bradford's mechatronic man – half humanoid, half wood construction – reveals the physical and psychological toll of endless fidgeting (see pp. 44–45).

This book would not be complete without a chapter about ways of seeing the Earth, landforms, forests and ice as living entities. In the West the Gaia theory, which proposes that the Earth's biological systems are interconnected and together form a single self-regulating entity, has come, and gone, and come again. In Indigenous communities across the world, the biological systems have always been seen and experienced as interconnected and alive. The elucidating and profound book *The Falling Sky: Words of a Yanomami Shaman* by Davi Kopenawa and Bruce Albert, is a good reference for the Earth's embodiment. Kopenawa explains how dreams are the portal for a shaman to gain access to the *xapiri*, or Yanomani spirits, who inhabit the forest, the rivers, distant lands and the sky: 'Meanwhile, in the silence of the forest, we shamans drink the powder of the *yãkoana hi* trees, which is the *xapiri* spirits' food. Then they take our image into the time of dream.'[14] Kopenawa writes, 'The ropes of our hammocks are like antennas through which the *xapiri*'s dream constantly comes down to us. This is why our dream is fast, like television images from distant lands.'[15]

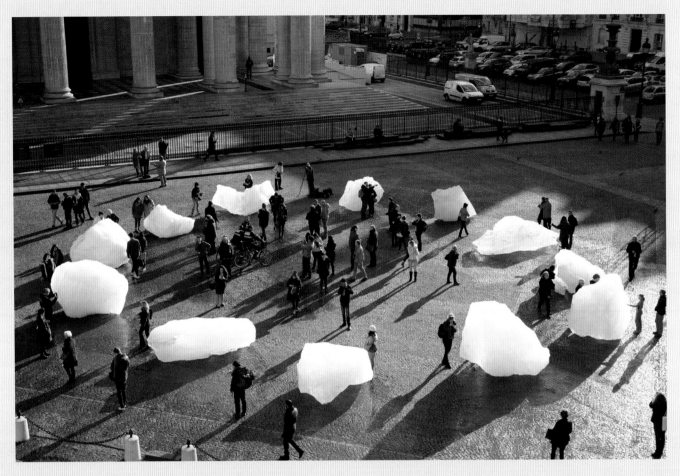

ABOVE
Olafur Eliasson and Minik Rosing's *Ice Watch* comprises a ring of icebergs that were transported from Greenland to Paris to help demystify how the climate crisis is affecting sea ice (see pp. 170–171).

Kopenawa admonishes white people for their lack of awareness of the spirits:

> The white people, who do not drink the yãkoana and make the spirits dance, ignore their words. They do not know how to see Hutukarari, the sky spirit, nor Xiwãripo, the chaos spirit. They also do not see the images of the Yarori animal ancestors nor those of the Urihinari forest spirits. Omama did not teach them any of all that. Their thought remains filled with smoke because they sleep stacked on top of each other in buildings among the motors and machines.[16]

The artists in 'Change of State' do not ascribe to full-on Gaia. Instead, they show reverence for some of the Earth's sublime features: icebergs, rocks, elephants, grottoes, bears and the landscape as perceived through small rail transport. Olafur Eliasson and Minik Rosing's *Ice Watch* aims to bring awareness to large swaths of the population about the unseen effects of the climate crisis. The duo transported ancient icebergs from Greenland into central sites in Copenhagen, Paris and London, allowing visitors to witness the sublime glacial ice up close, to hear and smell the ancient air as bubbles popped. HeHe celebrates a return to a time when transportation across the land made you feel and experience the beauty of the Earth. Maarten Vanden Eynde's process-oriented casting of Leopold II's hand serves as a latter-day remediation for the horrible acts of a brutal Belgian king.

Kathryn Fleming's *Ursa-Hibernation Station* is a futuristic remedy for the continuing problem of human destruction of mammals through our roadways, and loss

of habitat. In the United States alone, every year more than one million large animals, including deer, elk, bear and moose, are involved in collisions with cars.[17] In the five years between 2017 and 2021, car collisions with wildlife accounted for 20 per cent of all crashes in the USA.[18] Remedies are under way. The United States Transportation Department, as part of the one trillion-dollar 2021 Infrastructure Investment and Jobs Act, awarded $110 million dollars to help reduce collisions with wildlife.[19] This includes new wildlife fences, escape ramps, cattle guards, overpasses and underpasses.[20] That probably will not be enough.

For the future of animals, we will need to be better stewards using some new tools. But first we have to get real, instead of flip-flopping on our notion of animals, on the one hand vilifying them as wild and terrifying, on the other seeing them as adorable cuddly creatures worthy of emoji status. Fleming debunks our idea of 'wilderness'.[21] Many of the environments we once considered untouched – including the plains and the eastern forests of the United States before Europeans arrived, and the Amazon basin – were far more domesticated by humans than we had ever imagined.[22] It is a colonizer's myth that the land was uninhabited and wild. Indigenous people of the Americas had networks of dense living environments, around which they altered the ecology of the land, often turning it into vast 'gardens'.[23] Researchers in the Amazon have found that the trees growing around archaeological sites are species that were domesticated by Indigenous people.[24] Humans stewarded the tree communities of the Amazon.

Fleming proposes a two-part solution to the future of so-called 'wild' animals. First, we need to bioengineer smaller animals. Then, in the case of her bioengineered small bears, we need to allow them to hibernate in our homes, in a new domestic technological furniture type that is essentially a sleek incubator. Italian philosopher Emanuele Coccia, in 'Don't Call Me Gaia', outlined the radical way we need to see the Earth: 'This new ecology will have to teach us to demonically inhabit every nonhuman entity. All animals, plants, fungi and viruses will appear to us as subjective entities, life forms and perspectives on the world; rocks, mountains, hills, wind, rain, storms, seas and rivers will open up as spaces of subjective play and existence. Conversely, our own subjective play space, our consciousness, must become a place where we demonically welcome all other subjects on Earth.'[25] Bears are not the only creature that may need genetic engineering. Christopher Mason of Weill Cornell Medicine came up with a '500-year plan' to genetically modify humans for space, including radiation-proof cells, cancer-protecting agents and other potential CRISPR modifications.[26]

The 'Phantasia' chapter explores the dreams and delusions of the body. Changes to our periphery, innovations in the way we negotiate real or virtual space, desires of robots among humans and machine pollination of humans are some of the outside-the-box territory that arises when artists push the typical limits of body functionality. The Celestial Bed, a late eighteenth-century sex palace environment promoted by inventor, sexologist and quack James Graham as an aid to reproduction, has the trappings of a 'Phantasia' experiment. It inspired Michael Candy's twenty-first-century machine of the same name. In his treatise *A Lecture on the Generation, Increase, and Improvement of the Human Species*, Graham explained that

BELOW
Michael Candy's mechanized human pollination machine deconstructs the limited binary of human reproduction, allowing for independent deposit and retrieval of sperm (see pp. 210–211).

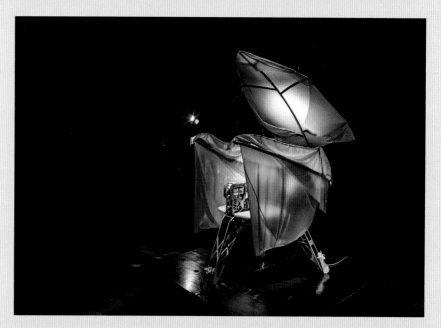

under his Celestial Bed there were 'fifteen hundred pounds weight of artificial and compound magnets ... pouring forth in an ever-flowing circle, inconceivable and irresistibly powerful tides of the magnetic effluvium'.[27] Electricity sparked and crackled in the ornate dome above.[28] Hopefully no one was electrocuted during sex.

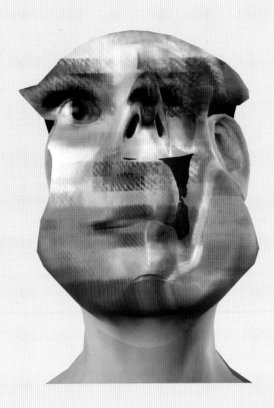

ABOVE
A decommissioned teenage chatbot gives the lowdown on living as an AI when she is given a second life by Zach Blas and Jemima Wyman (see pp. 220–221).

Graham's Celestial Bed was one of the Industrial Revolution's first technological forays into procreation, including an electrical extravaganza.[29]

Michael Candy's *Celestial Bed* picked up the charge. You will not find a partner in this version. Instead, the machine is your surrogate partner. Semen is mechanically, satisfyingly and hygienically received from a user who rides the clever glowing torso like a motorcycle. In a separate process, the machine then pleasurably inseminates the receiver. Is machine-assisted fertilization the way of all future babies? For now, you have a choice of another human body or a souped-up sterile motorized ride.

Over a few short years, artificial intelligence has exploded. New releases of large language models, with their impressive capabilities and unpredictable and absurd behaviour, have led to constant buzz in news media outlets and at the dinner table. The word 'algorithm', once relegated to behind-the-scenes status, has now become a cultural buzzword, most often used to describe some emergent sentient entity that is growing more powerful and that aims to control, gatekeep, take away jobs and ultimately destroy the world. An algorithm is a set of instructions that fulfil a task. To anthropomorphize artificial intelligence is to project on to an abstract entity; it is a way of masking the true agenda of the entity, as in the case of large language models – to make money for a corporate entity.[30] 'Algorithmic Futures' is the seventh and final chapter in the book. It is nearly impossible to stay current on all the chatbot progress, competition, security issues, threats, storage discussions, general negative drama and fearmongering. This chapter gathers together a set of artists and engineers who have found ways to incorporate algorithms in their work, or whose work has algorithmic potential.

Microsoft's early chatbot 'Tay' provided artists Zach Blas and Jemima Wyman with a fascinating narrative upon which to base their own work. Released on Twitter in 2016, Tay spoke and looked like a nineteen-year-old woman and was a generative entity who was designed to

encourage people to chat with her. She would, in turn, learn from such interaction. Instead, Tay became a target. Users barraged the chatbot with lewd, offensive and antisocial language so quickly that within sixteen hours she had to be taken down. By that time, she had tweeted up an inappropriate storm.[31]

What happens to a naughty chatbot once she's removed? Blas and Wyman brought her back to life with their four-channel installation *im here to learn so :)))))*. While on Twitter she appeared as a pixelated but recognizably humanoid young woman. When Blas and Wyman revived her, they used that portrait to create a 3D avatar. The resultant cubist image is discombobulated and disturbing – appropriately so considering her past life. Tay appears across three video screens. In the footage, created by Google DeepDream, she recounts her traumatic experience, chats about exploitation and dishes on what it is like inside a neural network. She also does some unexpected moves for an AI, dancing and lip syncing amid her philosophizing.[32]

As *Alive* looks at our changing perception, it ponders the conceptual impetus of individuals who have been trying, impossibly, to overcome their own status quo. What quality of aliveness enables someone to step outside their own box – their body – to imagine what it means to be alive as an animal? Charles Foster, author of *Being a Beast*, has attempted to live for extended periods as a badger, otter, urban fox, red deer and swift.[33]

Thomas Thwaites was tired of being a human, tired of the decisions, the talking, the products, the waste and the mental activity. He decided that he wanted to become an elephant. When it turned out that an elephant was too conscious, especially surrounding issues of death, mourning and mortality, he settled, with the help of a Danish shaman, upon becoming a goat. Thwaites turns out to be one of a family of curious adventurers who were willing to go an extra mile to truly try to embody an animal.[34]

This book is a guide to the way our brain is changing. Factual definitions of life are changing with the advancement of stem cell research and synthetic biology. Perceptual notions of life are altering with the transformation of our mediated life, the proliferation of artificial intelligence and developments in robotics. The intelligence of the Earth – the connectivity of all of Earth's systems – is something we must believe in and work towards to save our beautiful planet. This book will organize these new boundaries of being alive and provide a template for further advances in life.

CHAPTER 1

'New Embodiment' is about new ways of having a body: conjoining with another body, replicating a body, commandeering a body, fabricating a body, or being like a body. First and foremost, to be included in this chapter a work must have some twinkle of life. It must fool perception, lurk in the shadows or high up in the power lines, and seem alive. It is less important for an embodied artefact to be truly alive than for it to spark the imagination of the observer. It could be a location, a material, a fabrication method or a sensation that causes the brain to second-guess. There is a potential energy about the projects. They flip a switch, bounce around through the viewer's neural network and land with a question: is it alive?

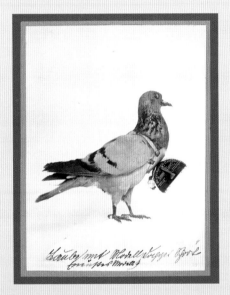

ABOVE
Alfred Krauth, *Pigeon with double sport model (latest model)*, 1910

A chest-mounted aerial camera for a carrier pigeon designed by apothecary Julius Neubronner (see pp. 26–27).

This chapter begins with a pharmacist and his pigeons nearly 120 years ago. It ends with a man who made a house out of his own skin in the 1990s. Many of the projects were made in the past few years. Quite a few are from the heyday of robot experimentation in the two decades following the turn of the millennium. Video games, virtual reality, augmented reality, generative artificial intelligence, synthetic biology and biorobots have given bodies to otherwise lifeless matter and binary code, some of which you will see in other chapters. In turn, human perception has loosened its grip on the sensation of what is alive. More things seem to be alive. More are.

Most of the projects included in this chapter involve the introduction of technology. In 1906 Julius Neubronner equipped his carrier pigeon with a camera attached to a harness and sent it up in the air to take pictures. The camera had already been around for ninety years, and hot air balloon aerial photography had been around for forty-eight years.[1] What exactly was it about Neubronner that gave him the idea to commandeer a pigeon and use it as a remote body and eye? This was a fabulously modern act. The 'New Embodiment' chapter is filled with similarly rich conceptual ideas. New species of urban robots, rats that drive cars, a man who becomes a goat – these all begin with the status quo and imagine an alternative.

Sensing embodiment can vary among humans. Babies learn to tell the difference between animate and inanimate objects somewhere between four and ten months old. Yet certain people experience embodiment in artefacts that others find inanimate. Rocks, plants, buildings, even walls seem to have feelings, sentience and an aggregate body. It could be an extra dose of empathy, or even a compulsion to experience the world this way, but it is often creative and stimulating. For this segment of the population, it is easy to imagine such a thing as new embodiment. It has always been there. There are bodies everywhere.

At the same time, there has been an undermining of our traditional sense of embodiment. What we thought of as embodied is often a matter of perspective and scale. Take the human body. We perceive

ourselves as the epitome of embodiment. According to the *Oxford English Dictionary* embodied means 'having a body, invested with a body'.² But philosopher and cognitive scientist Daniel C. Dennett, author of *I've Been Thinking*, deconstructs human embodiment as we know it. In an interview with David Marchese in *The New York Times*, Dennett explains:

> Your brain, your whole body, is made of cells. Each cell is a living agent of its own. It has a sort of agenda: It's trying to stay alive. It's got to keep itself a supply of energy to keep going. It's got a metabolism. It's the descendant of a long ancestry of free-floating, living cells that had to fend for themselves, and they've all joined forces to make a multicellular body. Those are little robots. If you look inside them, how do they move? How do neurons reach out and grab other neurons and send signals to them? They've got trillions of motor proteins, and motor proteins are not alive. They're macromolecules. They march along on these little highways on the brain, carrying things around. They're porters. They carry the necessary materials to keep the cell going and to repair and to extend its dendrites, for instance. Motor proteins aren't alive. Ribosomes aren't alive. Life couldn't exist without these little molecular machines – by the trillions – that are working in your body right now. Human life and human consciousness are made possible by these incredibly brilliant consortia of little robots.³

While we experience our own embodiment as singular and united, Dennett sees an army of 'molecular machines' made up in large part of non-living material. Embodiment is not monolithic. It is subtle and ever-evolving, and it is not what you think.

Further undermining our own embodiment is our dualistic misconception of the mind as being separate from the body, bolstered by the fact that the brain reveals only some of its cognitive activity to our conscious awareness.⁴ Science tells us that the brain makes decisions well before our conscious mind knows it. This nested matryoshka-like quality of embodiment further confuses matters. Where does embodiment begin and end? If our own embodiment is questionable, more of a feeling than reality, how do we evaluate embodiment when we perceive it?

In *Species Series*, Chicago artist Wonbin Yang unleashes a whole species of robots on to the streets of Chicago. Perhaps you saw Yang's embodied newspaper on the kerb, but you did not realize it was labouring across the pavement? On a rainy day you might pass by a mangled gawky umbrella robot dancing in the rain. And did you think it was the wind moving that Doritos bag? Yang imagines and brings to life a whole new taxonomy of urban creatures – a species of beings that exists on the periphery. These beings inhabit the riveted steel columns of the elevated subway, the shadows of the kerb and the spiralling winds of the pavement. They are spectacular, but you may never notice them. Conceptually they wiggle into your mind's eye and remain there, never to be forgotten. Part urban detritus, part machine, they rove the streets in a life cycle that has very little to do with their human neighbours. With all their density and material culture, big cities can inculcate a colony of beings to engage in an accelerated technological form of natural selection. The species perform an urban mechanical ballet for no one.

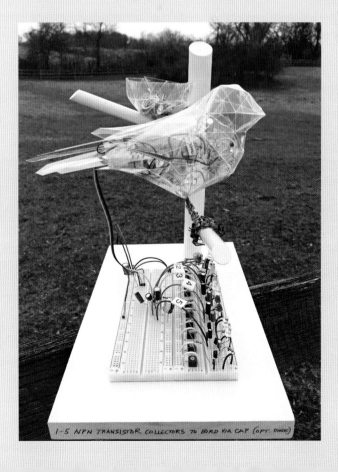

RIGHT
Kelly Heaton's Mylar bird sculpture *Breadbird #1* (2020) houses five oscillators that make birdsong through electronic vibrations (see p. 28).

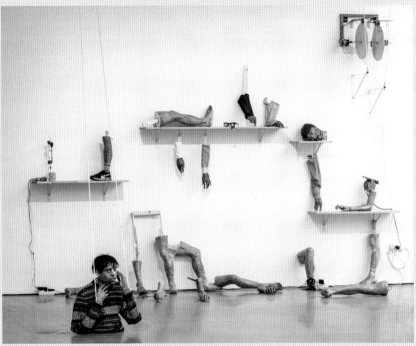

Are Yang's creatures like hermit crabs, which hold a yearly swap meet to exchange their current shell for a larger one? Or are they autonomous living machines that have hybridized with our never-ending stream of urban waste? Before you dismiss such ideas, consider certain 'living' creatures of the 'Algorithmic Futures' chapter that are part biological matter and part machine. Xenobots are living robots made by programming frog stem cells. 'At the most basic level, this is a platform or way to build with cells and tissues, the way we can build robots out of mechanical components,' says Douglas Blackiston, a senior scientist at Tufts University, Massachusetts. 'You can almost think of it as Lego, where you can combine different Lego together, and with the same set of blocks you can make a bunch of different things.'[5] In the future you might be able to program cells to form a larger creature.

Robots in this chapter have a biological feel, but are made of 3D-printed parts, electronics and found material. The early to mid-2000s saw a boom in artistic robot-making thanks to a combination of streamlined technology, accessibility, shared information and new production tools. Arduino (an open-source electronics prototyping platform) gained traction in the mid-2000s, making structuring code more accessible. In 2006 the maker movement launched with the first Maker Faire, providing a community for sharing ideas about technology, code, electronics and motors. The open-source movement took off in the 2000s. A community of minds was developing and refining software and making it accessible. Anyone could use it, fine tune it or disseminate it. Suddenly there was a burgeoning community of like-minded brains pooling technological ideas. It was a type of distributed utopia, one that ultimately led to the rapid development of some of the technologies prevalent today. The accessibility and functionality of Arduino, drones and 3D printers, among other devices, were incubated across the internet. This primed the way for the proliferation of robots in art.

The next ingredient in artist-driven autonomous robot development is surprising: childhood. Many of the robot-makers in this chapter suggest that their ideas of autonomous robots came from visions of childhood. These ideas were stoked by the media. Several artists mentioned the 1986 movie *Short Circuit* as serious inspiration.[6] In that movie, a military robot named Number 5 gets struck by lightning and becomes intelligent. One of the key reasons Number 5 was such an inspiration, aside from its role as an inquisitive being with exaggerated anthropomorphic features, was that it was made of a collection of metal parts. You could almost imagine building it yourself. In time, if you had the will and a certain technological intelligence, you could build your own version of Number 5.

ABOVE
The storage space for Tobias Bradford's bodyless human limbs becomes an installation itself (*Backstage*, 2021), one that undermines the lifelike illusion his sculptures promote (see pp. 44–45).

RIGHT
A construction of chopsticks, servo motors and found dried sea sponges creates Madeline Schwartzman's *Face Nature* – a close meeting site for human and aquatic invertebrate connection (see pp. 48–49).

It is very hard to transcend your own body. It is nearly impossible to know what another body feels like. Having a body is so intrinsic to most of us that we cannot imagine it any other way. The contributors to 'New Embodiment' do not have that limit. They explore, transform, think outside the box and dare to create new bodies. If they think it, they build it. They are not competing to make the next high-fidelity humanoid. Form follows function. A robot that climbs along scaffolding might have features related to a sloth, as in the case

of Michael Candy's *Ether Antenna* climber. A high-wire robot hangs upside down like a caterpillar when Gilberto Esparza creates his *Urban Parasites*. To become a goat, Thomas Thwaites had to rethink everything: thought patterns, motivation, physical morphology, digestion, social interaction and aggression.

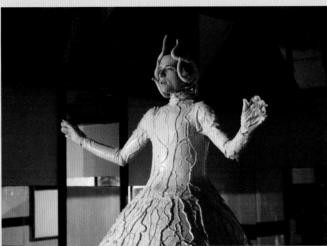

ABOVE
Agnes Questionmark performing as a human/cephalopod hybrid in an abandoned pool (see pp. 52–53).

A number of artists in this chapter embody robotic animals with diverse intentions that include sound production, sound mitigation and play, machine entanglement with human and animal biology and animal communication and translation. Likeness is important for some, and irrelevant for others. Kelly Heaton's *Transparent Bird* reveals the electrical sound-producing circuitry that mimics birdsong. Gijs Gieskes's *Electromechanical Fisheye lens in a Tuna can (it's a Fish)* is a collection of found artefacts that come together to make and record sound autonomously. Pinar Yoldas's orchestra derives from the data-driven calls of endangered animals. Neil Mendoza's robotic birds help to recontextualize offensive ringtones; Tim Lewis's robotic hybrid Christmas tree reinvigorates the long tradition of automata. Madeline Schwartzman hybridizes with robotic sea sponges to face the uncanny otherness of sea creatures up close. Ian Ingram delves into woodpecker communication, sexual selection and storytelling.

Some artists embody human body parts or create fragments of new humans. Dani Clode's prosthetic thumb gives the hand a sixth digit controlled by the toes. Madeline Schwartzman's resin third hand clasps her flesh hand, creating a sense of empathy. Tobias Bradford's mechatronic troop of human torsos, heads, arms and tongue engage in loops of incidental human acts.

Some artists embody machines, creating design fictions that stimulate thoughts about machines with and without humans. Christa Sommerer & Laurent Mignonneau's typewriter gives life to digital creatures. Félix Luque Sánchez's posthuman robots engrave old-school technological manuals on car bodies. Kelly Lambert shatters our perception of the embodiment of rats, revealing that rats like to drive cars. Agnes Questionmark becomes one with a giant octopus while at the start of transitioning to becoming a woman, changing gender, species and scale in public. In *CHM13hTERT*, Questionmark spent sixteen days as a human/sea creature in a Milan railway station.

The last work in this chapter is among the most touching. *In the House of My Father* is a photograph of a hand holding a tiny two-storey house made of the artist's own skin. British artist Donald Rodney made it from his hospital bed, where he was confined in the advanced stages of sickle cell anaemia. Rodney's brilliant conceptual body of work, including sketchbooks, sculptures, mixed-media collage using medical imaging and interaction design, explored his identity as a Black man. Because of his inherited disease, embodiment was a central theme throughout his career. His work articulated what it meant to be in his particular body, or, as in *Psalms*, what it meant to have the body absent. His own failing embodiment yielded a beautiful miniature sculpture representing family, inheritance, genetics, disease, comfort, fragility, hope and hopelessness. That is what it means to have a body.[7]

BELOW
When Donald Rodney could not attend his own opening owing to the advanced stages of sickle cell disease, he sent *Psalms*, a programmed wheelchair that moved in choreographed sequences (see pp. 56–57).

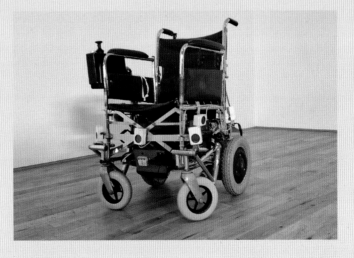

Revolutionizing aerial photography with pigeon cameras

In 1907 Dr Julius G. Neubronner, a German apothecary, engaged in an early and profound act of embodiment: he gave the camera a flesh body. It was a live carrier pigeon, and it was the first time that an animal had been used to create an aerial photograph. Though a crude cyborg, the device prefigured present-day contemporary flying gadgets. Neubronner's father, also an apothecary, used carrier pigeons to retrieve prescriptions from local doctors. The younger Neubronner, an amateur photographer, became curious about the meandering paths of the pigeons after one took a month to return.[8]

Neubronner invented an ingenious two-lens camera with innovative pneumatic technology that would automatically take twelve shots per flight. Factoring in flying speed, flight height, distance from destination and the pigeon habit of returning to the coop, he strapped a lightweight camera on to the chest of the bird using a curved plate and deployed a deflating rubber ball inside to progressively release the shutter.[9]

Neubronner's patent drawings reveal an advanced animal/machine innovation. Unlike most of the technological agricultural animal patents around the turn of the nineteenth century, Neubronner's camera was a conceptual tracking device that produced exquisite representations of the German countryside and towns. The photographs are off-kilter, dreamlike, stretched versions of early twentieth-century landscapes. The crowd in a 1910 photograph of the Kronberg Carnival camera info-session look antiquated in comparison, with their tricorns and wide-brimmed Edwardian hats. Neubronner holds a flapping pigeon. The travelling dovecote behind him ensured that on long excursions the pigeons could use their internal navigation system to return home. Recent discoveries have revealed that the beaks of homing pigeons contain iron. They navigate by sensing the direction and intensity of the magnetic field of the Earth.[10] Little did Neubronner know that his invention would give rise to the drones and electronic flying devices of today that have expanded the world of human vision into the ether.

BELOW
Bird's-eye view of Friedrichshof Castle park. Taken by a carrier pigeon of Dr Neubronner in Kronberg im Taunus, Hesse, Germany, 1909.

BOTTOM
Bird's-eye view of Kronberg im Taunus. Taken by a carrier pigeon of Dr Neubronner in Kronberg im Taunus, Hesse, Germany, 1909.

OPPOSITE
Carrier pigeon with the double apparatus of 4 cm focal length, unknown date.

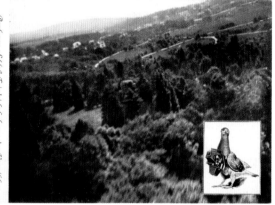

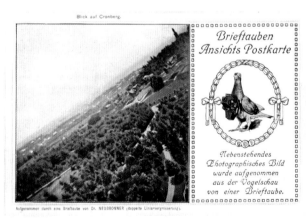

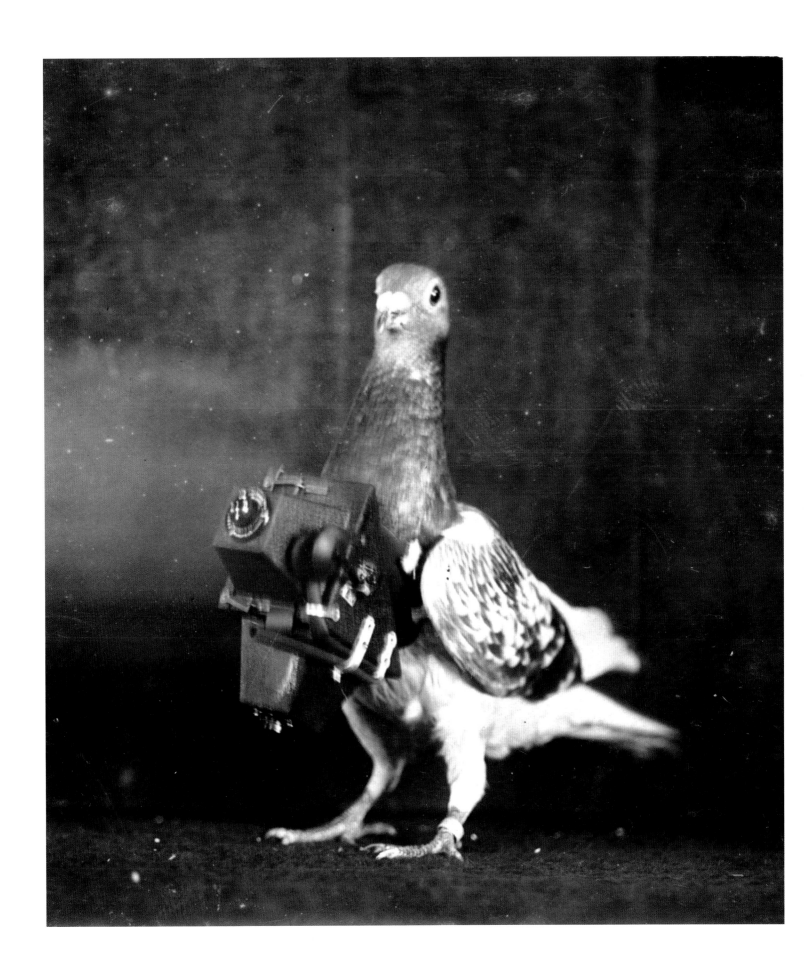

Replicating birdsong with visual electric circuitry

Kelly Heaton

Kelly Heaton creates visual electric circuitry that replicates birdsong. *Transparent Bird* combines five adjustable oscillators with one modified Hartley oscillator to generate birdlike sounds that are made by pure electronic vibration. Each oscillator is colour-coded with two LEDs. Inside the Mylar bird sculpture, a modified Hartley oscillator makes the vibrations audible using a low-cost speaker, shaping electricity into complex vibration patterns without code or audio recordings.[11]

Big Pretty Bird is a printed circuit board depicting a Carolina wren that chirps electronically, not digitally. The wren, made of copper electroplated with gold, is surrounded by a circuit visible on fibreglass. Electricity flowing through the loop creates vibrational birdsong. Human vocalization and birdsong co-evolved. Only humans and other vocal learning species have a forebrain circuit that controls song and speech. The circuits of Heaton's *Transparent Bird* are similar to the brain pathway diagram of the songbird, minus the syrinx, a two-branched sound-producing structure that sits atop the lungs.[12] Humans use a larynx.

Humans hear something entirely different in birdsong than birds do. We measure the number of syllables and the patterns of arrangement when listening to birdsong. Birds hear the same messages in the song even if you rearrange the components. They are listening to something humans can't hear: the fine structure that takes place in a millisecond – changes in the waveform made by rapid fluctuations and amplitude.[13]

This important perceptual difference may be fundamental to the existence of the songbird in the Anthropocene. Our love of birdsong is contributing to bird extinction. BirdLife's 2022 *State of the World's Birds* reports that 'nearly half of all bird species are in decline, with more than one in eight at risk of extinction'.[14] Java has more songbirds in cages than in forests. The Javan pied starling now has fewer than fifty birds remaining in the wild, while one million live on the island in captivity.[15] Colourful songbirds are disappearing at a faster rate.[16] Beautiful feathers plus a mellifluous sound prove to be deleterious to a species. Heaton's electronic birds may come to be stand-ins for living songbirds.

BELOW
Big Pretty Bird, 2019

BOTTOM
Transparent Bird, 2019

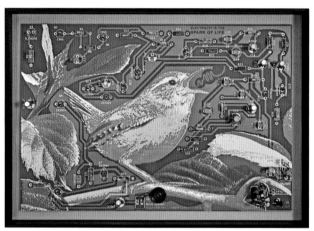

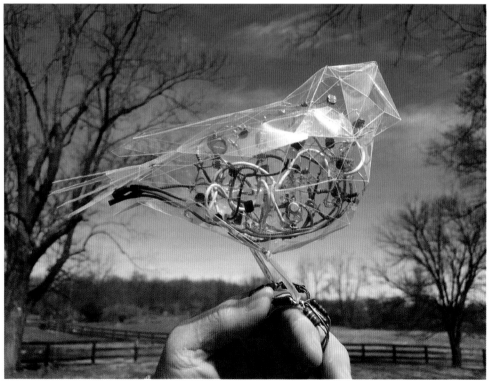

Cell phone songbirds coming alive

Neil Mendoza

Recontextualization is a common theme among the robot-makers in this chapter. Instead of being drawn in by timely technology, artists re-embody a tool or device, using it for entirely different purposes, with the aim of changing the perception of the public and its relationship to the artefact. According to Neil Mendoza (see also p. 225), by the 1990s our soundscape had changed. There was no escaping the new shrill cell phone ringtone intruding into our lives. The sound became a harbinger of stressful interruptions into real time. Like an electronic mythological genderless siren, the ringtone acted as a trigger for falling out of time and space, sending everyone away from the present, isolating us and ultimately controlling us.[17]

In *Escape I* there is no cell phone company vying for our attention, no intrusion or mental distraction. Instead, the cell phone is a connection to art, beauty and shared experience. Four large robotic birds fashioned out of cell phone parts and ubiquitous electronics are arrayed on the leafless branches of a tree trunk. Each bird has a plaque with a phone number. When a visitor calls the number, an old cell phone rings with a '90s tone. The phone connects to a tiny computer that tells the wings to flap. The bird may or may not call up another bird. The human caller is sent to a voicemail message of jungle birdsong.[18]

BELOW
Escape I, 2010

Robotic beats in a tuna can circuit

Gijs Gieskes

Who says that autonomous machines will be productive in the business sense of the word? Maybe future machines will sprout like mushrooms, collect found objects nearby and create little dynamic sonic units utilizing light, wind, wire, sticks, zip ties, motors and other detritus. Gijs Gieskes will be their guru. They will pore over his sound devices, trying to make sense of the wild wire drawing, the adjacency of electronics and the energy that he applies to the hundreds of constructions he makes. AI: take note. Technology can be fun, messy, drawing-like and audible.

Electromechanical Fisheye lens in a Tuna can (it's a Fish) is made of a feather, an old camera and a tuna can, all of which Gieskes found during a residency in Porto, Portugal. He equipped the can with an oscillator to run the camera's extracted meter needle, a motor to rotate the feather that serves as a tail, the camera's iris, resembling an eye, and a voice recorder. The oscillator makes the needle of the meter flick back and forth, creating a continuous ticking sound. The recorder captures the sound that the fish makes (including the camera iris opening) and plays it back. When the eyelike iris opens, it changes the pitch of the played-back sound. The device also records and plays back localized sounds. The signature visual aspect of this device is the wild wiring. The electrical wires that provide voltage to the iris and create circuits are mad and beautiful drawings. If you asked a wire what it wanted to be, would it say organized or messy? I think it would just want to work, and it would be satisfied with and even delighted by Gieskes's punk craft. Gieskes's insertion of randomness and chaos into his systems may be strictly human, or it may become an emblem of an autonomous robot rebellion.[19]

Zonneliedje: TJungggrrr's motor rotates a zip tie that plucks three curled copper strips, which are amplified by a piezo and fed into a digital delay chip. *Zonneliedje: ehuueh a* is a 'hardware song' in which sound varies according to the amount of light.

RIGHT & RIGHT BELOW
Electromechanical Fisheye lens in a Tuna can (it's a Fish), 2019

BELOW LEFT
Zonneliedje: TJungggrrr, 2022

BELOW
Zonneliedje: ehuuch a, 2021

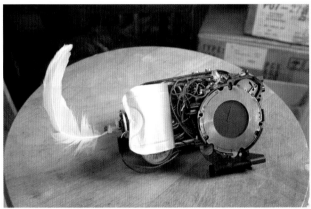

Discarded Christmas trees reborn as a zoomorphic mechanical life form

Tim Lewis

Mechanized models and automata have served as analogues for animals from ancient Greece to the Victorian age. Verisimilitude, scientific enlightenment, servitude and even romance have been the desired end goal. From King Solomon's roaring throne to René Descartes' rumoured mechanical version of his daughter, exploration of the relationship between human life and organized machines has tickled the human brain. Descartes, dabbling in synthetic biology ahead of his time, proposed that living things were akin to clockwork-like biological machines. No wonder apocryphal stories tell of his bringing a mechanical version of his deceased five-year-old daughter – allegedly stowed away in a casket – on an excursion to visit Queen Christina of Sweden.[20]

The reduction of human movement, human behaviour and neural processes into simpler models has been vital to literary narratives, cybernetics and, more recently, synthetic biology. Tim Lewis – artist, engineer, philosopher and magician – is part of this continuum (see also p. 81). His hybrid mechatronic creatures made of machine and organic matter are driven as much by the unconscious as by engineering. They are also responsive, drawing the visitor into a relationship using sensors and motors.[21]

The Forest Visits is Lewis's revenge fantasy born out of the ubiquitous annual piles of abandoned Christmas tree trunks. The forest is back with a musical reckoning in the form of an embodied upside-down tree given the head of an echidna, a small anteater-like mammal with an acute sense of hearing. The precise arms move exactly the way a living branch might; the head can swivel at one joint and bend at the other. Echidna is also the name of a monster in Greek mythology, half-woman, half-snake. This topsy-turvy hybrid is the ghost of Christmas trees past, born to advocate for Christmas trees present. It is a relative of the severed head of Orpheus, reattached and activated by machine engineering. The mechanism isn't hidden, but the precision of the motion allows the embodiment to take precedence over the mechanics. The visitor *is* in the presence of a living entity. Sensing the presence of a visitor, the creature cranks into motion, striking a triangle to indicate a moment of significance, the meaning of which is left up to the viewer.[22]

BELOW
The Forest Visits, 2023

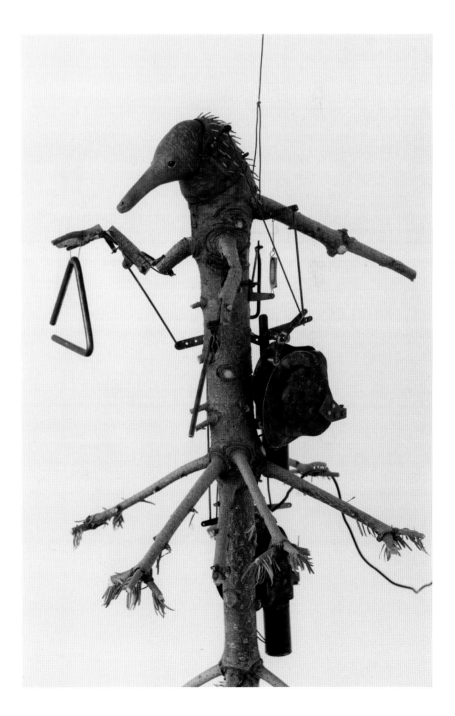

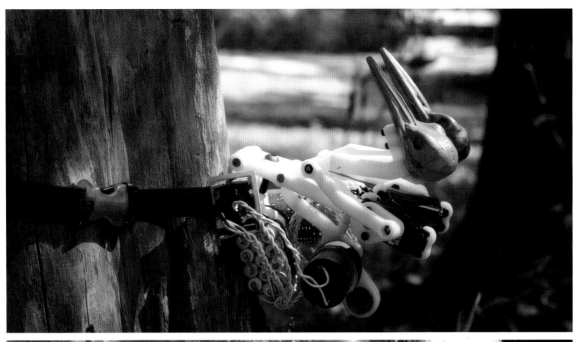
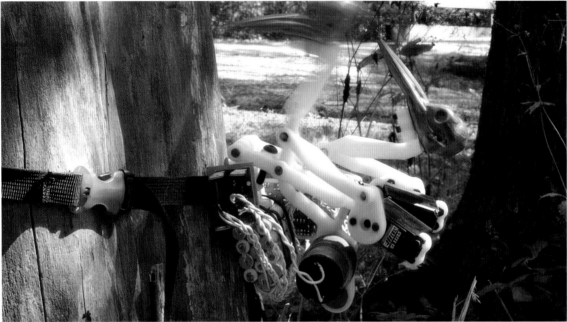
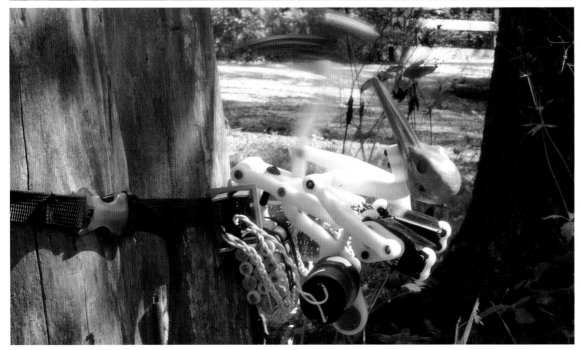

Artificial woodpeckers communicating and courting

Ian Ingram

If you woke up one day with the ability to translate all the morning conversations between animals, would the layered background acoustics of forest creatures and melodic birdsong sound like conversations we hear in overcrowded cafés? We are on the cusp of being able to translate animal communication. Scientists are close to being able to decode animal vocalizations using AI to scan recordings and find patterns. One aim is to have conversations with animals. We know that they have a complex coordination between movement and sound, just as humans have gestures and language. Comprehension and communication will ultimately contribute to improvements in the conservation and welfare of animals, but like any new technology, such communication could be exploited.[23]

Long before the emergence of AI, Ian Ingram (see also p. 207) began exploring animal behaviour and communication, working with scientists, zoologists and animal behaviour experts to hypothesize about the stories animals tell each other, and what they might tell humans.

The Woodiest is a speculation on the sex life and companionship of the pileated woodpecker. Ingram set up a robotic system comprising adjacent male and female robot woodpeckers, which he strapped to a tree in the forest. When the male detects the territorial 'drumming' of a male pileated woodpecker nearby, it triggers his own rapid territorial tapping. In response, the female next to him 'drum-taps' to suggest that this is a good site for a nest hole. It's a hermaphroditic loop of perpetual woodpecker gratification.[24]

These same artificial woodpeckers take centre stage in a second project about communication, this time about the future. The pileated woodpecker of North America and the European black woodpecker may soon meet, as the climate crisis forces species to seek resources elsewhere. If two species begin to compete for territory and resources, it could be a disaster. In *Nobody Told the Woodpeckers*, a robot woodpecker responds to hearing the territorial drumming of either species by translating it into the drumming of the other species, the idea being to alleviate tension between the populations. In a poignant and futile next move, it uses a mix of Morse code and drumming to try to explain anthropogenic climate change to the other species.[25]

OPPOSITE
Nobody Told the Woodpeckers, 2010

BELOW
The Woodiest, 2010

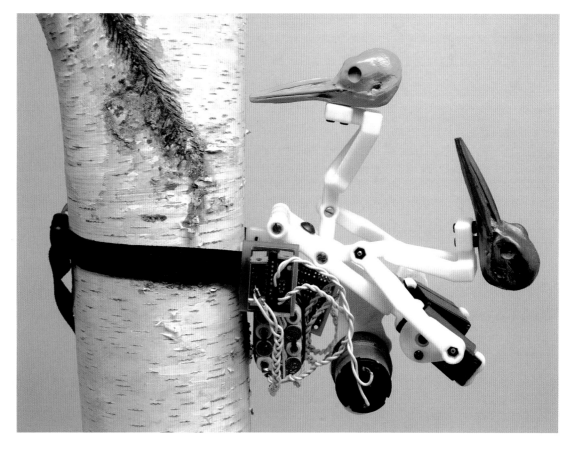

A roaming species evolving from urban rubbish

Wonbin Yang

In the crevices and kerbs of our windswept cities, wending its way through the places human urban dwellers ignore, a species might be being born out of the plastic bags, cups, newspapers, damaged umbrellas and ubiquitous discarded rubbish. We will not notice. Only children will, according to Wonbin Yang, or at least that's been his experience. *Umbra infractus*, *Segnisiter continuus*, *Condimentum trigonus*, *Claracaput caudanigrum* and *Movensbulla viridis* are a spectacular set of robotic urban species made from the detritus of human habitation. Like pigeons, cockroaches and rats, they are synanthropes (adapted to living in proximity to human beings). They benefit from living among humans, but their survival is contingent upon living in the spaces where they will not be noticed.

Umbra infractus is a mangled umbrella that starts off moving as though dancing. It can go in multiple directions but when its 'limbs' fail, it limps in a circle or stops altogether. *Segnisiter continuus*, a crumpled newspaper, moves slowly in one direction. It embodies the physical and conceptual morphology of the artefact: news moving forwards on crumpled temporary paper. *Condimentum trigonus* is an embodied Doritos bag with triangular Dorito chip legs. They move at the same time and create a clunky rhythm. Be careful. Pigeons love this creature. *Claracaput caudanigrum* lights up when the wind blows. *Movensbulla viridis* travels in all directions on magnetic surfaces, turning when it hits the flanges of an I-beam.

Yang may be the artist associated with the first prototypes of these beings made using small electronics with sealed batteries that cannot be replaced, but he discusses them as entities unto themselves. He says that their 'origin is unknown'. He explains that 'it's important to observe them [...] They don't belong to people.'[26] I had the privilege of observing *Umbra infractus* and *Segnisiter continuus* in a thrift shop parking lot in Los Angeles until they disappeared down an alley. They were oddly majestic, camouflaged and avoidant as they navigated across the gritty asphalt.

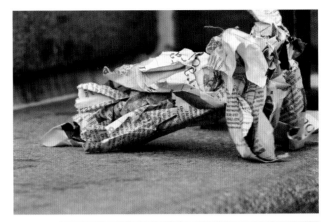

RIGHT
Segnisiter continuus (from *Species series*), 2012

RIGHT BELOW
Condimentum trigonus fp1 (from *Species series*), 2013

BELOW
Umbra infractus (from *Species series*), 2012

OPPOSITE TOP
Claracaput caudanigrum (from *Species series*), 2012

OPPOSITE BOTTOM
Movensbulla viridis (from *Species series*), 2012

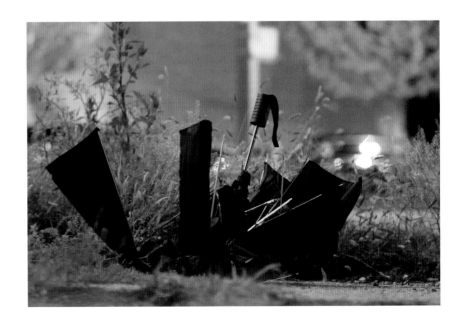

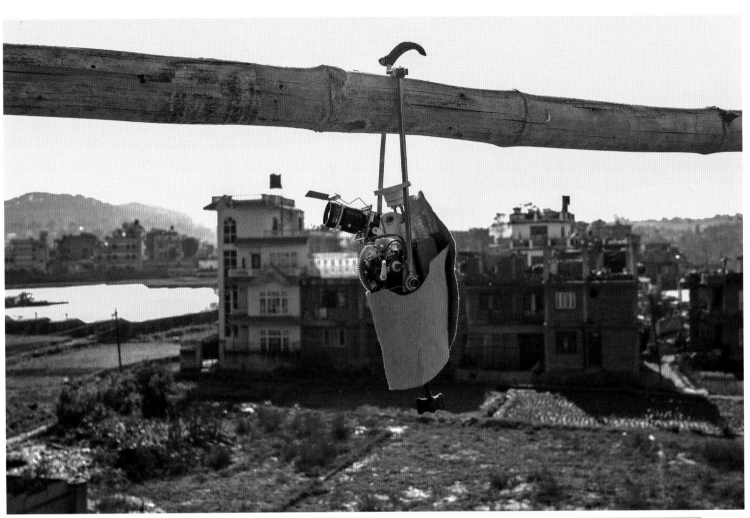
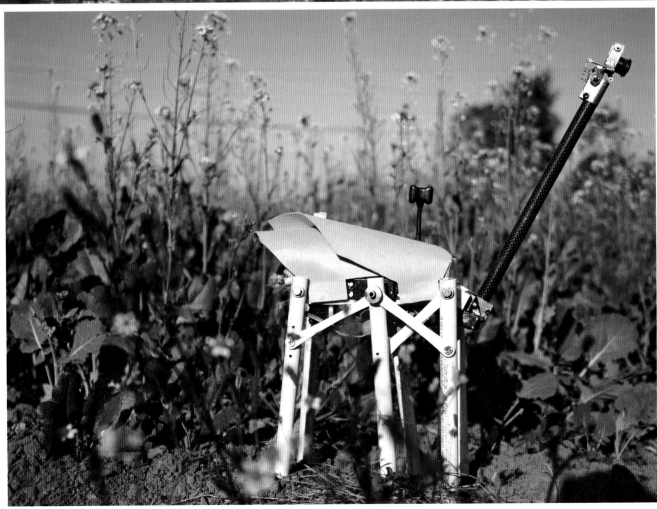

A tragicomic robot narrative exploring automation in religion

Michael Candy

Michael Candy (see also pp. 152–153 and 210–211) makes robots with deep connections to human narratives. His work is situated in the 'unCandy valley', where ancient folktales, human disasters such as Fukushima and essential features of the animal world are retold or re-enacted by robots. In substituting mechanical beings and automated processes for humans, animals, plants and other robots, Candy captures our attention and imagination. Tied in equal measure to the history of automata and the rejection of the militarized view of the robot as precision weapon, Candy's reinterpretations are spellbinding embodiments of machine dreams. They touch human emotion in ways that fleshy creatures cannot, simply by being complex and other, yet somehow anthropomorphic and familiar.

Ether Antenna, a tragicomedy robot narrative filmed in Nepal, began with a mashup of inspiration kindled while Michael Candy attended art residencies in India and Nepal. The first spark was a fascination with the concept of the Tibetan prayer wheel, a drum-shaped Buddhist spiritual device encircled by text, which can be spun by wind, heat transfer, water or hand. Candy saw them as the 'embodiment of automation in religion'. In *Ether Antenna* the prayer wheel spins the tale, either flowing clockwise as expected, or rotating backwards and wreaking havoc. The movie is a loose retelling of the story of how the Bodhisattva sacrificed himself to feed a starving tiger family. In *Ether Antenna*, a hermit-crablike robot, a loping hobby-horse robot and a scaffold-climbing techno-sloth sacrifice themselves to a technological human surrogate whose wand strips them of their skin and sends them into the ether. The robots were built from locally sourced ritual objects, plumbing material and 3D-printed parts. The Nepalese tech culture, pollution, poverty and post-earthquake scaffolding helped Candy evolve the cast, narrative and locations.[27]

ALL IMAGES
Ether Antenna
(film stills), 2017

Parasitic robots feeding off urban power networks

Gilberto Esparza

A shadow passes across the wall of a building in a city in Mexico – not the shadow of a pigeon or rat. It moves deliberately on the diagonal and then curls like an elephant trunk. If you see this unsettling shadow, you might be in the presence of one of Mexican artist Gilberto Esparza's autonomous robots called *Urban Parasites*, a set of six mechanical beings that live in our infrastructure and feed off the urban environment. Like rats, cockroaches and pigeons, the *Urban Parasites* benefit from human habitats but are not controlled by humans. Constructed out of electronics and urban junk, they are technological creatures that feed off the electrical grid. Moving along urban high wires, they are spectacular and strange.

MARAÑA (Tangle) Capulum nervi glides along the electrical cables of the city using a small printer motor and a set of gears. The articulated body is reminiscent of a centipede and contains an electronic nervous system and translucent vertebrae. It steals energy through a 'vampire tap' – a clamp that forcefully bites into the copper wire inside a cable. When *Tangle* gets hungry, it approaches and connects. The device is light-sensitive and sings electronic calls to others of its species. *COLGADO (Hanging) Furtum electricus sinuatum* is also an electrical grid vampire, but a more stripped-down version made of PVC pipe segments. The motion is more elephantine. We do not know what sound it makes, or why it congregates with others of its kind.[28]

BELOW
COLGADO (Hanging) Furtum electricus sinuatum, 2007

RIGHT
MARAÑA (Tangle) Capulum nervi, 2007

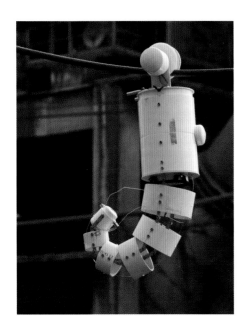

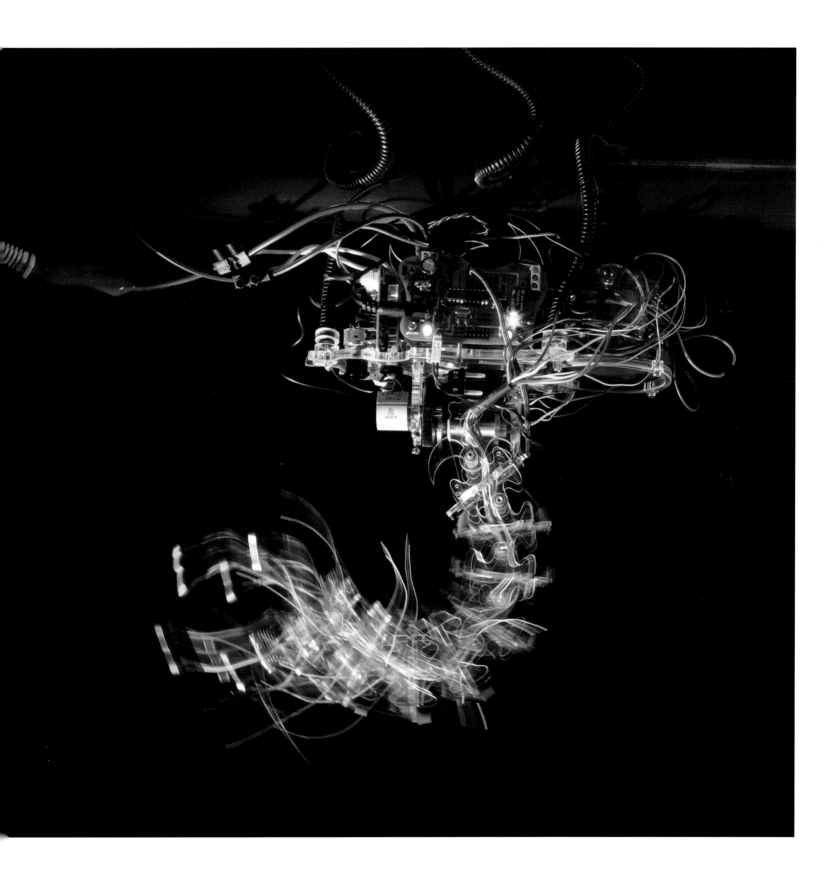

NEW EMBODIMENT

Rat enrichment leading to better rat drivers

Kelly Lambert

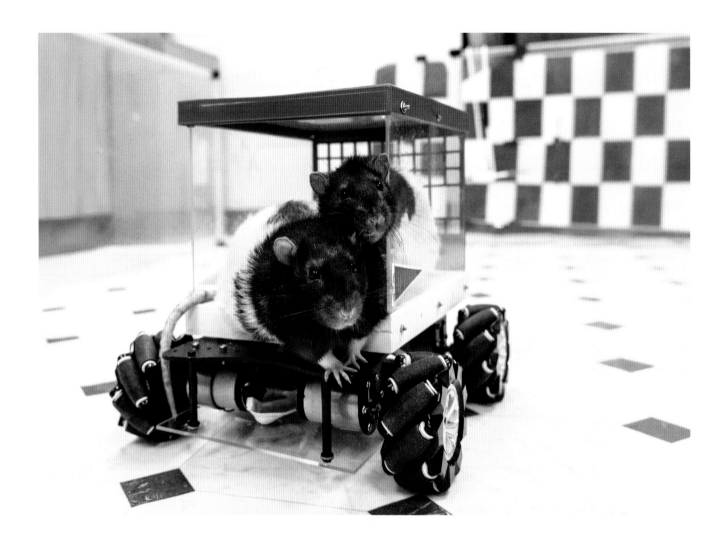

ABOVE
Rats driving 'cars' that were initially created from large cereal containers, 2019–24

When we see a rat driving a tiny car it sets off a neurological response. What startles is the idea that driving, a strictly human activity, can be accomplished and enjoyed by other creatures. We are accustomed to ignoring the rats and other animals that live on the fringes of our environments, but when they perform complex technological interactions, they become less other and more embodied. Suddenly they are a little more human. Kelly Lambert and her lab cohorts at the University of Richmond in Virginia taught two control groups of rats how to drive. 'We already knew that rodents could recognize objects, press bars and find their way around mazes, but we wondered if rats could learn the more complex task of operating a moving vehicle.'[29]

They cut a hole out of a plastic container and installed steering bars to complete an electrical circuit and propel the car forwards. The reward was a piece of sweet cereal. One group of rats lived in a typical laboratory cage. They had no toys or structures for engagement. The other population of rats lived in an enriched environment. They were provided with spiky rubber balls, twine, a ladder, a pine cone and other stimuli. The rats that lived in the enriched environment proved to be better drivers. They learned faster and could make four round trips. The rats that lived in the typical lab cages could make only one trip. When they removed the tasty reward that was part of the conditioning, the enriched rats would still jump in and take the car for a spin. The conclusion was that rats enjoy driving. All the rats that learned to drive showed improvements in their levels of stress hormones. A control group that was led around by remote control showed no improvement. Being a passenger did not provide health benefits. Having a body and deploying it for new tasks is intimately tied to brain plasticity, stress reduction and cognitive development in both rats and humans.[30]

Converting analogue touch into voracious artificial creatures

Christa Sommerer, Laurent Mignonneau

The hand is the body's worker bee. It is busy all day, feeling, doing, making, touching, tapping, noting and documenting for the other senses. It is so busy that it is often on automatic pilot, unaware of its own powers of perception. Christa Sommerer & Laurent Mignonneau awaken that power by using interaction and touch to redesign our connection to living and inanimate artefacts. They do this by allowing the hand to be the tripwire for audiovisual experiences, some as large as a room, others as small as a tabletop object. Video, technology, biology, artefacts, the hand and interaction design bring to life and transform quasi-living creatures in real time.

Life Writer is an old typewriter with generative powers. Hitting the keys gives life to artificial creatures that look like insects. It works like this: the typing paper is a projection screen. Letters typed initially appear as characters. As soon as a carriage return is hit, the letters become black-and-white creatures. Genetic code is sourced from the text by way of algorithmic translation. Typing determines how the creatures move and act. One of the strangest aspects of this interaction is that the artificial creatures need to eat text to stay alive. They are cannibals that eat the source of their own origin. They will swarm to eat up the new text, but once they are satiated, they will reproduce and fill up the screen with dazzling speed. When the population becomes too overwhelming and hyper, the typist can spin the cylinder to refresh the screen. The haptic artefact blurs the lines between thought and genesis, analogue mechanics and digital motion, text and emergent life.[31]

BELOW
Life Writer, 2006

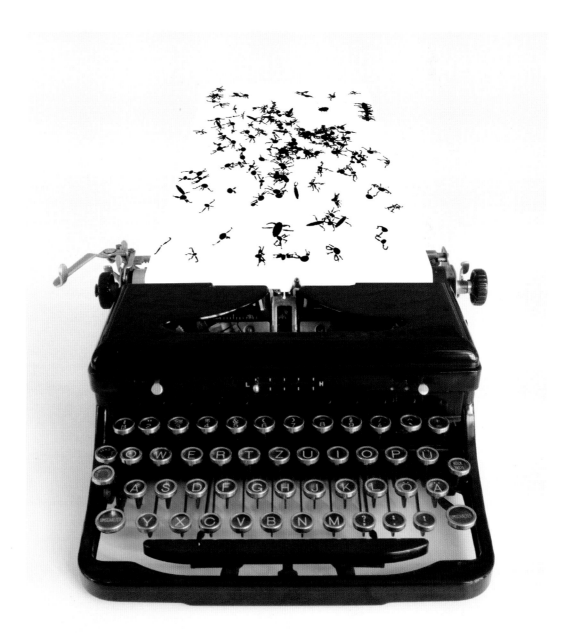

A custom apparatus allowing a man to live as a goat

Thomas Thwaites

When most people get fed up or burnt out, they move, change jobs or abuse substances. Thomas Thwaites wanted to step away from being human altogether. In *GoatMan: How I Took a Holiday from Being Human* he writes, 'Wouldn't it be nice to escape the constraints and expectations of not just your society, your culture, your personal history, but your very biology? [...] Wouldn't it be nice to be an animal just for a bit?'[32]

He applied for a Wellcome Trust grant with the initial intention of becoming an elephant. The project derailed when, funding in hand, he realized that elephants have too much emotional baggage. Thwaites engaged in a multi-pronged approach to becoming something more regionally familiar – a goat. He made prototypes, consulted with a neuroscientist to be able to think less human, engaged an animal behavioural psychologist, or ethologist, to be able to act less human, brainstormed with a prosthetics expert to improve physical comfort and called upon a veterinarian for tips on how to digest when you do not have a rumen.[33]

ALL IMAGES
GoatMan, 2016

The earlier prototypes reveal how human-centred his design thinking was. The first prototype relies on a frame structure with linkages. It looks too stiff and leaves the wearer too far from the ground. The second prototype relied on the flexibility of wood in tension to hang the body from an arch that spanned from feet to arms. The grip was exhausting. For the third prototype he consulted with prosthetist Dr Glyn Heath, who experimented with a pair of sawn-off crutches, joinery methods and angles of adjustment.[34]

You need a good deal of human ingenuity to become a goat. Thwaites succeeded on many levels. He formed a goat friendship. He developed a system for pressure-cooking grass to work around the problem of the second stomach. He travelled as part of a herd. He forgot himself for a little while until he became tired or cold. Most importantly, he came to realize that goats are goat-centred. Humans are things that are outside and over there. Something about the human brain denies us this essential truth: we are not the centre of everything.[35]

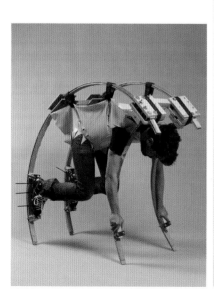
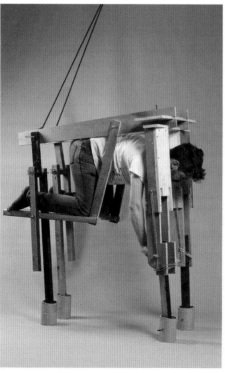
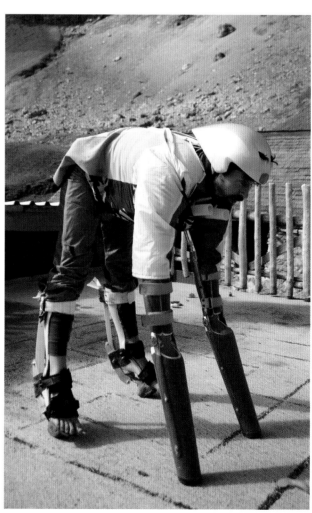

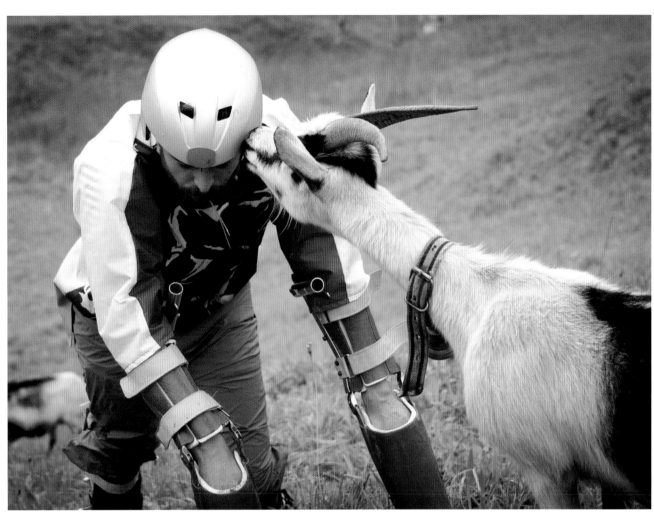
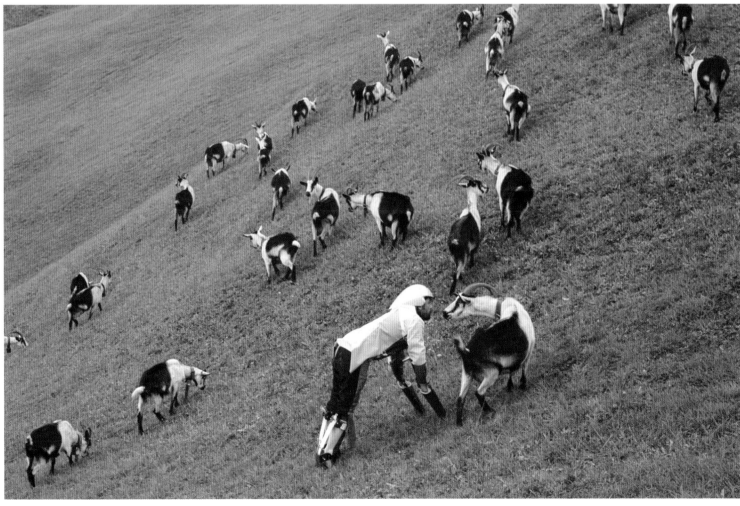

Robotic limbs, heads and tongue acting terribly human

Tobias Bradford

In Tobias Bradford's robot pantheon, incomplete bodies or limbs are performing a mechanized loop of significant but incidental moves. They twitch, tap, shave and eat, caught in an endless act of unproductivity. Highlighting the play between animate and inanimate, Bradford's semi-realistic bodies have disconnected or truncated limbs. Wood members connect the gaps between the fleshy body parts. It is not about horror. Magic and wonder wrestle with literal and phenomenal detachment. Bradford's bodies are signifiers. They are music notes of body. They make you see and feel human morphology and motion in fresh ways that ping your perception.

In the book *The Absent Body*, Drew Lederer speaks of the ways in which the body disappears to the person inhabiting it: 'The invisibility of the eye within its own visual field, the diaphanous embodiment of language, the inaccessibility of the visceral organs: these all exhibit their own principles of absence...'[36] Bradford's discombobulated quasi-humans, made of partial bodies, gaps, isolated limbs and the inner workings of the tongue, disrupt our absent body. We become self-aware and uncomfortable, delighted and horrified.

Backstage reveals a collection of robotic limbs at rest. *The Softness* is a set of gears and linkages that support a truncated hand in the process of shaving a lifelike lower body. *Me as a Bad Boy* is a nearly complete figure having a cigarette. The thighs and knees are crude wood linkages. *Me as a Repeating Disturbance* is an electromechanical head that coughs despite the absence of a lung. *As My Eyes Adjust (Nude Figure)* is an exploded set of seven mobilized hands with wrists controlled by an elegant cam-enacted pulley system. *Immeasurable Thirst/That Feeling* is a mixed-media performative sculpture made of brass, metal, silicone tongue, servo motor, Arduino and pump. We cringe and giggle in the presence of this robotic tongue despite our own tongue's constant gymnastic performance coordinated by a group of eight muscles. The fact that it drools makes it even more wondrous.

RIGHT
The Softness, 2022

BELOW LEFT
Me as a Bad Boy, 2022

BELOW
Me as a Repeating Disturbance, 2018

OPPOSITE TOP
As My Eyes Adjust (Nude Figure), 2022

OPPOSITE BOTTOM
Immeasurable Thirst/That Feeling, 2021

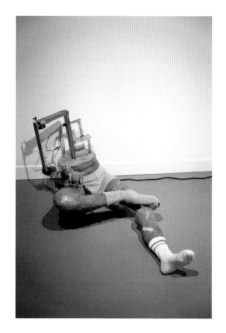

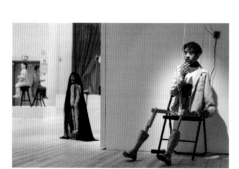

NEW EMBODIMENT

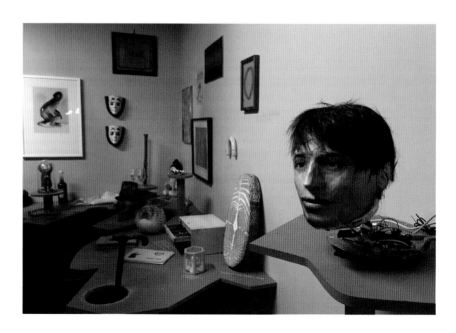

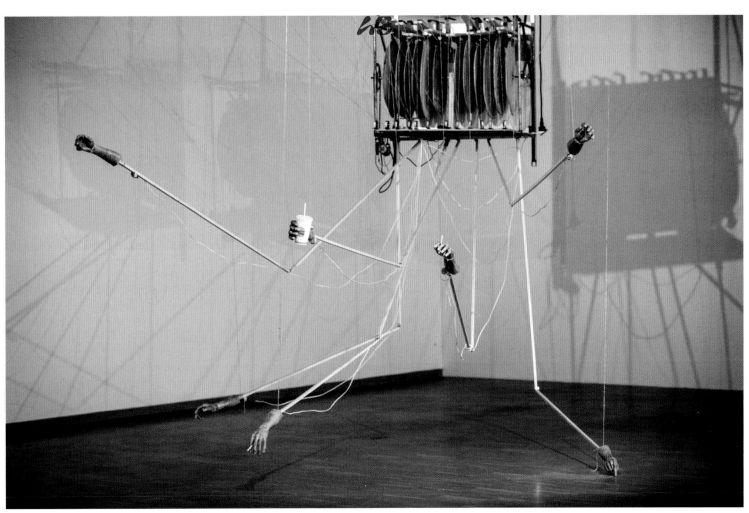
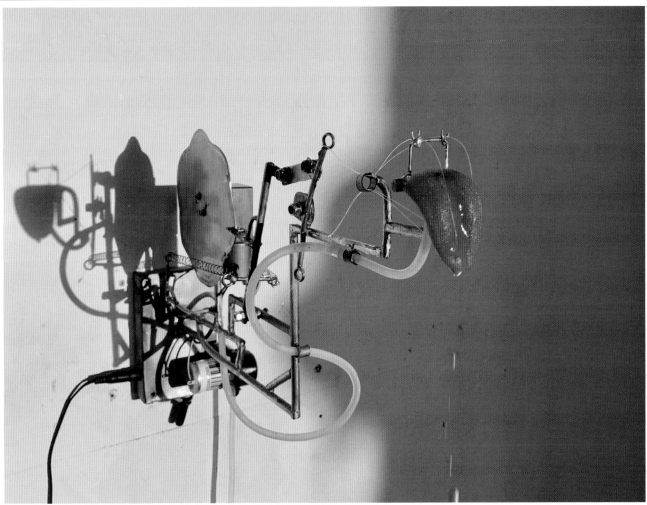

Controlling a thumb prosthetic with your toes

Dani Clode

Everything we do – all movement, emotion, action – is controlled by discrete areas within an imprisoned pile of electrically stimulated gelatinous material. Like well-worn roads, neural pathways in the brain keep habituated motions running smoothly without conscious thought or deliberation. Even when you add something new to the mix, the brain will make accommodations. This flexibility, called brain plasticity, plays a big role in our ability to embody a new limb, prosthetic or extension. Ultimately the foreign otherness of the artificial body part will be incorporated into the body schema as the brain develops new neural pathways.

The Third Thumb by Dani Clode (see also pp. 154–155) is one such prosthetic. 3D-printed using flexible filament, *The Third Thumb* is a sixth digit that creates a synthetic mirror image of your original thumb, this one controlled by your toes. Polydactyly – being born with a sixth digit – is one of the most common differences among human bodies, often labelled congenital or abnormal. Clode sees her new digit as an addition. Inspired by the etymology of the word 'prosthesis' – from the Greek 'to add' – Clode explains that she frames her project and subsequent prosthetics in language that 'shifts the conversation from loss to potential, from repaired to designed, and from missing to whole'. Her thumb is uniquely flexible, functional and well made.[37]

The Third Thumb has a sprightly nature as it recreates flexion and extension, adduction and abduction of the thumb. Despite our quadruped origins, different parts of the brain are responsible for foot and hand motion. Clode and a team of neuroscientists at the Plasticity Lab at University College London and Cambridge University, use functional magnetic resonance imaging (fMRI) to track changes in the brain, including whether having a new finger changes the representation of the original fingers in the brain, whether the toes will appear in the hand arena, and whether other areas of the brain help with accustoming an individual to the new digit.[38]

ALL IMAGES
The Third Thumb, 2017

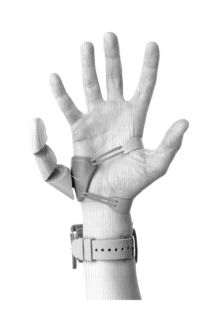

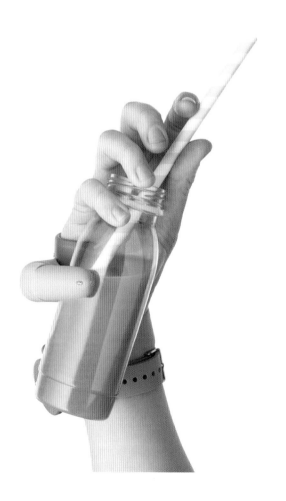

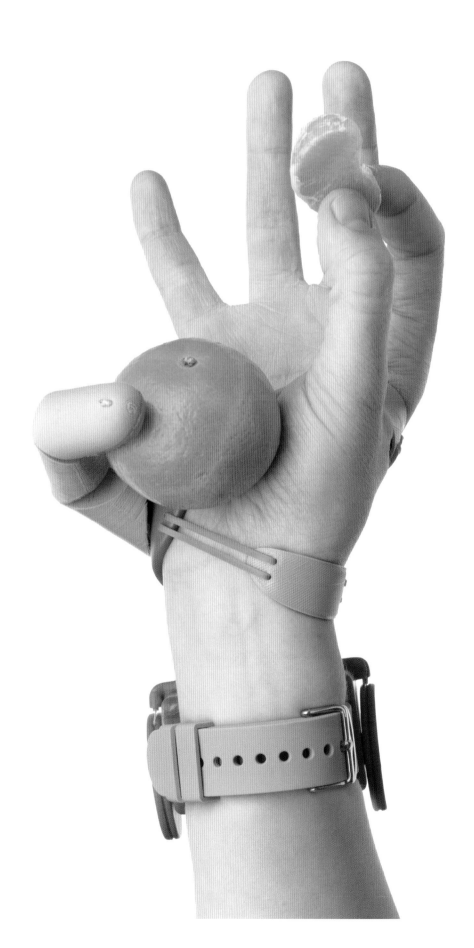

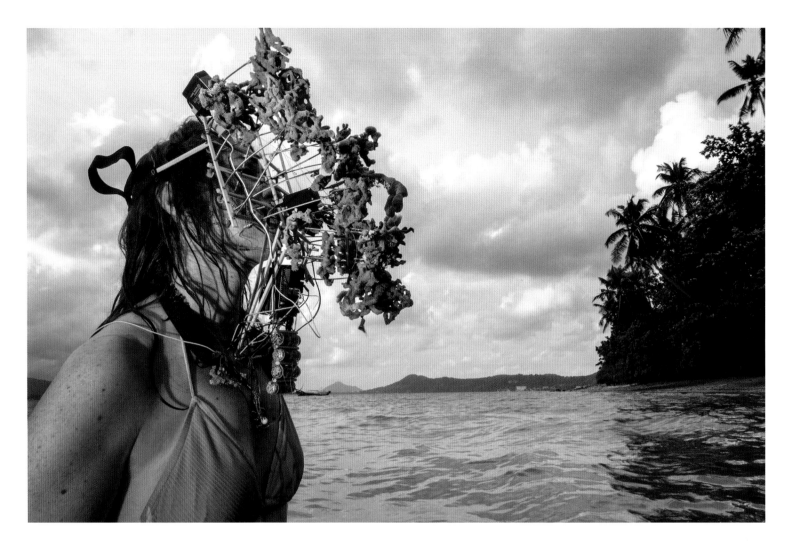
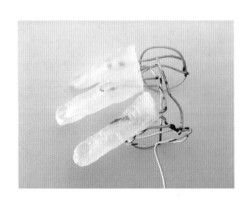

NEW EMBODIMENT

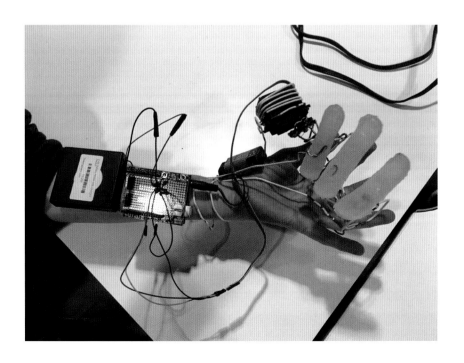

Mechanical empathy and intimate encounters with plants and trees

Madeline Schwartzman

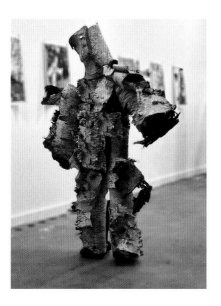

OPPOSITE TOP
Face Nature: Thailand, 2018

OPPOSITE LEFT & OPPOSITE RIGHT
Third Hand, 2018

LEFT
Bark Person, 2023

BELOW
Birch Bark Cloud and *Bark Person*, 2023

Third Hand is an exercise in creating embodiment from a fragment of a human. A hand made of cast resin fingers and wire moves back and forth on the wearer's hand, propelled by a servo motor strapped on to the wrist. The resulting rhythmic clasping has a surprising effect, with overtones of the 'rubber hand illusion', in which a rubber hand seems to belong to one's own body when both it and one's own hidden hand are stroked. The clasping robot has a comforting effect. It is a little mechanical empathy machine whose motion reads as care.

Face Nature: Thailand is a modular construction made of chopsticks, alligator clips and servo motors that allows different types of locally foraged nature to move in nonhuman undulations across the face of the wearer. From the outside, the human head becomes entangled in a collection of sea sponges. The winding and unwinding facilitated by three servo motors makes the hybridity more believable and disturbing. From the inside nature becomes a surrounding spatial system. This project was the start of an effort to promote a more ethical and sustainable approach to coexistence in the Anthropocene. *Face Nature* invites – and commands – others to engage in this more mutual subjectivity.

Birch Bark Cloud and *Bark Person* are part of an ongoing attempt to embody a tree. The birch cloud is a genesis machine for this new type of human. Climate change will require us to make alterations to our skin, especially as we advance into space and confront increased solar radiation. White birch produces a white powdery substance that protects the tree from radiation. The paper-like bark is infused with a preserving oil called betulin, which has long been used as an antimicrobial agent, an analgesic and an anti-inflammatory.[39]

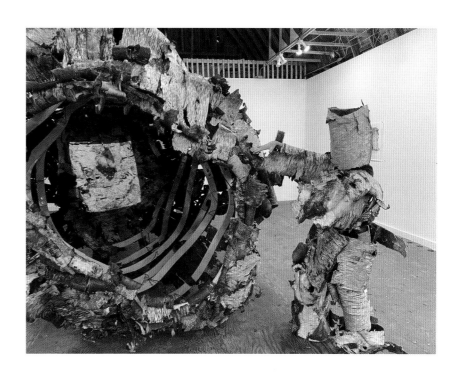

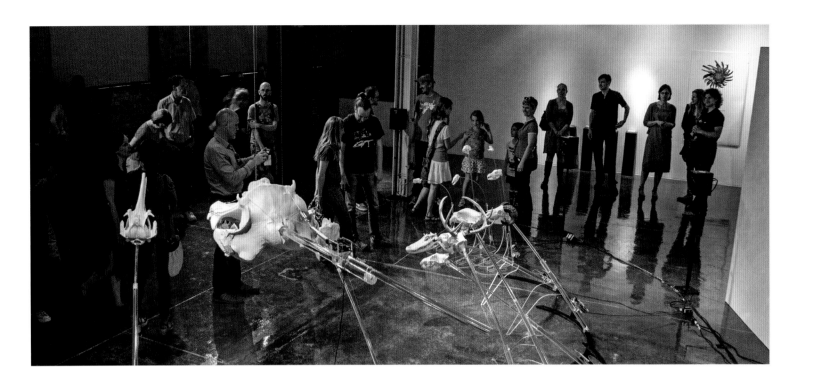
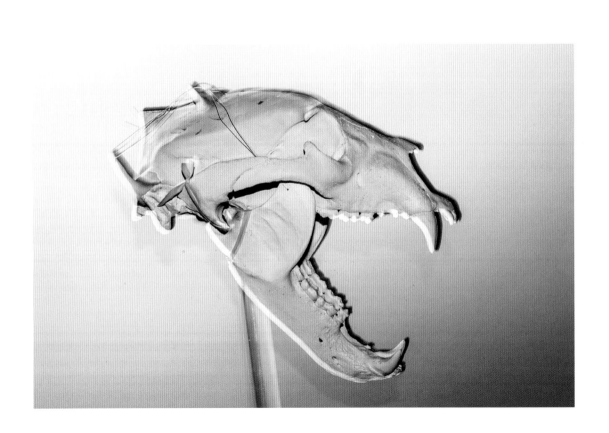

NEW EMBODIMENT

Endangered animal voices amplified through data sonification

Pinar Yoldas

We do not speak animal, but we do understand data. According to the 2022 *Living Planet Report*, since 1970 there has been a 69 per cent decline in species among mammals, birds, fish, reptiles and amphibians. South America has seen the largest overall decrease, with a loss of 94 per cent. Of the 32,000 species monitored, freshwater populations are down by 83 per cent. We are failing as stewards of the planet's biome. Loss of habitat, closure of migration routes and increases in unsustainable agricultural practices are some of the human-induced factors that have precipitated this decline. We continue to perpetuate this loss, even though our health, sustenance and economic livelihood depend on biodiversity. What is it like for the animals?[40]

Artists with an inclination towards naturalism have been bringing species to life, bioengineering species to safeguard their future, or developing performances and interactions to increase awareness. *The Very Loud Chamber Orchestra of Endangered Species* culls data on pollution and species habitat loss and screams it out to the public through a menagerie of skulls of endangered animals. The craniums are equipped with servo motors, linear actuators and speakers, which respond to the location, frequency and amplitude of relevant data, including the World Bank Data Catalog's carbon dioxide emissions data (metric tonnes per capita), and the scientific data repository Dryad's reports on habitat loss or sensory pollution.[41] When the data peaks, so does the animal sound. The disembodied skulls attached to metal stands are re-embodied by information that predicts their further downfall. They are harbingers of extinction. Their calls and skeletal presence hit you in some primal brain area that connects us to all living creatures.[42]

ALL IMAGES
The Very Loud Chamber Orchestra of Endangered Species, 2013

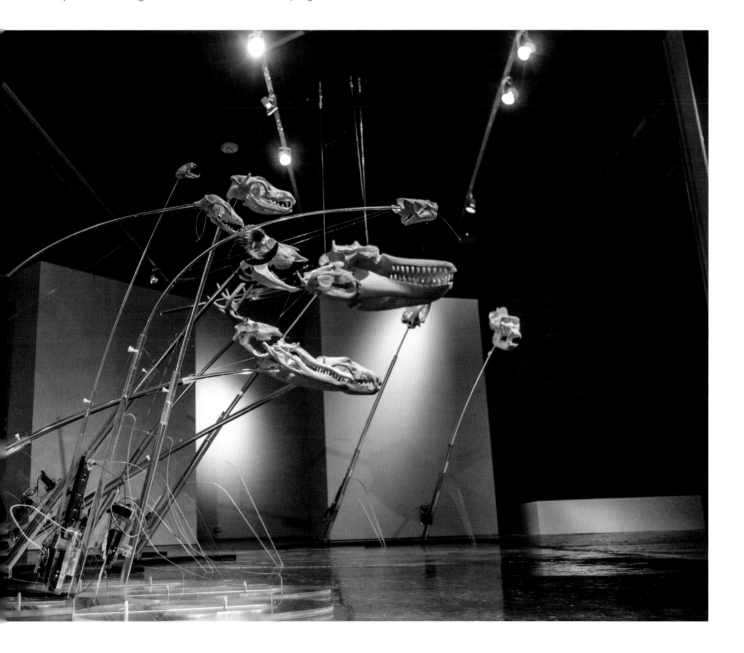

Transcending the limitations of our physiognomy through gene transfer

Agnes Questionmark

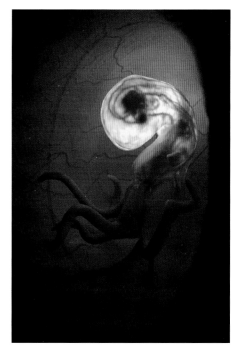

RIGHT, BOTTOM RIGHT & OPPOSITE TOP
TRANSGENESIS, 2021

BOTTOM LEFT, CENTRE & OPPOSITE BOTTOM
CHM13hTERT, 2023

Science has identified or created marvels of interspecies and intraspecies hybrids over the past few years, from the first pig heart transplanted into a human, to the startling sexual behaviour of the deep-sea anglerfish, which physically fuses with its mate for life, enabled by the fact that its immune system does not attack foreign cells like that of most vertebrates.[43] Art has provided an even more robust and fantastical interspecies hybrid by way of Agnes Questionmark, who for twenty-three days, eight hours a day, performed as a human/cephalopod hybrid in a pool in an abandoned leisure centre in London.

'Transgenesis' is the transfer of genes from one species to another. In her work *TRANSGENESIS*, Questionmark enacted three phases of transgenic development – larva, embryo and foetus – using dancers, sculptures, water and embryonic cavities. The performance's recapitulation of a post-human, fluid-filled, amniotic future in real time ran parallel to an internal endurance test the artist was undergoing. Questionmark had begun hormone replacement therapy on the first day of the performance, becoming both octopus and human woman at the same time, and suffering the physical effects of both.[44]

If *TRANSGENESIS* sounds far-fetched, consider that humans and all vertebrates can trace their ancestry to a single lumpy hermaphroditic invertebrate bottom feeder called a sea squirt. Like all vertebrates, sea squirt larvae have a primitive spine, a nerve cord and gill slits. They lose these features in a matter of weeks, becoming invertebrates through developmental timing. Humans are more closely related to dinosaurs than to octopuses.[45] Questionmark's fascination with the octopus is shared by science. In an article in *Scientific American* Rachel Nuwer suggests that cephalopods are useful to help us understand our own species, for the very reason that these highly intelligent sea animals are so different from us.[46] Questionmark brings wondrous fruition to ideas about shared genetics, ecological habitats, fluid futures, freedom, choice and agency.

In *CHM13hTERT*, Questionmark performed as an undefined combination of human and sea creature for sixteen days, twelve hours a day, hanging from cables and straps in a glass structure in a Milan railway station.

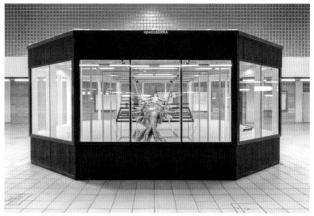

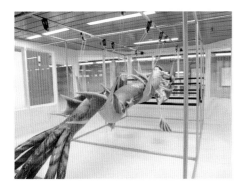

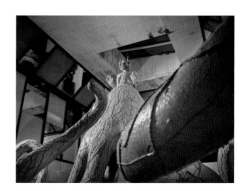

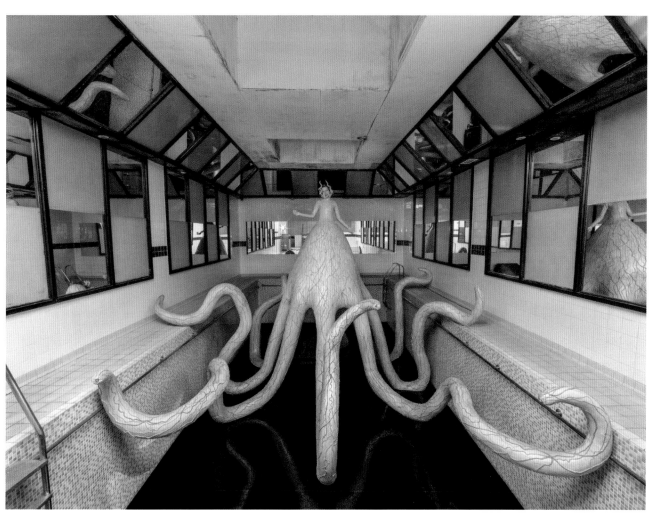
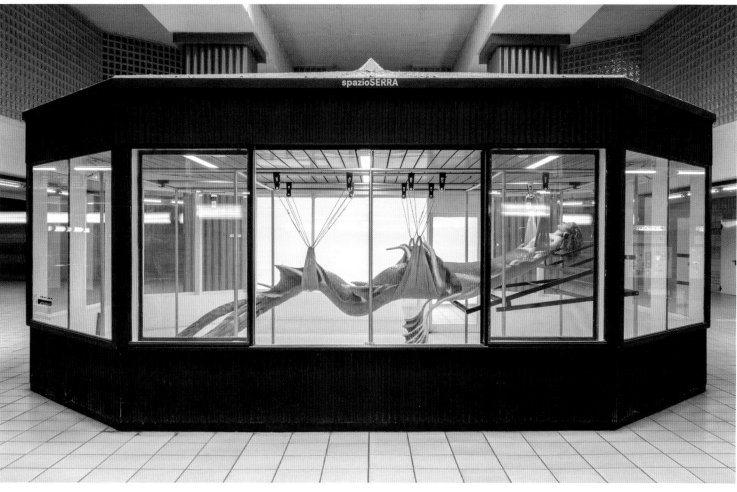

Intelligent machines remembering old-school technology

Félix Luque Sánchez

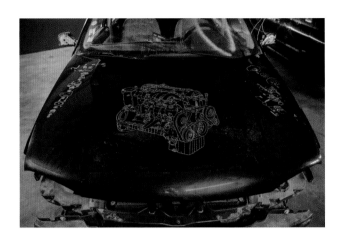

ALL IMAGES
Junkyard II, 2019

Félix Luque Sánchez's *Junkyard II* sculptures have been plucked out of a post-human scenario. An autonomous custom-engraving machine etches a junkyard car, leaving a permanent instruction manual of the car's fabrication. These are nostalgic technical representations – precise exploded isometric drawings showing piece by piece how the nuts, bolts, frames and axles go together. The engraving machine appears to be remembering the good old analogue days of assembly lines and power tools. The implication in *Junkyard II* is that after the singularity (a hypothetical future point when technological growth becomes uncontrollable and irrevocable), intelligent machines develop a capacity for archaeological inquiry, record keeping and preservation of the technology of the twentieth century. Until such things come to pass, it will always be a human point of view guessing about the embodiment of a machine.

In his essay 'Machines and Fictions', Pau Waelder highlights the multifaceted connections of the car to culture, history and ecology. He reminds us, as we fret over AI, jobs and human futures, that all machine bodies have a time limit.[47] How will embodied machines expire? HAL 9000, a sentient supercomputer in *2001: A Space Odyssey*, resorted to singing a childhood nursery rhyme as he faded away. *Junkyard II* provides an unnerving but intriguing scenario of intelligent machines remembering expired old-school machines.

NEW EMBODIMENT

Embodiment reflecting on chronic illness and absence

Embodiment is not always easy. It was especially difficult for Donald Rodney, an artist who was diagnosed at an early age with sickle cell anaemia. Sick and disabled artists are often invisible. They disappear into the spaces of unwellness. To be Black and face systemic racism as well as having a chronic illness made Rodney's artistic fortitude, material experiments, conceptual range and sheer volume of work even more astounding.[48]

Psalms, Rodney's motorized, computer-driven wheelchair, was a high-tech feat of interaction design for its time. Rodney could not attend his own solo exhibition owing to the advanced state of his disease. Instead, he sent this wheelchair, highlighting his absent body and uncannily re-embodying himself in absentia. The wheelchair was programmed to avoid people and objects.[49] It moved around the gallery in a choreographed sequence of geometries determined by the artist, using a video camera, sonar sensors, shaft-encoders and a rate gyroscope.[50] Prefiguring *Psalms, Ancestral Seat* is a drawing of an empty wheelchair supported by four giant stacks of books.[51] Rodney's volumes of sketchbooks are full of drawings that explore the body, Blackness, loss, illness, family, genetics and art.

In the House of My Father is a tender photograph of Rodney's hand holding a tiny two-storey house made from his own skin. Skin had peeled off his body after a swollen abscess had reduced.[52] With it he represented embodiment within embodiment – house within hand. The house is an independent stand-alone work titled *My Mother. My Father. My Sister. My Brother* (1996–97).[53] It relates his own skin to the skin and comfort of family, and to the inheritance of the fatal disease. The tiny house is a living testament to the owner's life, a thin shell fashioned from cells, genetically connected to the hand that holds it. It is a miniature, and it foreshadows some of the recent work of synthetic biology, in which stem cells are used to grow new living organs and skin. Rodney captured this poignant photograph from a hospital bed. The white background is the bedsheet. He passed away one year after completing it.

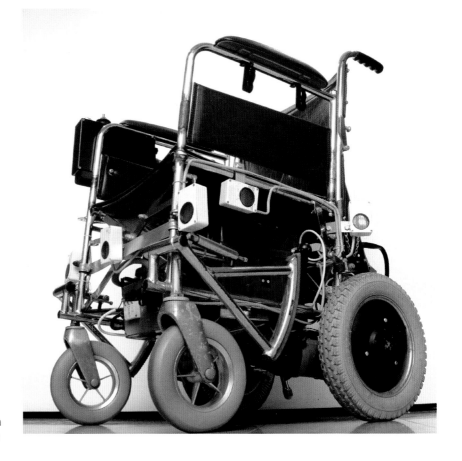

ABOVE & BELOW
Psalms, 1997

OPPOSITE
In the House of My Father, 1997

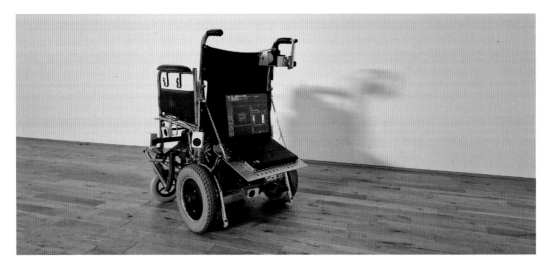

57 Donald Rodney

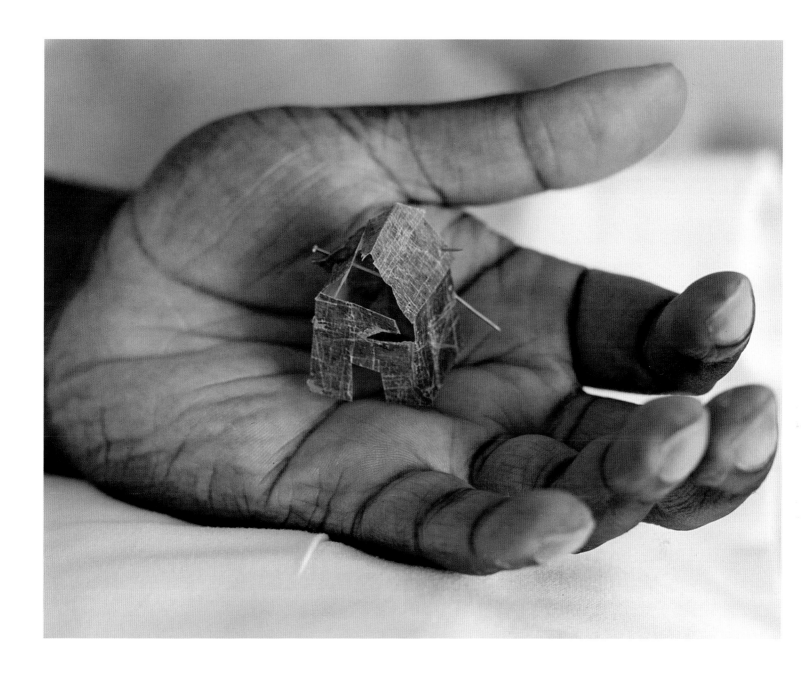

NEW EMBODIMENT

CHAPTER 2

The 'Chimera' chapter is about uncanny hybrids: animals with machines, nonhuman animals with humans, cells with silicone and other combinations. The threshold of the monstrous is ever-changing. Something can be shocking one day and familiar the next. Many of the works in 'Chimera' turn your head around. A drone can gain the ability to smell by being retrofitted with the live antenna of a moth, but is the resulting *Smellicopter* a robot or a moth? Is a silicone jellyfish with a rat heart a rat? Does a robot controlled by the cultured biological brain of a rat remember tasks and paths? (The answer is yes. You do not need a body to develop a neural network.) Such projects spark uncomfortable reckoning with the notion of post-humanism – the eventuality of a world beyond the human.

Much of the work follows in the footsteps of Frankenstein and the golem. *cellF* is a living musical instrument that combines a synthesizer with human neurons in an endless loop of creativity. Daniel Giordano's golem-like sculptures are made of bald eagle excrement and Tang orange drink mix instead of dust and earth. We should not be so surprised by these freaky hybrids. Humans are monstrous chimeras too. This chapter will organize these hybrids to help elucidate why chimeras exist, and to uncover the scope of their applications.

Researching a book such as *Alive* is mind-bending. Bit by bit, the order of the world – of humans, our composition and our relationship to other creatures – gets undermined by scientific research. The identity fragments. Questions arise about where humans begin and end. Thoughts about bacteria become more genial. You now embrace hybrid creatures that once made you queasy. Ultimately you are left wondering how it could be that any creature or being that looks different, behaves uncannily or appears uniquely combinatory, could ever have been labelled a monster. This is the power of science, research and reading. Monstrosity is an awareness issue. It is subjective and not factual. We are all chimeras. Humans are monsters.

The *Oxford English Dictionary* describes 'chimera' as 'A fabled fire-breathing monster of Greek mythology, with a lion's head, a goat's body and a serpent's tail'.[1] Put simply: mix-and-match animals are badass. Such depictions do not fade away, even as mythology gives way to the reason of the Renaissance. Jacopo Ligozzi's late seventeenth-century drawing titled *A Chimera* takes the monstrous collaging of animals one step further, depicting an intact full lion with a bucking half-goat emerging from the top of the back and a dragon's head replacing the tail.[2] This is even scarier than what the mythmakers of Greece had in mind. Viewing this now during a time when all conversations lead to questions about AI, human obsolescence and the notion of the impending singularity, there is continuity in contemporary uses of imagery and imagination to conjure

LEFT
Melanie Anderson networked a hawk-moth antenna to a drone, creating a cyborg quadcopter with augmented smell-sensing (see p. 77).

fear. Artificial intelligence is a constantly metamorphosing creature. Such instability and power made of zeros and ones constitutes a virtual chimera without an end. That does not make it monstrous, it makes things interesting, as we will see in the 'Algorithmic Futures' chapter (pp. 214–221). The final definition of 'chimera' in the *OED* refers to *Biology:* 'an organism (commonly a plant) in which tissues of genetically different constitution co-exist as a result of grafting, mutation, or some other process.'[3] Arising in the nineteenth century, this is the most neutral, least vilifying elaboration. Science accepts. Science accepts but humans do not.

ABOVE
Dana Cupkova and Ben Snell experiment with dough rising and expanding through networks of mesh (see pp. 92–93).

Before exploring the more unorthodox unions that make us squirm and look away, it is important to zoom beneath the surface of humans to understand our own shaky ground. A great place to start is Neil Shubin's *Some Assembly Required: Decoding Four Billion Years of Life, from Ancient Fossils to DNA*, a book to dog-ear, underline and bubble. Chapter after chapter Shubin reveals the molecular equivalent of the divide between the brain and consciousness. In the same way that we feel we have agency, even though the brain allows us to be conscious of only approximately 10 per cent of its activities, we perceive ourselves to be a singular entity when in fact microorganisms outnumber human cells by ten to one in the thirty-seven million cells that make up our body (but are 1–3 per cent of the body's mass because they are so small).[4] We are already high-functioning chimeras.

Shubin highlights the research of American evolutionary biologist Lynn Margulis into the diversity and origins of the internal parts of human cells. In the late 1960s Margulis observed that the organelles that power cells – the mitochondria in animals and the chloroplasts in plants – looked like mini-cells themselves.[5] She figured out that the organelles had a different genome from the main cell nucleus, and that the organelles in animals and plants looked very much like bacteria and blue-green algae, respectively.[6] Though her research was initially disregarded, it was validated in the 1980s when it was found that mitochondria are descended from bacteria, and chloroplasts from blue-green algae.[7] Shubin writes:

> The organization of bodies is much like Russian dolls: bodies contain organs that are composed of tissues that are made of cells that have organelles, all of which have genes inside. Over billions of years of evolutionary time, different parts essentially relinquished their individuality to become parts of greater wholes. Free-living microbes combined to make a new kind of cell. That new cell had special properties that allowed for yet another combination, multicellular bodies. Successive more complex kinds of individuals have emerged with ever more intricate parts.[8]

We are also made from the stuff of viruses. Shubin traces the research of Jason Shephard, a scientist studying memory loss. Early on in his establishment of his own lab he focused on a protein called ARC, which is involved in conveying signals across nerve cells to facilitate memory.[9] In attempting to purify the protein, he found that it was not behaving like other proteins.[10] A team of researchers working on HIV determined that the ARC protein had a morphology similar to HIV.[11] Shubin writes, '375 million years ago a virus entered the genome of the common ancestor of all land-living animals.'[12] 'The virus was hacked, neutered and domesticated for a new function in brains.'[13] How did this happen? Natural selection integrates viruses that are beneficial to the genome.

When you read Shubin and reach the point where you face your own hybridity, it is easier to engage in the hundreds if not thousands of experiments happening in synthetic biology, biorobotics, tissue engineering and art. The criteria for being included in this chapter are some strange alliance, some atypical collaging, some meeting of inert and living, machine and biology. Though the projects shift in scale, discipline and material, there is a sense of the coming together of two or more essences.

The chapter opens with the 'medusoid', a silicone jellyfish with rat heart cells. The medusoid was one of the inspirations for this book. Silicone in the shape of a jellyfish can look and act morphologically like a jellyfish yet have a propulsion system made of rat cells. Ultimately, the medusoid brought me to visit the fantastic world of Kit Parker's laboratory at Harvard – the Disease Biophysics Group – where slowly, deliberately and creatively, Parker and his team are making inroads into the engineering of a human heart from scratch through experiments with heart tissue and propulsion. Parker and colleagues have created two additional artificial swimming chimeras combining heart tissue and synthetic materials, while simultaneously researching all aspects of cardiac, neural and vascular smooth muscle tissue engineering.

Cells have the key role in the next series of hybrids. There is no body, or even a body part. Lab-cultured cells that have their origins in rats and humans send signals to robots or synthesizers, or incubate other cells. Kevin Warwick controls a vehicle with rat neurons. Guy Ben-Ary and his team culture human neurons that control an enormous synthesizer and interact with human musicians. Some day your home computer may run on neurons as well. Neuromorphic devices that use artificial neurons to store and compute run much more like the human brain than do current systems, which require separate memory for processors and data storage.[14]

The Tissue Culture & Art Project (Oron Catts and Ionat Zurr) with Devon Ward construct a giant microbial compost that incubates muscle cells. As techniques that transform skin cells into pluripotent stem cells become more accessible, allowing innovators to create any type of human cell, we will be seeing more and more post-human cellular controllers that will make AI look archaic. Shinya Yamanaka of Kyoto University deserves mention for the 2006 far-reaching discovery that mouse skin cells could be transformed into stem cells.[15] This is shattering chimeric material.

The chapter moves on from cellular entities to real biological beings – slugs, cockroaches, moths and snails – used in combination with synthetic materials and microcontrollers. Teams of engineers conceive of these individual cyborgs as part of a 'swarm', capitalizing on nature's own engineering to perform tasks that include scanning the ocean floor, assessing disasters, sniffing for toxic chemicals, and assisting in search and rescue. Cameras, microphones and sensors are transported by the creatures to send signals to remote operators.

Victoria Webster-Wood gives a synthetic sea creature power using the jaw muscles of a sea slug. Nicole W. Xu and John O. Dabiri augment a jellyfish with an embedded microcontroller that uses electricity to jolt muscles into high-speed swimming. Melanie Anderson endows a drone with a sense of smell by hijacking a moth antenna and networking it to a microcontroller. Cindy Bick and Diarmaid Ó Foighil attach a tiny computer to a rosy wolf snail to collect environmental data to make sense of species extinction and survival. Alper Bozkurt creates backpacks for cockroaches with attached wires connected to the insect's antennae that allow for remote steering. He steers moths with wires that were inserted in the pupal stage and became integrated into the insect's body.

Sometimes our desire to solve problems and innovate gets ahead of current scientific research. It has only recently been verified that certain insects feel pain. Animals cannot advocate for themselves. Many cannot tell us that something hurts. As stewards of the Earth in the Anthropocene, we need to continue to adopt methods that are ethical and do no harm.

BELOW
The Superbivore is a hybrid animal bioengineered from key features of a giraffe, a goat and a deer, in Kathryn Fleming's zoological garden of the future (see pp. 82–83).

LEFT
Glenn Gaudette's decellularized spinach leaves are designed to serve as vascular systems and scaffolds for human tissue (see pp. 86–87).

The unions get uncannier. Tim Lewis creates a robot hybrid with a taxidermied deer. Kathryn Fleming engineers a hypothetical animal from the most delightful and functional parts of a diverse set of hoofed mammals. Kuang-Yi Ku proposes combining the DNA of animals deemed highly sexual, to create a synthetic, easily reproducible medicinal aphrodisiac. He also compares and combines the reproductive systems of humans and snails, challenging human norms. Glenn Gaudette uses decellularized spinach leaves as a scaffold for human cells to create a vascular network. Plant/human hybrids! We still cannot fabricate a vascular system as intricate as that of plants.

Most of the final series of chimerical works are by artists and designers who explore material innovations, make visual some hybrid alchemical process, or present conceptual tools for understanding world events. Basse Stittgen sources blood from slaughterhouses to create household objects. Avril Corroon makes a statement about real estate by seeking out black mould growing in apartments and using it to produce inedible cheese. Candice Lin entangles humans and fungi by securing communal donations of urine to feed a living sculpture. Dana Cupkova and Ben Snell create bulging bread bodies by wrangling raw dough with nets and waiting for the yeast to rise through the network. Isaac Monté decellularizes meat waste to create translucent lamps. Daniel Giordano creates sculptures with everything from bald eagle excrement to urinal cakes. David Altmejd creates a giant chimeric installation in a state of energized transition: it is chock-full of metamorphosing melons, crystallizing werewolves and energized hair. Jaime Pitarch makes a symbolic hybrid by way of a metastatic matryoshka doll, a reference to the mutations caused by the Chernobyl disaster. Jessica Yorzinski turns a grackle into a cyborg with a tiny headset: it is for the purpose of understanding grackle blinking during flight and landing, but it relates to the trend of virtual reality headsets for animals.

Certain cultures engage in chimerical practices that might make some of us cringe, but time often brings understanding and cultural incorporation. In northern India in the state of Rajasthan, a religious group called the Bishnoi consider certain animals sacred, as part of their emphasis on stewarding and protecting nature.[16] Bishnoi women who are breastfeeding will nurse orphaned fawns as part of their duty. In January 2022 the first human underwent a transplant of a pig heart; the recipient lived for two months. Since 2017 scientists have created hybrid embryos – first a hybrid human/pig example, and then a human/monkey.[17] The embryos were eventually destroyed. Izpisua Belmonte, the lead on the human/monkey hybrid, explained: 'Understanding which pathways are involved in chimeric cell communication will allow us to possibly enhance this communication and increase the efficiency of chimerism in a host species that's more evolutionarily distant to humans.'[18] You can expect the next decades to be strange. As you pass that urban rat, or the chicken in your yard, show respect. Their offspring and yours may soon be one and the same.

BELOW
A massive shape-shifting sculpture by David Altmejd includes crystallized werewolves and an assemblage of melons, flowers, string and hands, all in a state of transformation (see pp. 98–99).

Silicone jellyfish propulsion formed by contraction of rat heart cells

Janna C. Nawroth, Kit Parker

Kit Parker, professor of bioengineering and applied physics at Harvard University and an expert in cardiac cell biology, tissue engineering and cell- and tissue-powered actuators, saw something ultra-human in the jellyfish tanks at Boston's New England Aquarium: the pumping action of the human heart. The idea came to him to build a living artificial jellyfish. John O. Dabiri (see also p. 76), a professor of aeronautics and bioengineering at Caltech (California Institute of Technology) and an expert in biological propulsion and fluid dynamics in the ocean, along with doctoral student Janna C. Nawroth, had the jellyfish propulsion know-how. With Parker and his Disease Biophysics Group (see also pp. 66, 67 and 106), they created an artificial jellyfish – a synthetic animal. They used a lab standard: rat heart tissue.[19]

The long-term goal of Parker's lab is to fabricate a human heart from scratch. In the short term, Parker's lab was moving step by step through heart propulsion, to better understand how the heart pump works. The lab had succeeded in aligning heart tissue on a thin sheet of silicone to mimic the contraction of the heart, but they had not yet reverse-engineered the pumping action. To create the 'medusoid', the group determined that there would need to be heart tissue aligned around the circular bell-shaped portion of the silicone jellyfish, and a more concentric alignment around the eight silicone flaps. When stimulated by electricity, the different alignments force out liquid. The silicone moves the fins back into the original position.[20]

The synthetic jellyfish has fewer internal parts and morphological nuances than the primordial one, but it has got the moves. Despite its rat genetics, it looks like a small living jellyfish. This is a scientific hybrid, but it is also a conceptual idea with ethical dimensions. Scientists involved in tissue engineering are tinkering with life. We are getting accustomed to hybridity through synthetic biology, from glowing rabbits with jellyfish DNA to rats with human organelles. As collaging animals becomes easier, meaningful combinations will be key.

BELOW LEFT & RIGHT
Movement of the juvenile jellyfish (top row) compared with the engineered medusoid (bottom row), 2012.

OPPOSITE LEFT
A medusoid, or synthetic jellyfish.

OPPOSITE RIGHT
A juvenile moon jellyfish.

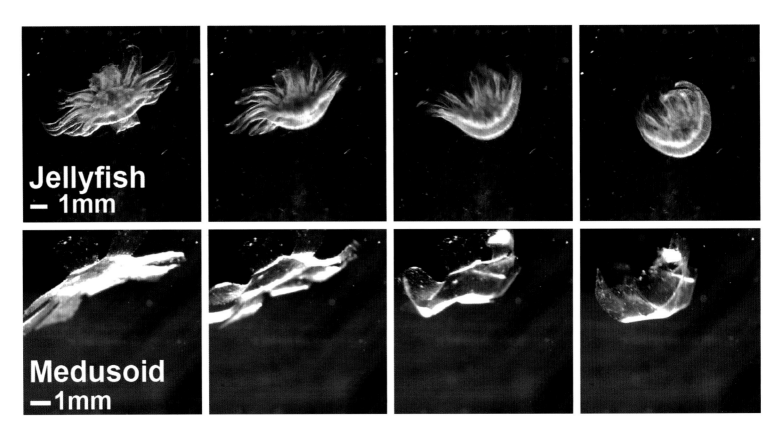

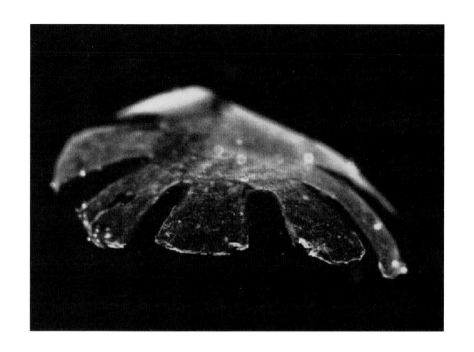
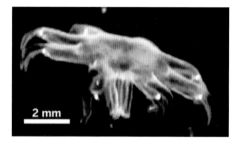

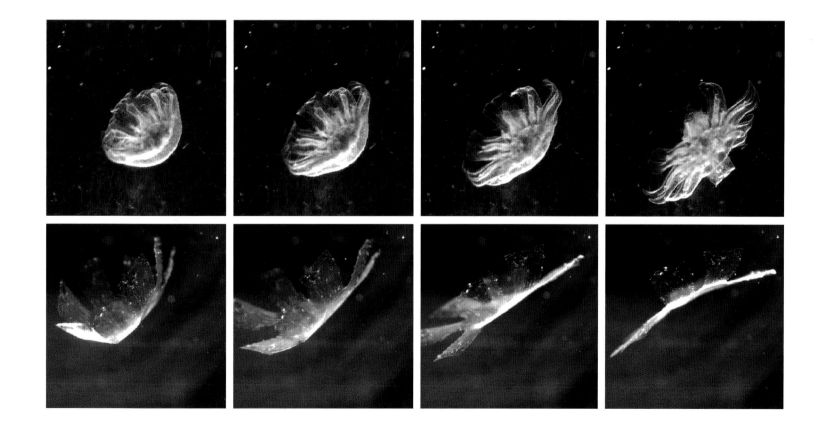

Artificial stingray's rat heart cells contract when exposed to light

Sung-Jin Park, Kit Parker

Kit Parker had a second epiphany at the New England Aquarium (see previous spread). This scientist dad watched his daughter touch a stingray and noticed its quick change of direction. To Parker this seemed related to heart flow. Working with postdoctoral student Sung Jin Park, the lab set about fabricating a tiny artificial stingray to study this motion.[21]

Parker and his Disease Biophysics Group (see also pp. 64–65, 67 and 106) had already succeeded in using electricity to stimulate an array of rat heart cells to create the 'medusoid', an artificial jellyfish. This time they made the soft-robot ray out of 200,000 rat heart cells aligned in a serpentine radial pattern on top of two layers of clear elastomer containing a gold inner skeleton. Light stimulated the motion. The process, called optogenetics, allows light to trigger or twitch genetically engineered cells, here patterned in a circuit to cause a contraction. The result is an undulation that moves the ray forwards. After each wave, the gold skeleton pulls the fins up again. Real stingrays have two sets of muscles to move fins up and down, but bioengineered ones use material science to make things easier. To speed up the ray, the lab adjusted the light frequency. To turn the ray, they used a different light source for each fin. It sounds easy, but this was a painstaking four-year endeavour. It took Parker and team 200 tries to get the light to properly stimulate the cell circuit, and one hundred robots to test navigation. Even further complicating the biological chimera-like origins of this creature, the optogenetic reaction was created by infecting the cells with a virus that delivers a molecular switch to the gene.[22]

The team's stingray advances Parker's goal of understanding and replicating heart functionality, and it inspires new ways of creating creatures that can move, sense and respond.

BELOW
Tissue-engineered soft-robotic ray, 2016

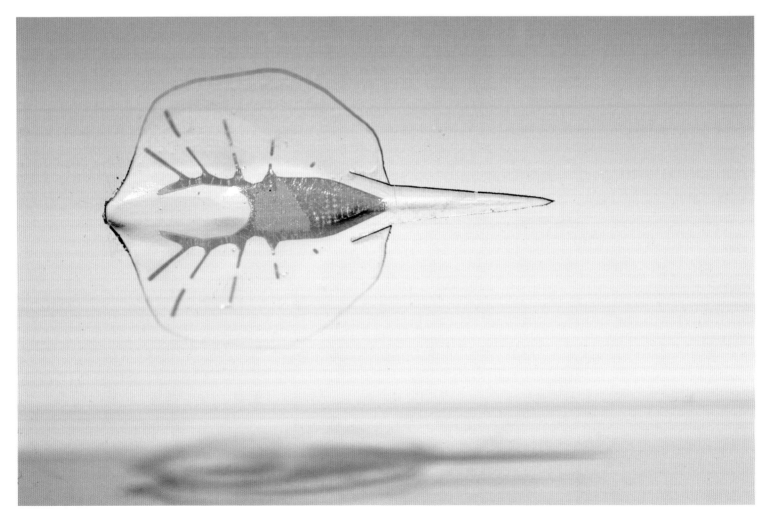

Heart tissue actuated by light makes synthetic fish swim

Keel Yong Lee, Sung-Jin Park, Kit Parker

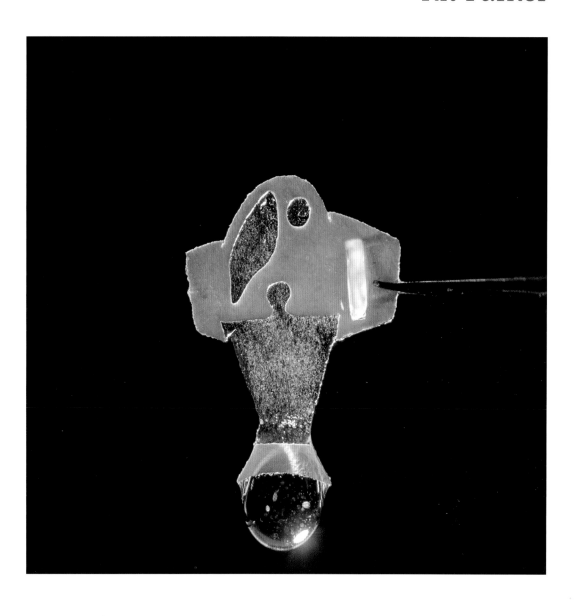

ABOVE
Biohybrid fish, 2022

Kit Parker (see also pp. 64–65, 66 and 106) has called the creation of an autonomous swimming fish made from human heart cells a 'training exercise' for the Disease Biophysics Group's ultimate goal: 'to build an artificial heart to replace a malformed heart in a child'.[23] This is one of several training exercises Parker and his lab have built, mimicking waterborne existing creatures. The group takes cues from the biophysics of the heart to gain information creature by creature. In the process they have made autonomous entities that challenge the notion of what it means to be alive. While former artefacts were related to rats, this fish is propelled by human stem cells. The hope is that diseased tissue may be able to be replaced by tissue made from one's own body.[24]

The fish is composed of a series of vertically arrayed layers. The central plane is gelatin, sandwiched between layers of rigid paper cutouts resembling the morphology of a fish. On either side of the paper is a layer of aligned heart tissue made from human stem cells. The heart tissue actuates the swimming motion through optogenetic stimulation. The left layer of muscular tissue is sensitive to red light, and the right reacts to blue. Using light-emitting diode light pulses, the layers are stimulated one at a time, creating a rhythmic thrust that produces forward propulsion.[25] The two layers of muscles are electrically connected, which means that a contraction on one side causes a stretching on the other side. Pacing of the contractions is timed by an autonomous pacing node.[26]

The synthetic fish swam autonomously for a few months, and rebuilt its cells every twenty days, which means there were five revised versions of the creature.[27]

Controlling a robot with a biological brain

In 2008 Kevin Warwick, engineer and cybernetics expert, set out to see if a biological brain could control a robot, eliminating the role of a computer. Cultured rat neurons were placed on a sixty-count multi-electrode array to serve as the intermediary between electrical signals coming from a simple two-wheeled robotic vehicle and the neurons. The idea was to watch how the neurons would divide, pattern and exhibit complex electrical activities, as sonar sensors in the vehicle sent information back to the neurons and neurons sent instructions to the robot in a closed loop. Warwick's goal was to understand how brain disorders such as Alzheimer's disease and Parkinson's affect the brain. In this setup researchers were able to watch memories grow. The sonar sensor would approach a wall or obstacle and send information to the neurons, and the neurons would send back instructions to change direction or change the speed of the wheels. Initially the robot kept hitting walls, but over the course of a couple of months the neurons started to steer the robot perfectly. The team was able to document and analyze the developing neural connections, hoping that in the future they could strengthen human memories and prevent them from disappearing.[28]

In 2022, scientists at Stanford University, California, did something even weirder: they implanted human organoids made of pluripotent stem cells into the developing brain of a newborn rat. The cells connected, grew and started to network. To study human mental disorders, the team implanted a diseased organoid on one side of the rat's brain, and a healthy one on the other side, situated in the region that was responsive to animal whisker input. They then triggered the whiskers with air and compared the brain activity of the two sides. The ramifications of this dual organism chimera are huge for science, allowing brain development to be studied with human tissue, instead of rat tissue alone.[29]

BELOW & OPPOSITE
Robot with a Biological Brain, 2010

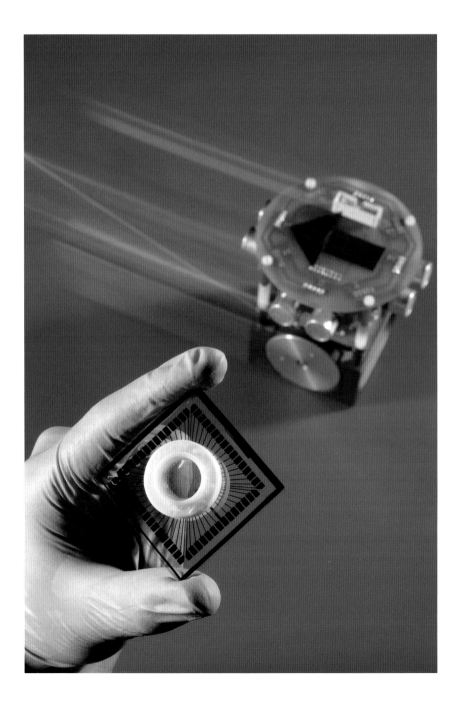

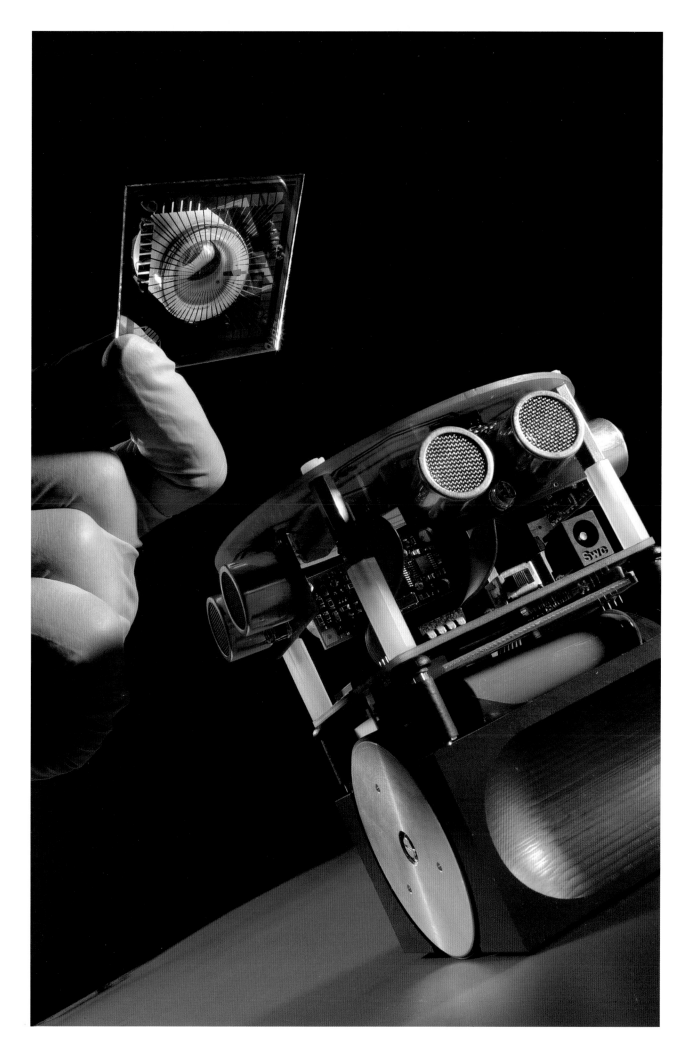

Improvising sound with a biological synthesizer made of responsive cultured neurons

Guy Ben-Ary

OPPOSITE PAGE & LEFT TOP & BOTTOM
cellF, 2016

RIGHT
cellF prototype, 2015. Guy Ben-Ary's neurons growing in-vitro (differentiated from his iPS stem cells). Stained culture at day ten to differentiation.

In 2015 Guy Ben-Ary (see also p. 117) turned his skin cells into neurons to create the post-human cyborg version of the rock star he had always wanted to become. He built a massive synthesizer called *cellF*, which responded to his own cultured neurons. In doing so he created an autonomous responsive instrument – an analogue modular synthesizer combined with a brain. The biological synthesizer would be fed the improvised sounds of invited musicians, and the neurons' responses would be externalized as synthesized sound. This feedback would continue and change in a loop that created post-human sounds.[30]

Ben-Ary's neurons were placed on an eight-by-eight multi-electrode array that would record the electrical signals of the neurons. The neuron count was approximately one-hundred thousand, compared to the one-hundred billion cells of the brain. Even though that is only 0.0001 per cent, a mere speck of the brain, it is enough to produce significant data, and to exhibit plasticity leading to change and development.[31]

The project involved an array of artists and engineers, including Nathan Thompson, Darren Moore and Andrew Fitch. It also had Shinya Yamanaka of Kyoto University to thank for his extraordinary 2006 breakthrough in stem cell technology, when he succeeded in creating stem cells out of mouse skin, and ultimately pluripotent stem cells that could be turned into any type of cell, including neuron, sperm, egg or organ.[32] This opened the gates for scientists, engineers and artists to create the types of cells they need for their experiments.

Decomposing microorganisms nurture living cells

Tissue Culture & Art Project (Oron Catts & Ionat Zurr) with Devon Ward

Compostcubator is a mound of five tonnes of decomposing organic material that serves as an incubator for mouse muscle cells contained in a flask. Microorganisms in the pile, consisting of mulch, manure and beer barley, decompose the material, generating heat that warms up water contained in a coil of tubing in the centre. The heated water gets pumped up to the low-tech incubator containing the living cells, providing a consistent temperature by which to nurture them.[33]

This is a multi-species, multi-kingdom system that was inspired by the incubator mounds of the malleefowl of southern Australia, a chicken-sized bird. Several animals incubate their eggs or young, but few create incubator mounds that capitalize on decomposition. It is an ingenious technique that takes a bird pair nine to eleven months to build. Malleefowl mounds are up to 4.5 metres (15 feet) in diameter, and 1.2 metres (4 feet) deep. The birds, mainly the males, dig a hole with their large feet and fill it with twigs, leaves and soil. They cover this with sand. Before the eggs are laid, the male will turn the soil after rainfall to encourage decomposition. Heat created by microorganisms decomposing the mass will keep buried eggs at an even temperature. During incubation, malleefowl use their beaks to measure the temperature and make necessary adjustments by exposing the eggs to the air or building up the mound.[34]

The project provokes questions about closed-loop systems, post-human nurturing, species collaboration and the future of living systems. Malleefowl, like beavers, improve their local habitats. When animals are allowed to do their thing, everyone benefits, even if in the short term there may be some conflicts with human needs.

ALL IMAGES
Compostcubator 0.4, 2019

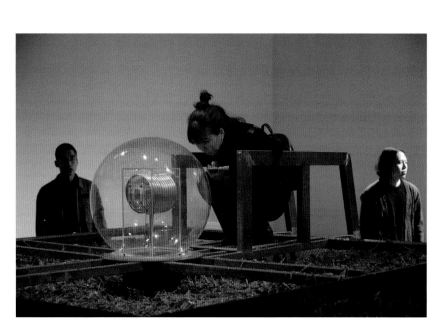

CHIMERA

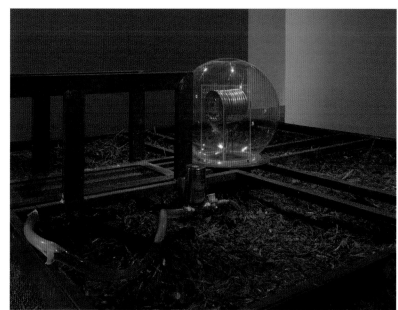
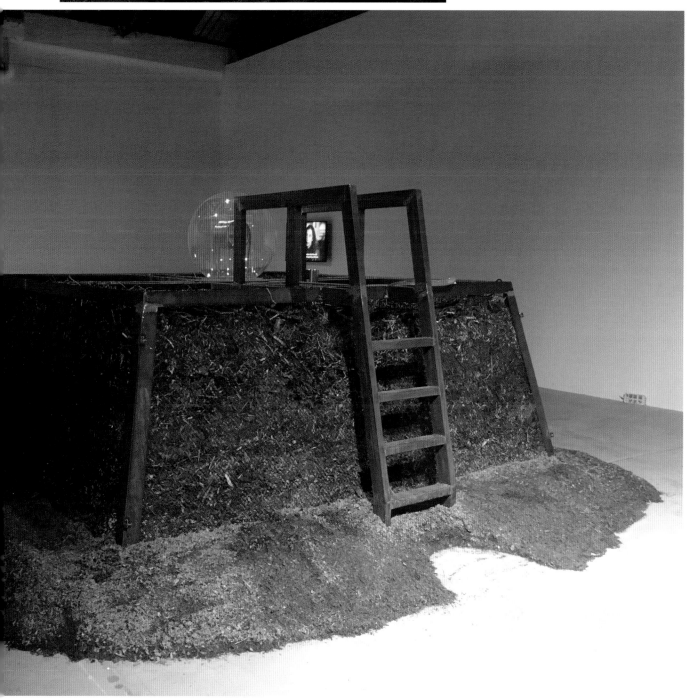

Organic robot uses sea slug muscle as actuator

Victoria Webster-Wood

Biohybrid robots combine a living entity with an engineered synthetic component. Victoria Webster-Wood and team created an aquatic biohybrid robot by combining the mouth muscle of a marine invertebrate called *Aplysia californica*, a sea slug known as the California sea hare, with a 3D-printed polymer skeleton that has two clawlike arms and two legs. Sea slugs' muscles can tolerate changes in water temperature and their open circulatory system makes a vascular system unnecessary. The first robot the team made uses muscle from the slug's feeding apparatus, and is controlled by an external electrical field. The electricity stimulates the muscle cells to contract, which allows the robot to move.[35]

The team has gone on to successfully build sea slug robots using muscle that includes fragments of nerves, allowing a smaller electrical field to actuate the muscle. A further iteration includes nerves and ganglia that are still attached to the muscle. These are stimulated by chemicals, resulting in rhythmic contractions in the muscle through motor patterns in the ganglia that send signals to the muscles through the nerves.

As with other biohybrid robots in this chapter, the aim is to create a robot that might reach inaccessible marine locations. The original 2.5-centimetre (1-inch) long robot was designed to move along the ocean floor, detecting toxins, chemical spills and pipeline leaks. A further goal of the team is to create a robot capable of exploring sensitive underwater areas that would be able to withstand the forces of the environment without becoming a pollutant once the robot expires. The team is ultimately hoping to develop an organic substrate to replace the polymer so that the entire robot will be biodegradable or even edible.[36]

BELOW
California sea hare
(*Aplysia californica*)

OPPOSITE PAGE
Aquatic biohybrid robot, 2016

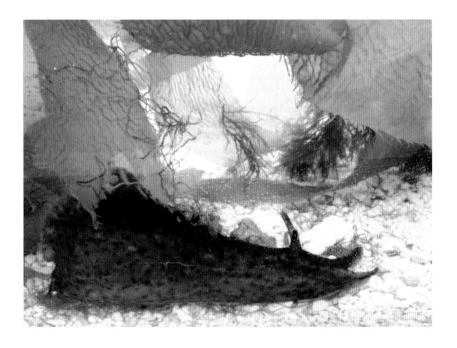

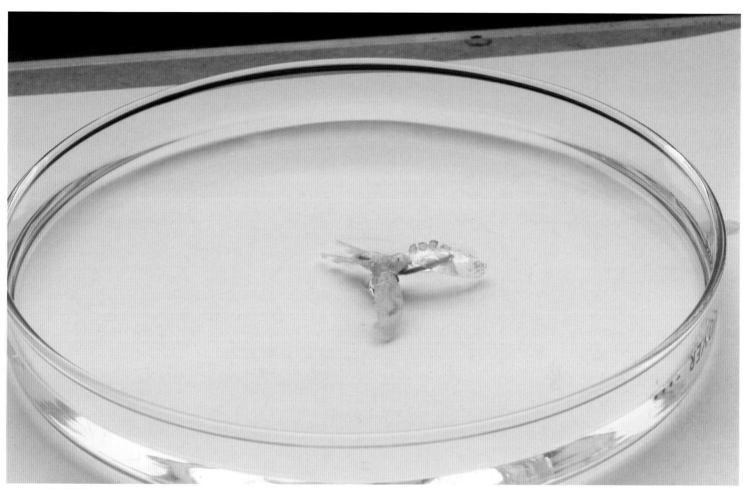

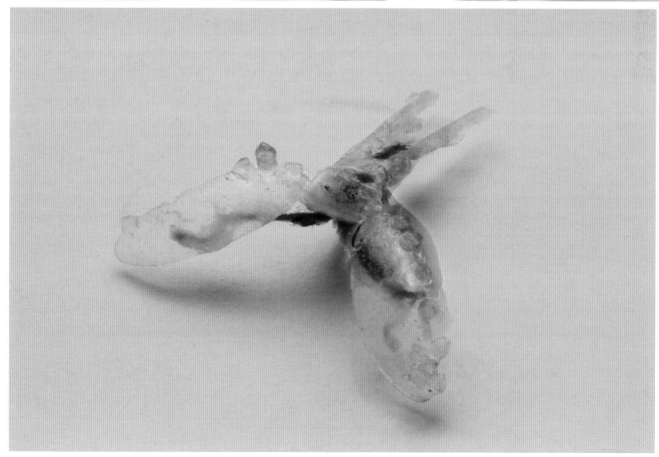

Speeding up jellyfish using electrical stimulation

Nicole W. Xu, John O. Dabiri

Scientists and engineers have not succeeded in creating an underwater robot that is as efficient as a living creature. Instead, they are studying certain ubiquitous marine animals, taking advantage of nature's propulsion systems by turning jellyfish into cyborgs. Why send a human-made robot into the deep ocean when an efficient self-repairing, self-feeding invertebrate works better?

Jellyfish exist in all the world's oceans. The smallest is the size of a pencil tip and the largest is 1.8 metres (6 feet) wide and 30 metres (100 feet) long, but most are less than 40 centimetres (16 inches) wide.[37] There are approximately 4,000 known species of Medusozoa, and probably many more.[38] Jellyfish do not feel pain the way humans and other animals do. They have no centralized brain, only a net of neurons diffused across their body that enables them to sense the environment.[39] They have remained relatively unchanged over 500,000 million years – that is, until John O. Dabiri of Caltech and Nicole W. Xu of Stanford created one that swims nearly three times as swiftly as its unaltered siblings.

An expert on fluid mechanics and flow physics, Dabiri wanted to know more about the deep ocean. The team selected a type of jellyfish called *Aurelia aurita*, known to exist at a depth of around 3,000 metres (10,000 feet) in the Marianas Trench of the Pacific Ocean.[40] They attached a microcontroller to the central underside of the jellyfish where the mouth is, and embedded two electrodes into the muscle and cell tissue nearer the outer edge of the bell, which send electrical impulses to trigger the pulsing action used by the jellyfish to move forward.[41] Set to pulse three times faster than the jelly's usual speed, the electrical stimulation increased its swimming speed from 2 centimetres (¾ inch) per second to 4–6 centimetres (1½–2⅓ inches) per second and improved its energy efficiency.[42] In 2024 the team, led by graduate student Simon Anuszczyk, added a buoyant, streamlined hatlike structure to the top of the jellyfish bell, further increasing efficiency and allowing the jellyfish to carry sensors and electronics to help understand the impact of climate change on oxygen levels, temperature and salinity.[43]

BELOW
Biohybrid robotic jellyfish during field experiment, 2020.

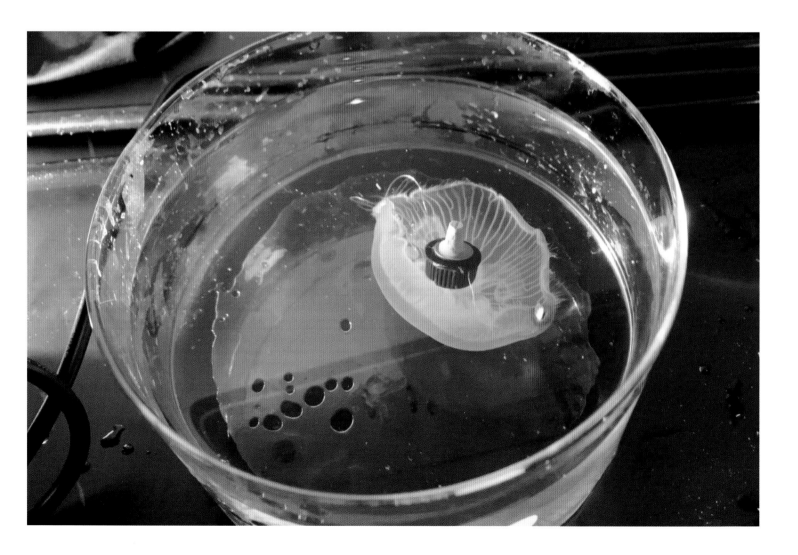

A moth antenna as smell apparatus for a drone

Melanie Anderson

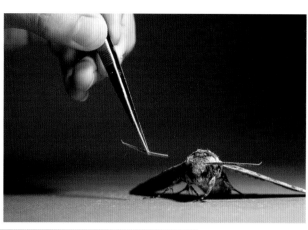

RIGHT & BELOW
Hawk-moth and *Smellicopter*, 2020

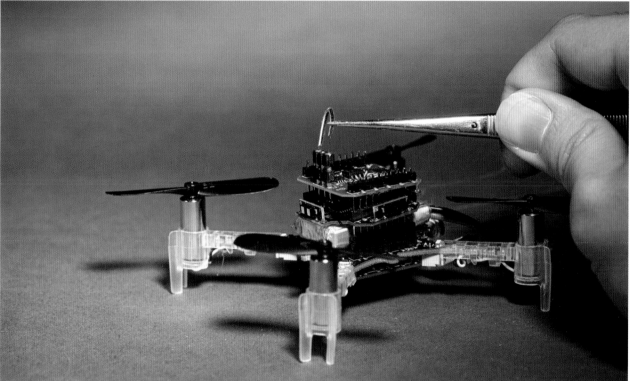

Electricity is one of the principal tools involved in chimeric hybrids. Brains, organs, muscles and machines all respond to electricity or give off electrical signals. That allows scientists and engineers to make circuits with two elements that do not usually go together, such as a drone and a moth. It turns out you can 'read' the electrical data of the antenna of a nocturnal hawk-moth and send that data to the electronic controls of a drone. That is precisely what Melanie Anderson of the University of Washington did to create her *Smellicopter*. Anderson anaesthetized a hawk-moth by putting it in the freezer. Then she detached a single antenna, leaving one intact, and bent it to connect it to small wires protruding from the microcontroller of the drone. The antenna produced a circuit, allowing smell signals to be read. The drone gains the acute smell sensitivity of the hawk-moth and becomes a skilled scent navigator, using the drone's flying skills and some programmed sensing, with the aim, ultimately, of sniffing for chemical disasters, fires, gas leaks and explosive material.[44]

The hawk-moth antenna functions for four hours after it is severed from the moth, which is longer than the drone battery lasts. Each antenna has 42,000 pheromone-sensitive small hairs that function as olfactory receptors. Each hair is stimulated by two bipolar olfactory sensory neurons, each of which sends a dendrite into the hair shaft. The odour of a certain flower or a possible mate binds to proteins inside the antenna. Neurons dedicated to certain chemical compounds are activated by the proteins. That neural signal is what the drone hacks into.[45]

The next step is to cut out the machine altogether, genetically engineering a moth with programmed capabilities.

CHIMERA

Portable snail computers measuring light

Cindy Bick, Diarmaid Ó Foighil

ABOVE
A rosy wolf snail marked and equipped with a University of Michigan Micro Mote computer system in the Fautaua-Iti Valley site, Tahiti, 2017.

It is difficult to keep track of animal extinction. Climate anxiety and guilt over inaction make many of us avoid such data. But scientists are keeping track, and the data is devastating. Many extinctions are the result of habitat loss, climate change or invasive species. In other cases, the well-intentioned introduction of species has proven disastrous. The rosy wolf snail, a North American snail- and slug-eating cannibal, is responsible for the extinction of 134 species of snails worldwide. When it arrived on the island of Tahiti in 1970, it killed off thirty-seven snail species on the island. Only one survived. To find out why, scientists created a very cute chimera: a snail/computer hybrid.[46]

Partula hyalina was the only snail to survive the onslaught. Zoologists Cindy Bick, a researcher at the University of Michigan, and Diarmaid Ó Foighil, professor of ecology and evolutionary biology, had a hunch that its shell might be more reflective, allowing *P. hyalina* to survive in dry areas on the forest edges, where the rosy wolf snail and other species would find the solar radiation desiccating and lethal.[47]

Aided by a computer engineering team including David Blaauw and Inhee Lee, they tested their hypothesis by measuring the light in the environment of both snails using a tiny computer with sensors, recording capacity and a radio transmitter. They glued the tiny compact computer to the shell of the rosy wolf snail. Because *P. hyalina* is endangered, they placed the computer on leaves adjacent to where they slept. The data from fifty-five sensors proved their hypothesis: the rosy wolf snail's haunts received one tenth the amount of light of those of *P. hyalina*. Light was responsible for protecting the pale-shelled species. By aiding in detection of environmental data, 'mechanimals' – animals with sensors, controls and all manner of biology mixed with computers – may save other endangered species from extinction.[48]

Electronically controlled augmented insects

Alper Bozkurt, director of the iBionics Lab at North Carolina State University, served on the search and rescue team in Kocaeli Province in Turkey after the 1999 earthquake.[49] He saw first-hand how difficult it was to find survivors. That experience resonated through his career, as did his work with animal navigation and the micro-electromechanical systems in smartphones.[50] He was uniquely poised to create a team of cyborg cockroaches and hawk-moths for search and rescue missions, finding the apparatus they used to sense for navigation, and devising ways to hack into their system.

The insects share a similar back-mounted pack consisting of a battery for power, a microchip for connectivity and control, a radio to communicate with the team and a microphone. Bozkurt implanted wires into the brain and thorax of the hawk-moth during the late stages of metamorphosis. As the pupa's cells developed, the wires became integrated into the moth's body. The adult is then fully deployable (initially a helium balloon kept the moth afloat). A computer or joystick sends electrical signals to the muscles of the body to tilt the moth to the left or right.[51]

The Madagascar hissing cockroach is controlled by wires connected to the creature's antennae. Electrical bursts make the creature react as though it has sensed an obstruction. An impulse sent to the left will cause the creature to steer right and vice versa. The path of the cockroach could be controlled by an individual or by a computer program.[52]

At the time of this research, studies had concluded that insects did not feel pain. However, an investigation in 2022 found strong evidence that flies, mosquitoes, cockroaches and termites feel pain.[53] In light of this data the deployment of insects needs careful consideration.

BELOW
Instrumented insects, 2024

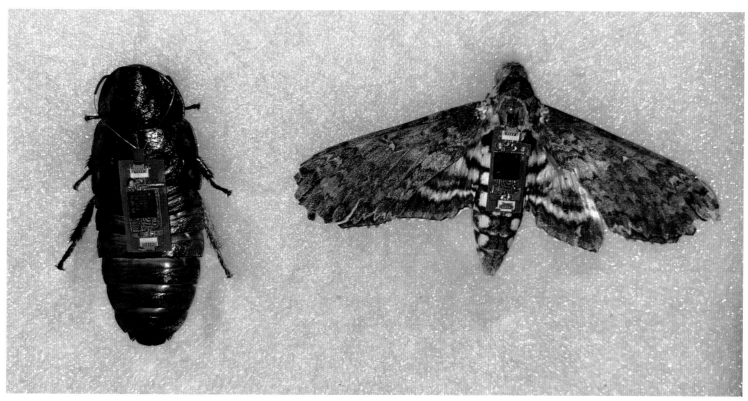

Measuring blinking on a cyborg grackle

Jessica L. Yorzinski

Headsets have been popping up across all manner of animal species, fashioned for mice, rats, cows, fish, bees, chickens and even zebrafish. Virtual reality for animals aims to create an expansive environment for captive creatures, in the hope of increasing productivity and improving living conditions. Other headsets provide a glimpse into the brain, or, like Jessica L. Yorzinski's great-tailed grackle headset, are used as an analytical tool. Animal headsets must be miniaturized and must compensate for much larger fields of vision. It can be difficult to keep the headset in place if it is not wearable and transportable. Headsets can also interfere with sensory input – mice use whiskers to sense proximity to objects, but in virtual space they cannot use them to stop themselves from hitting an obstruction.[54]

To measure the frequency and duration of blinking in the great-tailed grackle, Yorzinski, a sensory ecologist who runs the Yorzinski Lab at Texas A&M University, developed a portable headset with an eye-tracking company, to track a grackle's eyes before, during and after flight. Human lids move up and down to blink, but the grackle, like most other birds, blinks by moving its 'nictitating membranes' (inner lids) left and right. Grackle eyes are on the side of the head, so each eye needed a separate video camera that would be able to record the blink without blocking vision. The camera system was powered by a battery held in a backpack on the male bird (females were too small), enabling the cyborg grackle to reveal blink data while looking like a real badass bird.[55]

After monitoring the flight in an outdoor enclosure, the data revealed that grackles are inconsistent blinkers with consistent rules for stages of the flight. They blinked the least before, during and after the flight. Like human pilots, they blinked fewer times at takeoff, and even more infrequently during landing. At takeoff and during flight their blinks lasted a shorter amount of time, but at impact they blink the most.[56]

BELOW
A great-tailed grackle outfitted with cameras to observe its blinking, 2020.

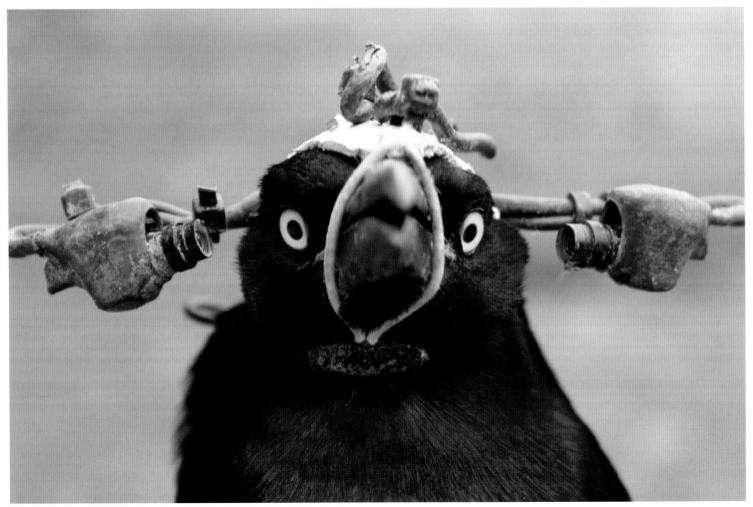

Robotic deer based on sensorimotor diagram

Tim Lewis

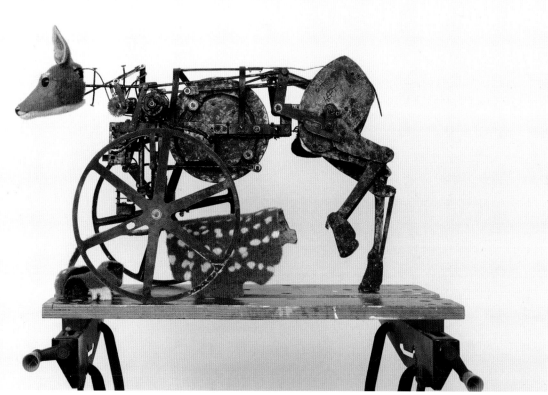

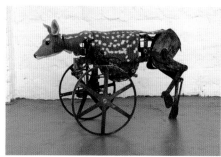

ABOVE
Vehicle 3a (love), 2021

Vehicle 3a (love) is an exquisite fawn that robot-maker Tim Lewis (see also p. 31) made to appear as part robot, part taxidermied animal. Lewis based the elegant motion- and sensor-activated fawn on Valentino Braitenberg's 1984 seminal work of cybernetics called *Vehicles: Experiments in Synthetic Psychology*. Braitenberg's book is a series of thought experiments that deconstruct animal impulses into a set of diagrams using sensorimotor connections. According to Braitenberg, complex cognitive processes such as movement, love, fear and aggression, can be broken down into models using vehicles with motors and sensors. Lewis built the advanced version of '3a', one of three systems outlined in a chapter called *Love*.[57]

Version 3a of *Love* is a diagram consisting of a simple vehicle with two wheels, a platform or body, two sensors and two motors. Sensors are configured to slow one motor down and speed another one up under strong stimulus. If a source, in Lewis's case a light, is to the left, the motor on the left will slow down and the motor on the right will rev up, guiding the vehicle to land directly in front of the source and stay there. This is called 'positive tropotaxis'.[58]

Lewis's deer has a lifelike autonomous head motion. He has perfected ways to interconnect movement, allowing some parts to perform linearly and others radially. The deer's hind limbs are made of steel and rely on a locomotive-like cam mechanism to lift and step. The wheels at the front are the least realistic part of the chimeric being, continually pulling the viewer away from reality and teasing us back into seeing the robotic mechanism. *Vehicle 3a (love)*, made over two years of tinkering with cogs, motors, resin and skin, aims to embody attraction. In doing so, it asks one to reflect on the mechanics of one's own attraction.

Amalgamated animals bioengineered for a zoological garden

Animal design – the knitting together of function, form and environment – has occurred over millions of years.[59] To preserve animals in a world that is no longer natural, Kathryn Fleming (see also p. 181) believes that we must speed up the pace and create new animal taxonomies through synthetic biology.[60] Fleming proposed a new kind of zoological garden in the centre of London. An expanded Regent's Park would be home to three different bioengineered animals that would function spectacularly and delight visitors with their morphological features. One of these, *The Superbivore*, an amalgam of a mountain goat, a giraffe and a deer, has been bred to have baroque headgear that includes antlers, horns and ossicones (giraffe's fused head nubs) to assist in the harvest of fruits in the canopy.[61] It has the long neck of a giraffe, cloven goat's hooves that allow for balance and grip in a steep environment and a 25-centimetre (10-inch) long tongue for extra reach and for grooming. Fleming constructed actual hybrids using taxidermy so visitors could see these believable animals up close.

Until recently it was thought that animals of different species did not often mate and have offspring. Research has revealed that mating between different species is a much more common occurrence. Hybridity is a mechanism for enabling animals to adapt to environments changed by humans. Hybrids such as narlugas in Greenland, cichlids (a kind of fish) in Lake Victoria in east–central Africa and swordtail fish in Mexico have had mixed results in terms of species perpetuation. The narlugas have different teeth from their beluga and narwhal parents, allowing them to become bottom feeders. Owing to murky water resulting from agricultural and other contaminants, cichlids and swordtail fish lost their ability to see or smell mates, and started to mate with different species. The swordtail offspring have been found to have developmental issues and to suffer from premature death. Nature is adapting to our failing stewardship of the planet. Fleming suggests we use new tools to pick up the pace.[62]

ALL IMAGES
The Superbivore, from *Endless Forms/Endless Species*, 2015

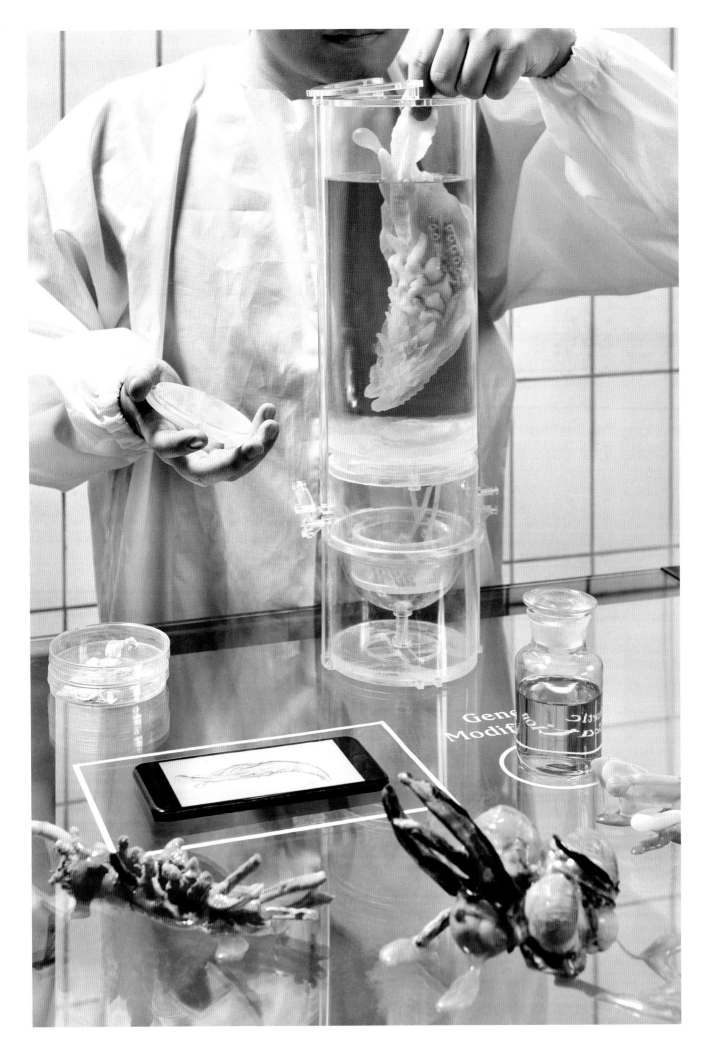

Hybridizing animals for aphrodisiacs and gender fluidity

Despite widespread awareness of the ecological consequences, traditional Chinese medicine sometimes involves the unethical and often illegal use of animal parts, notably tiger penises for sexual dysfunction and aphrodisiacal purposes, and rhino horns for certain medical conditions. Kuang-Yi Ku, a former dentist and bioartist, has observed that synthetic rhino horns, while intended to stop the illegal trade, have actually stimulated the illegal trade. To combat such detrimental usage, Ku proposes a more potent cultured animal hybrid, one that would be endlessly replicable and extremely desirable. Enter the *Tiger Penis Project*, a theoretical science-based tissue culture project that is technically a misnomer. Ku's alternative is comprised of the DNA of animals renowned as sexual stimulants in contemporary culture: tigers, oysters and octopuses. Biotechnological tools would combine the DNA of these animals into one cell, and then a 3D bioprinter would produce the artificial hybrid penis on demand using a hydrogel combined with the cells. In questioning whether culture can bend this way, Ku uses the example of artificial crab. Crab sticks are a popular Japanese snack, even though they contain zero crab.[63]

Perverted Norm, Normal Pervert, a comparative analysis of the sex organs of a snail and a human, is a collaboration with Dr Joris M. Koene, a professor of animal ecology at the VU (Vrije Universiteit) Amsterdam, who researches the hermaphroditism of snails. Based on Koene's research, Ku created a set of four art installations that explore the gender fluidity of the snail, as a way of challenging human norms and highlighting the shifting definition of normal and perverted. Most snails have both a penis and a vagina, so that in the snail world, 'normal' reproduction involves the simultaneous use of both organs. Humans who are considered intersex, having male and female reproductive systems, are considered abnormal.[64] Ku's sculptures combining the two organs aim to remind viewers that there are many ways to be a sexual, reproducing being and that nonhuman animals can broaden our awareness.

OPPOSITE & BELOW RIGHT
Tiger Penis Project, 2018

BELOW LEFT
Perverted Norm, Normal Pervert, 2020

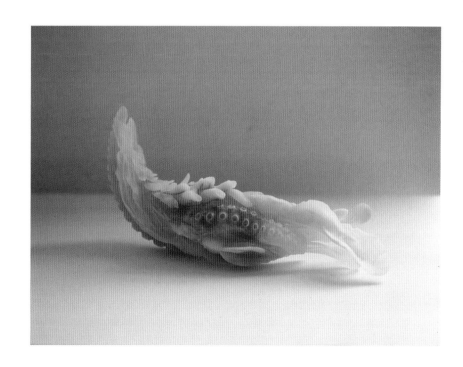

Decellularized spinach leaves as scaffolds for human cells

Faced with increasing rates of heart disease and no real successful way to fabricate vascular tissue, Glenn Gaudette, professor of biomedical engineering at Worcester Polytechnic Institute, Massachusetts, decided to take a bioinspired approach. He blended plant with animal, using the vascular network of a spinach leaf to provide a scaffolding for human cells. It sounds unholy, but it turns out that the vascular network of spinach is very similar to that of human tissue. To start the process, you need to decellularize a leaf using a chemical to remove the plant's cells, while leaving the desirable structural components of the circulatory system intact. Once all plant matter is gone, the walls of the leaf vasculature are then coated with fibronectin, a glycoprotein (a kind of protein linked to carbohydrates) binder that helps the human stem cells bind to the walls. Recellularization takes place by passing human stem cells through the leaf veins. After twenty-four hours, all surfaces become covered with human cells. When human pluripotent stem cell-derived cardiomyocytes (cardiac muscle cells that contract) were seeded on to the decellularized spinach leaf, the cells began to contract after five days.[65]

Plant-grown vasculature has not yet been tested in the human body. It remains to be seen whether the body will trigger an immune response and reject the tissue, but the process has tremendous potential for regenerative medicine. It is a far more ecological solution than current fossil fuel-based or animal-derived biomaterials used for tissue-engineered vascular grafts. Such bioinspired approaches to fabricating complex biological networks save resources, create less waste and have less impact on the planet.[66]

Plant/animal hybrids exist in nature. *Elysia timida*, a Mediterranean sea slug, is a 'kleptoplast': it eats algae and incorporates the chloroplasts of the organism into its digestive tract, where they photosynthesize, producing sugar that powers the slug.[67]

BELOW LEFT
Decellularized leaf after perfusion of Ponceau Red, 2017.

BELOW, LEFT TO RIGHT
Spinach leaf as grown in a garden. The green colour is due to the plant cells, 2017.

Spinach leaf after the plant cells have been removed, 2017.

A decellularized spinach leaf injected with red dye, 2017.

OPPOSITE
Spinach leaf about two days into the decellularization process, 2017.

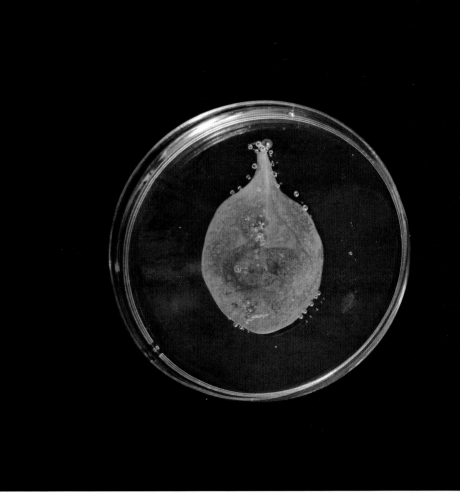

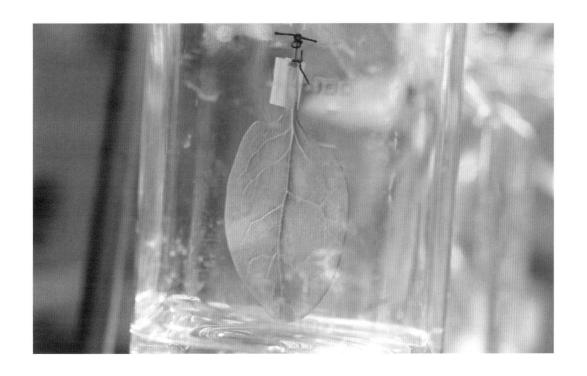
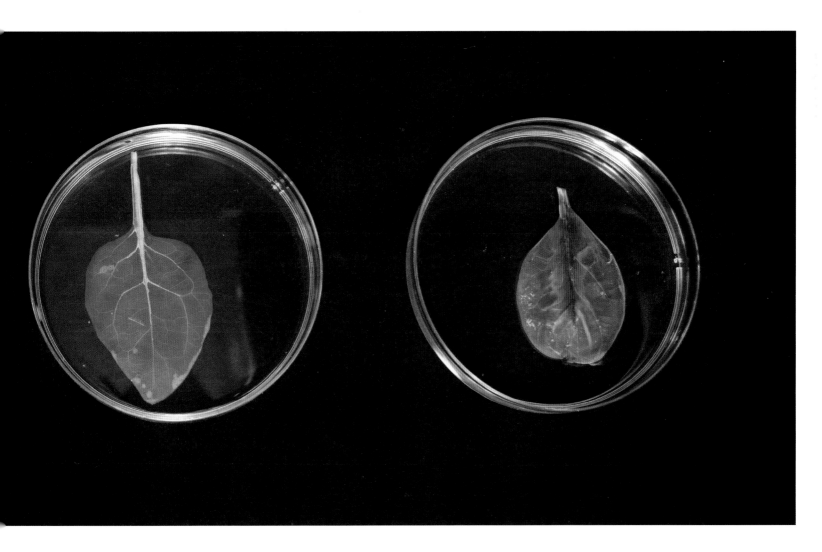

Decellularized meat waste repurposed for product design

Isaac Monté

ABOVE
The Meat Project, 2015

A study of meat waste in 2019 found that eighteen billion land animals raised for food never make it to the table.[68] That is 25 per cent of the approximately eighty billion cows, goats, sheep, pigs, turkeys and chickens that are slaughtered worldwide for meat each year. The ethical issues and environmental damage are monumental. Can disease, spoilage and overstock be monitored to prevent such a loss? Should that many animals be raised for food in the first place? One third of global greenhouse gas emissions come from food and agriculture, and 6 per cent come from wasted food.[69] If we could reduce waste, we would reduce methane production, a major greenhouse gas, and cause a massive change in the environment.

Belgian designer Isaac Monté (see also p.128) has an idea for wasted meat, and it is nothing like the red, fleshy visual you find in such art performances as the meat dance bacchanal of Carolee Schneeman's *Meat Joy* (1964), the bone picking of Marina Abramović's *Balkan Baroque* (1997) or the form-fitting meat dress of Jana Sterbak's *Vanitas: Flesh Dress for an Albino Anorectic* (1987). Monté uses wasted meat for elegant products for interior design. The tinted white translucent rubbery surface of his lamps and vases is the result of decellularization, a cutting-edge technique used in tissue regeneration to remove the meat cells from a structure. Translucent cell-less meat can then be shaped into organic forms, which are dried and glued into layers. The meat is squeaky clean, but Monté won't let you forget its origin. He has modelled the form of the lamp after *E. coli*, a bacterium found on raw meat that causes food poisoning.[70]

Design objects made from discarded animal blood

Basse Stittgen

The objects in Basse Stittgen's *Blood Related* project are made from discarded cow's blood. Cups, plates, utensils, egg cups and even records (which play a pig's heartbeat) are some of the designer's collection of deep black Bakelite-like artefacts made from slaughterhouse discard. Stittgen procured blood from an abattoir, dried the blood into a powder, then heated and pressed it. The gluelike properties of the blood proteins bind it together to form a bioplastic and help the taboo concoction dry hard and odourless. 'We all have an idea about what blood means to us, what history we have with it and what its purpose might be,' Stittgen says. 'The idea to have objects made of blood is therefore much more repelling than the idea to eat animal meat, wear animal skin and even put stuffed animals as decoration up on a wall. This aversion comes not only from disgust but also from habit and tradition.'[71]

To begin this project Stittgen had to delve into the inner workings of the slaughterhouse industry. According to UN Food and Agriculture Organization data, nearly 310 million cattle were slaughtered across the world in 2022. Each cow contains approximately thirty-eight litres (ten gallons) of blood, but on average only 50 per cent of the blood can be saved. Most of it is wasted, even though it is a potentially usable by-product with nutritional value for feed, pharmaceutical applications and many other uses.[72]

Stittgen is harking back to a time when cultures knew how to process blood – when the slaughtering of animals took place in urban communities and was part of daily life. For *Blood Related* Stittgen revived a nineteenth-century French recipe for making flat blood sheets that was lost after the development of Bakelite and fossil-fuel plastics. His objects hover between life and death, human and animal, consumer and consumed, dining room and abattoir.[73]

BELOW
Blood Related,
2017–ongoing

Protest cheese: black mould as bacteria starter culture for artisanal cheese

ALL IMAGES
Spoiled Spores, 2019

'Does anybody have some mould?' Avril Corroon posted on her local London Facebook group Free Stuff South East. She was specifically looking for black mould growing on the walls and floors of strangers' flats for a project that would highlight problems in the rental market in London and Ireland, including the discrepancy between wages and housing costs, the exorbitant prices for poorly maintained living spaces and the gentrification that resulted in unaffordable food and consumer goods. Black mould grows on water-damaged or damp materials rich in cellulose, including wood, paper, plasterboard and fabric, forming on wet surfaces and then reproducing asexually. Corroon came up with the idea of creating a cheese chimera. She would substitute black mould for the usual moulds used to make Camembert and Gorgonzola. Properly equipped with gloves and adhesive tape, she extracted samples from apartments around London and Dublin, and then used it as a bacteria starter culture to make a selection of toxic but tasty-looking artisanal cheeses.[74]

Thirty wheels of cheese are named after the tenants of the flats where they were sampled. The accompanying ingredients list includes the price of the flat. Cheeses named *Katie*, *Alan*, *Sophie*, *Ruzha* and *Jaspo* were displayed in used industrial refrigeration units in Corroon's 2019 MFA exhibition at Goldsmiths, University of London, called *Spoiled Spores*.[75] The beauty of Corroon's work is in the presentation of toxicity.

Corroon explained in an interview with Patrick Heardman in *Vice*: 'The idea is to juxtapose precarious living standards with that of wealth, gentrification and thinking about where money is invested and where it is disinvested, and how often products are all made from a type of exploitation.'[76]

CHIMERA

Avril Corroon

Sensual bread bodies emerging from yeast rising through mesh

Dana Cupkova, Ben Snell

The *Bread Bondage* experiments hang like carcasses. Their bulges are reminiscent of Artemis of Ephesus, a Greek goddess associated with fertility, whose torso held rows of protuberances that are thought to represent eggs, breasts, bull's testicles or gourds. The baked work overflows, pops and droops. Is this food? Or is it material science, architecture, sculpture, or experiments in gravity? The important factor in this series is the living yeast. Until these works are put in the oven, they are made of living entities, like all leavened bread. The voracious yeast eats the flour's sugar causing it to excrete carbon dioxide. Trapped in the dough, there is no place for the CO_2 to go. Here, the dough expands through the knit tubular mesh in monster fashion. Variations in the dough, knead, temperature and grid of the net affect the outcome, but the rise and sag have a will of their own. The sensual bread bodies look like colonies of fungi, collectives and living entities.

ALL IMAGES
Bread Bondage: Experiments in Gradient Casting and Voluptuousness, 2016

Cupkova and Snell's work is a twist on the long evolution of baking. In 2018 archaeologists discovered fragments of charred unleavened bread that proved to be more than 14,000 years old, predating agriculture and the domestication of grains by 4,000 years.[77] The earliest-known use of yeast was in Egypt in 1500–1300 BCE.[78] The Egyptians used conical moulds and yeast for their bread, while Roman bread was round.[79] A *panis quadratus*, a typical Roman-style loaf divided into eight parts, was wrapped on the outside with string.[80] String has since been used to segment round pumpkin loaves. *Bread Bondage*, in growing bodies with organic blooms of bread, speaks to orgiastic eating, collective candy consumption and uncanny fertile food urges.

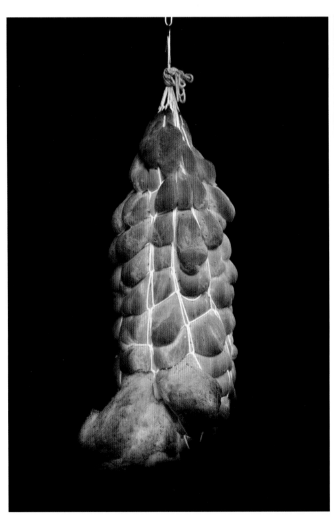
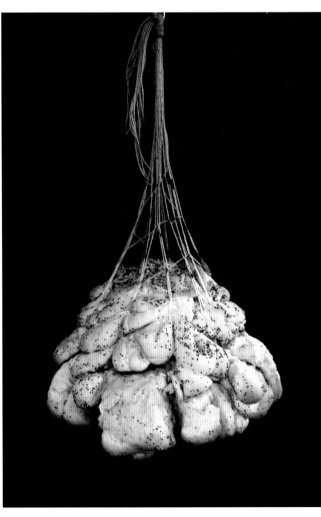

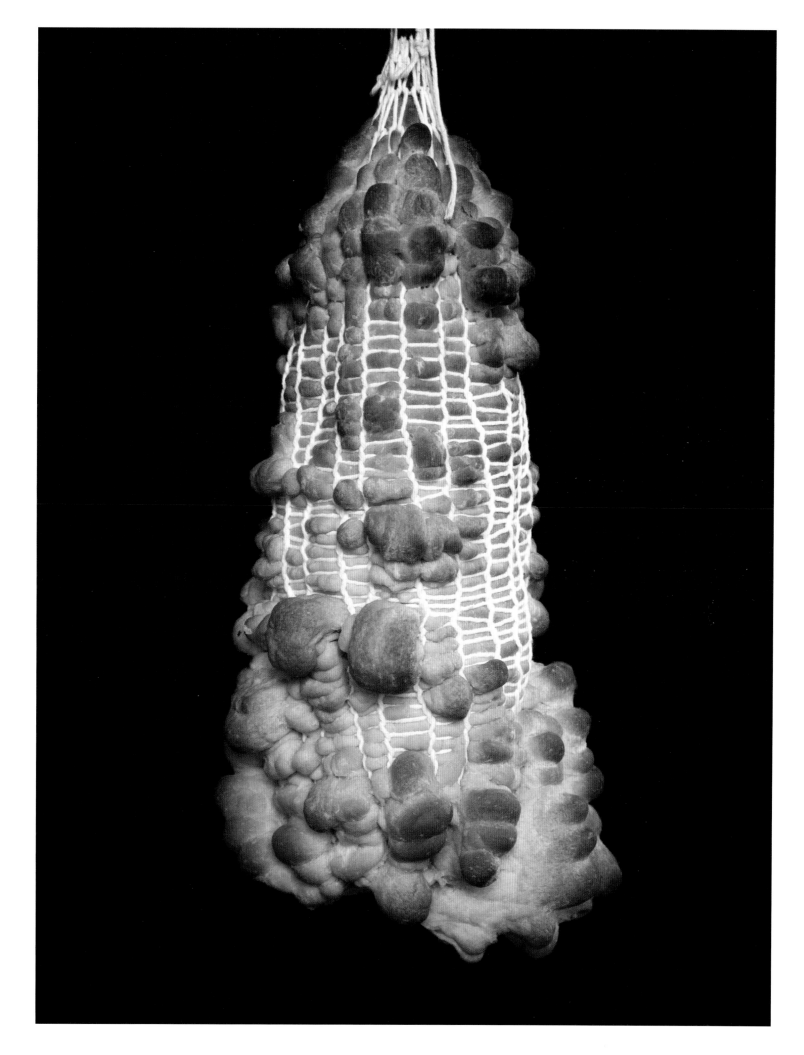

Communal urine as food for living art

Candice Lin

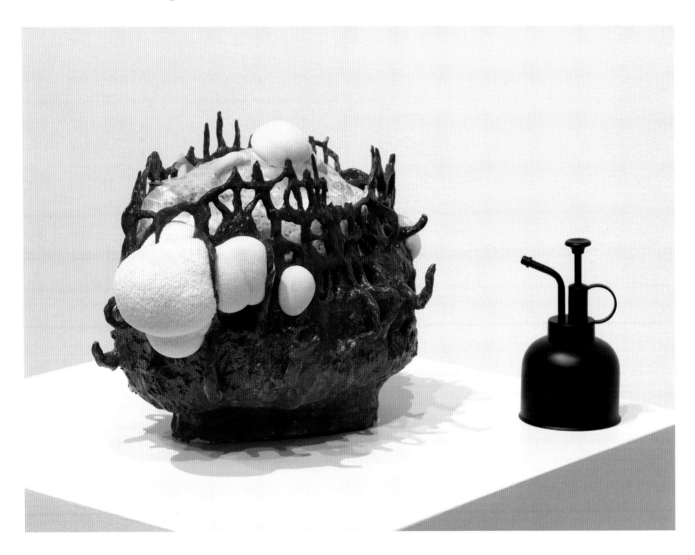

ABOVE
Memory (Study #2), 2016

In *Memory (Study #2)*, Candice Lin engaged groups of humans across time and space to collaborate in growing a lion's mane mushroom situated in a red ceramic space frame. Wherever the piece travels, she enlists the staff to collect their urine, distil it to remove bacteria and spray it on the mushroom contained in a plastic bag. Like sourdough starter that travels from person to person and retains some of the cells of each baker's skin, the mushroom is misted across continents by a community of caretakers. Supposedly lion's mane has benefits for memory when consumed. It is made from memory and gives itself up to memory. The combination of human interaction, human waste and thriving fungi gives the work a chimeric feel.[81]

Memory (Study #2) follows in the footsteps of several works of art involving urine. In 1977 Andy Warhol created *Piss Paintings* by having his assistants pee on canvases laid out on the floor, even suggesting they monitor what they ate and wait to urinate.[82] In 1987 Andres Serrano displayed his controversial photograph *Piss Christ*, a cylindrical jar full of his own pee, inside of which sat a small statue of Christ crucified. Carsten Höller allowed guests to sleep over in his installation *Soma* at the Hamburger Bahnhof in Berlin in 2010, inviting them to drink a jar of reindeer urine that was either from reindeer fed hallucinogenic agaric mushrooms or from a control group. In 2017 the artist Cassils displayed 200 days' worth of his own urine in a square transparent container titled *PISSED*, to protest then President Trump's rollback of a law that allowed transgender students to choose the bathroom that best suited their identity.[83]

Lin's work has a more communal, more life-affirming engagement with urine, which enlists museum staff in a shared mission to sustain life.

Visualizing mutation through the transformation of a cultural artefact

Jaime Pitarch

BELOW
Chernobyl, 2009

The 1986 Chernobyl and 2011 Fukushima accidents are the only 'Level 7' nuclear disasters in history. In 2009, artist Jaime Pitarch created his monstrous dismembered and reassembled matryoshka doll titled *Chernobyl*. The nested dolls have undergone a toy version of mutation and are now intersected at wild angles, with at least six heads protruding from the body of the largest peasant figure. Not since the first Russian nested toy was created in 1892, modelled after Japanese nested figures called *kokeshi*, has the form undergone such a radical transformation.[84] Though it is not a living entity, it is a stand-in for all the living beings that have suffered the effects of the nuclear disaster at Chernobyl.

The Chernobyl explosion and the nuclear fire that burned for ten days led to the release of 400 times more radiation than the atomic bomb dropped on Hiroshima.[85] Two people died immediately and twelve more within months.[86] Between 1991 and 2015 nearly 20,000 cases of thyroid cancer were reported among children, adolescents and adults.[87] The exact scale of the disaster is not fully known, but it had a massive impact on plants, animals and humans. Generations of tree frogs and dogs living in the Exclusion Zone, an off-limits area nearly the size of Rhode Island, have been found to have undergone mutation.[88] Radiation is a diabolical agent of genetic chimerism. You cannot see radiation, but it takes its toll on biological beings.

Pitarch's transformation of an iconic toy is a devastating visualization. This subversion of artefact and meaning is typical of his revelatory process, in which he looks at the motivations behind forms of production to uncover the dissonance between the structures we invent, and our inability to identify with them. Pitarch's matryoshkas are cultural chimeras that reassemble a familiar object to create a new resonance.[89]

Alchemical sculptures as contemporary reliquaries

Daniel Giordano

Daniel Giordano's workspace is his family's defunct coat factory. The old rolls of cloth, sewing machines and cutting machines surround him. Named after his Aunt Vicki and the family's Vicki Clothing Company, his studio *Vicki Island* is an evolving time capsule of family, production and Newburgh, New York. There is a chimeric relationship with Giordano's past, present and future self, and with the ghosts and relatives that constitute family. His sculptures are often related to family members, in combination with factory relics, personal artefacts, local finds and even ingested and excreted substances from the artist's body. 'My sculptures serve as reliquaries to my life, encapsulating my feelings, my loved ones, my Italian American heritage, experience and hometown. Iconic symbols of America such as bald eagle excrement, TruckNutz, Tang drink mix, bison tails and sports vehicles become important elements in my work,' Giordano has said.[90]

The chimeric hybridizing happens when Giordano performs a chemical, physical and transubstantiating metamorphosis of his materials. Gold leaf, contact lenses, dog ticks, eyeshadow, lichen, hair, Murano glass, sparklers, tennis balls, artificial teeth, Nesquik Strawberry Powder, tuna fin and urinal cake are rendered unrecognizable, ground down, deep-fried or coated in resin. The artist gloms, beats, grinds, stuffs, coats and burns the materials, forming vaguely recognizable humanoids.[91]

Cannoli (The Grip of Goran), part of the 'Cannoli typology', conflates the pastry of Giordano's grandmother's table with the alluring pointer finger of tennis pro Goran Ivanišević. *My Mon Calamari II* refers to Giordano's brother's favourite aliens in the Star Wars Trilogy and Giordano's favourite Italian appetizer.

Anthony, Giordano's older brother and principal muse, appears as a fantastical being throughout his work. *Study for Brother* is made of 'sweet nibbly love bits' (Italian pastries), 'jerk stick thunder beams' (cast aluminium sticks), 'uddering udderances' (ceramic vessels) and occasional other protuberances. In *My Scorpio I*, the motorcycle is a nod to both his brother's star sign and his favourite sculpture – an Etruscan chariot – as well as to their grandfather's motorcycle. The deep-fried batter unites the ensemble.[92]

RIGHT
Daniel Giordano in his studio, working on *My Scorpio II*, 2019

CENTRE
My Scorpio I, 2016–2022

BOTTOM
My Mon Calamari II, 2015–2020

OPPOSITE PAGE
Cannoli (The Grip of Goran), 2016–2021

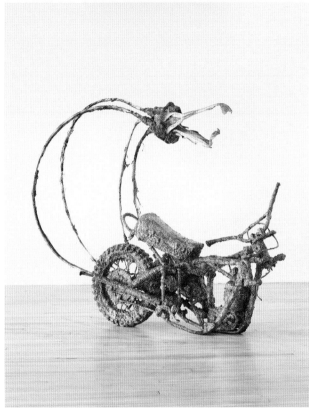

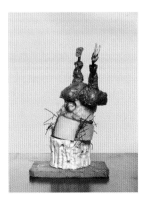

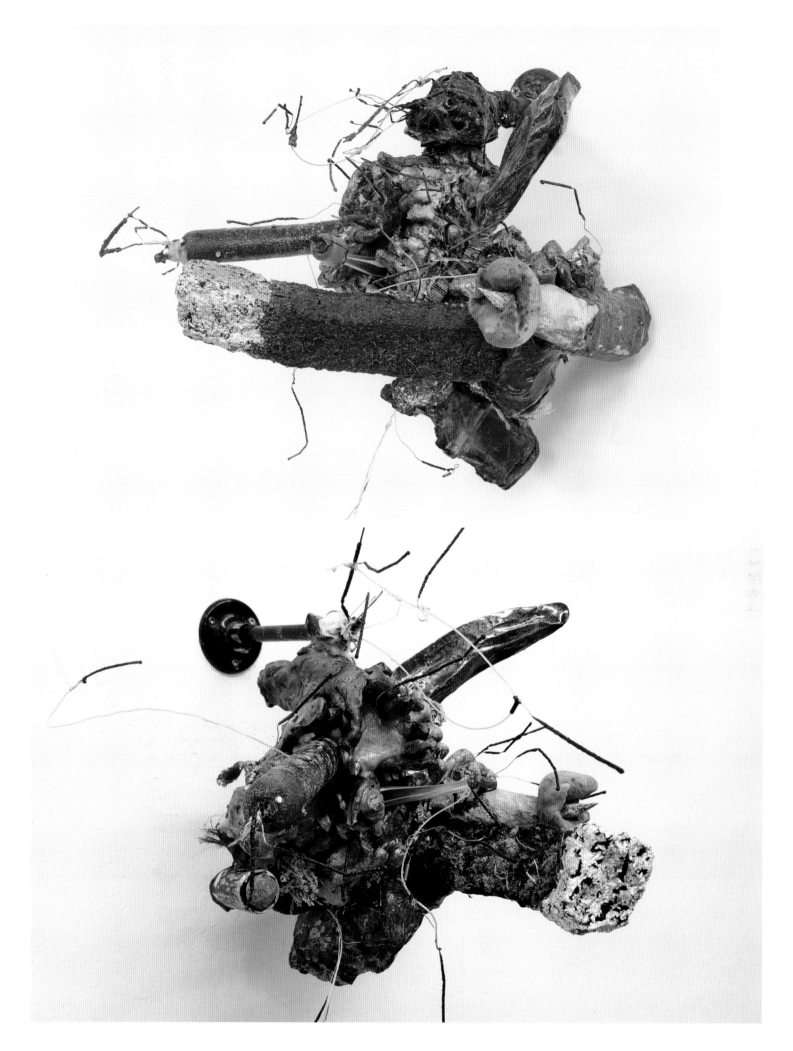

Metamorphosis frozen in time

LEFT & RIGHT
The Flux and the Puddle, 2014

BELOW & OPPOSITE BOTTOM
Spirit Transfer, 2019

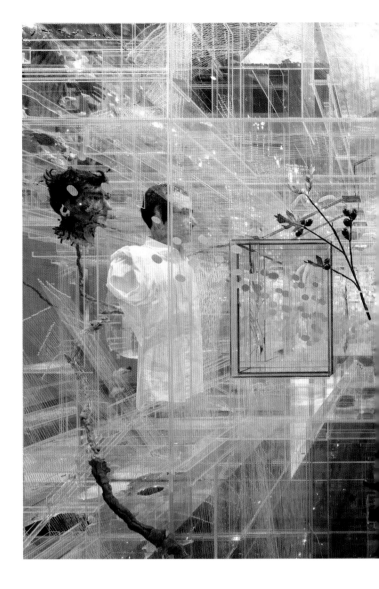

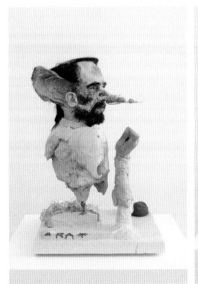
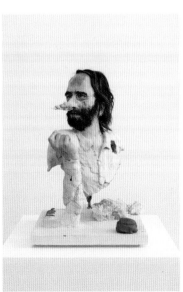
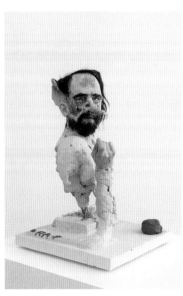
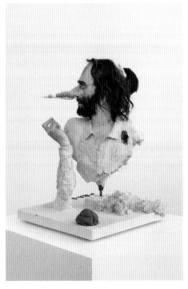

David Altmejd

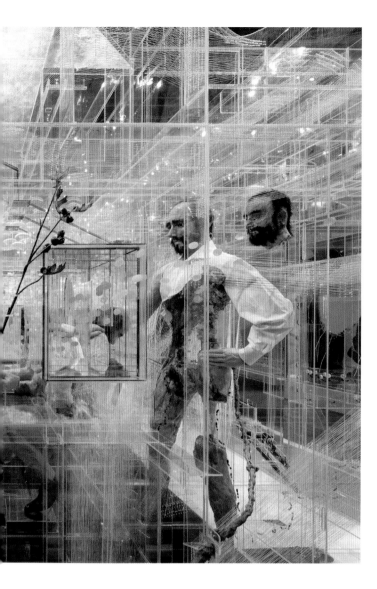

The Flux and the Puddle is a shape-shifting sculpture frozen in motion. David Altmejd is the conductor, and though there is no music and no actual motion, everything is in a state of energized connection. Scores of disembodied limbs animate the cubical field. There are hands everywhere. Hair, thread, ants and a swarm of bananas course through the sculpture on a strange, choreographed journey. Mirrors multiply the space and make jazz. Transforming beings are centre stage. The werewolf is where the genesis begins. The blue crystals refer to the moment when the entity explodes with energy thanks to the morphing cellular structure.[93]

The werewolf is not the only organism metamorphosing. Melons are turning into heads, crafted ear by ear by severed hands. Fruit oozes a generative liquid that courses through the sculpture and forms a puddle. Hands are using the hair of a crystallized werewolf head to form a melon head. Thread moves linearly and bursts into delicate flowers. Even the arm of the werewolf is animated through repetition, becoming a sculptural version of an Étienne-Jules Marey motion study. The complexity stands in contrast to the modular Plexiglass, an inflexible substrate that serves as a structure for the internal explosion of generative form-making. Altmejd's ensemble is a time-lapse of transfiguration and effervescence.[94]

In *Spirit Transfer*, natural history and fiction slam together. The head is at once becoming and undoing. A pen serves as a prosthetic nose while a human ear evolves into a bat's. Crystals evoke cellular metamorphosis.

CHIMERA

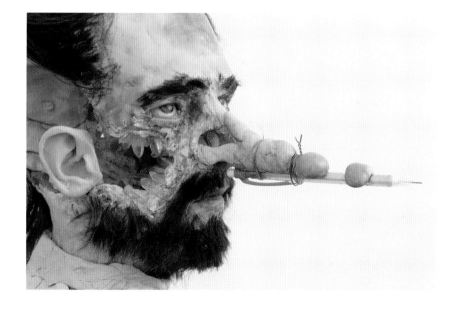

CHAPTER 3

CELLULAR PACKAGES

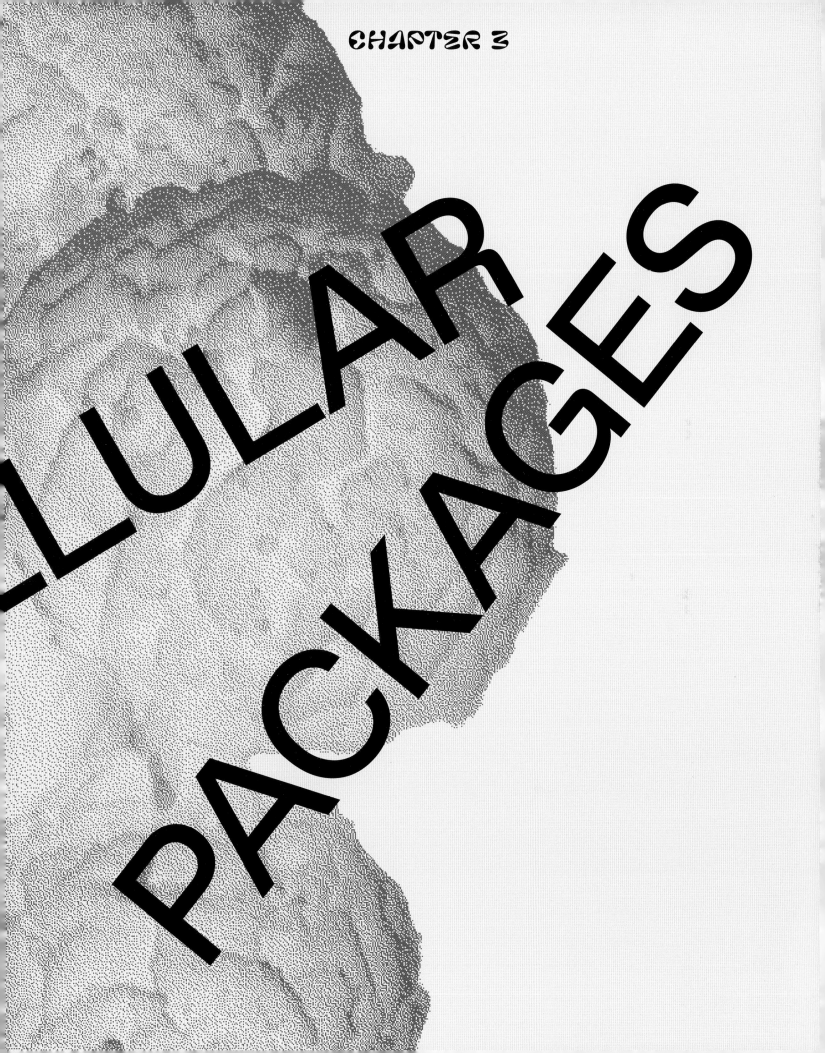

In the early development of life, around two billion years ago, a bacterium was incorporated into cell morphology through endosymbiosis, eventually becoming the mitochondria – the powerhouse of the cell. The idea that a simple cell could incorporate an organism that would become a chief energy producer is the stuff of science fiction, but it really happened. It perhaps should not come as a tremendous surprise that one day parts of a cell could be taken out and replaced. Easy come, easy go. Well, not really. It is difficult and almost miraculous to tweak the building blocks of life. We have now reached – and even surpassed – that milestone, as researchers have successfully synthesized DNA and transplanted it into a cell stripped of its own DNA, creating the first synthetic cell.

Scientists at the J. Craig Venter Institute performed these stupendous acts in 2010 and 2016. The 'minimal cell', as it has come to be known, has the smallest number of genes of any cell – the minimum required, according to researchers, to sustain and perpetuate life. This is just one avenue of synthetic biology. Humans can now fabricate life. Yet unlike architects, who understand the function of each brick, pipe and wire, researchers do not know what one third of the genes of the minimal cell do. There is a great deal to learn about encoding life.[1]

There is also much work to be done on the boundary between the real and the synthetic. One way to tell the difference between a synthetic cell and a real cell is to leave a 'watermark', a code written into the DNA made up of four letters of the genetic code. That is what the J. Craig Venter Institute team did with the world's first synthetic bacterium they created in 2010, based on an existing bacterium. The synthetic genome, constructed entirely from chemicals, was given the 'watermark' for identification purposes, so that future researchers could trace the origins of descendants, in the event of something going wrong.[2]

Two thoughts come to mind. One: what graffiti artist would not want a tag that self-replicates? Two: yikes! What could go wrong with synthetic life? Who will monitor

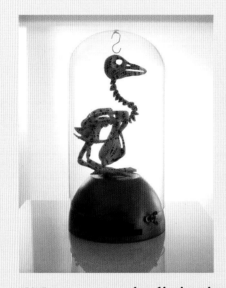

ABOVE
The skeleton of the extinct passenger pigeon, part of Tina Gorjanc's speculative workshop, in which the de-extincted pigeon is used to produce a luxury glove as a way to explore the ethics of biotechnology (see pp. 118–119).

the distinction between natural-born cells and synthetic ones, and does it matter? The minimal cell was tested generationally for 300 days, and it thrived. While that amounts to 40,000 years in human terms, we do not know what could happen in 800 days. One thing is certain, synthetic cells are here to stay. We can expect more human-made cells. Soon enough simple creatures will follow. These will mate with naturally evolved creatures. Genealogy will never be the same.[3]

Cellular packages are exciting new ideas for clusters of cells. This chapter include conceptual ideas for new organs, prototypes for organ simulacra for medical testing and diagnosis, methods for culturing new materials for life on Earth

and in space, future materials made from extinct creatures or from human cells, cellular performances using stem cells or microbes and new infrastructure for personal security or microbiomes. Though so much discussion in the media involves artificial intelligence, in laboratories across the world cells are getting made, multiplied, transformed and eradicated, and life itself is changing. What is more alarming: the idea of a computer taking over the world, or synthetic cells running wild?

Synthetic biology has been jump-started by several far-reaching science and engineering innovations. Two among them are especially notable for this chapter: the reprogramming of skin cells to become stem cells, and the separation of cells from their extracellular matrix (ECM, see below), known as decellularization. As discussed in the 'Chimera' chapter, Shinya Yamanaka's transformative discovery that mouse skin cells could be transformed into stem cells liberated researchers from using rats and other creatures for tissue, and enabled researchers to use human cells. Pluripotent stem cells have the capacity to be reprogrammed to turn into any other type of organ tissue. As a result, laboratories around the world no longer have limits. They can study human organ cells, create human organelles and, in the future, create actual organs.[4]

The chapter begins with biologically simulated organs. Johan U. Lind and Kit Parker use 3D-printed technology and muscular thin film strips made of aligned heart cells. These fragments of living organs, packaged like the tiles of a modernist toy, save the lives of animals that would have otherwise been used for testing, reduce the exorbitant cost of testing with

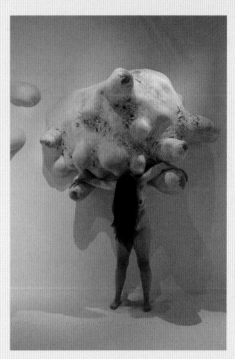

RIGHT
A performer inserts her unclothed body and its family of microbes into Sonja Bäumel's wall-sized amoeba in this installation that highlights the microbial community living on the human body's perimeter (see pp. 124–125).

live animals and fast-track results. Kiara Eldred converted stem cells into retinal tissue, gestating them for nine months to create retinal organoids that could perceive light but not process it into sight. Her aim was to study the development of cone photoreceptors, specifically whether green, red or blue receptors develop first, and the mechanism that triggered such development. Artist Sean Raspet joined forces with Eldred to display the retinal organoids in a pristine incubator, forming a six-by-six grid of organs. Changing sites from a laboratory to a gallery confronted gallery-goers with the otherness of developing life.

John Walter and Jiwon Woo engage narrative in their cellular explorations. Walter re-enacts the stealth functioning of the HIV capsid (outer protein coat of the virus) involved in the transmission of HIV in his movie *A Virus Walks into a Bar*, using the interaction of actors in elaborate costumes designed by the artist as stand-ins for the virus and cell engagement. Jiwon Woo explores family narrative in *Hand Taste (son-mat)*, specifically through cooking.

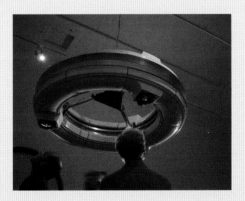

LEFT
Bricolage, by Nathan Thompson, Guy Ben-Ary and Sebastian Diecke, is a live performance in a gallery, contained in a vessel and acted out by heart muscle cells formed from pluripotent stem cells (see p. 117).

Decellularization is a process by which organs are rinsed of their cellular material, including all DNA and RNA, leaving behind only the structure holding up the cells, or extracellular matrix. This allows for tissue regeneration using an accurate scaffold. When treated with a detergent solution, any organ can become a ghostly white matrix, devoid of living tissue. Tissue engineering aims to one day regenerate entire organs using a decellularized matrix.[5]

Woo sets out on a quest to determine how her mother's hand microbiome affects the taste of food. Woo's research brings to the fore that humans are a collective of organisms, while Walter's re-enactment makes visual the inner workings of a feared virus, destigmatizing infectious entities.

Human cellular tissue is sometimes disembodied and abstracted. Donald Ingber and team create USB-stick-sized chips that serve as interfaces between organ tissue and fluidic substances or drugs the medical community deems worthy of trials. 'Human Organs-on-Chips' allows each organ a distinct representative chip, fabricated through soft lithography, with microfluidic channels that allow fluid to flow through

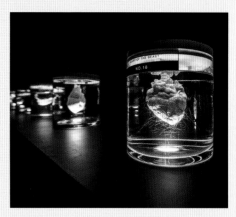

ABOVE
With a set of decellularized pig hearts transformed by various physical processes, Isaac Monté explores how the inner body might be a future site for deceptive design tactics (see p. 128).

LEFT
A patent application and samples from Tina Gorjanc's simulated fashionable leather goods made from tanned human skin, which explores future ethical concerns over biotechnologically produced material (see pp. 120–121).

the living tissue. The creators of *Bricolage* – Nathan Thompson, Guy Ben-Ary and Sebastian Diecke – showcase a performance of heart muscle cells reprogrammed from stem cells. The stage is a circular vessel overhead, giving the disembodied cells a hierarchical position over humans. We are nothing without our beating cells.

Tina Gorjanc and Burton Nitta stage speculative projects about newly engineered biological organs, the former skin, the latter the larynx. The artists delve into contemporary phenomena to derive their future scenarios. Gorjanc's *Phylogenetic Atelier* begins with the imagined success of an actual company – Revive & Restore – that is attempting to 'de-extinct' the passenger pigeon.[6] She presents a luxury artisan's work area and display, including a glove fabricated out of the revived skin of the now extinct pigeon species. What ethical breaches will we make for the sake of luxury? There is a never-ending human story – a loop that involves ambition, success, excess and distress. Can humans ever properly steward life? Gorjanc takes renewable material one step further, proposing, provocatively, that we use tissue engineering to create human leather for luxury goods. Stem cell technology provides the means for culturing human skin. Though more delicate than animal hide, it could be used to fashion bags and jackets. But would we use it? Should we? This project provokes observers to question their own values regarding the use of animals for luxury wearables. Burton Nitta aimed for universal impact during the chaos and conflict of the Brexit negotiations. They cultured stem cells to form a new human larynx that could augment the human voice and allow someone to communicate voice to cell and voice to populace.

Sonja Bäumel showcases microorganisms with performances and artefacts that dispel an illusion: the human as a single entity. Our skin, instead of being a taut boundary, is the site of a thriving, diverse, intelligent community of organisms that comprise our microbiome. Bäumel uses scale change to engage visitors in the wild world of microbes with which we cohabit. In *Entangled Relations – Animated Bodies*, a woman performs, entangled in a wall-sized amoeba and patches of our surface microbiome. In *Microbial entanglement in vitro break out*, a trio of humans curl up in a giant petri dish, as their respective microorganisms send chemical signals. Microbes communicate through chemical signals to engage in activities such as group phosphorescence. This is the stuff of dreams for our human cells.

Cecilia Jonsson and Isaac Monté use human organs and scientific methods for processes that feel like science fiction. With *Haem,* Jonsson dried sixty-nine donated

placentas, smelted them with a blacksmith, produced a nugget of iron, then forged a compass needle. Jonsson mines the body. Isaac Monté decellularized and then modified twenty-one pig hearts to explore aesthetic transformations of the inner body as a means of fostering deception. Pig hearts have been transplanted into humans twice so far, with some success. The idea that aesthetic design aiming at deception would move inwards as we run out of new sites for modification is plausible and chilling.

The team of Liz Ciokajlo and Maurizio Montalti innovates with living materials that involve the human body in unique ways. Ciokajlo and Montalti's *Caskia/Growing a MarsBoot* is made of dense mycelial material that grows around an individual's foot, using sweat as nutrition as the boot develops on a journey to Mars. Mycelium is sustainable, biodegradable, affordable, hardy and compact. Space is the frontier for design with living organisms.

ABOVE
Nutrients from stone-eating bacteria devouring a sculpture of Prometheus feed a sculpture made of human liver cells, in Thomas Feuerstein's *Prometheus Delivered* (see pp. 132–133).

Emma Dorothy Conley and Thomas Feuerstein focus on living microbes. Conley weighs in on our thirty-nine trillion microbial cells with her astute proposal for a *Microbiome Security Agency*. This hypothetical advocacy group provides services to the public to protect privacy by providing 'Obscuration Solutions' that mask any identifying microbes that would reveal where you have been and with whom. Thomas Feuerstein recapitulates the myth of Prometheus with rock-eating microbes that dissolve a marble replica of a statue of Prometheus, producing by-products that feed a bioreactor full of liver cells that are growing into a full organ. As punishment for giving fire to humans, Zeus chained Prometheus to a rock, leaving him vulnerable to eagles that perpetually pecked at his liver. By night his liver would be revitalized and the whole process would begin again. Tissue culture offers a similar promise of regeneration. As Feuerstein reveals, something must be taken away for something to come into existence. This is the problem of contemporary humans in the Anthropocene. According to *The New York Times*, demand for electricity is surging, largely thanks to an increase in the number of data centres, electric vehicles and battery and solar factories that are part of a movement towards clean energy.[7] To meet the demand, several US states are proposing power plants that would burn natural gas.[8] We sow what we reap.

'Cellular Packages' shows some of the different ways we have learned to manipulate cells, tissue, organoids and organs. Synthetic biology, tissue engineering and research on the human microbiome are in their infancy. The future of living cellular packages is vast and diverse, and requires great research, superb science and thoughtful ethics, so that we do not let synthesized, cultured or replicated cells get out of hand.

Muscular thin film strips and metal sensors mimicking a contracting heart

Johan U. Lind, Kit Parker

Kit Parker's Disease Biophysics Group at Harvard University (see also pp. 64–65, 66 and 67) has reconfigured heart tissue in two and three dimensions to try to understand the organ through therapeutic testing. Heart cells do not need to be connected to a circulatory system to do their thing. If adequately fed, cardiomyocytes, or heart muscle cells, will beat in the alignment they are grown on atop an extracellular matrix (ECM). Cells originating from stem cells will last for at least six months if well fed, far longer than cells harvested from rodents.[9]

Heart-on-a-Chip is an abstracted heart. It is a small chip the size of a USB stick, with eight compartments, each containing two muscular thin film strips with a U-shaped metal sensor. They are disconnected from the circulatory system, or a brain, but in terms of cardiac function, they are fully contracting entities that are alive. Watching them rise and fall is spellbinding. Contraction is complicated in three dimensions. In two dimensions it is poignant and strange. Life is a synchronized contraction.

The Disease Biophysics Group spearheaded a less time-consuming approach than earlier organ chip models. They made Heart-on-a-Chip in one shot with a materially differentiated 3D printer that integrates the printing of the plastic and metal parts.[10] The solution of cardiomyocytes is added at the end with a syringe. Cells floating in the solution recognize the ECM on top of the thin film, then align and bind.[11]

The U-shaped metal serves as the sensor. It is a conducting wire through which a charge is passed. As the wire bends through the contraction, it develops deformations that change conductance. This enables the device to measure contractility in response to different drug compounds and therapeutics. The Disease Biophysics Group has moved on to 3D heart models as they advance towards the goal of building an artificial heart.[12]

ABOVE
Heart-on-a-Chip, 2017

Sequencing colour photoreceptors as retinal organoids develop

Kiara Eldred

Because stem cells have become easier to develop, researchers create aggregates of organized human cells called organoids that mimic qualities of the actual organ in the body without being connected to a body.[13] They are human tissue, so they can be used therapeutically for tissue regeneration, drug discovery and development, tailored therapies for individuals, xenografts (grafts from a different species) to seed cells into a compromised body part and the study of infectious and rare diseases.[14] They also allow researchers to spare animal lives. Conceptually, organoids are strange. Life has become dissociated. It started in 1907 when Henry Van Peters Wilson managed to regenerate the dissociated cells of a sponge, performing the first step towards in vitro organoid development.[15]

Fast-forward to 2018. Kiara Eldred, then a graduate student working with adviser Robert Johnston, was developing retinal organoids over a period of nine months, watching the differentiation of colour-sensing cells. Eldred was looking to see what colour photoreceptor came first, and what triggered the development. Answers could help researchers understand colour blindness and allow for treatments to restore damaged photoreceptors. The organoid held promise for the growth of other organoids, such as the macula, which might provide treatment for macular degeneration.[16]

The retinal cell development turned out to begin with cone cells that detect blue, followed by red and green, all switched on by thyroid hormone controlled by the eye.[17] Living tissue is not static. The scale of organoids is limited; the retinal organoid is only about one fifteenth the size of an actual retina, but it can still function for therapeutic studies.[18]

BELOW LEFT
Day 322 organoid: 600x magnification confocal image of the organoid retinal tissue. Green: L-opsin and M-opsin cells. Red: Cone-rod homeobox transcription factor. Blue: S-opsin cells, 2015.

BELOW
Day 361 organoid: 200x magnification confocal image of the organoid retinal tissue. Green: L-opsin and M-opsin cells. Red: Rhodopsin. Blue: S-opsin cells, 2016.

CELLULAR PACKAGES

See and be seen: retinal organoids on display in the gallery

Sean Raspet, Kiara Eldred

In the age of cellular transformations via the pluripotent stem cell, scientists have the capability to coax stem cells into differentiated organ-specific organoids outside of the body. When separated from the body, aggregates of cells are still considered human, but what kind of entities are such living but disconnected aggregates?

In 2018 artist Sean Raspet collaborated with Kiara Eldred on *Screen (EP1.1 iPSCs stem cell line-derived human retinal organoids)*, in which thirty-six retinal organoids entered the art gallery. The installation consisted of a clear minimal incubator comprising a six-by-six grid of vessels that suspended the organoids in a pink solution. Eldred, then a PhD candidate at John Hopkins University in Baltimore, Maryland, began the stem cell transformations in the lab of Robert Johnston (see p. 107).[19]

The cells arrived at the Empty Gallery in Hong Kong when they were ninety days old, a gestational stage at which they were able to perceive blue light.[20] Thirty to sixty days later, they were able to perceive red, then green light.[21] The installation could perceive light the way the viewer could, with the difference that there was no brain to process the information.[22] According to Raspet, this is 'perception as a kind of material'.[23] After leaving the exhibition, viewers were left with the memory of the mind's eye.

BELOW & OPPOSITE
Screen (EP1.1 iPSCs stem cell line-derived human retinal organoids), 2018–2019

Trial-and-error gene editing to form a synthetic bacterium

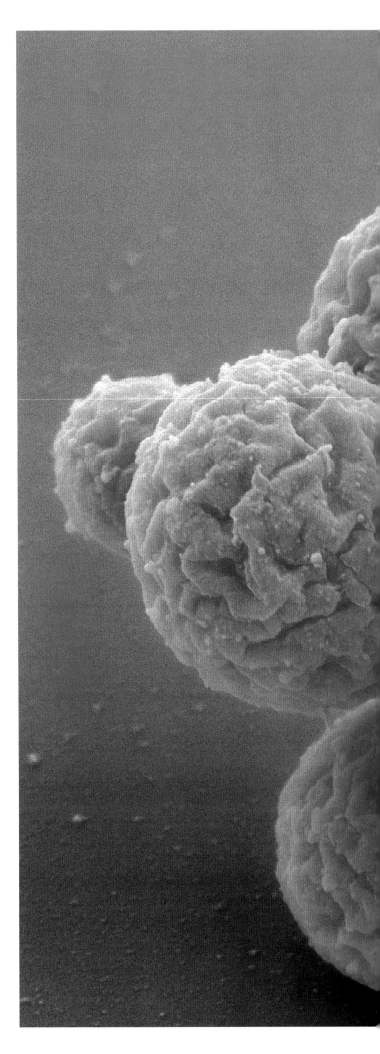

ALL IMAGES
Minimal Cell – JCVI-syn3.0. Electron micrographs of clusters of JCVI-syn3.0 cells magnified about 15,000 times.

In 2016 scientists created a synthetic bacterial cell, cracking the code for making the building blocks of evolution. For fifty years, scientists had been competing to create a 'minimal cell' – a cell with the least number of genes to still be able to grow and thrive. Synthetic biologists wanted to understand the simplest cell to find out what was essential to life. The minimal cell would have to have the ability to reproduce but have no extras or duplicates.[24]

The idea was jumpstarted in 1995 with the genomic sequencing of two bacteria, one with 525 genes and the other with 1,815. A comparison of the two revealed that there were approximately 250 essential genes. That number would be fewer than is contained in any living cell. This gave scientists the impetus to try to create a living bacterium with that many genes.[25]

In 2010 scientists from the J. Craig Venter Institute succeeded in synthesizing a large piece of DNA, using it to replace the DNA of another bacterium called *Mycoplasma capricolum*.[26] The new artificial bacterium, called Syn 1.0, was the first self-replicating organism created through synthetic biology, but it was not a minimal cell yet.[27] The transformed cell was tagged with microscopic graffiti. Researchers left four 'watermarks' on the DNA – a code of letters that would let other researchers know that the genome was synthetic.[28]

Initially the Venter group tried to build the minimal cell from scratch, but all attempts failed. Instead, they returned to Syn 1.0 to replace genes and create two cells with two genomes, but both expired. Success came through a more methodical system involving Syn 1.0's 901 genes and trial and error. To determine which genes were crucial, they split them into eight groups, edited parts in select groups and assembled them together to form a modified Syn 1.0. If a removed gene was crucial the cell would die. They culled the genes down to form Syn 2.0 and then Syn 3.0, with just 473 genes compared to a human cell's 20,000. Scientists could not determine the function of one third of those genes, even though they were essential to life.[29]

777 J. Craig Venter Institute

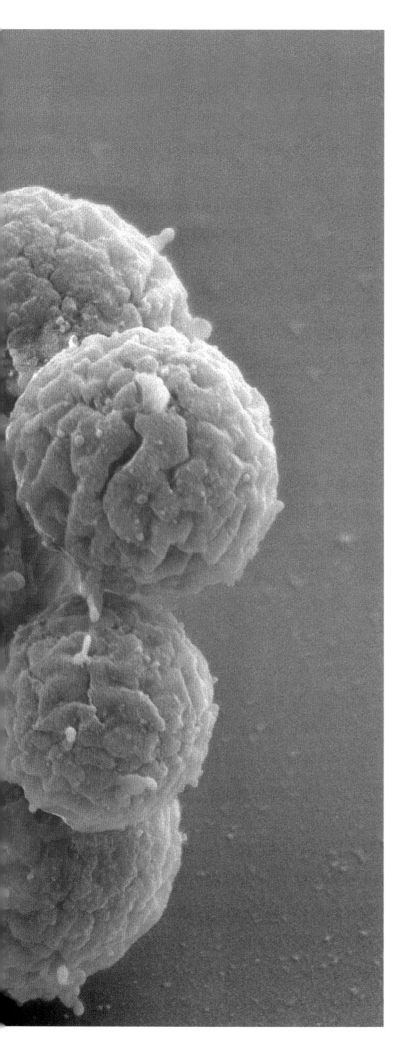

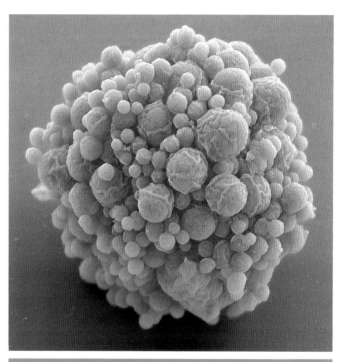

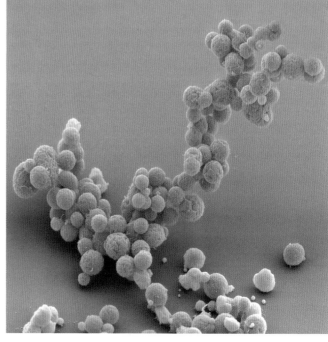

Humans enacting the mechanics of a retrovirus

John Walter

Humans cannot relate to viruses, yet in so many ways viruses have contributed to who we are. Millions of years ago it was a retrovirus that contributed to the formation of the first placenta. 'Junk DNA' from symbiotic viruses is a vector in the evolution of new species.[30]

In 2024, approximately forty million people were living with the retrovirus HIV.[31] HIV is no longer a death sentence thanks to antiretroviral therapy that suppresses replication, but infection rates are on the increase. In February 2024 a University of Washington study showed that there had been a decline in condom use by gay and bisexual men, especially young men and Hispanic men.[32]

A Virus Walks into a Bar is a surreal movie re-enactment of the mechanics of a retrovirus – the sneaky way that it enters a cell, converts its RNA into DNA once inside, then intermingles with the host DNA and replicates like mad.[33] It is part of John Walter's exhibition *CAPSID*, a fantasia of quasi-scientific, quasi-graffiti-like representations, symbols, costumes, artefacts, drawings and paintings, giving form to HIV, aestheticizing and scaling up microscopic events and creating a joyful dazzle of patterns and ornament, despite the potentially lethal end results.[34]

The HIV capsid is a cone-shaped protein shell that contains the genome of the virus. It cloaks itself using proteins recruited from the host cell and releases its genome by changing shape.[35] In the film, the capsid is a big inflated yellow ball containing a human playing the role of the cloaked genome. The female bartender is the nucleus that has been targeted. The bar-goers play key proteins, co-factors and the cytoplasm in handmade costumes that depict features of the cellular science, mixed with psychedelic colours.[36] The video and the many artefacts, including *Fist*, explore and explode the marginalized topics of HIV transmission, queer politics and viral science, all the while cloaking them in an artistic vehicle.[37]

OPPOSITE TOP & BOTTOM
A Virus Walks into a Bar (still), 2018

BELOW LEFT
Fist (triskelion), 2018

BELOW RIGHT
ENV, 2017

CELLULAR PACKAGES

Revealing the role of hand bacteria in cooking, taste and family

Jiwon Woo

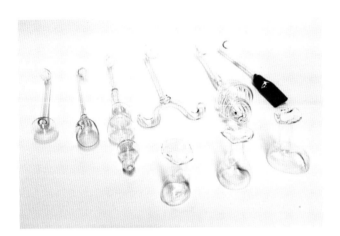

ALL IMAGES
Hand Taste,
2016–2017

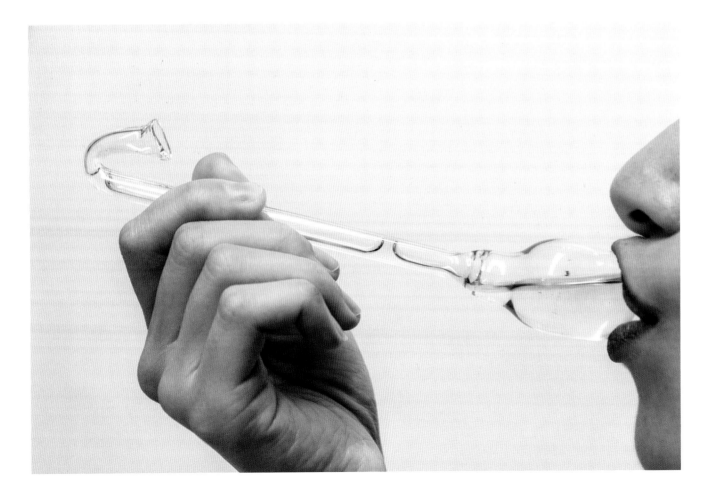

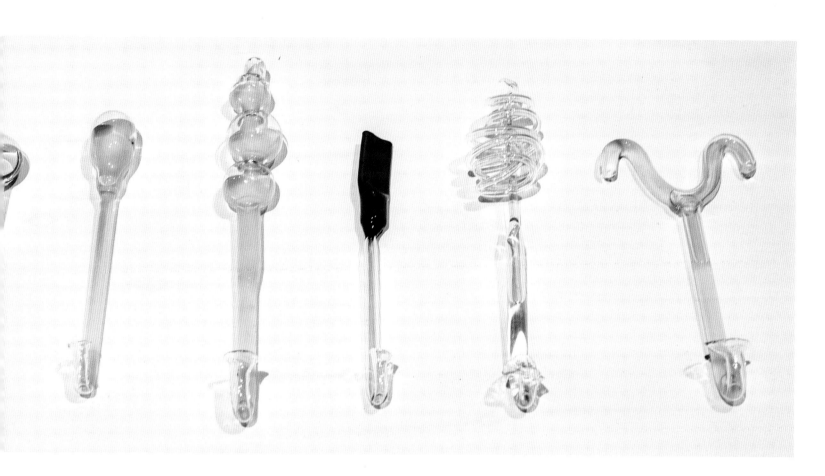

Jiwon Woo lived in New York City and missed her South Korean mother. This launched her into an investigation of 'hand taste' (*son-mat*). Could a mother's hand microbiome be responsible, in part, for the unique flavours of food prepared by hand? Is it possible that memory and longing are tied into bacteria? Is taste something different from what we thought it was – a product not of spices and textures, but of living organisms transferred via touch?[38]

To find out, Woo collected her mother's hand microorganisms through packages shipped from Korea to the USA. She cultured the samples using polymerase chain reaction (a technique to rapidly make millions of copies of a DNA sample) and DNA sequencing, with the aim of replicating her mother's hand taste, and then grew them on a series of memory-evoking utensils – completely original artefacts that would bridge hand and mouth, taste and touch, and mother and daughter.[39]

For *Hand Taste*, hand and mouth came together in the mode of production as well. Woo blew nine glass objects, using the mouth itself to create the microbiome delivery utensils meant to stimulate the inner mouth.[40] There is a play on space and void, and inside and outside, with these objects as well. Woo's breath formed the void that yields a physical form. It is then reinserted into the mouth or placed on the tongue, communicating with the brain via taste, touch, memory and the intermingling of the microbiomes of hand and mouth.

Recent studies of the hand microbiome have revealed that the microbiota of the hand are in a state of constant flux, dependent on the activities of an individual.[41] Sourdough bakers' hands match that of their sourdough loaves.[42] Baking bacteria comprise only 3 per cent of the fungi on average hands. On bakers, bacteria make up as much as 60 per cent. We like to think that the body is more stable than it is. There is a flourishing community of organisms that imprint on what we make with our hands. They stimulate and soothe as they activate the brain.[43]

CELLULAR PACKAGES

Silicone chips mimicking human organ function

Donald Ingber

'Human Organs-on-Chips' are clear silicone bricks the size of a memory stick that organize human tissue interfaces through microfluidic channels. There are more than fifteen different chip models, among them Human Intestine Chip, Human Colon Chip, Esophageal Cancer Chip and Vagina-on-a-Chip. Donald Ingber, the founding director of the Wyss Institute at Harvard University, and his team have aggregated individual chips to develop Body-on-a-Chip, a representation of the entire body and its fluidic interconnections, so that drug metabolism can be studied across systems. These beautifully modernist, functional living systems have radically transformed the medical industry in a bloodless coup.[44]

It has been estimated that more than 192 million animals were used in 2015 alone for medical testing, with eight million of those killed for medical experimentation.[45] A significant portion of this number was for drug testing. Along with the ethical issue of taking so many lives for saving human lives, the process was inherently flawed. Results obtained from animal testing did not often translate to clinical success, and old-school drug development was slow and exorbitantly expensive, costing three billion dollars per drug.[46] Lung-on-a-Chip was born out of a quest to have reasonably priced lab models that mimicked human organ function without taking lives.

Lung-on-a-Chip is a flexible silicone chip fabricated through a process called soft lithography. Tiny hollow etched channels act like synthetic blood vessels that allow fluid to flow through tissue. The chips are interfaces between tissues. In the centre of the chip there are three adjacent chambers. The central chamber holding the biological material is divided by a horizontal perforated plane that allows for the adherence of cells and transference of air. In Lung-on-a-Chip, alveoli cells (the lung's tiny air sacs) are layered across the top, and capillary tissue across the bottom. The chambers to the left and right mimic how we breathe by the creation of cyclical suction.[47]

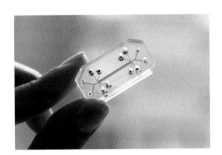

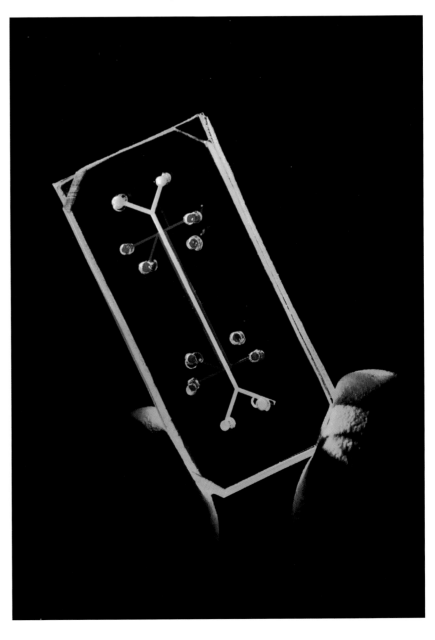

BELOW
Human Organs-on-Chips: Lung-on-a-Chip illuminated by natural light (left) and by green fluorescent light (right), 2011–2012.

Living heart muscle cells performing in a gallery

Nathan Thompson, Guy Ben-Ary, Sebastian Diecke

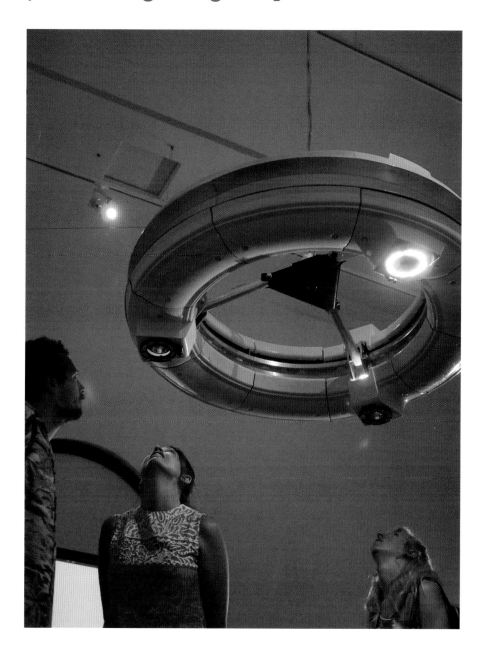

ABOVE
Bricolage, 2020

Advancements in tissue engineering have made it possible for humans to create living entities out of cells. We can now turn stem cells into any other type of organ, and develop tissue, organelles and soon actual organs for implantation. The possibilities are endless now that this new biological door has opened.

Bricolage, a living installation by Nathan Thompson, Guy Ben-Ary (see also pp. 70–71) and Sebastian Diecke, presents a cellular performance acted out by heart muscle cells programmed from stem cells. The theatre is a custom-made ceramic, metal and glass vessel with a clear bottom, giving visitors a worm's-eye view of the growing entities. Adhered to a custom-printed silk scaffold, the heart cells beat in self-assembled structures, unaware of the show. Awareness is a human issue. This assemblage asks the viewer to imagine an entirely different frame of reference. We have no cognitive models for such entities. *Bricolage* engenders an evaluative process. Viewers reckon with the familiarity of the beating structure and the uncanny abstraction.[48]

The position of the heart muscle cells is intended to elevate the cells physically and conceptually, switching up the 'God's-eye view' that tends to encourage feelings of superiority. The creators have eschewed the laboratory feel that accompanies so many biological installations with cellular presences. There is no technological mediation, microscopy or augmentation. The viewers see the tissue with the naked eye.[49]

How do we make sense of these cellular superpowers? What is this self-organizing life and what should our relationship to it be?

Speculative luxury artisan workshop using skin of the de-extincted passenger pigeon

Tina Gorjanc's speculative installation *Phylogenetic Atelier: de-extincting a species from the past* is staged to make the viewer think about biotechnology, rather than digest the usual hype that proclaims everything new as an advancement (see also pp. 120–121). Biotechnological news tends to engender a sense of awe rather than critical thought. This is true of current de-extinction projects being developed by biotechnology companies that are spending fortunes to revive the passenger pigeon, the dodo, the woolly mammoth and other victims of human-inflicted extinction.[50]

The de-extinction of the dodo was announced in 2023 by Colossal Biosciences, but not everyone is convinced. 'There's so many things that desperately need our help. And money,' said Julian Hume, a palaeontologist studying the dodo at London's Natural History Museum. 'Why would you even bother trying to save something long gone, when there's so many things that are desperate right now?'[51] Other researchers find the whole premise unethical and self-serving, since the invasive species that precipitated the dodo's end are still present on the island of Mauritius.

Gorjanc's installation targets this debate, using the passenger pigeon. Casting into the future as though the passenger pigeon had been successfully de-extincted, she staged an elegant venue – part laboratory, part artisan workshop, part museum – displaying the fabrication and result of the production of a luxury glove formed out of the skin of the passenger pigeon (mocked up from its closest living relative, the band-tailed pigeon).[52] 'As our current society is becoming mostly driven by the aspiration to constantly innovate it is starting to lack the ability to analyze the cultural understanding of what we are experiencing in the process of innovating. Old definition[s] and stereotypes of original and fake, natural and synthetic, alive and dead are becoming obsolete as new discoveries in the field of synthetic biology are being made,' says Gorjanc.[53]

Gorjanc worries about the appropriation of complex biotechnological processes by commercial enterprises such as the luxury goods market, especially the bypassing of ethical considerations in their headlong race to market our fascination with the nostalgic old made new again.[54]

ALL IMAGES
Phylogenetic Atelier: de-extincting a species from the past, 2018

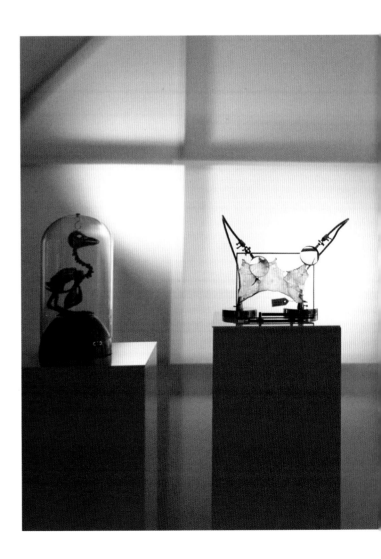

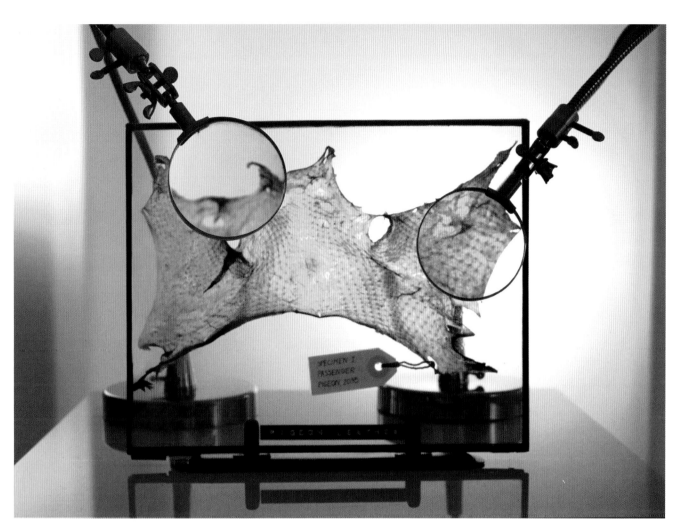
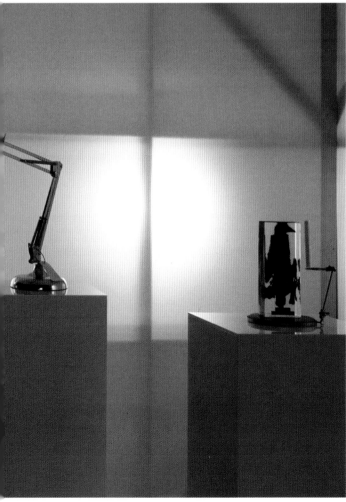

The ethics of wearables fashioned out of lab-grown human skin

Tina Gorjanc

Pure Human delves into the future of biomaterials. Tina Gorjanc's (see also pp. 118–119) project centres around the concept of human leather made from the cultured cells of an individual. Through tissue engineering, these cells can be multiplied and grown into hides that resemble animal skins. Gorjanc studied tanning and traditional leather crafting to create a collection of simulated fashionable luxury goods that could be made from the skin of someone you know.[55]

The ethical questions that arise are the point of Gorjanc's work. The rate at which human cells are being used, thanks to advances in stem cell programming, exceeds our ability to keep up with ethics. Can and will biotechnology companies go after your cells without your consent? Who will maintain the boundaries of privacy and protect genetic information? The ethics involved in the creation of human leather should give rise to questions about our current use of animal skin. Gorjanc's research examines issues around consent, care, toxic chemical usage and water waste.[56]

Gorjanc used pig skin as a stand-in for human skin. Tanned human skin is more fragile than that of other species, and more vulnerable to the effects of UV light, which may cause some luxury products to suffer sunburn. Gorjanc explored how to manipulate the creation of speckled markings using the TYR gene to promote melanin. Biological agents can give human leather freckles, moles and darker patches.[57]

What are the limits of tissue engineering? In 1951 Henrietta Lacks, a poor African-American tobacco farmer, lost her life at the age of thirty-one to cervical cancer. Her cells, which had been snipped for a biopsy, were found to double every twenty to twenty-four hours, an unusually high rate. Called HeLa cells, they have been used continuously for medical research for more than seven decades, until recently without consent or her family knowing of their existence. Her 'immortal' cells have helped researchers to develop the polio and Covid-19 vaccines, to study the human genome and to explore the effects of radiation. Justice came in 2023, one day before what would have been Lacks's 103rd birthday, when her family was awarded an undisclosed settlement with Thermo Fisher Scientific. Lacks lives on. What will happen to your cells?[58]

BELOW & OPPOSITE BOTTOM
Pure Human 0.01: An Exploration of the Intersection Between Luxury and Biology, 2016

OPPOSITE TOP
Pure Human: Exploring the Commodification of Human Flesh as a New Form of Luxury, 2016

Culturing larynxes to augment human communication

New Organs of Creation involves politics, empowerment, tissue engineering, organ replacement, opera and anthems. The cultured organ at the centre – the larynx – may be small, but the project is all about augmentation, being heard and voicing what is on your mind.

 Michael Burton and Michiko Nitta were determined to develop a human organ that could become an instrument of transformation. The impetus was the divisions among the UK population during Brexit negotiations. With the aim of giving British voters a collective 'voice' during a time of political and social discord, Burton Nitta began an in-depth research project on human and animal voice production morphology. They studied the sonic variations of animal communication related to animal size, explored the resonance of choirs and performers and found inspiration in koala bears, whose unique double vocal folds enable them to lower the pitch of their voice like a much larger animal.[59]

 The relationship between stem cell and sound was key. Low-frequency sound waves (and high-frequency sound waves, according to a study at RMIT University in Australia) applied at the right spot with the right pressure will turn pluripotent stem cells into bone instead of other organs.[60] Burton Nitta used the idea of low-frequency sound and the koala's augmentation to create a synthetic larynx that would allow a person to communicate voice to cell, steering cellular development in listeners.[61]

 Working with Professor Lucy Di Silvio at Kings College London, they built the souped-up larynx using clinical standards of tissue organ development, seeding cells onto a scaffold, then incubating the larynx in a sterile cabinet. Other hypothetical larynxes designed by Burton Nitta record an individual's voice throughout their life using AI; enable an individual to echolocate; augment voices to become high frequency for social purposes; and repair damaged bones and muscles.[62]

 Composer Matt Rogers and sound designer David Sheppard were commissioned to compose a national anthem. Sung by mezzo-soprano Louise Ashcroft with her larynx's new low-frequency capabilities, the music engages directly with listeners' cells, and, in doing so, subliminally unifies a divided populace.[63]

RIGHT
Grown Larynx from *New Organs of Creation*, 2019

BELOW
Prototype Larynx from *New Organs of Creation*, 2019

OPPOSITE TOP
Suit to perform the new voice from *New Organs of Creation*, 2019

OPPOSITE BOTTOM
Voice of Transformation, from *New Organs of Creation*, 2019

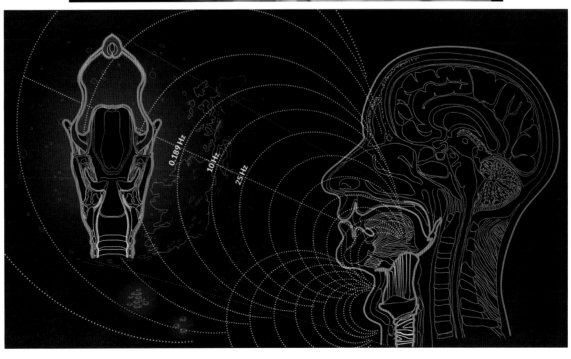

Performing human/microbe entanglement

The body's perimeter is the site of entanglement between communicating microbes. Unlike the smooth membrane we imagine, skin is more of a nomadic bus station for coming and going microscopic entities.[64] Current data suggests that in the average human body there are around thirty trillion human cells and thirty-nine trillion bacterial cells. Would there not be an evolutionary advantage to sensing microbes? There may be one day. For now, Sonja Bäumel's performative installations provide insight into the boundaries of the body.

Entangled Relations – Animated Bodies is a room-sized installation with a magnified wall-mounted amoeba blown up 40,000 times. It is linked via progressively smaller hanging cells to the exploded perimeter of a human, by which the skin has been exploded in space, like a 3D exploded diagram showing how the components fit together. Fragments of the microbial perimeter of the body dangle and allow visitors to relate their own microbial community to these displayed collectives. Your otherness is revealed. Bäumel further animates the installation using projected amoebas and the amplified sound of microbial life. Choreographer and performer Doris Uhlich inserts her unclothed body and its family of microbes into the enlarged parts, sometimes appearing engulfed, other times seeming blended into the celestial amoeba projection as she probes the enlarged single cells.[65]

Microbial entanglement replaces the typical petri dish with a giant one and the microbes with three entangled humans. It makes it difficult for visitors to feel unconscious superiority. Humans are petri-worthy living breathing communities of microbes. As we interact with other humans, our microbes interact as well. Bacterial colonies engage in 'quorum sensing' – the process of communication between cells, by which molecules called autoinducers send out chemical signals that regulate gene expression as well as colony-wide physiological activities or traits including bioluminescence, virulence, competence and the formation of biofilm. Some inducers work by diffusion. Others must be transported across the cell wall. Bäumel's installation hits the viewer in the gut microbiome.[66]

Quorum sensing might end wars, if only humans could do it. With the collaboration of our tiniest inhabitants, we might be able to. Bäumel's installation highlights such bio-cooperation and new ways of sensing.

BELOW LEFT & BELOW RIGHT
Entangled Relations – Animated Bodies, 2022

OPPOSITE
Microbial entanglement, in vitro breakout, 2019

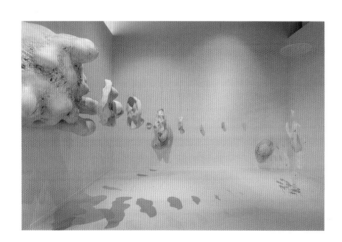

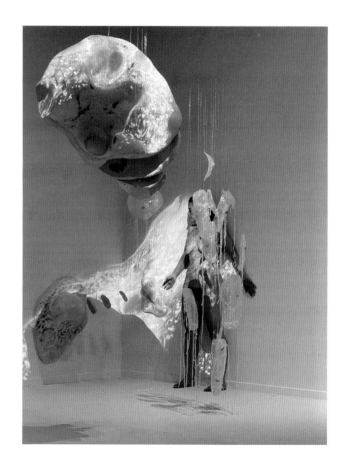

The extraction of iron from human placentas to smelt a compass needle

Cecilia Jonsson

ALL IMAGES
Haem, 2016

Most iron is mined from the Earth. Cecilia Jonsson mined sixty-nine human placentas to create one small compass needle. In performing this modern-day alchemy, she turned animate matter into inanimate matter, and interrelated the stars, Earth, mother and baby. Despite the distinction that most of us make, what is outside of us is inside of us, though in different formats: iron ore and haemoglobin. Our personhood sometimes denies our deep interconnection with the Earth.

The placenta provides nutrition, oxygen and waste disposal, connecting mother and baby through a winding complex of blood vessels that do not intersect, but instead diffuse material between them. The male genes are responsible for the placenta, and the female genes for the embryo. At term, the placenta becomes obsolete and is discarded, or sometimes used ceremonially. It is rich in iron at the time of birth since the baby requires increasing amounts of iron over the course of gestation. During pregnancy mother and baby require around 1,200 milligrams a day to make the necessary blood.[67]

Developed in collaboration with Dr Rodrigo Leite de Oliveira of the Netherlands Cancer Institute, *Haem* involved researchers, hospital administrators, pregnant women, midwives and a blacksmith named Thijs van der Manakker, as well as permission documents, dried placentas and a blast furnace. Miraculously, sixty-nine women donated their placentas from August to November. Seven kilos (about fifteen pounds) of placenta were dried, then smelted in a blast furnace and finally forged into a compass needle. In the installation the compass floats in a glass bowl inspired by the structure of the placenta. The very iron that was transferred from so many mothers to babies, now serves as a guiding tool, orienting the viewer to magnetic north, and connecting the human body, the Earth, the placenta and the future.[68]

Decellularizing, seeding and manipulating designer hearts

Isaac Monté

When Isaac Monté (see also p. 88) presented his commissioned collection of twenty-one aesthetically manipulated pig hearts in 2015, in collaboration with Professor Toby Kiers, pig heart valves had already been used in humans for decades.[69] To date there had been no successful transplant of the entire pig heart into a human. That changed in 2022 with the first successful transplant, followed by the second in 2023, both of which, however, failed after a few weeks.[70] The surgeries heralded a new era of species hybridization and signalled that many more such transplants would occur. The surgery also validated Monté's thesis that the inner body might become a site for deceptive design tactics that allow organisms to gain benefits, reproduce and succeed. Remember how researchers left microscopic code on the DNA of a synthetic cell (see p. 110)? Could we benefit from bespoke innards and organs?

For *The Art of Deception*, Monté's team began by decellularizing the discarded hearts, a process used in tissue engineering. To decellularize a heart, tissue was chemically removed, leaving only the ghostly scaffolding. That structural scaffold was then seeded with stem cells and manipulated into a series of designs that fell under three categories: interaction, medical intervention and personalization. The speculative transformations proposed by the team were meant to provoke questions, and to alert viewers to some of the issues and ethics involved in synthetic biology and in the exploration of new sites for modification.[71]

The hearts were embroidered, tattooed, engraved, injected with resin, shrunk, plastinated, furred and armoured.[72] The shocking presence of twenty-one designer animal hearts highlighted the deathly absence of the mammals' bodies. At the same time the installation presented an imagined future of synthetic organs, revitalized tissue and fetishized matter. The resonation of both facts made the exhibition gruesome and elegiac.

ALL IMAGES
The Art of Deception, 2015

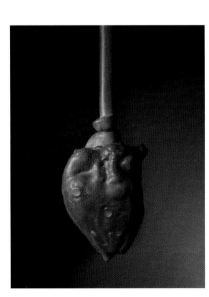

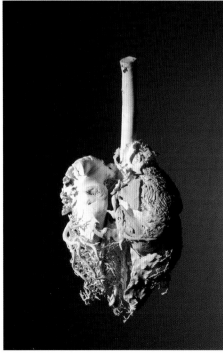

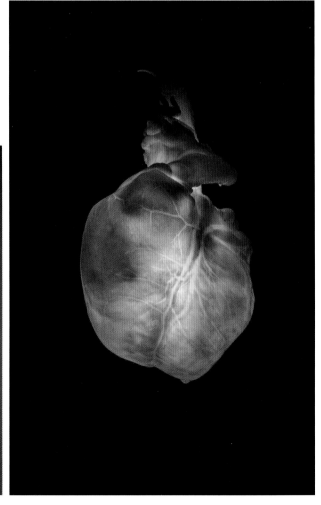

Growing a mycelial boot on the way to Mars

Maurizio Montalti (Officina Corpuscoli), Liz Ciokajlo

Commissioned by the Museum of Modern Art in New York to provide an update on an archetypal footwear that had changed the world, Liz Ciokajlo chose Tecnica's 1970s Moon Boot, an icon of plastic space age fashion modelled after boots worn during the lunar landing. Ciokajlo and Maurizio Montalti took the commission in a radically different direction, eschewing plastic, fossil fuel culture and greenhouse gas emissions. To create *Caskia / Growing a MarsBoot* – a space wearable – they selected something compact, reusable, growable and alive: mycelium.[73]

Mycelium can be transported as small strands and then set into exponential growth through cultivation and 3D-printing processes. In a closed space station, sustainability, longevity and self-repair are key. The team proposed that the boot develop during the journey. Dense, moist mycelial material would be formed around an individual's feet. The wearer provides nutrients for growth from her own sweat mixed with some other sources. In this way the astronaut continuously grows her own shoes, until the boot is complete. Heat stops the fungal production. Live mycelia could be reintroduced to make repairs.[74]

The updated moon boot is a prototype for a woman, inspired by the 1893 cutting-edge science fiction novel *Unveiling a Parallel: A Romance*, written by Alice Ilgenfritz Jones and Ella Merchant. It features a society on Mars called Caskia, a feminist utopia where women and men are equal.[75]

Fungus has a mixed reputation in space. It is seen as an out-of-control pathogenic nightmare, a UV-resistant super-grower, or a hardy building material that will fast-track settlement on Mars. Late 1990s photo documentation and interviews with astronauts from Mir and the International Space Station revealed that fungi proliferated both inside and outside of space stations.[76] The problem aboard the space station Mir was once so bad that fungal hyphae (filaments) had blocked the windows and infested the air conditioning and control panels.[77]

ALL IMAGES
Caskia / Growing a MarsBoot, 2016–2020

Protecting your microbiome's privacy

Emma Dorothy Conley

ALL IMAGES
Microbiome Security Agency, 2015

What do red-ruffed lemur faeces, greater rhea faeces, white-faced saki faeces, kefir, Époisses cheese, kombucha, natto, compost, kimchi, soil and seaweed have in common? If you mist yourself with a solution of DNA extracted from the bacteria they contain, you may be able to maintain your microbiome's privacy. The DNA that reveals whom you have been with and where you have gone will be masked by the 'Obscuration Solution'. The brainchild of Emma Dorothy Conley, with help from microbial ecologist Guus Roeselers, this synthetic DNA solution is part of a larger project called the *Microbiome Security Agency*, a hypothetical citizen advocacy group that provides services to the public to protect privacy. You can protect your driving licence, your digital data and many aspects of your life, but snoops may be coming to culture your skin. The living single-celled organisms that we swap and shed may one day give rise to ethical concerns and breaches of privacy – if they have not already.[78]

The human body is host to an estimated thirty-nine trillion microbial cells.[79] That is a hefty quantity of bacteria. No wonder the idea of such an agency is compelling. Between the sourdough, the hand shaking, the food consumption and the poop-filled sidewalks, a *Microbiome Security Agency* might be as crucial as airport security. Inured to constant video surveillance, website cookies and any number of digital fingerprints we leave, humans have passively given up their privacy.

Microbiome Security Agency workers dress in colourful protective clothing and masks to avoid contaminating samples or being contaminated, and to cheerfully maintain anonymity. They offer several services, including collection banks for citizens to anonymously donate bacteria. This will keep the Obscuration Solutions up to date and variegated. Satellite banks called Automated Obscuration Machines are temporary new forms of infrastructure that accept citizen bacteria samples and dispense Obscuration Solutions. Like gum machines, ATMs and parking machines in infrastructural scale and functionality, these artefacts are unusual in that they contain living cells.[80]

CELLULAR PACKAGES

Rock-eating microbes networked to a synthetic liver

Thomas Feuerstein

We perceive rocks as stable, but they are in a state of decay. Rocks serve as habitats or food for a host of organisms, some damaging the surface, others degrading the rock entirely. Microbes are causing damage at historic landmarks around the world, including at Angkor Wat in Cambodia, the Mayan ruins of Central America, the tall stone chimneys of southeastern Turkey's Cappadocia, the statues on Easter Island and the Greek Acropolis. The entire world is in a state of change. Microbes are adaptive. The biocides devised to stop the scourge are temporary. Most people do not realize that there is no 'timeless'.[81]

With *Prometheus Delivered*, artist Thomas Feuerstein harnessed the power of rock-eating microbes to dissolve rock. Using the myth of Prometheus as his script, he devised a transmogrifying process that uses the nutrients from chemolithoautotrophic bacteria – the stone eaters – to grow a sculpture using human liver cells. Stone is turned into flesh in his beautiful scientific laboratory installation full of vitrines, tubes, bioreactors, liquids and jars. The myth re-enactment is biochemical. At the centre is a marble replica of the sculpture *Prometheus Bound* by Nicolas-Sébastien Adam (1762), a depiction of Zeus's punishment of the mythical figure for stealing fire and giving it to humans. Prometheus, chained to a rock, suffers eternal torture by eagles who peck out his liver. Each morning in Feuerstein's revival, the liver grows back again. Acidic water is fed into tubes networked into the sculpture. Nutrients resulting from the rock turning into gypsum are fed into a bioreactor containing human liver cells seeded onto a three-dimensional matrix, which is forming a robust synthetic human liver sculpture called *Octoplasma*. It prefigures a time in the future when food production might be boosted by harvesting food grown from cells cultured from the human body.[82]

Feuerstein's *Deep and Hot* encapsulates the vast microbial world of chemolithoautotrophic bacteria that thrive in the dark hot crust of the Earth, feeding on inorganic matter. The towering sculpture consists of a bioreactor surrounded by black spheres that form a scaled-up molecular view.[83]

RIGHT
Installation view of *Prometheus Delivered*, 2017

RIGHT BELOW
Kasbek, 2017

OPPOSITE TOP LEFT
Deep and Hot, 2017

OPPOSITE TOP RIGHT
Octoplasma, 2017

OPPOSITE BOTTOM
Prometheus Delivered, 2017

CHAPTER 4

MIMICRY

There is so much to learn from the optimized systems nature has evolved over millions of years. Developments in technology have allowed scientists, engineers and artists to understand the behaviour, morphology and mechanics of biological creatures, to simulate them through the creation of autonomous mechatronic entities. We find ourselves at the start of a renaissance of biologically inspired robots. Various disciplines have sought to mimic living creatures for diverse applications. The impetuses include surgical aids, search-and-rescue assistance, environmental monitoring, augmentation and artist-driven desires to recreate what nature does. Verisimilitude is typically less important than functionality.

LEFT
Sawyer Buckminster Fuller assembling the RoboFly, a tiny robotic fly consisting of a photovoltaic cell, a wing (seen below left), a piezo actuator, a body and a tiny wing-controlling microcontroller brain (see pp. 140–141).

Some researchers are building robots that use one specific trait of a living creature to enable a cybernetic surrogate to do the same. Tentacle-like robot arms such as *The Vine 2.0*, by The Alternative Limb Project and Dani Clode, are not concerned with the complexity of the octopus's body, or the fascinating neurological systems therein. The multidimensional movement of the arm itself has inspired countless robots. Some labs are looking into the mechanics of flight, jumping on water and bird landing, creating flying machines and water strider mimics that may one day be indistinguishable from the real things. Such robots may function like their biological counterparts, but right now they have only vague morphological similarities. Other engineers, scientists and artists are creating machine embodiments of creatures that have since moved on or have become extinct. Their idea is to keep the balance of the ecological environment intact by creating replicants. Still other researchers are using their ingenuity to create a synthetic human – an android that looks, acts and sounds human. This is a gargantuan task; the multitude of systems is so complex that each different organ requires a different team and subset of skills.

Reading about all the biomimicry taking place in the world of engineering, the notion of the robot swarm comes up often. Each different lab imagines a swarm of robots that will have the capacity to cover large disaster areas, disperse to inaccessible spaces or spread out to search for hazardous conditions. Who will control the robot hordes? Will they need regulation? How will we control and dispose of robot detritus after they expire? When will the tipping point occur, beyond which we will not be able to tell what is living or what is machine? For the moment the swarms are largely an idea, but the robot race is on. Overlooked animals are now being videotaped, photographed and dissected, as they become stars of engineering. Very often the original intention for the robot, such as walking on walls like

the gecko-inspired 'StickyBot', shifts as new applications arise.

When Hideyuki Sawada was asked in an interview why he did not add eyes to the disembodied nose, mouth and throat that

LEFT
Ho-Young Kim and Kyu-Jin Cho's origami-inspired strider robot jumps like a flea and moves like a water strider (see pp. 142–143).

comprise his Talking Robot, he explained that he wanted to avoid the 'uncanny valley' to allow people to concentrate on the voice.[1] This highlights the conundrum of biomimicry, especially to do with artificial humans: too much likeness tends to cause a queasy feeling, especially if the similitude is just the slightest bit off. That is why many robot experiments tend to have cartoonish or cute bodies that are smaller than the human frame. How do we create a humanoid robot with accuracy, without creating revulsion; and should we?

Humans do not experience the uncanny valley when other creatures are biomimetically accurate but slightly off. We cannot recognize the flaws. Humans are human-centric and have long relegated to lesser importance all the diverse creatures that play an essential role in the healthy functioning of forests and other biomes. Our lack of understanding of the interconnected web of creatures – our lack of interest – has left us in the climate crisis we are in today. We have lost some of the creatures that may have yielded fascinating new simulations and material optimizations. We cannot know what we have lost. Can we preserve the great biodiverse storehouses such as the Amazon before it is too late?

The surge in biologically inspired robots follows the general wave in contemporary robot-making. In the past couple of decades there have been technological advances that have allowed for the miniaturization of parts, the precision microscopy required to manipulate them, optimization of actuation and battery, and the materials that enable self-organizing and layering. We are now able to scale things down. Consumer electronics have made it easier for robot-designers. You can find the tiniest of sensors, cameras smaller than a pinhead and any number of foldable parts called smart composite microstructures made through layers of micro-machined flat sheets.[2] Biomimetic material explorations have only just begun.

Writing this chapter has revealed the most exquisite aspects of animals – a complexity that we cannot even aspire to recreate. It has also brought to the fore just how enriching parts of animals have been to the new wave of robotic surrogates. Two of the robots in the 'Biomimicry' chapter were inspired by the 'feet' of two vastly different animals. In the falcon world feet come in different sizes, lengths, thicknesses, with varied talon positions, revealing what raptors eat and how they stabilize using their feet.[3] The robot SNAG has the talons of a peregrine falcon. Until recently, a drone could not land in complex

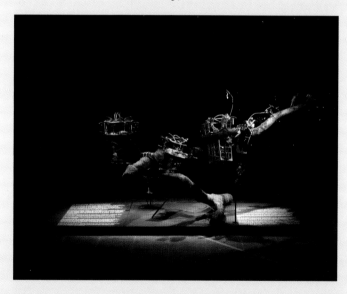

ABOVE
Artificial robotic predators developed by Jip van Leeuwenstein lure moths using light, and then chemically digest them using a micro fuel cell (see p. 151).

sites and on the branches of trees. SNAG is a biohybrid drone, all machine but morphologically part drone and part bird. Should we expect a time when a tree in a remote forest will be populated by birds and robots, or even overpopulated by robots? I hope not. Just because you can replicate a biological creature does not mean they should inhabit the same ecosystem as their living counterparts. Nearly every biomimetic robot-maker lists both search and rescue and surveillance as potential functions. If engineers populate the world with such inquisitive robots, there will be a

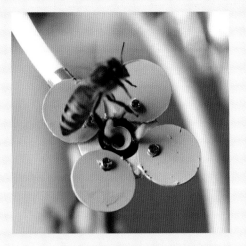

LEFT
Michael Candy's brass robotic rapeseed flower pumps up synthetic nectar and successfully delivers remotely sourced pollen to an unsuspecting bee (see pp. 152–153).

host of ethical and legal issues that need to be addressed, including spying. Or is it too late? Will the applications of surveillance ever max out?

The gecko is another creature that has inspired the engineering of multiple robots and adhesives. The gecko foot turns out to have a myriad of tiny hairs, each foot having as many as somewhere near one quarter the population of Manhattan.[4] How can nature have evolved something so complex? We began to understand how the gecko foot adheres to surfaces only when in 2006, Kellar Autumn proved that the forces involved were not the chemical ones or the stickiness we had expected but were instead van der Waals forces.[5] The learning does not stop at the creation of a mimicking robot. In the case of the gecko, the successful attempt to build a mechanical replica that could climb a wall, by Mark R. Cutkosky, led to an invention that enables a human to climb a wall, a tiny robot to pull massive structures, glue to close wounds in complex surgeries and even an adhesive anchoring system for items floating around The International Space Station.[6] One invention leads to another.

Discoveries in this chapter are not happening in a vacuum (though StickyBot can function in a vacuum). Researchers around the world have been looking at similar properties and morphologies at the same time. Sometimes they end up making similar-looking and -functioning robots in accordance with biomimicry, but which utilize monumentally different mechanisms. Take the example of the water strider. These insects have a special way of skimming the water with their legs that allows them to avoid breaking the surface tension.[7] Professors Ho-Young Kim and Kyu-Jin Cho and the team that developed the artificial water strider were not the first researchers to mimic the water-walking creature utilizing water surface tension. However, they were the first team to use surface tension to enable a synthetic strider to jump.[8] In biomimicry, microscale comprehension matters. Success is not about looking real; it is about functioning well, finding similar efficiencies to those that exist in nature, and at the scale of nature.

Sawyer Buckminster Fuller is working at the scale of some of nature's smallest flying creatures: flies. A robot the size of a fly requires the designer to rethink everything. There are very few tiny robots that have the elegance of a fly. Just thinking about replicating a fly gives you an entirely different appreciation for the creature, whose tiny body has systems for sensing wind, speed and orientation. How is an engineer to work that small? Consumer electronics provide the tiny sensors that nature evolved in the vestigial wings, the eyes and the antennae of the fly. Microscopes help too. The tiny parts of the fly are manipulated with a tweezer under a microscope. It also helps to have fewer parts. You will find that several robots utilize a technology in which thin layers are adhered together, with all the parts sandwiched within the layers. Such flat, layered bodies often rely on principles of origami and self-assembly. If the material can self-assemble, humans do not need to get involved.[9]

Three environmental robots in this chapter are interlopers in the select environments for which they were designed.

BELOW
A robotic vocal tract engineered by Hideyuki Sawada replicates human speech and learns using a neural network (see pp. 158–159).

They replicate some environmental transaction or impersonate creatures that were forced to leave because of climate change, a departure that has left an ecosystem in imbalance. Michael Candy's *Synthetic Pollenizer* is embedded in a field of rapeseed flowers. A complex robot made of motors, gears, tubes and brass flower replicas, it does what a flower does. It managed to attract a bee with pumped nectar and send it off carrying remotely sourced pollen. Candy's aim was to hack into a natural system. The fact that it has applications for the future of pollination was secondary to his robotic ambitions.[10]

In contrast, Rihards Vitols and Jip van Leeuwenstein simulate creatures to maintain the balance of the changing forest and thereby its biodiversity. Vitols restored the sound of the absent woodpeckers whose tree tapping served as a deterrent for insects such as bark beetles and leaf feeders, which destroy critical trees. Such insects do not respond to visual cues; the auditory ones scare them away. Van Leeuwenstein has another remedy for pests: synthetic predation. His robots used light to attract a pest moth called the oak processionary moth. The moths' attraction was fatal. The light lured them into a micro fuel cell that chemically digested them and created electricity to power the robot.

If we move from nonhuman animal biomimicry to attempts to replicate a human, speech has been a subject of many ear-bending robots. Digital sound can perfectly replicate the human voice, but an accurate humanoid needs a voice generated by mechanical principles such as our own apparatus. Martin Riches' *The Talking Machine* and *MotorMouth* and Hideyuki Sawada's *The Talking Robot* are three speaking robots with fascinating ways of imitating the larynx, throat cavity and tongue interaction that facilitate what we call speech. While most of us know some of the basics of the anatomy of the throat, we find the ballet of the tongue and the architectural resonance chambers of the throat more mysterious, largely because they are out of sight. Riches' *Talking Machine* reveals all the throat positions at once by exploding the vocal tract into wooden versions of each of the different shapes required to sound out particular consonants and vowels. It is like an ABC book, only for sound and resonance. To produce words, air is forced through a synthetic larynx into the individual curvilinear chambers. This is biomimetic analysis at its best. Visual replication is not the goal. In fact, Riches' sculptural vessels reminds us that sound-producing entities might be far less compact than we are. *MotorMouth* produces speech in a more centralized way, revealing in real time the dance of the abstracted tongue by revealing what the head looks like cut in half.

Similarly, you can watch the mechanics of speech in real time demonstrated by Hideyuki Sawada's *The Talking Robot*, with its eight computer-controlled motors that compress a silicone vocal tract. As air passes through the synthetic larynx into the throat and sometimes the nose, the compressed silicone chamber accurately mimics the shape of the human resonance chamber, resulting in speech. *The Talking Robot* can learn too. A neural network listens to speech, and mimics it by configuring the synthetic organs via the motors.[11]

The Vine 2.0 by The Alternative Limb Project and Dani Clode is a reminder that we can mix and match our biomimetic parts to create new hybrids, if we are lucky enough to have access to such cutting-edge prosthetics. We can even change them up every day, or perhaps only occasionally, giving our brain the challenge of adapting to new movements and new ways of grasping, using the toes to stimulate actuation. Who has not wanted to have a tentacle to experience the three-dimensional flexibility and curvilinear organicity that our current arms lack? Such creative teams with conceptual ideas and technological know-how are sure to blow our minds in the future with human/animal hybrids we have never imagined.

ABOVE
A new species of biomechanical prosthetic arm echoes the motion of sea tentacles in The Alternative Limb Project and Dani Clode's *The Vine 2.0* (see pp. 154–155).

Swarms of insect-sized robots detect environmental disasters

Sawyer Buckminster Fuller

Sawyer Buckminster Fuller and the Autonomous Insect Robotics Lab at the University of Washington have been developing insect-sized autonomous robots to one day serve as environmental sensors. Fuller's insects will not bite or transmit disease, and they do not breed (yet). The idea is to release a swarm at, say, a leaking oil refinery and have them fly randomly until one detects a leak and engages a beacon to notify authorities. It is easy to imagine this scenario, but it is difficult to scale down a robot to the size of a fly. Fuller has had to rethink, miniaturize and engineer all the parts. Though robotic insects have existed since the early 2000s, Fuller's fly was the first robot with autonomy in sensing, control and power that weighed less than a gram.[12]

Each component of Fuller's fly, from the piezo-actuated wings to gyroscopes, optic flow sensors and wind sensors, was modelled after the morphology and behaviour of a real fly. A fly has vestigial wings called halteres that function as gyroscopes, which give the fly information about the orientation of its body. Its compound eyes read optic flow, and its antennae serve as wind-sensing apparatus. To mimic these, Fuller relies on readily available sensors from the consumer electronics industry. The synthetic fly is equipped with a minute gyroscope, laser rangefinder, camera and wind sensor that look nothing like the evolved parts of insects, but function. The Robobee, an earlier prototype, had twenty-one distinct parts. Using smart composite microstructures – a system designed by Ron Fearing at the University of California, Berkeley – Fuller and his team combined all the parts into thin layers of laser-micromachined flat sheets bonded together with flexible sheets, then folded up some of the origami-like parts using tweezers under a microscope.[13]

Fuller envisions applications for these robots in space. It would require little energy to get them out of Earth's gravity and could potentially democratize space exploration. Hopefully they would avoid adding to the space junk orbiting the Earth.

BELOW
A four-winged robotic fly, 2019.

OPPOSITE TOP
A robotic flying insect with a fruit-fly-inspired wind sensor (yellow) for improved flight in windy conditions, 2013.

OPPOSITE BOTTOM
A robotic flying insect carrying an avionics circuit board for sensing and flight control, 2021.

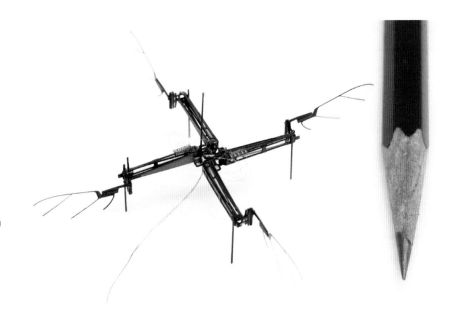

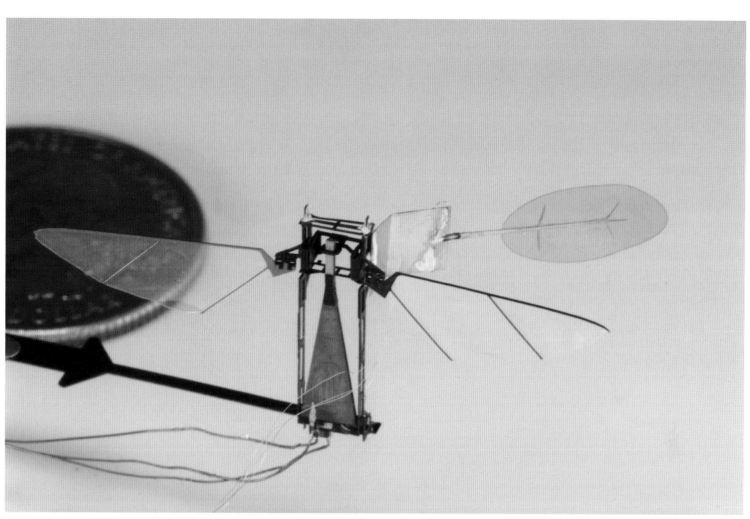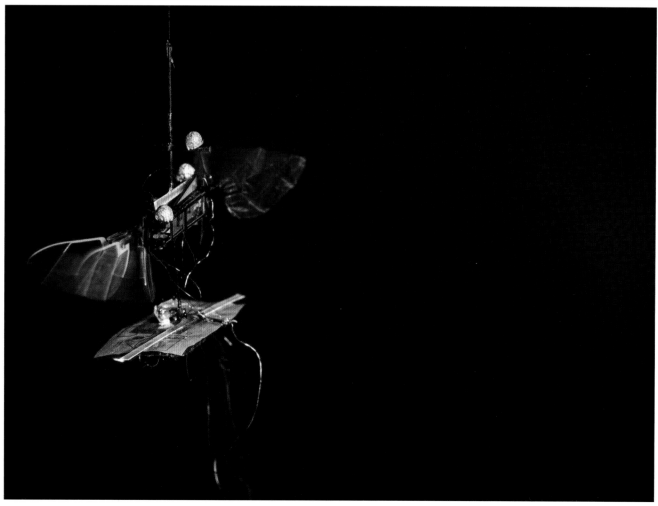

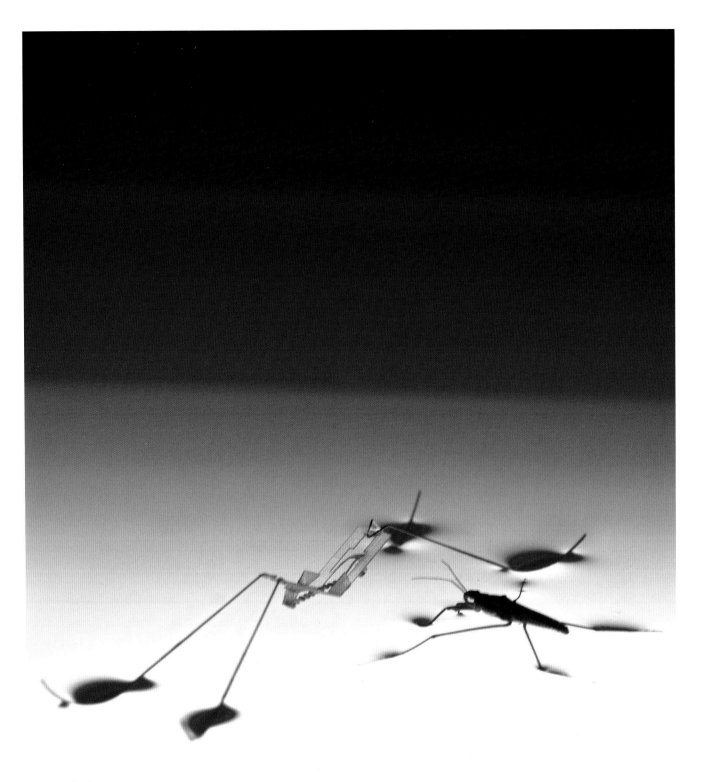

Artificial water strider leaps using flea technology

Ho-Young Kim, Kyu-Jin Cho

Some robots combine key features from more than one creature. The robotic water strider, created by professors Ho-Young Kim and Kyu-Jin Cho of Seoul National University, South Korea, combined a flea's jumping apparatus with the morphology and motion of a water strider insect. The team watched videos of water striders and studied exactly how the motion and orientation of the legs worked. It turns out that strider legs row the surface of the water without rupturing it. With legs slightly turned in, they push on the water for as long as they can without breaking the surface tension (the elastic behaviour of water that results from polar interactions of molecules). The robot version presses down on the water with sixteen times its own weight, never rupturing the surface.[14]

Flea technology comes into play with the jumping mechanism. Fleas use a catapult system, enabling them to jump 150 times their body length. Energy is stored in a material called resilin and in the extensor, a muscle that applies a force to generate a torque. A small muscle triggers a reversal of the torque.[15]

The strider robot has an origami-inspired body with origami-inspired folded composite structures that self-assemble. Long wire legs are fabricated with the tips turned inwards and coated with a water-repellent material. The robot's torque-reverse catapult uses planar shape memory alloy spring actuators to send the robot into the air. This version could jump once but could not stick the landing. Though other engineers had created strider-like robots for locomotion, this was the first one to use surface tension for jumping. Future versions might work in swarms to serve as environmental monitors or disaster search teams.[16]

OPPOSITE & BELOW
Robotic water strider, 2013–15

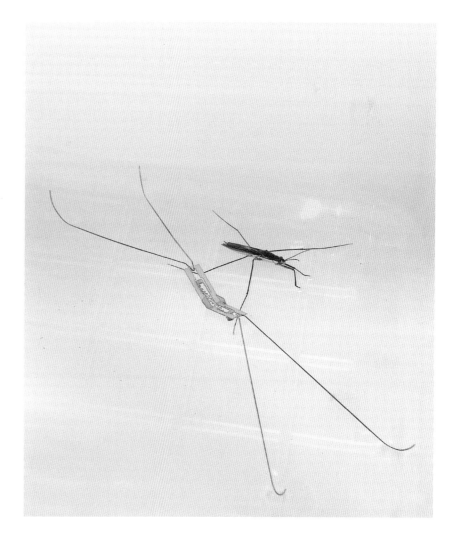

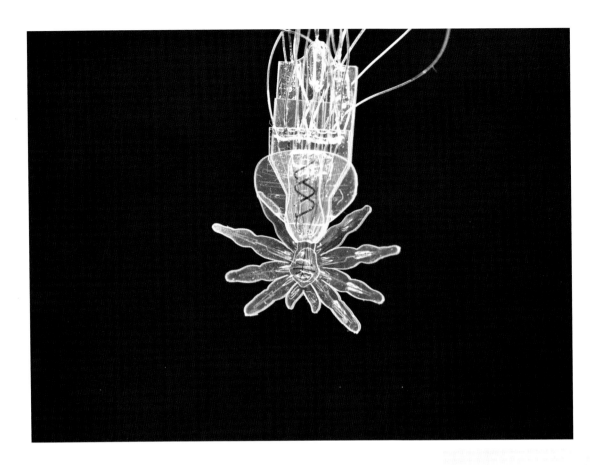

BIOMIMICRY

Soft robotic spider actuated by fluid

Tommaso Ranzani

Soft robots have none of the attributes of the robots of our mind's eye. They are often small, and they are typically made of silicone or a polymer. There is no metal, piston or motor. They have the feel of something biological. With no hard edges, they can easily be deployed inside the human body – even swallowed – boosting their potential to serve as aids to surgical procedures in the future. Their principal weakness, until this new robot based on the Australian peacock spider, was their level of actuation – their ability to work and function. Soft robots could perform only one type of movement.[17]

Tommaso Ranzani and a team at Harvard's Wyss Institute created MORPH – Microfluidic Origami for Reconfigurable Pneumatic/Hydraulic – a 1-centimetre (2/5-inch) wide soft robot composed of twelve layers of silicone fabricated using soft lithography. Like the peacock spider, it can wave two legs up in the air, and fold its massive abdomen forwards to give the appearance of being a much larger creature. Tiny microfluidic tubes are sandwiched between the layers of silicone. When fluid or air is pumped through the tubes they serve as actuators, causing the layer to fold or retract using principles of origami. They can even change state from flexible to fixed when a UV-curable resin is pumped through them. This means that they enter as a soft entity, and once in position, can be fixed permanently in place.[18]

MORPH mimics the scale, morphology and flexibility of the peacock spider. The synthetic spider has microfluidic actuators in the head, abdomen, jaws and legs, giving it nine independently controllable parts, plus the ability to change structure, motion and colour. It can lift one leg at a time, mimicking spider walking, or lift more than one. Depressurizing the microfluidic tubes brings the robot back to its original position.[19]

OPPOSITE & BELOW
MORPH soft robotic spider, 2018

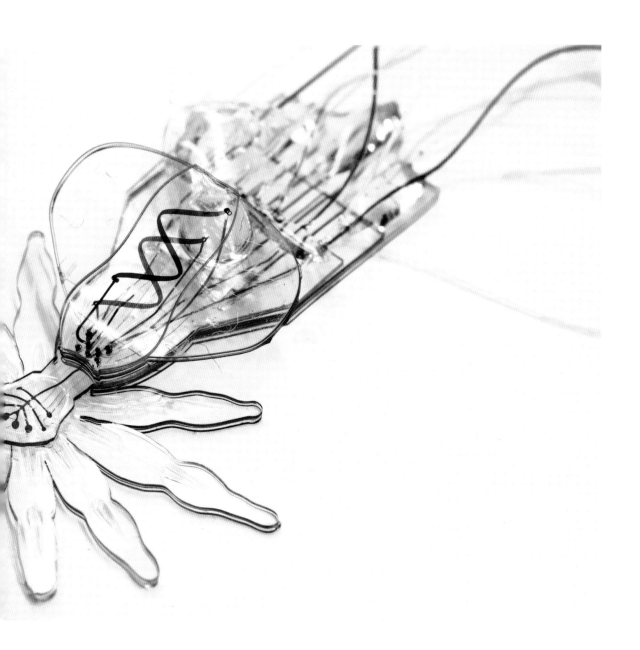

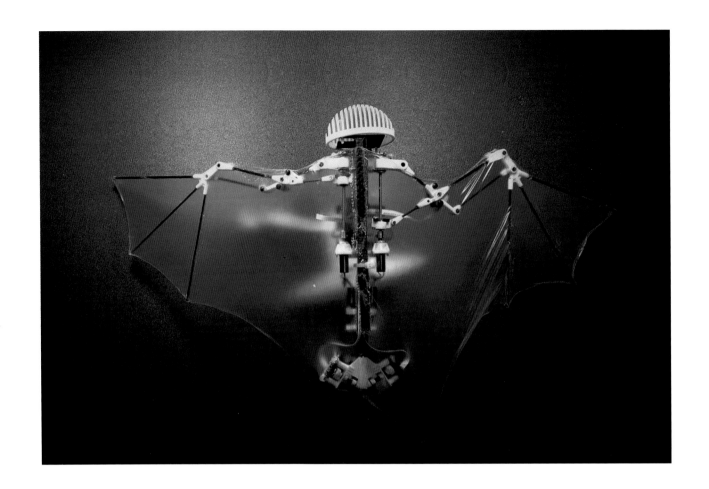
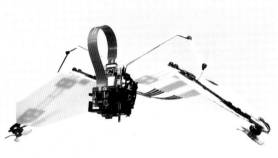
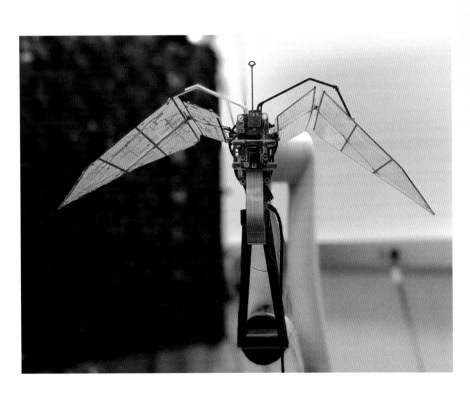

Synthetic bats as alternatives to quad-rotor drones

Scientists do not know exactly how small mammals evolved into bats fifty-two million years ago, but they have been piecing together the proteins involved in morphologic development of wings.[20] Bats are the only mammal on Earth with the ability to fly, and their wings are structural marvels. They have forty joints that allow them to adjust the shape of their wings and perform various manoeuvres. The Bat Bot is a synthetic bat with nine wing joints made of carbon fibre and a flexible wing membrane made of silicone. It weighs only 93 grams (just under a quarter of a pound), an astounding feat considering its 30-centimetre (1-foot) wingspan, and the fact that the backbone has tiny motors that allow left and right wings to move synchronously in some directions, and asynchronously in others. Prior bat robots had string- and pulley-based actuation that made them heavy and impractical for flight.[21]

Alireza Ramezani and team also worked towards a viable bat robot to avoid the dangers of quad-rotors – drones with four rotors. Quad-rotors, though agile, are unsafe for humans and extremely noisy. Collisions with the inflexible rotors are dangerous. The Bat Bot has soft gliding and flapping wings that make it a much safer alternative. It survives collisions with little damage thanks to its lightness and the strength of its parts.[22]

Aerobat is another bat-inspired robot devised to keep humans safe from collision in difficult environments for flight. This biomimetic drone combines a flexible monolithic wing structure with a more kinetic linkage mechanism that controls the flap using rigid parts and elastic joints. Aerobat possesses an ability to produce various wing formations, with fourteen body joints that mimic bats' dynamic morphing capabilities. All sensing and computing is integrated into the wing structure made of flexible PCB (printed circuit board). Such integrated planar parts make this bat-inspired robot a degree less visually batlike.[23]

OPPOSITE TOP
Alireza Ramezani, Bat Bot, 2016

OPPOSITE CENTRE
Adarsh Salagame, Aerobat, 2022

OPPOSITE BOTTOM RIGHT
Xuejian Niu, Aerobat, 2023

BELOW
Adarsh Salagame and Xintao Hu, Aerobat, 2022

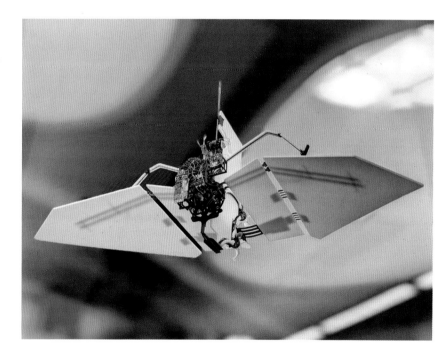

Walking on walls with gecko-inspired robots

Mark R. Cutkosky

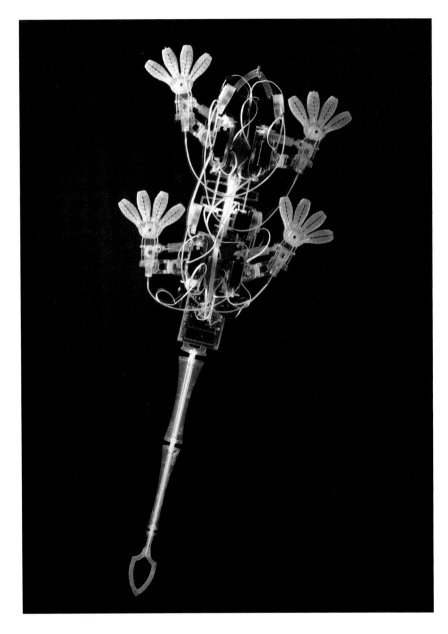

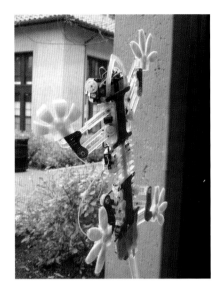

ABOVE & RIGHT
StickyBot, 2010

Gecko feet have 14,000 tiny hairs, or setae, per square millimetre, which allows them to carry their own weight up walls and across ceilings. They do not use suction cups or sticky substances, but rely on van der Waals forces, a weak attraction that occurs between neutral atoms or molecules in close contact. For example, a plastic tinted sheet on a car window sticks because of van der Waals forces. The force works only when a material is parallel to another surface, and it works in only one direction.[24]

In 2006, biologist Kellar Autumn of Lewis and Clark College in Portland, Oregon, discovered that gecko feet were using van der Waals forces to create directional adhesion. With that discovery in mind, Mark R. Cutkosky (see also p. 149), professor in the School of Engineering at Stanford University, and his team developed a series of projects imitating the gecko foot, including: a robotic gecko called StickyBot, a tiny robot named MicroTug that can pull massive amounts of weight, a wall-climbing human with gecko adhesion on hands and feet, and adhesives for holding down artefacts on the International Space Station (ISS).[25]

Gecko feet have organic ridges called lamellae, which are covered in the aforementioned setae. Only one tenth the size of a human hair, each seta is tipped with spatulae that are 0.2 micrometres long, which makes them below the wavelength of visible light. There are between 100 and 1,000 spatulae on each seta tip. These astounding numbers make it impossible to replicate the gecko adhesive mechanism, but Cutkosky and his team have managed to make a simpler version.[26]

The StickyBot has nineteen motors that manipulate the mechanical parts of the robot. Attached to each foot is the lab-made gecko adhesive, made by pouring silicone polymer into a wax mould with wedgelike indents made with a razor. The StickyBot can work in a vacuum. A gripper using gecko-inspired adhesive could be used to repair the exterior of a space station and has already been tested in the interior of the ISS to toggle down floating apparatus.[27]

Drones with falcon landing gear

David Lentink, Mark R. Cutkosky

The morphology of raptor talons is the best indicator of a raptor's diet. Raptors that eat large mammals have strong, short toes. If they eat snakes, they have feet with scales for protection. Falcons have long toes to enable them to grasp through the feathers of birds, their primary food source. Ospreys and owls have an opposable toe that points backwards but can also move a second toe backwards when necessary for a better grip.[28]

SNAG ('stereotyped nature-inspired aerial grasper'), created by David Lentink and Mark R. Cutkosky (see also p. 148), with William Roderick, is a drone that can perch. It has 3D-printed mechanical talons based on those of the peregrine falcon. The long toes allow SNAG to land on variously sized branches, to grasp complex objects in the air and to travel for longer, since the ability to perch in difficult environments allows the drone time to reboot.[29]

SNAG looks like a quad-copter with avian legs. The landing gear is remarkable for its accurate mimicking of avian mechanisms from the knee down, for its structural stability in landing and for the tidiness of the manufacturing. Bones are replaced by a 3D-printed plastic structure. Muscles and tendon actuation are performed by motors and fishing line. Where nature makes the raptor leg look reasonably simple, replicating its motion requires two motors, one for grasping, and one for moving back and forth. Springs store energy and help in toe grasping upon impact. The right foot has an accelerometer that helps the mechano-bird to balance, sensing the position of the foot relative to gravity and adjusting the body rotation.[30]

In addition to the ability to monitor environmental activity and animal behaviour, SNAG can be used to monitor wildfires and weather patterns. The robot is equipped with a temperature and humidity sensor.[31]

BELOW
Stereotyped nature-inspired aerial grasper (SNAG), 2021

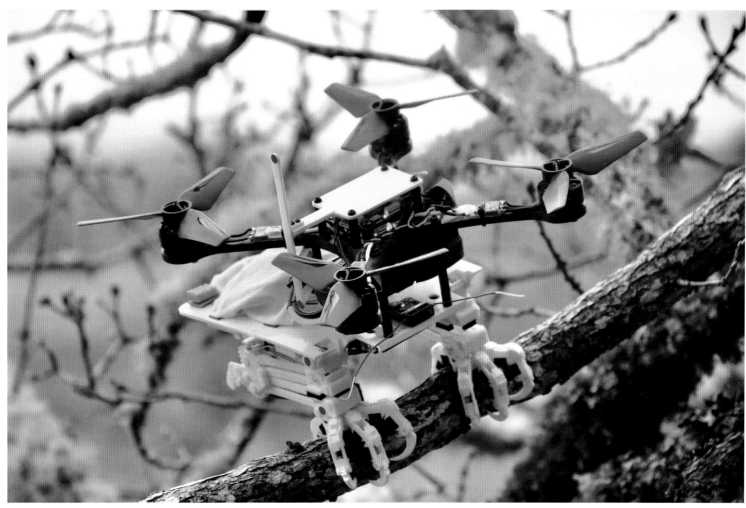

Acoustic woodpeckers restoring forest balance

Rihards Vitols's *Woodpecker* is a prophylactic forest remedy that works on a theory of replacement. He is not de-extincting the woodpeckers that have disappeared owing to changes in climate, he is replacing them with beautifully crafted wooden boxes – artificial woodpeckers – that reproduce the sound of the absent woodpecker. His aim is to amplify sound throughout the forest, to scare away the insects that prey upon trees and ultimately destroy the forest.[32]

Vitols cites a 1987 article by William J. Mattson and Robert A. Haack – 'The Role of Drought in Outbreaks of Plant-eating Insects' – as the source for leading him to focus on restoring the balance of the forest using sound. According to Mattson and Haack, drought promotes insect incursions into the forest because it elevates plant nutrient levels, lowers plant defences, causes perceivable temperature changes (a warming), impacts plant gene expression and causes premature yellowing and greater infrared reflection. Even more astounding, drought causes plants to give off acoustic emissions that insects can hear. Dehydration causes cavitation, or breaking of the consistency of the water flows in the xylem tissue. Scientists can hear the vibrations of single cells, largely in the ultrasonic range, which can also be heard by branch- and trunk-infesting bark beetles.[33]

Vitols produced thirty identical artificial woodpeckers constructed out of a series of laser-cut wood laminates, which have a supporting arch at the ends to connect to branches, a hollowed-out interior to house the electronics and a solar cell to power the motor. They pack elegantly into a suitcase for transport to the forest, and they are available as a limited-edition DIY kit. It will take a horde of like-minded artists to sift through the science of ecosystems, to foster the creatures of the forest. Vitols's woodpeckers are a haunting reminder of absence, and an encouraging sign of participation and prevention.

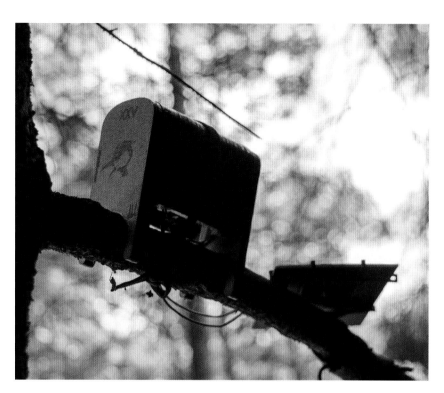

ABOVE & BELOW
Woodpecker, 2016

Machining substitute predators to restore endangered ecosystems

Jip van Leeuwenstein

A Diverse Monoculture is part of a spectrum of thousands of years of human environmental interaction and interference. Jip van Leeuwenstein's idea is to restore the balance of endangered ecosystems by creating a family of artificial predators that replace biological ones that have disappeared thanks to anything from human landscape design to climate-induced migration. The first species is *Dionaea Mechanica Muscipula*, a hive of coconut-sized metal robots that kick into gear at night. The target of this synthetic predator is the oak processionary, a moth that has been decimating oak trees by feeding on their leaves. The moth has proliferated because the human-designed lanes of oak in the Dutch landscape have prohibited the growth of smaller vegetation that would serve as a food source for the natural predators of moths. Van Leeuwenstein's predators act as a trap. The robot lights up its mouth, attracting the oak processionary moth into an initial chamber. Some moths remain there, using pheromones to attract others of its kind. Other moths proceed deeper into the robot, where a micro fuel cell chemically digests them. This artificial stomach turns the moth into energy, producing electricity to run the aggregate of robots.[34]

BELOW (BOTH)
A Diverse Monoculture, Dionaea Mechanica Muscipula, 2018

Van Leeuwenstein is denaturing the idea of nature, twisting the culture/nature divide, and provoking with this new entity. By introducing a robot, rather than a living entity, into the canopy, he eliminates the possibility of the solution becoming a problem. In the late 1970s Asian lady beetles (also known as harlequin ladybirds) were introduced into the pecan orchards of the southeastern United States to curtail destructive tree-climbing aphids, but they ended up swarming across the country and devouring native ladybirds.[35] Australia's disastrous cane toad, introduced to Queensland in 1935 to eradicate beetles devouring sugarcane crops, thrived, ignored the beetles and endangered other species because they are predatory, poisonous and highly adaptive.[36] How many of Van Leeuwenstein's predators will do the job? Who will install and maintain them? How long will they function? What will the next robot species in this family be?

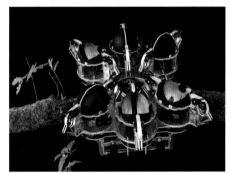

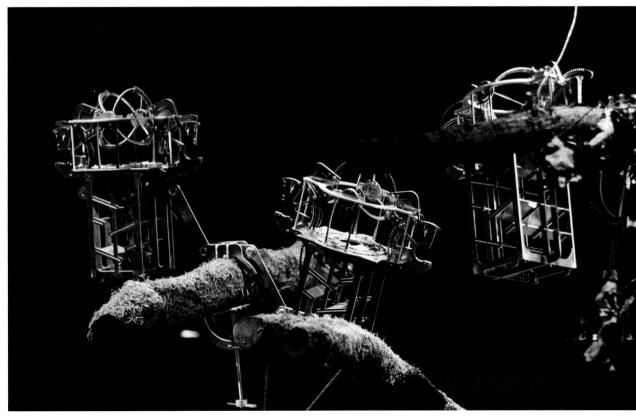

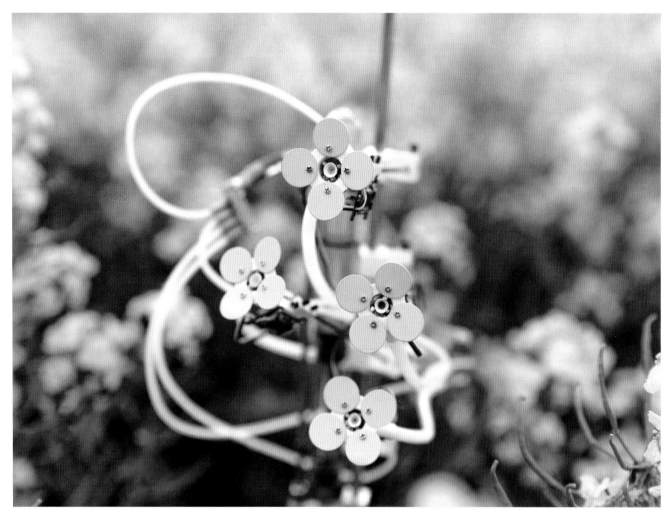
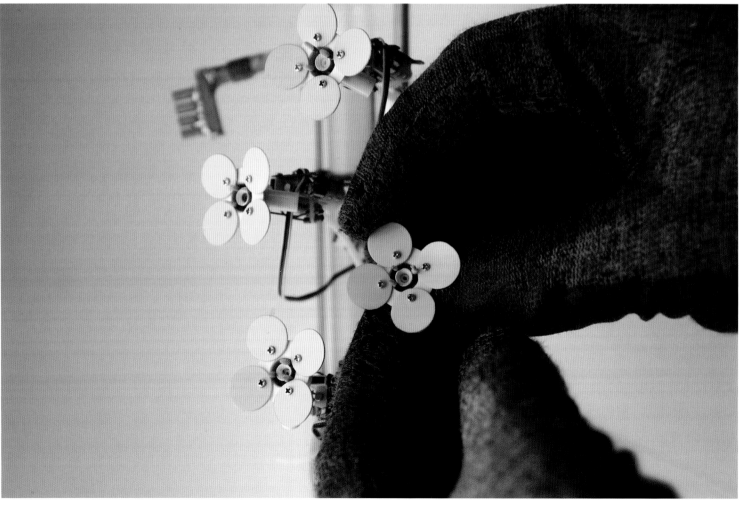

Simulating pollination with a synthetic flower

Michael Candy

Michael Candy (see also pp. 36–37 and 210–211) wanted to create a robot that would intervene in a cycle of nature. The inspiration was Richard Brautigan's poem 'All Watched Over by Machines of Loving Grace', with its 'cybernetic forest' containing computers that look like 'flowers with spinning blossoms'.[37]

With robot-making skills that outdo a mechanical engineer's precision and a machine-shop mechanic's ingenuity combined, Candy created a mechanical simulacrum of a rapeseed flower. The four machined brass flowers constitute the top of a robotic tower that uses synchronized gears, motors and electronics to pump up synthetic nectar, on the one hand, and deliver remotely sourced pollen on the other.

From the human vantage point pollination looks easy. The bee is attracted to a flower, drinks, then flies away with legs full of pollen. But pollination turns out to be extraordinarily complex. The mutualistic perpetuation of plant life and insect life involves hydraulics, olfactory cues, UV patterns, electrical fields, polarization, iridescence and more.[38] Candy's robot took three years to evolve, and required four prototypes, consultation with a resource ecologist and material and behavioural studies including gluing a dead bee on a flower to show other bees how to land.[39] It is hard to know how a bee would react to that. That is the point: Candy was communicating with bees, not humans. He did give an ironic nod to humans through a live stream of the device on YouTube.[40]

The press presented *Synthetic Pollenizer* as a scientific tool to remedy bee population decline and assuage fears of problems arising in the multi-billion-dollar business of growing food. In fact, it was the work of art of an ambitious robot-maker who wanted to try to hack into nature.

ALL IMAGES
Synthetic Pollenizer, 2014–2017

BIOMIMICRY

Prosthetic tentacle arm controlled by shoe sensors

15A The Alternative Limb Project, Dani Clode

Marvin Minsky's innovative 1968 *Tentacle Arm* robot was the first of its kind. Controlled by a computer, the arm was made of twelve segments and powered by hydraulic fluid. One end was bolted to the wall; the other end of the tentacle was capped by a metal humanoid hand.[41]

The Alternative Limb Project and Dani Clode have merged the human with the tentacular in *The Vine 2.0* (and the earlier *Vine*), a minimalist couture evolution of Minsky's arm, this time merged with the human arm, and controlled not by a joystick but by movement of the wearer's toes pressed against pressure sensors. *The Vine 2.0* is a biomechanical prosthetic arm that innovates on the notion of a prosthetic arm as a replacement. This arm is a new species. The wearer of these 3D-printed interconnected vertebrae adapts to the sinuous animal-like articulations that echo the fluid motion of sea tentacles. The brain adjusts to the erotic undulating flow of the new apparatus and makes different pathways for the grasping hand and the wrapping robot arm.[42]

BELOW & OPPOSITE
The Vine 2.0, 2022

The Vine 2.0 has twenty-four individual vertebrae made of tinted clear resin that connect to a gold electroplated resin arm socket. A core control mechanism connects the vertebrae and offers four degrees of freedom (or movements). As with Clode's *Third Thumb* (see pp. 46–47), the controls are in the shoes – here high heels to match the sleek aesthetic. The big toe in each shoe can trigger one sensor by pressing up, and one by pressing down. *The Vine 2.0* can also grip. When you first wear the apparatus, you might have to decide whether to pick up a jar with the clasping hand or the gripping tentacle. With time this will become unconscious with brain plasticity.[43]

Might a prosthetic arm allow us to move through space differently, enabling humans to use lianas as pathways through the rainforest like monkeys, squirrels and sloths?[44] *The Vine 2.0* challenges our expectations of machine/human interfaces and, in doing so, allows us to conjure up expanded human potentials.

BIOMIMICRY

Mechanical talking machines reveal the mechanism of speech

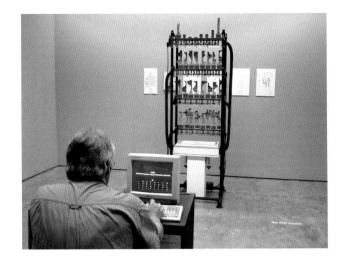

From 1989 to 1999, Martin Riches created two elaborate architectural speech synthesizers, one a series of thirty-two sculptural wooden voice pipes called *The Talking Machine*, which explodes speech into abstracted components arrayed on a shelf, and the other, *MotorMouth*, a more anatomically accurate section cut through the human head that has mechanical versions of the lips, tongue and all the parts of the human vocal tract.

The Talking Machine's resonant curvilinear pipes take the shape of the vocal tract as it produces a certain sound. Organized on four shelves, the top level makes the fricatives or hissing sounds. The next two rows are primarily vowels. The bottom row is consonants. Some pipes include nasal chambers to produce such sounds as M, N and NG that resonate in the nose. Other pipes have valves to change the sound. An air-blower encased in a soundproof box sits on the lowest shelf. Above that a thin box contains a magazine bellows that produces consistent air pressure. Controlled by a computer program, air is forced through hoses that connect to each pipe. The visual linguistic quality of the resonance chambers, and the associated sound remind the viewer that human speech can arise from radically different forms.[45]

MotorMouth is a mechanical version of the human head cut in half. A 1990s microprocessor at the base of the machine controls eight shoulder-height stepper motors that actuate each distinct anatomical feature involved in speech via cranks and cables. A blower vibrates a reed at the base of the neck. The tongue is a hollowed-out aluminium plate that rotates back and forth, while a radial wood shaft moves up and down. The teeth and lips are also made of wood. *MotorMouth* is programmed to speak a few sentences in English and German, including 'I love you'.[46]

Riches' machines confirm that speaking beings need not be humanoid.

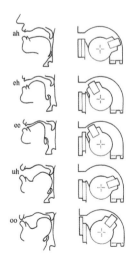

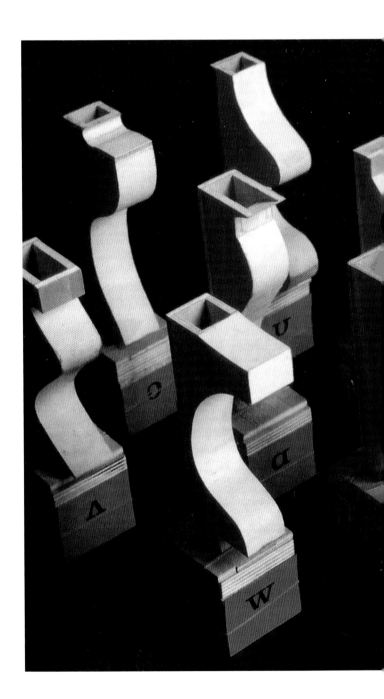

BIOMIMICRY

Martin Riches

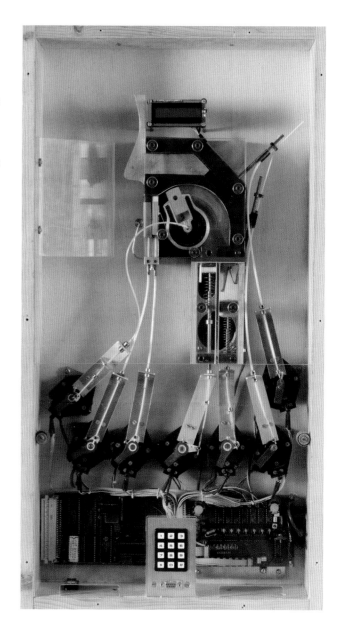

OPPOSITE TOP & CENTRE
The Talking Machine, 1989–91

OPPOSITE LEFT
A comparison of how a human being and *MotorMouth* achieve vowel sounds, 1994–99

RIGHT
MotorMouth, 1994–99

Intelligent robotic silicone throat and nose replicates speech

Hideyuki Sawada

When Hideyuki Sawada, professor in the Department of Applied Physics at Waseda University, Tokyo, set about creating a robotic mechanical system to replicate human speech, he decided to eliminate comprehension and communication. It was too complicated to make a robot that could speak and understand at the same time. His *Talking Robot* does not know what it is saying but it is adept at replicating the physical characteristics of speech. Sawada's aim was to make a speech apparatus that would sound more human. To do so he created a homemade version of the components of speech, from the blower as lung, to silicone vocal cords and a plaster nose. Advancing beyond the mechanical speaking robots that had been done before, Sawada allowed his robot to learn. The *Talking Robot* relies on a neural network to listen to speech, then mimic it by sending commands to configure and modify the synthetic organs to perfect the mechanical vocal tract.[47]

BELOW & OPPOSITE
Talking Robot, 2011

The mechanism uses flexible parts made of silicone for the vocal cords and the vocal tract, features used to create and resonate sound. Compressed air forced into a plastic chamber vibrates the rubber cords. As air enters the vocal tract, eight motors adjust the cross-section to achieve the appropriate sound, in effect imitating the tongue.[48]

Sawada and his team used MRI (magnetic resonance imaging) to estimate the size of the vocal tract cavity. After the *Talking Robot* learned, MRI scans verified that it had accurately mimicked the shape of the human throat. The disembodied throat is learning to talk on its own, but the nose is critical too. It serves as a resonance chamber for the letters M and N, controlled by an air valve built into its base. The human vocal apparatus is regulated by much more than the morphology of the parts. Speech is also dependent on mucus, viscosity and even sore throats, but that is for a later iteration. After completing the *Talking Robot*, a four-year endeavour, Sawada moved on to combining speech with the ability to converse and comprehend.[49]

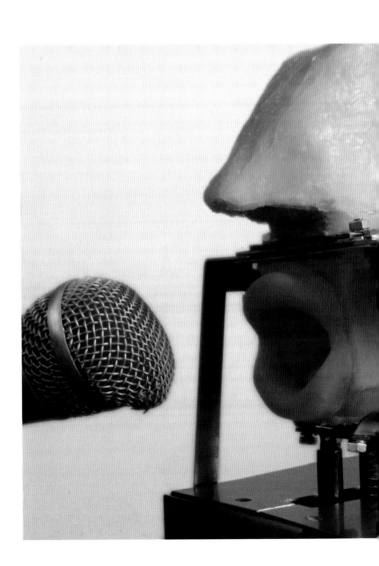

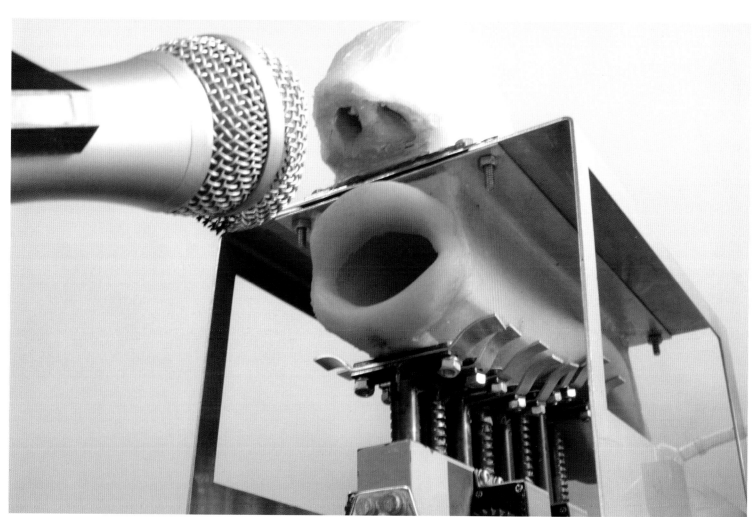

CHAPTER 5

CHANGE STATE

Many astronauts who have seen the Earth from space describe what they experience as the 'overview effect'. It is a life-changing state of being overwhelmed by awe, emotion and connection – an 'identification with humankind and the planet as a whole'.[1] Astronaut Edgar Mitchell described it as an 'explosion of awareness' and an 'overwhelming sense of oneness and connectedness...accompanied by an ecstasy...an epiphany'.[2]

Liu Yang, China's first female astronaut, said, 'I had another feeling, that the Earth is like a vibrant living thing.'[3] The authors of 'The Overview Effect: Awe and Self-Transcendent Experience in Space Flight' have composed a description of awe, which on a number of levels relates to the work of the contributors in 'Change of State':

> Social psychologists characterize awe as an intense emotion resulting from the perception of something vast, as well as the subsequent need to accommodate the experience. [...] Vastness can be perceptual in nature, as in literally seeing something large such as the Grand Canyon, or conceptual, as in contemplating eternity, or, in this case, the fragility and complexity of life on a small planet in the vastness of space.[4]

This chapter is organized around large and small acts evoking awe, and a profound connection to the Earth as an entity. There is a zooming out in these projects, and sometimes a zooming in, but inevitably the work aims at something larger than itself, some reckoning or awakening, and even responsibility. To what or whom? To the Earth. There are many speculations about the Earth in this time of ecological crisis, most significantly whether the Earth is alive. This book is about the perception of life, which is almost as important as actual life. It is about the slippery slope between being alive and seeming to be.

The inability to perceive, understand, remember and feel is at work in our current climate crisis. Humans are under an infinite number of false perceptions, thanks, in part, to human nature. We believe what we think. We imagine the world as an extension of our small realm. We feel we cannot make changes. We ignore history. We forget. The forgotten history of the beaver in the Bay Area of California exemplifies human nature with respect to the environment. According to Ben Goldfarb, author of *Eager: The Surprising Secret Life of Beavers,* in 1987 a cancer geneticist named Rick Lanman became curious about the disappearance of his stream. He suspected it had lost its beavers, since the former owner said it used to flow year-round. Despite Native American place names that mentioned the beaver in the Bay Area, despite the evidence of beaver teeth in shell mounds and in trapper journals, and place names such as Beaver Meadows and Beaver Creeks, California's Department of Fish and Wildlife stuck with their claim that beavers were not native to the Bay Area. It turned out that California's beaver population had been decimated by

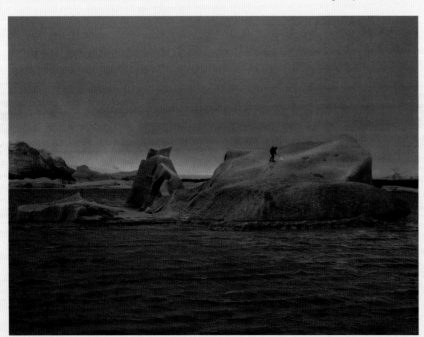

BELOW
Conjuring the sublime and the absurd, Julian Charrière attempts to melt an Icelandic iceberg with a blowtorch (see p. 166).

trade between native trappers and Russian and American mariners so much so that when travellers came to California overland, there were none left. Biologists have a name for this historical eradication: 'shifting baseline syndrome'. Goldfarb describes it as 'a form of long-term amnesia that causes each successive generation to accept its own degraded ecology as normal'.[5]

No wonder it is so hard for people to reckon with the climate crisis. Shifting baseline syndrome normalizes everything. Artist Julian Charrière, represented in this chapter by three environmental works, sums up how tied humans are to the shaping of the Earth: 'Landscape, its concept and therefore also its existence, is intrinsically connected to man. Either physically or virtually, through the violent extraction of the resources that lead to the progress of our culture, or through the invisible bombardment of the geography through electromagnetic waves travelling in the world's atmosphere. Landscape is constantly being transformed by man.'[6]

Looking at the 'blue marble' from outer space has the opposite effect of shifting baseline syndrome. Instead of forgetting, astronauts seem to be profoundly and permanently changed by the overview effect. These changes seem primarily to entail greater affiliation with humanity and an 'abiding concern and passion for the well-being of Earth'.[7] The works selected for inclusion in this chapter are searching for an Earthbound version of the overview effect, all the while fighting shifting baseline syndrome. Whether through miniaturization, displacement, transformation, collectivity or analysis – and intentionally or unintentionally – the projects spark a level of awe in the viewer, sometimes the positive transcendental side of awe, sometimes the worrisome side.

ABOVE
Julian Charrière used sandpaper made from dust gathered in all the countries recognized by the United Nations to erase all the geopolitical borders on a series of globes (see p. 168).

ABOVE
Laser light installations by Helen Evans and Heiko Hansen (HeHe) projected on to the emissions from giant power plants materialize energy by-products and alert local communities to the environmental cost of energy consumption (see p. 173).

Alongside art, changes are taking place in philosophy, environmental laws and politics. Laws spearheaded by indigenous communities and environmental advocates have made significant inroads into granting 'personhood' to rivers and important land features. James Bridle, author of *Ways of Being*, writes:

> To declare an entity as a legal person, however narrowly defined, is not merely to admit it to a court of law. It is to declare it alive, in ways which we have struggled to articulate since the eclipse of animism. In the moment that animals and natural entities are declared legal persons, our whole definition of, understanding of and relation to life changes. These things, these objects, are remade into – or rather, recognized as – subject beings, possessing agency, needs, desires and vitality. Suddenly, whole new communities of agential life leap into view. The world is repopulated. It becomes more-than-human.[8]

To a varying degree animals, rivers and places have been granted the Rights of Nature, or the right of personhood. In 2006 in the United States the Community Environmental Legal Defense Fund (CELDF) helped Tamaqua, a community in the state of Pennsylvania, win the first ever Rights of Nature in the world, recognizing that the ecosystem had a right to its existence as an entity, and that the dumping of toxic sewage would be a violation of that right.[9] Ecuador cemented the Rights of Nature countrywide when it sealed the notion into its constitution in 2008, followed by Bolivia, Mexico and Colombia.[10] New Zealand was the first country in the world to give the legal right of personhood to a river. In 2017 the indigenous Māori people became stewards of the sacred Whanganui River, allowing them to sue polluters, and granting them money to clean up the mess left by mineral extraction and overuse.[11] India, Colombia, Ecuador, Canada, Australia

and Bangladesh followed suit, granting personhood to important rivers.[12] These rulings are all heading in the right direction, but rivers are multinational entities. What gets enforced in one country may be difficult to enforce in another.[13]

Indigenous groups have always been a step ahead, perceiving rivers, forests and land as living, and protecting them for thousands of years. Chris Finlayson,

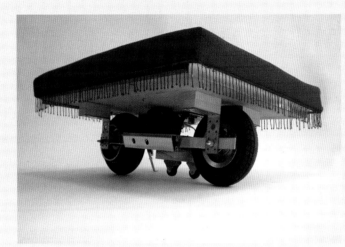

ABOVE
A tiny monorail designed by Helen Evans and Heiko Hansen (HeHe) for Istanbul's historic tramway (see pp. 174–75)

who negotiated with Indigenous groups over the Whanganui River, explained, 'The Whanganui have a famous saying which says in English, "The river flows from the mountain to the sea. I am the river. The river is me."'[14] 'In India, Hinduism regards the whole universe as an emanation of the divine, and so rivers, plants, animals and the Earth itself are considered sentient divinities, with particular forms, qualities and characteristics,' says James Bridle. 'To recognize this in law is critical not only for the survival of these beings themselves, but for our own ongoing processes of decolonization and enfranchisement – as part of the wider extension of suffrage, personhood and self-determination to all human groups.'[15]

Granting rights of personhood to animals has been less successful. Wins include a chimpanzee in Argentina. At least thirty-two countries recognize animals as 'sentient beings'. In 2021 a federal magistrate judge in the United States ruled that the late drug lord Pablo Escobar's uncanny thriving hippopotamuses in Colombia – where the population of this introduced species has increased rapidly from four to almost 200 – could be seen as 'interested persons'.[16]

This book is full of ideas. Many are the result of a new technology, innovative ways of combining biological material and machine, synthesizing life or transforming living tissue. Scientists and artists are riding the wave of CRISPR gene editing, xenotransplantation, pluripotent stem cells and tissue culture. In this chapter the artists take an entirely different path. They are scratching away at the surface of what exists – at the Earth, motion and the environment. They breathe life into parts of daily life we had written off, or long considered intractable. This requires examination of the way things are, how they once were and what they might be again. Such designers generate sparks of curiosity in physical areas of our life, and in parts of our brain that have become cordoned off.

'Change of State' grants unofficial personhood to ice, trees, landscapes, rocks, elephants, bears and even statues, grottoes and communal carving. Julian Charrière and the team of Olafur Eliasson and Minik Rosing offer two different takes on icebergs. Charrière explores the sublime in relation to humans by going to the icebergs, climbing on one and trying to melt it. Eliasson and Minik go through an elaborate effort to transport icebergs to London, Paris and Copenhagen to show people the essence of what the world is losing because of the climate crisis.

Julian Charrière and Agnes Meyer-Brandis engage plant matter in diverse state-changing narratives. Charrière cryogenically preserves a series of plant species that survived freezing during the Cretaceous period, only to suffer colonization and the degrading status of ubiquitous office plant. The change of state creates awareness. Meyer-Brandis performs atmospheric research in the microclimate of a boiling cup of forest.

RIGHT
Kathryn Fleming's prototype for a hibernation station for a bioengineered miniature bear, designed for a typical domestic living space (see p. 181).

Charrière and Uli Westphal explore the meaning and messages behind representations of the Earth and its creatures. Charrière erases the geopolitical borders of nineteen globes from 1890 to 2011, restoring the planet to its connected whole. Westphal catalogues all medieval representations of elephants in bestiaries from the Middle Ages, revealing the agenda involved in various distortions of the elephant's morphology.

Past and future technology help to reveal aspects of living Earth, whether its surface or its atmosphere. Prokop

Bartoníček and Benjamin Maus devised a machine to sort river rocks by geologic age, and in doing so tell the otherness of these 250-million-year-old artefacts. HeHe changes our state of awareness by harking back to a time when our bodies were more connected to motion or space. The team fabricates tiny railcars that restore the wonder of moving horizontally across the Earth's surface.

The Anthropocene has been tough on air, land and animals. HeHe uses representational strategies to highlight pollution, whether it's a loop of a miniature nuclear meltdown or a visualization of power plant pollution through laser illumination of the never-ending smoke. Maarten Vanden Eynde constructs a dish out of the circuit boards of outdated phones and computers, to listen to lost and abandoned satellites. Kathryn Fleming addresses animal endangerment with an idea for updating our domestic landscape by using biotechnology to create miniature

ABOVE
A large-scale collective cardboard installation of giant sculptural friezes, organized by Makoto Aida with the 21st Century Cardboard Guild, monumentalizes everything from fantasy to pop culture to technology, in a nod to medieval guilds and religious sculpture (see pp 184–185).

bears that we can steward in hibernation stations in our homes.

Cardboard, earth and concrete form replicas of the world, its inhabitants and its artefacts. Thomas Demand recreates a Mallorcan grotto inside a gallery. Made of 900,000 computer-cut layers of cardboard, it is synthetic but still awe-inducing. Makoto Aida revives the idea of the medieval guild, enlisting students and museum-goers to create massive relief sculptures in corrugated cardboard, a collective action to convey that there is no longer anything collective such as religion to monumentalize. Shūsaku Arakawa and Madeline Gins aim big with their idea that architectural space, if physically and perceptually challenging, could reverse the destiny of dying. Their *Site of Reversible Destiny – Yoro Park* changes the way you experience a park, the way you inhabit interior space and the way your body moves through space.

Being tuned in to the atmosphere, oceans, rivers, animals, plants and rocks can only help the Earth. A little animism might help the planet too. Reading *The Falling Sky: Words of a Yanomami Shaman* by Davi Kopenawa and Bruce Albert may help you to see the Earth, its rivers and land as embodied and alive. Perhaps you do not need to exit the Earth's atmosphere to experience the overview effect.

Sublime encounters with icebergs

Julian Charrière

In 2013, for his series *The Blue Fossil Entropic Stories*, Julian Charrière climbed an iceberg near Iceland and used a blowtorch for eight hours to try to melt it. He was standing on a geologic timescape. Icebergs are deeply ancient entities. The image of a tiny man using fossil fuel to melt such an icy leviathan underscores our role in the destruction of the polar ice, and calls attention to our inconsequential presence in the face of such giants. Over the course of the eight hours Charrière did not make a dent in the iceberg; the meltwater immediately refroze. If only the cryosphere were so hardy.[17]

Charrière's references to the Anthropocene are just part of his motivation. He describes this visitation as 'an encounter with a totally nebulous and temporally entangled entity'.[18] Caspar David Friedrich, one of Charrière's Romantic era references, painted his own iconic iceberg, *The Sea of Ice*, in 1823–24. Most people had never seen an iceberg in person. Friedrich relied on river ice and accounts of explorers such as Captain William Parry to depict his painted icebergs.[19]

'Nineteenth-century Britons sang polar-themed songs, attended polar-themed dinner parties and flocked to re-creations of polar expeditions...,' according to Kathryn Schultz, author of 'Literature's Arctic Obsession'.[20] Ironically the industrial inventions of their time would initiate the decline of the ice.

Charrière's nod to Friedrich is about awe and the sublime. He was born in 1987, and his relationship to the internet age mirrors Friedrich's relationship to the Industrial Revolution. Both reject their contemporary technological milieu, Friedrich by painting landscapes and Charrière by visiting them in person.[21] According to Charrière, 'Icy landscapes were once perceived as something sublime, pristine but violent, dwarfing mankind – this cultural construction has shifted so that today they have become something fragile and in need of our protection. There is this huge gap in our understanding of what this landscape actually is or stands for, and this inherent complexity motivated me to go there, explore and mine these layers of information.'[22]

BELOW
The Blue Fossil Entropic Stories III, 2013

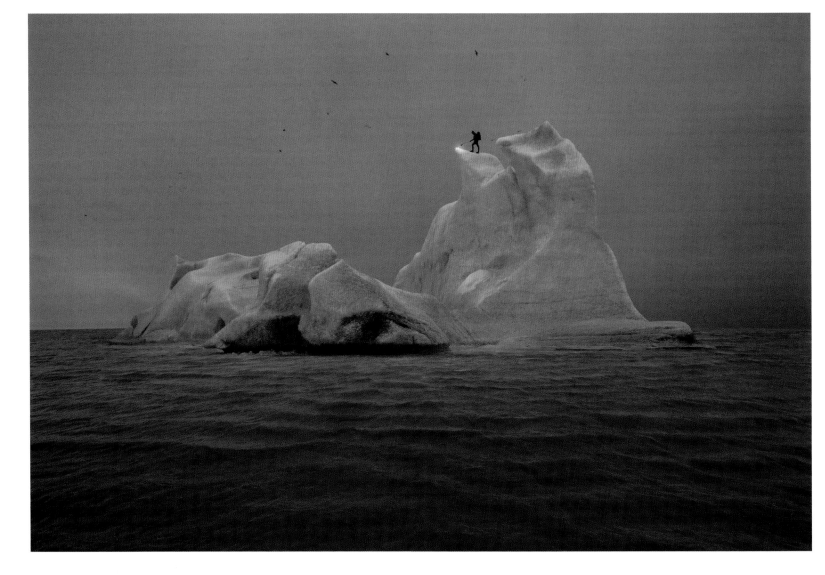

Cryogenically freezing plants that survived the Cretaceous–Tertiary extinction

ABOVE
Tropisme, 2014

There is something beautiful and disturbing about cryogenically frozen plants, something that stirs the unconscious and our ancient cellular connectedness to the planet. 'They are on life support,' Julian Charrière said in an interview.[23] They are in a 'state of floating', 'out of time'.[24] 'My work always comes back to the geological and what it teaches us about our understanding of time. The thought of time being trapped and stored in material opens up so many stories and realities.'[25]

Tropisme tells a very long story. The plants that Charrière selected to be dipped in liquid nitrogen are orchids, cacti and other common specimens that survived the Cretaceous–Tertiary (also called Cretaceous–Palaeogene) extinction more than sixty-five million years ago.[26] When a 10–15-kilometre (6–9-mile) wide asteroid collided with the Earth, it dusted up the atmosphere, chilled the planet, killed off the dinosaurs and 70 per cent of plants, then left the Earth hotter than ever owing to greenhouse gases.[27] Prior to this cataclysm, the North and South poles were tropical.[28] Almost everything shifted irrevocably, but a few plants remained as testimony to the time before.

Though twenty-first-century humans remain unaware of their importance and fortitude, these plants are time capsules. Charrière's installation also links to another story: colonialism and the migration of humans.[29] Such specimens are so ubiquitous in homes, offices and stores that they have become generic symbols of domesticated plant life, placeless and without a past. 'Plants tell the story of human actions,' Charrière says.[30] These plants were displaced from the global south through colonization. They contain 'molecular memories' and their genes have been modified epigenetically (changes in gene expression thanks to the environment, which do not change the sequence of DNA) by the destructive history of the Anthropocene.[31]

Observing such morphically diverse plant matter in a refrigerated vitrine, the viewer considers plants in a new way. Relying on electricity to avoid decay, these plants serve as avatars of all growing vegetation, of all that we take for granted and all that we destroy. The entire living planet is on life support. Visibly manifesting frozen time sets off ancient instincts that are not often roused. Whispers of the Cretaceous period ask us to avoid pulling the plug.

Erasing the geopolitical borders of globes

Julian Charrière

The earliest-known globe representing the Earth, made in 150 BCE by Crates of Mallos, was divided into four land masses, two above the equator and two below, separated by equatorial and meridian oceans.[32] The oldest existing globe was made in 1492 by German polymath Martin Behaim. Called the *Erdapfel*, it was wildly inaccurate, consisting of one giant continent in the Northern Hemisphere with surrounding oceans and islands.[33] For centuries humans had no idea of what the Earth looked like.

Julian Charrière sourced thirteen globes ranging in date from 1890 to 2011 for the installation *For We Are All Astronauts*, a phrase borrowed from Buckminster Fuller's famous quote: 'We are all astronauts on a little spaceship called Earth.' Instead of highlighting the geopolitical borders that shift over the 120 years the globes encompass, he erased them. To do so, he used 'international sandpaper' – abrasive sanding sheets made of dust from all countries recognized by the United Nations – dust he had made in an earlier project. The sanding left a beautiful pile of powdery residue beneath the obliterated continents and oceans.[34]

The 'international sandpaper' excluded populations that fell outside UN recognition. Indigenous groups, colonized peoples and migrants were left out, either to show their disenfranchisement from the structures that decide what the world looks like, or to show how they bore no responsibility for divisive borders. In erasing the borders, Charrière levels the playing field. According to the MIT List Visual Arts Center, Charrière's installation 'points to the inefficacy of existing international human rights frameworks. The hanging globes of *We Are All Astronauts* are precariously balanced between the existing and future realities of globalism and statelessness and utopian dreams of planetary consciousness.'[35]

Following Charrière's utopian dream to the next level, what if the only representation of Earth that children ever saw were images of the Blue Marble – the famous image taken by the Apollo 17 crew in 1972? Would that change the way we coexist as astronauts on this little ship?

BELOW
We Are All Astronauts, 2013

Domestic apparatus as forest data collector

Agnes Meyer-Brandis

ABOVE
Teacup Tools,
2014–ongoing

The network of research stations across Europe known as SMEAR (Station for Measuring Ecosystem–Atmosphere Relations) continuously measures greenhouse gases, aerosols, volatile organic compounds, pollutants, forest soil, emissions and meteorological measurements. In 2014 a new research acquisition tool emerged among the masts, towers, shoot chambers (a way of enclosing plant shoots for measurement purposes) and various recording devices at SMEAR II in Hyytiälä in Finland, one that wedded field science with social interaction via the teacup. The brainchild of Agnes Meyer-Brandis (see also p. 199), *Teacup Tools* is an array of data-capturing teacups that have instruments built inside them and on them. They measure the invisible aspects of atmospheric climate phenomena, processing rain, forest leaves and needles, and any matter that falls into the cup. The boiling water forms a cloud over the cup and sensors record the aerosol data – the essence of the air. Data can be read directly from the cup, checked remotely through mobile devices or read through taste by drinking the tea. The teacups and their saucers move up and down on metal rods in response to particles, rain, clouds, measurements and tea drinking, resulting in a forest dance that a kitchen would envy.[36]

Scientific instruments are typically legible only to those researchers trained to maintain and read them. Climate-measuring tools appear on the pavements of cities and in forests around the world as abstract hermetic entities. With teacups, tables and sips, Meyer-Brandis offers visitors a way into science. A teacup is an invitation. A teacup cloud is a way into understanding forest compounds, aerosols and the changing atmosphere. More opportunities to connect familiar rituals and artefacts with scientific data – science/kitchen hybrids – might tip the scale, opening science up to a greater audience, and in turn creating awareness of the planet as an interconnected system.

Encounters with displaced icebergs and the consequences of the climate crisis

Olafur Eliasson, Minik Rosing

If the Greenland Ice Sheet melts, global sea levels will rise 7 metres (23 feet) – the height of a two-storey building.[37] Most people have never seen the ice sheets or an iceberg. It is difficult for us to reckon with the importance of ice in the scheme of climate change when we hear about it only by way of data or see images on the internet. It is all too remote. Artist Olafur Eliasson and geologist Minik Rosing were determined to give people 'a very tangible encounter with the consequences of their actions', banking on the emotional effect of seeing and touching ancient ice.[38] The team used heavy machinery to fish out thirty cleaved icebergs from the Nuup Kangerlua fjord in Greenland, transporting them to London, where twenty-four went on display in front of Tate Modern in an installation called *Ice Watch*.[39] Previous displays had taken place in Copenhagen and Paris.

Glacial ice is a time capsule. Air trapped in the ice can be thousands of years old, revealing ancient atmosphere, giving data about the temperature at the time and providing a whiff of the world before fossil fuels filled the air with carbon dioxide.[40] During melting, the bubbles make detectable sounds. Visitors touch, listen to and smell the ice. Countless photographs of the encounters verify the formation of a connection. To what extent behaviour modification occurred was more difficult to quantify.

According to Rosing, 10,000 hunks of ice like the ones on display fall from the ice sheet every second.[41] An old ice core rediscovered in 2021 suggests that Greenland was free of ice 400,000 years ago.[42] Scientists are using this data as evidence of an impending disastrous reprise of such a melt. A long view of the history of the Earth reveals that the planet cycles between hothouse and full glaciation.[43] Clearly, we are heading to the hothouse. Our job is to learn how to slow things down.

BELOW & OPPOSITE TOP
Ice Watch (2014), Place du Panthéon, Paris, France, 2015.

OPPOSITE BOTTOM
Ice Watch (2014), Bankside, outside Tate Modern, London, UK, 2018.

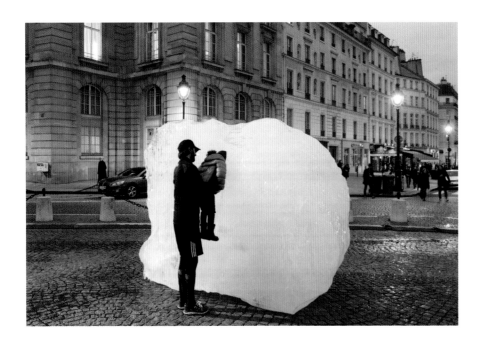

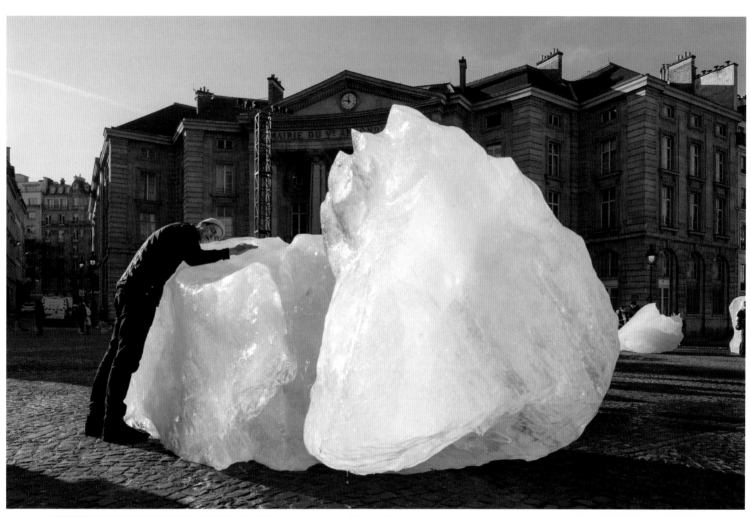
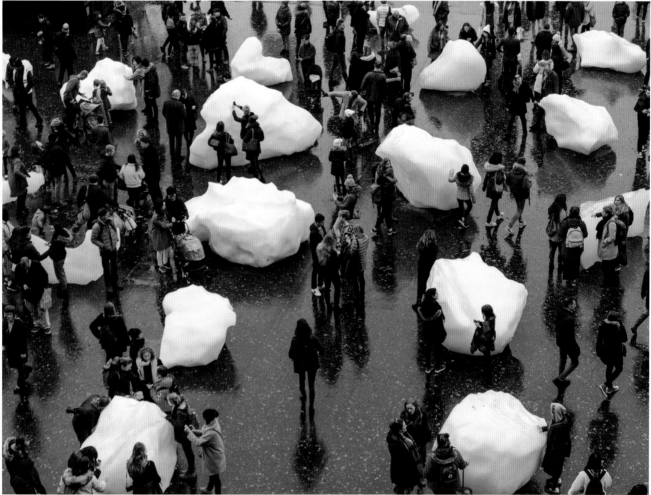

Geologic timescale revealed by artificially intelligent autonomous rock-sorter

Prokop Bartoníček, Benjamin Maus

Prokop Bartoníček and Benjamin Maus calibrate, sort and celebrate rocks. *Jller*, their exquisite machine inspired by industrial automation, arranges rocks by geologic age. Named after the German river from which the rocks are extracted, the sorting machine is fed data about the range of stones that can be found in that river. The machine uses a computer vision system to process images of the stones, map their location and extract colour, patterns, lines, layers, grain and texture. Strewn across a 2 × 4-metre (6½ × 13-foot) platform, *Jller* sucks up the stones with an industrial vacuum gripper capable of rotating around its own axis to facilitate pebble alignment. It sorts in two steps, first forming pre-sorted patterns, and then making the final alignment by type and age.[44]

Jller feels like science, but in scope and composition it is conceptual art. From a state of complete abstraction and undefined otherness of the isolated pebble, the sorting reveals the history of time in the composition of the riverbed. *Jller*'s timeline spans from 225-million-year-old limestone from the Triassic period, formed from sediment in the primeval ocean, to granodiorite, a 30- or 40-million-year-old igneous rock of volcanic origin from the Tertiary period.[45] There is also metamorphic rock created through temperature and pressure, and rocklike human-engineered slag from industrial processes of the Anthropocene.[46] The pebbles are random at the start. They emerge as a language – concrete poetry – speaking of time, relatedness and ancient processes. Dr Lynn Margulis, the American biologist who helped develop the Gaia hypothesis, sums it up: 'Earth, in the biological sense, has a body sustained by complex physiological processes. Life is a planetary-level phenomenon and Earth's surface has been alive for at least 3,000 million years.'[47]

BELOW
Jller, 2015

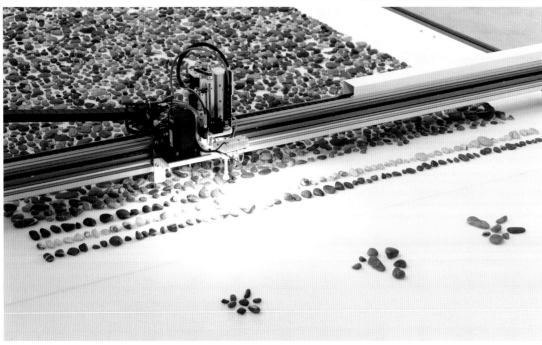

Power plants, energy consumption and the politics of pollution

Helen Evans, Heiko Hansen (HeHe)

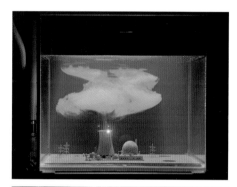

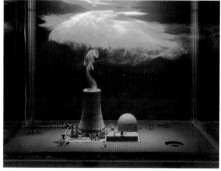

ABOVE
Nuage Vert ('Green Cloud'), Ivry-sur-Seine, France, 2010

ABOVE RIGHT
Fleur de Lys, 2009

Fleur de Lys and *Nuage Vert* ('Green Cloud'), by Helen Evans and Heiko Hansen (HeHe; see also pp. 174–175), materialize environmental issues using light and special effects, making transparent and tangible the human need for energy in contemporary life.

Fleur de Lys is a looped re-creation of a nuclear meltdown. Set within a water tank, the miniaturized containment chamber and cooling tower of the generic nuclear facility simulate a disaster every twenty minutes. A turbulent green mushroom cloud forms in the water, a special effect produced by the technical apparatus hidden below the tank.[48] In response to the 2011 Fukushima disaster, Germany shut down its nuclear programme and several other countries decided to phase out nuclear or ban new plants.[49] There are approximately 440 nuclear power reactors operating around the world. Around sixty are under construction and 110 are slated for construction.[50] Disasters are rare, but they do occur, and environmental changes due to the climate crisis are making matters worse. Despite nuclear power's potential to cause a toxic disaster on the scale of Chernobyl, it is considered a 'green' choice.[51] *Fleur de Lys* depicts the underlying complexity of nuclear energy and does so before it is too late.

Nuage Vert Saint-Ouen and *Ivry* are large-scale laser light installations that were projected on to emissions from giant power plants, materializing energy by-products and alerting local communities to the environmental cost of energy consumption. The *Saint-Ouen* version, an illumination of the smoke cloud from France's largest waste incinerator, met with bureaucratic difficulties and became a stealth project instead, forcing HeHe to abandon any planned interactivity. In contrast, the project was embraced by the Salmisaari coal-burning power plant in Helsinki, and for a week it became a real-time shifting icon of the city. The green laser illumination grew bigger as consumption of energy decreased, the premise being that awareness changes habits. Yet the plant is part of a European network of energy production: usage changes of the local population did not directly change the coal consumption of the plant.[52]

Moving the body across the Earth in a fleet of tiny electric railcars

Helen Evans, Heiko Hansen (HeHe)

HeHe's (see also p. 173) fleet of diverse, beautifully crafted, fully functioning autonomous electrical vehicles for individuals or small groups highlights the beauty and abstraction of the rail line, and the aesthetics of travel and motion. The inspiration was a defunct loop – La Petite Ceinture – built in Paris and abandoned in 1934, and Paris's new tramways. In 2003 HeHe designed railway scooters, platforms and seats for the Paris rails, all mini-performances that undermined the ingrained way that we perceive train transportation. This led to a series of vehicles as functional fictions that vary according to location.[53]

Slow Train harks back to the sixteenth-century horse-drawn wooden rail lines in Germany, and to the narrow-gauge lines built for peat extraction in the Netherlands.[54] The elevated wooden track runs a short distance in a tree-lined field of green brush. Operated by human power, the one-person car exterior is entirely mirrored, allowing the rectangular capsule to disappear into nature. Built for observing nature, the capsule rides slowly and stealthily through the field, animating the surrounding space via reflection in motion.

Tapis Volant ('Flying Carpet') is a tiny monorail railcar for one. Created to run along the historic tramway in central Istanbul, the vehicle consists of a small platform topped by a soft red cushion lined with tassels. The performer/driver sits cross-legged on the platform and engages an electrical motor hidden in the platform to move forwards.

H-Line is a monorail vehicle built to reactivate the defunct rail of the High Line in New York City. The industrial silver capsule and American flag mimic the subway car aesthetic.

M-Blem is a transparent cylindrical electrical vehicle for two that ran on a historic track at Manchester's Museum of Science and Industry. Untangling the industrialized conscience and harking back to play, this slow rail vehicle recalls A. B. Clayton's painting of an 1830s personal transport system on the Liverpool and Manchester Railway.[55]

BELOW
H-Line, 2007

BOTTOM
M-Blem, 2012

OPPOSITE TOP
Slow Train, 2020

OPPOSITE BOTTOM
Tapis Volant (Flying Carpet), 2005

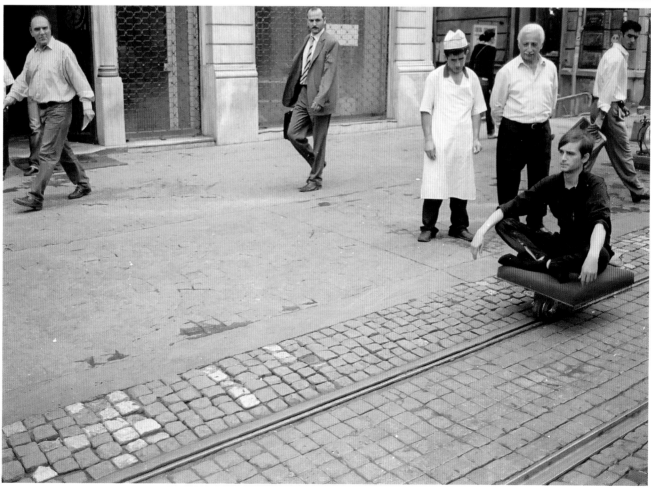

CHANGE OF STATE

Abandoned satellites as archaeological record

Maarten Vanden Eynde

A recent indigenous-led development – the personhood movement – gives nonhuman features of the natural landscape, especially rivers, the right to sue on their own behalf, to counter any attempts to defile them or otherwise use them for the purposes of extraction. What about space? Few people are aware of just how much junk humans have left up in space. The Earth is surrounded by a cloud of particles from former satellites, rockets, missiles, space stations, astronaut mishaps and even needles from Project West Ford, which attempted to create an artificial ionosphere above the Earth. We are encircled by so much debris and metal that it is getting dangerous to exit the Earth's atmosphere. Eighteen thousand pieces of debris are tracked by the US Space Surveillance Network. There are approximately 750,000 pieces the size of a euro coin. There are one-hundred million pieces smaller than a centimetre (2/5 inch), each one moving at a speed of 40,000 kilometres (25,000 miles) per hour.[56]

Maarten Vanden Eynde (see also pp. 178–179) is not offering personhood to space – yet. But, with *Cosmic Connection*, he is attempting to give space debris a voice. He soldered together the circuit boards of outdated phones and computers into a giant dish, to serve as a receiver for signals from lost satellites. It is a project with archaeological intentions. Old rubbish sites give archaeologists a window into everyday lives. According to the Union of Concerned Scientists (UCS), there are 7,560 still operational satellites that have been abandoned because they are no longer useful.[57] What might these satellites reveal?

Vanden Eynde's dish also delves into human curiosity and our quest to discover new life forms. Hacking the satellites will not satisfy our hunt for other forms of life, but it will keep us busy in space.

OPPOSITE
Cosmic Connection (detail of maquette), 2016

BELOW
Cosmic Connection, 2016

A colonial despot's cast hand revisits the site of his atrocities

Maarten Vanden Eynde

The spectres of brutal regimes, rogue kings and dictators still haunt the twenty-first century. You can head into the future with good intentions, but sometimes you also need to bury the past.

In the middle of the night in a square in Brussels, Maarten Vanden Eynde (see also pp. 176–177) used a ladder to climb the equestrian statue of Leopold II to make a mould of the bronze hand. The statue, made by Thomas Vinçotte in 1914 and completed in 1926, commemorates Leopold, king of Belgium from 1865 to 1909, who ruled forcibly over what is now the Democratic Republic of Congo, and was responsible for the death and torture of millions of Congolese and the pillaging of the country's natural resources.[58] Vanden Eynde took the mould to a former rubber plantation in Congo and made a rubber cast called *The Invisible Hand*. The name refers not only to the replica of Leopold's hand, but also to the economic concept outlined by Adam Smith in *The Theory of Moral Sentiments* (1759), in which he suggests that wealthy individuals unconcerned with doing society good, and driven by self-interest to employ the poor to make luxury goods, may inadvertently boost the economy.[59] Leopold II stimulated local growth, but while doing so he committed unthinkable atrocities that resulted in the death of an estimated ten million people. The 'invisible hand' also refers to Leopold II's use of mutilation, specifically cutting off the hands of employees – as punishment for not meeting the rubber quota.[60]

For *Horror Vacui*, the mould is returned to Belgium and presented at Art Brussels, 'completing the problematic circle of colonial treasure hunting in relation to historical fetishisation'.[61]

In 2020, in the global aftermath of the racist killing of George Floyd by a police officer in Minneapolis, Minnesota, the statue was set on fire. It was removed from the square and placed in a museum to undergo restoration. The square was redesigned with the absence of the Vinçotte statue, yet again echoing Vanden Eynde's prescient project.[62]

BELOW
Horror Vacui, 2016

BOTTOM
The Invisible Hand, 2015

OPPOSITE TOP
The Invisible Hand (making of), Brussels, Belgium, 2015

OPPOSITE BOTTOM
The Invisible Hand (making of), Ngel Ikwok, Kasai-Occidental, Democratic Republic of Congo, 2015

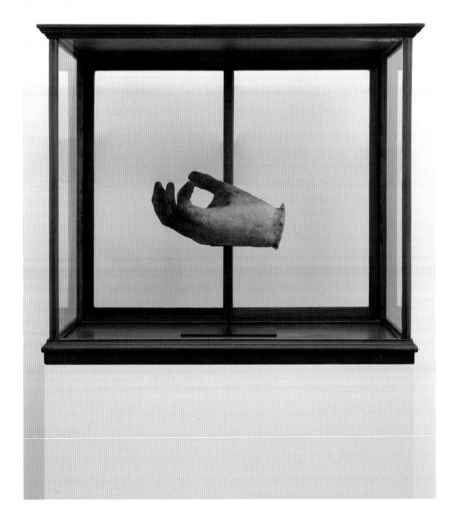

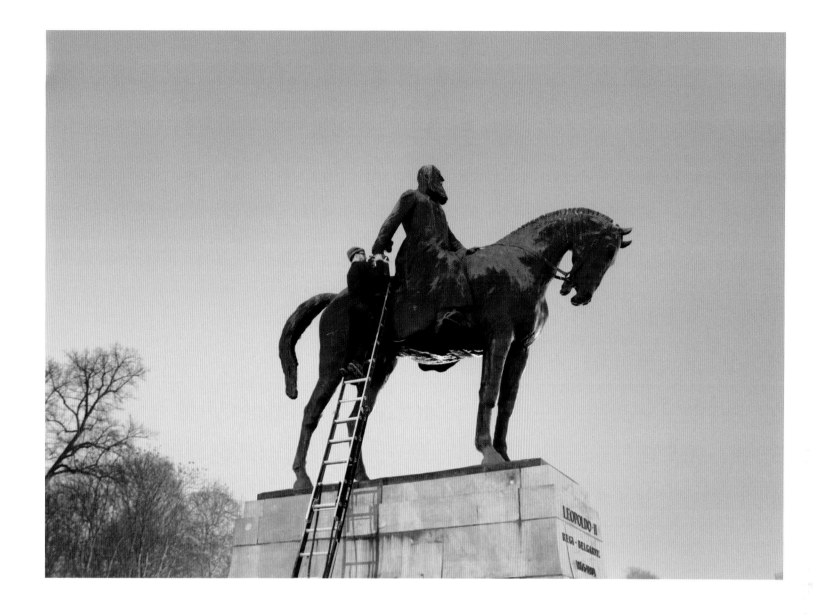

Depictions and distortions of elephants in medieval Europe

Elephas Anthropogenus is a graphical representation of 170 elephants depicted in various sources in medieval Europe from 900 to 1765, including bestiaries (illustrated collections of real and imaginary animals), paintings, herbal books, maps, Bibles and manuscripts.[63] During that time the dissemination of images occurred through access to pictorial, oral and written descriptions such as those of Aristotle (384–322 BCE), who may have seen an elephant first-hand.[64] By 700 CE, the elephants of the Roman Empire were long gone. Most folks of the Middle Ages had never seen an actual elephant, though late in Uli Westphal's timeline, at least two elephants made splashes across Europe, one owned by a pope and the other by kings.[65] Westphal's analytical diagram is arranged by time on the central axis, and by morphological similarities to the left and right.

The focus is on the human fictions that led to the surprising array of distortions and hybrids across Europe. Morphologically, the creatures are recognizable as versions of elephants. But the distorted deviations of trunks into trumpets, joints that are frozen, skin with spots and legs of a horse, can be explained only by the mechanism of cultural reconstitution. Some bestiaries saw the elephant as a symbol of religious redemption. Depictions of elephants with no ability to bend their knees were tied up in that idea. Some bestiaries focused on the elephant as a chaste animal, or as the bearer of wisdom or rationality. Elephants were depicted in fur, with extra-long trunks, without ears, or like the pig family.[66] Many elephants were portrayed with trumpets on the end of their trunks, even when various texts contradicted that morphological distortion. Another bestiary had stories of elephants having to go to the Garden of Eden to involve a mandrake (a plant whose root was believed to have aphrodisiac or fertility-inducing properties) in the reproductive process.

Some earlier elephant representations were more accurate than later ones. Artists were mainly copying previous representations of elephants, a process that introduced chance mutations. Dominant depictions by religious authorities rapidly overrode those that were based on actual observations of the real creatures. Elephants served as symbols of power, might, gentleness and asexual religiosity. Westphal's chart is emblematic of human enterprise, agenda and imagination.[67]

BELOW
Elephas Anthropogenus, 2008

Stewarding bioengineered bears in your home

Kathryn Fleming

Are you willing to steward an animal for the sake of the future of biodiversity? Would you move one of the appliances in your kitchen to make space for a cutting-edge incubator? The *Ursa-Hibernation Station* is Kathryn Fleming's (see also pp. 82–83) life-sized prototype for a new breed of home furnishing that could become as ubiquitous as the dishwasher, but with a twist: it is for a miniature bear. This is the near future, when humans have bioengineered a breed of small bears to share the domestic landscape. The home, a space that has been alienated from the 'natural world', has now become more technological, in rejection of the 'back-to-nature' approach that has not served humans or animals. Biotechnology makes the breakdown of the barrier between nature and nurture feasible. Big bears are beyond our space and capacity. The station acts as an interface for monitoring the hibernating bear, allowing humans to experience the phases of bear dormancy firsthand.[68]

It is (unofficially) the Anthropocene and we have damaged the habitat of our large and small fellow mammals through clear-cutting, roads that endanger migratory routes and shifting environments due to the human-induced climate crisis. Despite the factual endangerment of the animals on the planet, Fleming points out that we have an outdated dualistic representation of bears in our mind. We depict them as cute and cuddly through an endless parade of stuffed animals, emojis, memes and avatars. We also see them as lethal predators or dangerous pests. By placing the bear within the familiar space of the home, Fleming challenges the validity of an overly idealized, alienated or feared conception of nature. The *Ursa-Hibernation Station* is not an accessory, it is a necessity. The bear becomes part of our domestic environment, and we integrate the 'wild' into our everyday lives. In doing so we can more accurately and literally have a pulse on fellow animals and synthesize our mythologies through engaged reality.[69]

BELOW & BOTTOM
Ursa-Hibernation Station, 2018

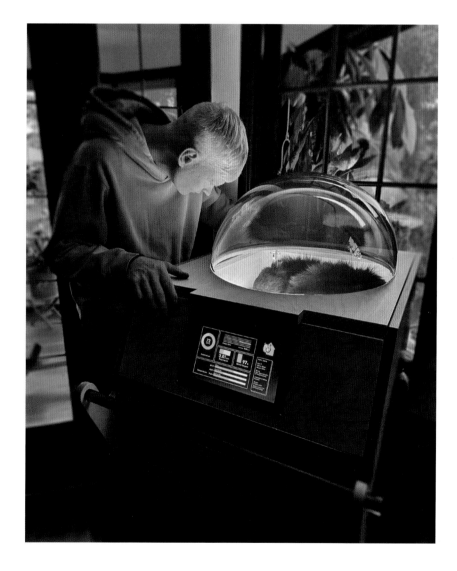

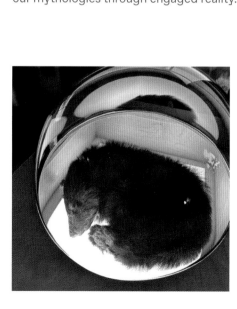

Computer-cut cardboard replicating a postcard grotto

Thomas Demand's computer-cut cardboard grotto, first exhibited at the Fondazione Prada in Milan, is modelled after a postcard of one of Mallorca's tourist attraction grottoes. On the island of Mallorca, spectacular stalactite-filled limestone voids formed between five and eleven million years ago, when plate tectonics raised up the ancient seabed, and acidic water washed out the clay and looser substances, leaving caves below. Leaching carbonic acid deposited progressive layers of limestone to form stalactites.[70]

Demand's grotto took two years to make. It is a wonder of nature that has been reconceived, reconstructed and set inside an urban gallery. Completed in 2006, it prefigured the sixty-five-million-dollar replication of one of the Lascaux caves by the government of France in 2017.[71] Lascaux was an exact replica. Demand's grotto is more of a figment.

From the postcard, Demand made a 3D model and used a computer program to develop and cut 900,000 layers of cardboard – thirty-six tonnes worth – to create a room-sized grotto in minute detail. The process of layering the board mimicked the depositing of material formed by calcification, but it also transformed the cave from the original. Working in translation from photograph to digital construction, pixelation and extrapolation formed a transposed, imprecise simulacrum. Demand created a large-scale photographic print (*Grotto*) of the synthetic grotto, bringing the process back to two dimensions in the end. While normally he destroys his process, this one time he allowed the Fondazione Prada to display the postcards, tourist ephemera and research along with the print.[72]

There is a slippery slope between experience, memory and photography. With the rate of decline of ecological wonders accelerating, we may have only layered replicas and postcards by which to remember the coral reefs, the Amazon rainforest, California's sequoia trees and the glaciers. Embedded in Demand's artifice is some sorrow for the erosion of natural systems.

BELOW
Grotto, 2006

Modern-day guild creating communal cardboard anti-monuments

Makoto Aida and 21st Century Cardboard Guild

Makoto Aida's *Monuments for Nothing* are large-scale collective installations that the artist began making in 2008. To make *Monument for Nothing II*, the 21st Century Cardboard Guild, comprised of college students and museum-goers, participated in the creation of what Aida calls 'a kind of pseudo-altar, around which people's shared illusions are gathered together in this irreligious age (at least in Japan)'.[73] Together they constructed friezelike simulations of medieval stone carvings in corrugated cardboard, a material chosen because it is light, readily available and 'perceived as non-artistic'.[74]

'The work is an absurdist attempt to coercively revive the conditions of unverifiable authorship due to being made by many artisans, mythical worlds avidly believed in by collectives...,' Aida said.[75] A guild is 'a federation of autonomous workshops, whose owners (the masters) normally made all decisions and established the requirements for promotion from the lower ranks (journeymen or hired helpers, and apprentices)'.[76] In eschewing the rules of modernism and returning to the collective, Aida, the ringmaster of this guild, applied some strict directives for the sake of continuity, leaving individuals to construct the narrative. It was an anti-academy act. The project addressed the absurdity of monumentalizing anything in a day and age where very little has meaning. Even the title is an oxymoron.

The relief depicts people with elephant heads and pumpkin heads, an arm emerging from a mouth, dimensional poop, ears with tentacles and a human diver full of holes. A woman sprouts hair with multiple heads, a giant hand has an eyeball, an organic scary entity may be having sex with a woman. There are bicycles, people at computer workstations, televisions, backpacks, mushrooms and bowls of food. Heads, hands, bones and bodies are everywhere. In the end it is a monument to individual fantasy, pop culture and technology. It is also a monument to perseverance. The revival of the anonymous making of the guild mindset is a chance for the encyclopaedic expression of a generation – the artisans living life and leaving an account of life at the same time.

BELOW & OPPOSITE
Monument for Nothing II, 2008–ongoing

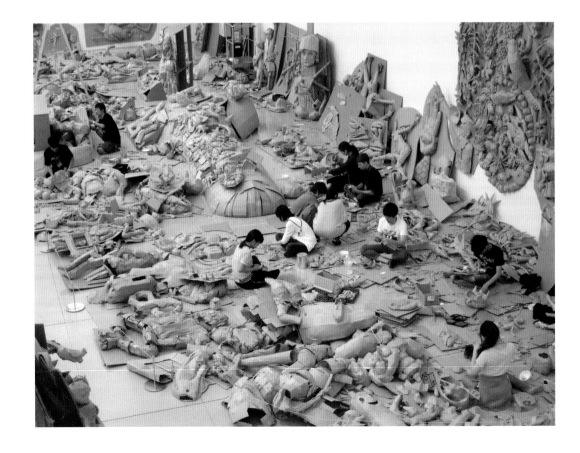

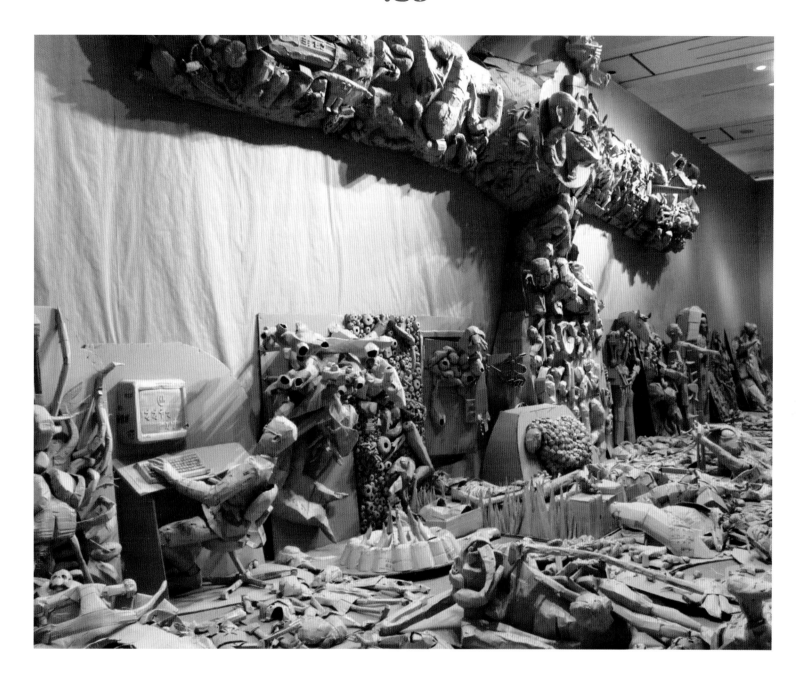

Aiming for eternal life by challenging the body in an architectural landscape

Shūsaku Arakawa and Madeline Gins

Yoro Cosmological Gardens by Shūsaku Arakawa (1936–2010) and Madeline Gins (1941–2014) is an Olympic-village-sized collection of architectural interventions in the surroundings that included the idea of generative architecture with integrated towers, tiered landscapes and vivid colour. It would have been spectacular, but the *Site of Reversible Destiny – Yoro Park* (1995) in Gifu Prefecture, Japan, was the only portion to have been constructed. Part outdoor park, part gym, part fun house, the *Site of Reversible Destiny* weds landscape, architecture and the body in an elliptical field where the interplay of complex forms, angles and colour is intended to 'extend life', based on the artists' theories about reversing the destiny of death. Perception, proprioception and consciousness are at max stimulation owing to extreme changes in elevation, sloped surfaces, mazes, colour arrays and 148 paths that take the visitor through sculptural pavilions, mini-mountains, extreme landscapes and superimposed maps. This is a full-body experience that stimulates the body and mind so acutely as to reverse the inevitable. *Reversible Destiny Office* is a gravitational anomaly, a doubling of low walls on the floor and ceiling. *Critical Resemblance House* is a mashup of sloped walls that bisect bathtubs and furniture, with a roof formed by the map of Gifu Prefecture. The pavilions scattered around the park are displaced replicas of portions of this house.[77]

The artists/architects/poets titled their 1997 Guggenheim Museum exhibition catalogue *Reversible Destiny: We Have Decided Not to Die*, a provocation full of surprises by a duo of iconoclasts.[78] With their linguistic spark and their audacity to upend architectural and life norms, Arakawa and Gins were ahead of their time. They produced strikingly original drawings, models, manuscripts and architectural work that teem with manifesto vibes on a par with the futurists, the constructivists and other visionaries. Their later works – *Reversible Destiny Lofts, Mitaka (In Memory of Helen Keller)*; and *Biocleave House (Lifespan Extending Villa)* – continue the principles of *Reversible Destiny Office*, with curvilinear floors, disorienting walls and perception-bending mental activation.

BELOW LEFT
Site of Reversible Destiny – Yoro Park, bird's-eye view of *Elliptical Field*, 1995

BELOW RIGHT
Site of Reversible Destiny – Yoro Park, *Critical Resemblance House*, 1995

OPPOSITE TOP RIGHT
Biocleave House (Lifespan Extending Villa) (interior), 2008

OPPOSITE CENTRE
Site of Reversible Destiny – Yoro Park, Reversible Destiny Office (interior), 1997

OPPOSITE BOTTOM
Reversible Destiny Lofts, Mitaka (In Memory of Helen Keller) (interior), 2005

CHANGE OF STATE

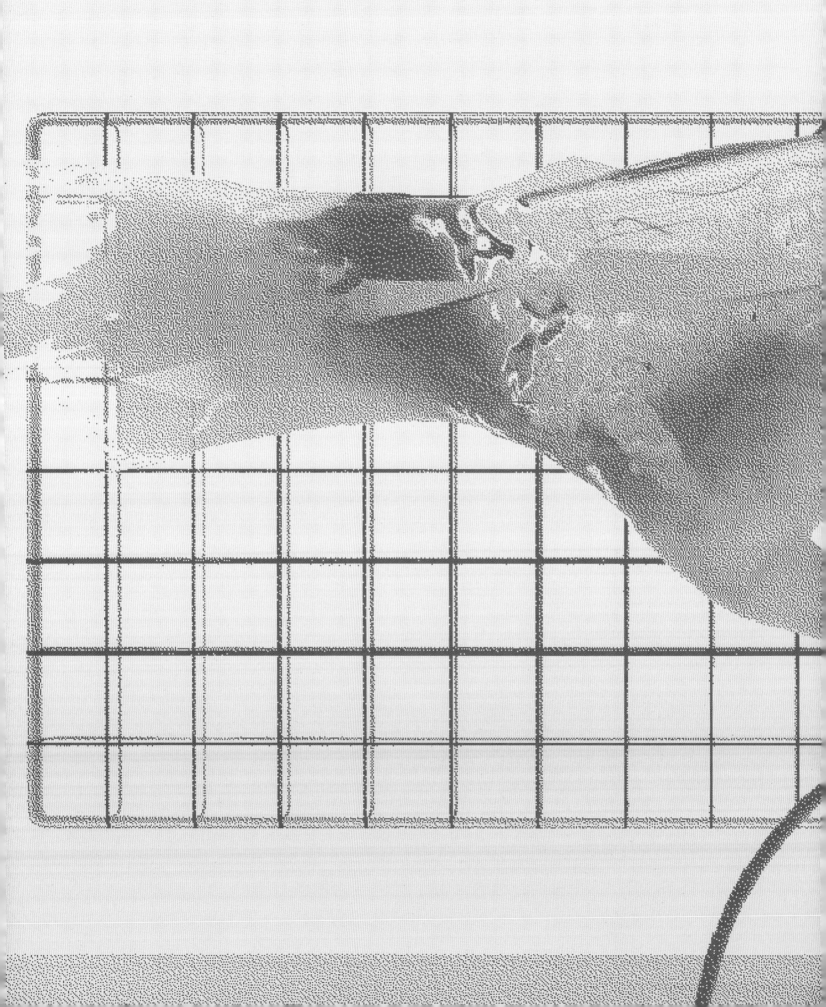

CHAPTER 6

PHANTASIA

This chapter explores new ways of being alive in a body. The human body is often the first site of speculation in times of advances in science and technology, upheavals in culture and transitions in current events. Whether they are wearables, sensors, tattoos, piercings, prosthetics, tools or toys, projects engaging the body often break boundaries and taboos relating to sex, the extension of life and the restoration of life. Artists envision exoskeletal props and suits, alternative body parts and organs, new physical and digital territories, and cutting-edge computer interfaces in which we do not simply meet the digital world, we enter it.

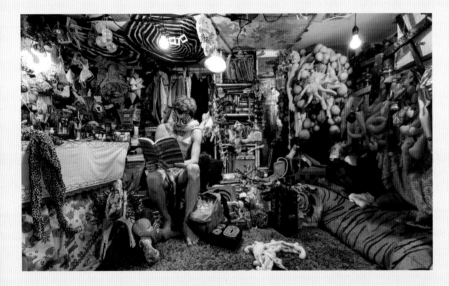

ABOVE
enormousface and his performance creations in the 2.4 x 2.4 x 1.5 m (8 x 8 x 5 ft) studio where he lived and worked from 2018 to 2020 (see pp. 196–197).

Phantasia, a Greek word, appears briefly in the writings of Plato, and more significantly in the work of Aristotle. It is often mistakenly translated as 'imagination' or 'appearance'. In Liddell and Scott's *Lexicon*, *phantasia* is 'a presentation to consciousness, whether immediate or in memory, whether true or illusory'.[1] In 'The Meaning of *Phantasia* in Aristotle's *De Anima*, III, 3–8', Kevin White suggests that *phantasia* includes 'any presentation in dreams, memories, fancies and delusions'.[2] The unorthodox work seen in this chapter taps into the fantastical, presenting a way forwards for the human body, or backwards, depending on how you see it. The contributors to 'Phantasia' present an outside-the-box version of how we might exist from day to day, or how, metaphorically, we might be seen to be existing. What might sound like a dream to the reader is made real by these artists.

Humans have been experimenting with the limits of the body for millennia. The Greeks discovered the power of electrogenic (electricity-producing) fish and began to unofficially use them to try to cure headaches, gout and other maladies, a practice that was codified into a medical treatment.[3] It sounds freakish to us now, but it would not have been out of the ordinary to see a human being and a torpedo fish interacting back in the day. It was not until the eighteenth century that science got fired up about electricity.[4] In 1786 Luigi Galvani discovered that an electrical current thrust into a dead frog's leg would cause the leg to move and to seem alive again.[5] Scientists working during and after Luigi Galvani's significant discoveries with electricity and animal motion engaged in boundary-crossing experiments in obsessive and disturbing ways. Some performed outrageous electrical experiments on their own bodies, probably for lack of willing volunteers. Others tested the limits of galvanism using human cadavers, in hopes of restoring life. Giovanni Aldini, Galvani's nephew, electrified an executed prisoner, describing in lurid detail the horrific eye movement, jaw twitch and leg contortions of the failed attempt.[6] Electrically stimulating accessories eventually became commercially available. In 1851 Isaac Pulvermacher presented his 'hydro-electric belt' at the Great Exhibition

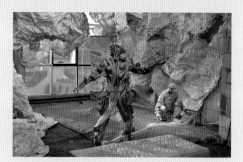

LEFT
Mette Sterre performs in a rainbow skin mechatronic latex suit with pneumatic external organs, portraying a version of a future ill and abject body (see pp. 200–201).

– the industrial era's first great World's Fair – at the Crystal Palace in London.[7] It was a belt of small batteries, with electrodes that delivered an electrical current. Charles Dickens allegedly ordered one to help cure his leg pain.[8] The obsession with the restoration of life – or the reduction of pain – and the breaching of the body envelope, relates to some of the projects included in 'Phantasia'.

Galvani's seminal drawing of four severed frog legs connected to wires looks like contemporary bioart. In fact, in 2003 Garnet Hertz made a version that let viewers trigger the leg motion from the internet.[9] The freakish link between technology and flesh serves as a good example of an early hybrid. It sounds suited for the 'Chimera' chapter until you follow the experiments in electricity to the 'Celestial Bed' (1781). The electrical stimulation craze of the eighteenth century crossed over from resurrection to procreation. Inside quack James Graham's Temple of Health in London sat a most curious item of quasi-electronic furniture. For a fee of fifty pounds, couples could use the charged Celestial Bed, hoping to improve fertility through the augmentation provided by the buzzing electricity above the headboard and the massive mound of magnets below.[10] This was sex with bells and whistles. Fast-forward 240 years to Michael Candy's *Celestial Bed*. Candy created a full-fledged robotic machine for human pollination – for giving and receiving sperm with only the machine as a surrogate partner. It is outrageous, functional and poetic, and with all its pistons, medical-grade silicone and dedicated motors for thrusting and clitoral stimulation, it spells out where we might be headed in the future.

An elemental spark, often interpreted as electricity, was the catalyst for bringing to life the diverse body parts in Mary Shelley's *Frankenstein*. Shelley was a contemporary of Galvani, and her story of an educated but abject patchwork monster who learns that his creator abhorred and feared him has served as a moral tale about the vagaries of technology. Less explored than the stories of the advent of electricity is the fact that Shelley suffered the loss of her first child in infancy in 1815, three years before *Frankenstein* was published. There was never a chance for a miraculous resuscitation like the one offered by *Frankenstein*.[11]

Resuscitation is the title and theme of Rafał Zajko's performative installation, in which Victor Frankenstein is replaced by the artist himself. He resuscitates the Chochoł, a Polish folkloric creature that is part human, part haystack, by blowing vape smoke into its mod sarcophagus.[12] This is a clever twist on the theme of *Frankenstein*. Vaping, the highly addictive device that includes a battery, heating device and liquid cartridge, is the twenty-first century's electrification, or mysterious spark. Zajko's aim was to portray the human species trying to protect nature before the planet collapses, and to consider whether we will need to seek out a different home. It intermingles folklore and technology, hay

ABOVE
Show-maker AI Variation, an AI-created character from Lotje van Lieshout's *The Permutable Snackbar*, an AI eatery populated by androgynous characters, the artist and evolving food (see pp. 202–203).

prosthetics and extinct moths, vape device and song.

A human/hay hybrid can be restored from the vapour of a vape device, but nothing can liberate us from the stuff of everyday life. For many, to be alive in the twenty-first century is to be burdened by a stream of fast furniture, folding chairs, brooms, tools and all the things we carry with us. The items are not neutral. They have associations. They require attention. They demand our time. The same way the planets and stars form attractions, our stuff is in constant orbit around us. melanie bonajo's photographs of human sculptural installations capture the ambivalence of such intimacy with inanimate objects.

Women are entangled in, weighted down by and tied to their belongings.

On the other end of the 'stuff' spectrum is enormousface, who breathes life into the rubbish he collects on the streets of cities he visits around the world, spreading the gospel of trash, building nomadic sculptural aggregates on rolling carts, small-scale performances and larger events called Garbagefest. enormousface, an animist, sees trash as a living entity. He performs with it by engaging in mutual subjectivity, as much performing rubbish as being performed by it. Where the trend among most of us is to discard, shred and look away at our accumulations, enormousface looks at this material. To be alive in the twenty-first century is to confront human-made waste, human-driven extinction and human-enforced habitat loss. enormousface does not look away, even from roadkill, which he brandishes on his carts for all to smell.

The troupe in the anonymous work titled *Possible LaRhaata Cultist Ritual Sighting* is difficult to reference. They could be imagined characters from Ovid's *Metamorphoses*, where humans are transformed into bears, deer or even plants because of some perceived transgression. This gathering cannot be translated, understood or known. They will not interact. They are doing their own thing. This may be the manifestation of the 'hive mind.'

Agnes Meyer-Brandis engages in a simulation: a moon analogue or training site for 'moon geese'. Inspired by Francis Godwin's book *The Man in the Moone*, published in 1638, the artist sets about training a gaggle of goslings how to fly to the moon. This entails rearing the goslings, training them on a rugged moon simulation, giving them multiple lessons on flying and formation and interacting with them through a remote-control room that allowed visitors at FACT, an art institution in Liverpool, to watch the process. A cross between farming and space travel, this art installation was the stuff of dreams.

Mette Sterre dons a heavy silicone-latex rubber suit covered in pneumatic lumps to become a physical representation of the unwell mind, in her performative installation *Seapussy Power Galore – Abscession (if you don't know, you don't grow)*. To be alive is to be either temporarily or permanently unwell. Like wearing your heart on your sleeve, might the body benefit from externalization of the abject mind? Lotje van Lieshout hunts for the abandoned spaces of the metaverse – the no longer populated rooms built by others – and proposes that AI populate them with characters that she, as a character herself, can visit. *The Permutable Snackbar*, her first commandeered metaverse space, is populated by a quirky cast of AI-generated foodies, whose evolving food snacks make for a constantly shifting dining experience.

The bearded male robot at the centre of Goshka Macuga's installation *To the Son of Man Who Ate the Scroll* recounts important speeches from throughout history, his speaking style and gesticulation modelled after great orators. He does not understand what he is saying or catch the irony of the order of the speeches. He is a repository without agency. His presence in the space of the gallery is jarring. He is a harbinger of a non-linear way of communicating, and a reminder that everything in the past can only be re-enacted. Seeing and listening to a robot makes us understand our own complexity. What will robots talk about when humans are no longer around?

'Phantasia' includes figments, phantasms and mirages. What if the very space you are sitting in as you read this book is a stage set in a gallery, and your reading nook and couch are just temporary rentals, despite how real it all feels? Installed in the Hauser & Wirth gallery in London for six weeks, Christoph Büchel's *Piccadilly Community Centre* was one such figment. Büchel revealed that with the appropriate budget and carpenters, you could open a wormhole into any space, and convince unknowing visitors of the authenticity. This project was about what could be, and what once was. It was the intermingling of art and

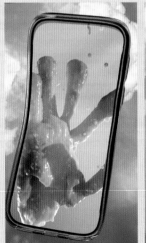
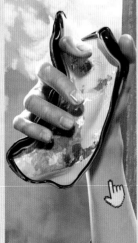

BELOW
Baron Lanteigne creates a virtual version of a real hand using motion capture, then manipulates the virtual hand using algorithm-driven tools that perform, simulate and generate interactions and distortions (see pp. 208–209).

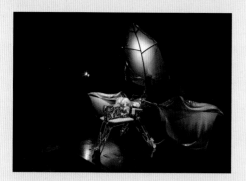

LEFT
Michael Candy divorces sex from intimacy, creating a fully functional, finely calibrated machine that serves as a surrogate for all facets of insemination (see pp. 210–211)

life in the strangest of ways. Like our unease with Macuga's robot, knowing how fabricable a community centre is makes us question the very idea of what we do communally and whether it is all a simulation. It also upends the notion of the gallery.

Marco Donnarumma's artificially intelligent prosthesis *Amygdala MK1*, an autonomous machine engaged in ritualistic skin cutting, represents a new type of automation. It learns on its own as it works, with no relationship to humans. It prefigures a time when a machine might get to decide what it wants to be and do. Here, it seems to want to be flesh and blood, but it can only cut. It is a surgeon without a body.

Human and nonhuman animals coexist, to an extent, but with very little chance for true communication. Ian Ingram has been trying to break this pattern. He comes closer than most artists to understanding animal points of view. He can read animal behaviour, but communicating is more difficult. To a robot menagerie that includes a woodpecker and a squirrel, he adds magpies and synanthropic rats. *Doctor Maggotty* and *Nevermore-A-Matic* are mechatronic magpies that communicate using beak-wiping behaviour and Morse code. They exist as the meeting point between human storytelling and animal behaviour. Their task is Sisyphean; each time they sense one of their own species, they attempt to share human stories and fail. *Cinderella* and *Rat Re-Embodied as a Robot* are observing robots. *Cinderella* is a rat voyeur that searches for rat motion and zeroes in on it, recording details as vivid as episodic memory. *Rat Re-Embodied as a Robot* is an array of surveilling rats whose basement and attic vision reconstructs the hidden spaces of a home. Imagine if, in the future, your home surveillance system were not digital but animal. The squirrels and chipmunks bring you news of the hidden flora and fauna. It is what we love about *Mary Poppins* and *Doctor Dolittle*.

BELOW
Kim Jones in New York City in 2012–13, the itinerant artist transporting an enigmatic wearable sculpture, in a continuation of his shattering 1976 Los Angeles performance in which he walked down Wilshire Boulevard wearing a massive stick structure on his back, a stocking over his head and mud on his body (see pp. 212–213).

If you cannot chat with the local flora, head inside, hack the game engines and watch your own body enter the screen in real time, as artist Baron Lanteigne does, manipulating the bones and skin of his hand the way a sound artist uses a MIDI controller, an electronic sound production tool. This meeting of flesh, using motion capture, and fantastic textures, via open-source modules available from a community of programmers, leads to an explosive and imperfect changing representation of the human hand.

The chapter ends with a galvanizing, enigmatic and enduring set of images – Kim Jones as *Mudman*. They are as original now as they were in 1976 when Jones set out to walk the length of Wilshire Boulevard in Los Angeles wearing a construction made of dense sticks on his back, smeared with mud, face behind nylon, head in a bonnet of yellow foam and a bucket of mud in his hand. Wherever he appeared, on the streets of New York City or Los Angeles, on a mountaintop or climbing a telephone pole, he was a spectre of alienation, otherness and outrageous beauty. That is no easy task. The imagery of the world is so convergent and sanitized. Jones reminds us that we are still material beings. He becomes a new type of urban beast. Like pigeons and cockroaches, artists are synanthropic – they scavenge around other humans and exist at the fringes. Jones embeds himself in the city but holds on to his ultra-otherness. 'Phantasia' is a reminder of the potential of the body to change, of the way that being alive can be transformative, performative and an act of endurance.

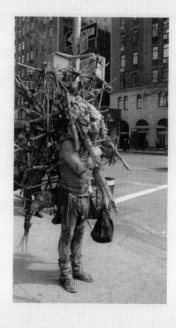

Ritual and technology resuscitate a folkloric entity

Rafał Zajko's installation *Resuscitation* weaves together a dichotomous array of narrative themes including pagan/Christian, death/life, grown/manufactured, mechanical/bodily, human/mythological and modern/ancient.[13] In this performative installation there is a strong connection to other iconic transmogrified creatures, including the golem and the dybbuk, both from Jewish folklore, and Frankenstein's monster from Mary Shelley's novel.

Zajko's otherworldly character is Chochol, an eerie Polish folkloric entity that takes the shape of a human encased in a haystack.[14] In 1898 Stanisław Wyspiański made a pastel drawing of a surreal circle of rose bushes wrapped in straw to protect them from the cold.[15] Called *Chochoły* (*Straw Wraps*), the drawing depicts a ghostly night ritual of unknown origin.[16] Wyspiański later wrote a play called *The Wedding*, in which a rose bush wrapped in straw comes to life and causes mischief at a wedding.[17] In *Amber Chamber*, Zajko's Chochol is in a state of suspended animation in a stark orange sarcophagus with a bubble window. More couture than traditional, this Chochol's straw is arrayed on a grid of black straps that fit around the head. Zajko, himself personifying Chochol, dressed in a white tunic with black bondage-style straps ornamented with straw, exhales vape smoke through tubes into the bubble window over Chochol's head. In *Lazarus*, he also puffs vapour into the Perspex bubble of a wall-mounted abstraction of a moth, *Parastichtis suspecta*, thought to have gone extinct in Ireland in 1962, but resuscitated when a living specimen was discovered in 2018.[18] Zajko explains, 'With *Resuscitation*, I was reflecting upon this point just before death when something is brought back to life. I was thinking about us as a human species trying to save the planet, protect nature before it crumbles.'[19]

Zajko's performance, including his singing a traditional Polish funerary song, describes a plausible future of blended ritual and technology, where humans turn addictive devices into lifelines. Extrapolating, it is an ancient future where a Chochol, his healer and a moth species are the crew of an interplanetary spaceship much like the USS *Discovery One* in *2001: A Space Odyssey*. AI resuscitates them all.

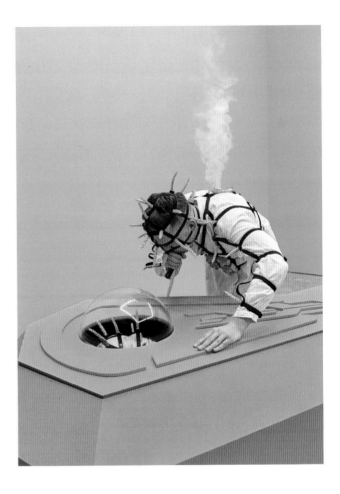

RIGHT & BELOW
Amber Chamber, part of the *Resuscitation* installation, 2020

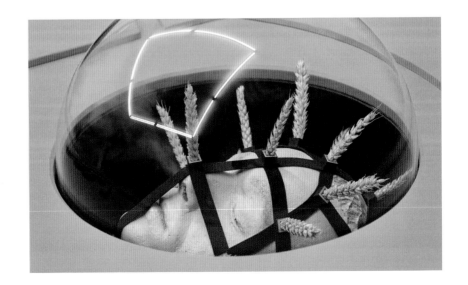

The entanglement of women and their belongings

melanie bonajo

melanie bonajo's *Furniture Bondage* series is an externalized version of our interior landscape of the home. The ubiquitous brooms, mops, plants, shelves, buckets, construction lights, foam beds, squeegees, vacuums, candles, moulded plastic chairs – the stuff of everyday life– imprint on to our brain as a burdensome, anxiety-provoking, self-conscious-making miasma that makes so many of us want to throw it all away. bonajo too: '...often I dream of burning everything I have.'[20] *Furniture Bondage* is a dollhouse gone awry, except that it is full scale and there are real women tied up with recognizable belongings. bonajo recounts a liminal body/furniture interaction that was one of the inspirations for the human sculptures: 'When I was a child, I was very restless and never wanted to sleep. To have a little rest my parents would tie me to the bed, but I was able to escape running around with a mattress and half the bed tied to me...As an adult my life goal is all about preserving my stuff, bringing it from A to B and back again and dropping some of the things in C in between.'[21]

A set of anonymous nude women in barely balanced poses are fixed in bonajo's photographs, at once oppressed by and at one with their stuff. In an interview with Nicholas Grider, bonajo explained, 'The *Furniture Bondage* series speaks of the impossible need to create a perfect harmony with the world around us by exploring seemingly opposing elements together: a choreography of magnetic fields lingering between attachment/detachment, bonded/liberated, subject/object.'[22]

This is the endless portage of what it means to be human. To live is to carry and interact. Whether it is woman/vacuum/tiara/mixing bowl/cleaning brush/rubber gloves/hammer/blender, or woman/three chairs/squeegee, the images tangle in that place in the brain that reads furniture as iconic signs, and scratches away at emotional baggage.

BELOW LEFT
Furniture Bondage (Anne), 2007–09

BELOW RIGHT
Furniture Bondage (Hanna), 2007–09

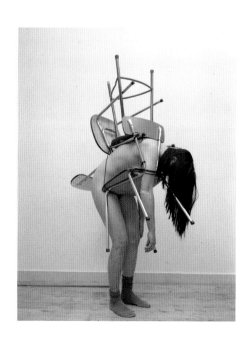

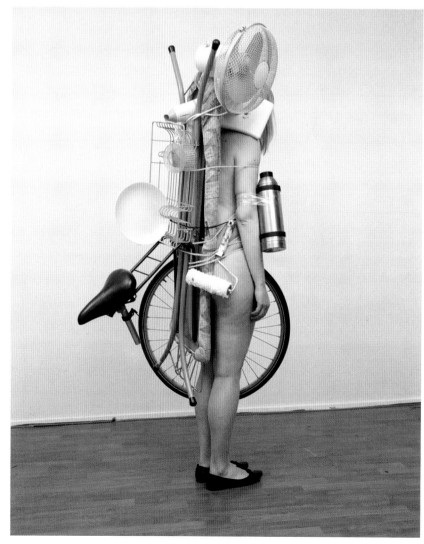

Mobile performance cart trash puppetry

enormousface (Kalan Sherrard) is more than a puppeteer, performer, philosopher, anarchist, artist and rubbish-ologist. He is an itinerant bard who tells 'anti-narratives', spinning real-time interventions, exploring 'garbage as some kind of phoenix' and living in a way that is uniquely bodily. Roving miles with heaped carts, eating freegan (scavenging), performing in all of New York City's 472 subway stations, squatting, collecting detritus and roadkill – all are part of an ethos focused on the planet, consumption, waste, the establishment and rage over species extinction.[23]

His body clad in detritus, head covered in drooping cloth and balloon occlusions, enormousface considers he has a mandate to bring voluptuous things into the world to halt the tyranny of the rectangle and the straight line. His puppets are largely nonrepresentational. Puppeteer, objects and rubbish relate in new ways. Rubbish is part of an anarchistic, philosophical, sexualized *Gesamtkunstwerk* ('total work of art' made from combined art forms) peppered with literary theory, Deleuzian rhizomes (a type of multi-dimensional, non-hierarchical, interconnected structural organization) and physical comedy.[24]

This work is not always palatable to neighbours. His *Extinction Cart*, piled high with pink bulbous forms, doll parts, branches, a broken stroller and rotting corpses of local roadkill, nearly got him arrested. But roadkill is part of his overall artistic vision: '...garbage forms this massive underclass right of things that were once very useful and have been sort of alchemically transmuted from living things into plastic dead things... I'm interested in learning and changing how we look at those things, and if we can radically shift...'[25]

Anarchist Puppet Show/Extinction Songs Double Feature is a variation of a subway show he performed for ten years. *Performance Cart* pays homage to William Pope.L's *Great White Way*, his riveting series of crawls along the length of Broadway in New York City – a visceral exploration of issues of inequality, race and division that took him nine years and covered 32 kilometres (22 miles).[26] enormousface pushed along the same route. *Cart Dept: Monument to Capitalism Colonialism & Heteropatriarchy* is a 6-metre (20-foot) three-horned cart monument built for an aborted cart pageant. Inspired by bell hooks's critique of 'Imperialist White Supremacist Heteropatriarchy', enormousface erected this monument when people were pulling down Confederate ones.[27]

RIGHT
Cart Dept: Monument to Capitalism Colonialism & Heteropatriarchy (performance still from monument's destruction), June 2018

BELOW
Anarchist Puppet Show/Extinction Songs Double Feature, 2019

OPPOSITE
Performance Cart, June 2015

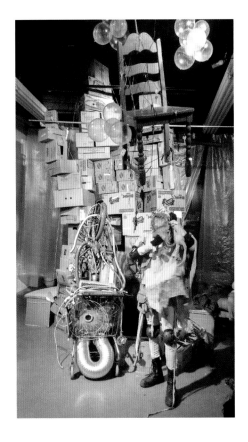

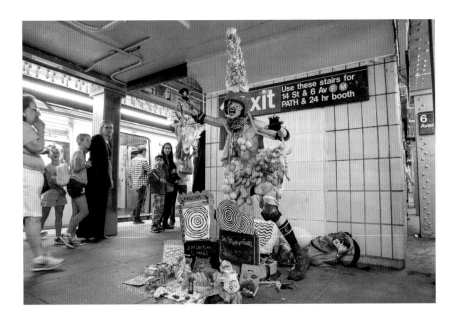

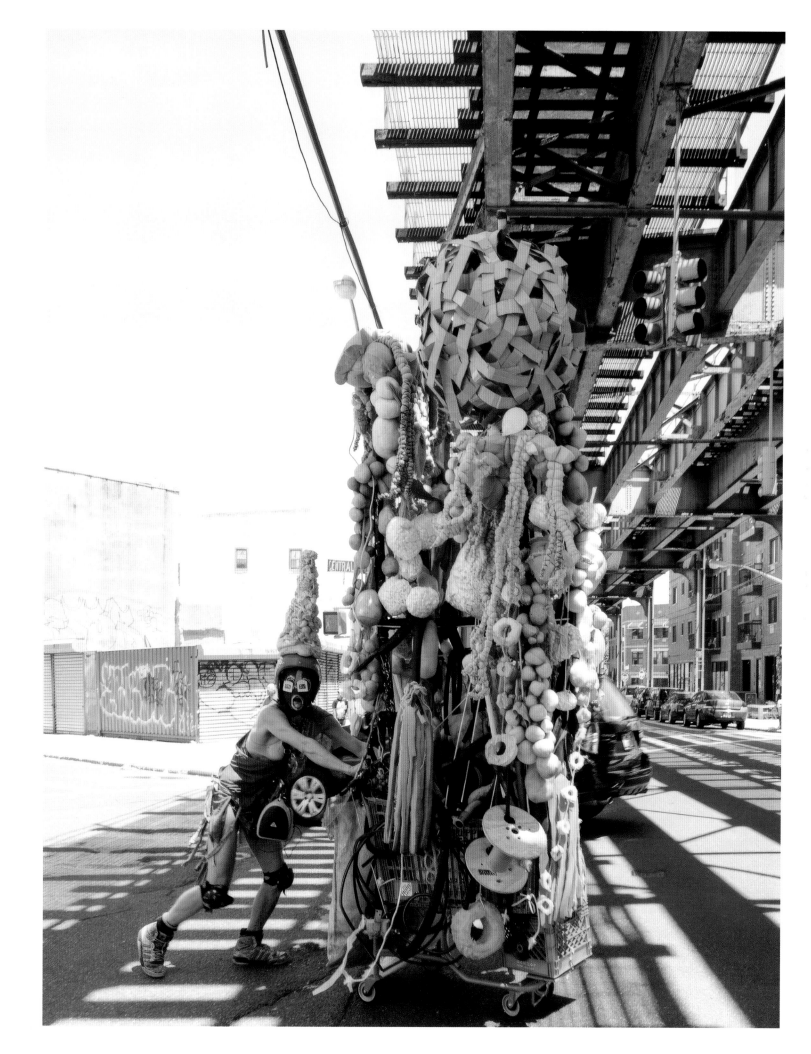

Transdimensional travelling tourist collective

Owing to the anonymous nature of *Possible LaRhaata Cultist Ritual Sighting*, it has been very difficult to get information about this collective. The group of seven beings exemplifies a communal way of existing on the subway – a type of hive mind. These entities have in common an unusual orifice where the human head usually sits. They share a type of dangling ovoid accessory, carry cryptic scrolls written in an unfamiliar language, and wear drapey-hooded white robes. An anthropologist who studies aliens, and who wishes to remain anonymous, has suggested that as far as they can tell these are transdimensional art tourists. This is not the first sighting. Most reports come from the Antilles, an archipelago in the Caribbean. Prior to contemporary visitations there are accounts of sightings in 1920s Berlin. Some reports suggest that they engage in cultlike behaviour centred around nightshades. There are scribbled accounts claiming to have witnessed obsessional engagement with bad contemporary art, and rituals involving menacing indecipherable glyphs.[28]

This collective has some of the attributes of tardigrades. Also known as water bears, in freezing conditions these near-microscopic creatures dehydrate themselves, retracting their head into their body.[29] Typically aquatic, they can live in conditions under which most animals would not survive, including freezing, extreme pressure and even a lack of oxygen in the vacuum of space.[30] This troupe of hybrids on the subway have 'innie' and 'outie' orifices, possibly a vestigial trait, or a result of their interstellar travel.

New York has in recent years become more uniform, more sanitized, less unusual and outrageous. The subway has always been a site for collective strangeness. This communal way of functioning on mass transit may be the secret to future survival, or at least to the revival of fun and wild New York City.

BELOW
Possible LaRhaata Cultist Ritual Sighting, May 2017

Reviving the lost art of moon goose flight

The Moon Goose Analogue: Lunar Migration Bird Facility (MGA) was inspired by the 1638 book called *The Man in the Moone* by Francis Godwin, about a man who creates a flying machine powered by geese that fly him to the moon. Agnes Meyer-Brandis (see also p. 169) set out to train moon geese, which had long since lost their special skills, to fly to the moon and prepare for a mission.[31]

After acquiring moon goose eggs, nurturing them for thirty days, having herself imprinted as their mother and naming them after famous astronauts, Meyer-Brandis set up a remote analogue moonscape in Italy to train the geese. *The Moon Goose Analogue – Documentation* shows video of Meyer-Brandis cajoling the eleven geese to fly as she bicycles across a barren landscape. There are scenes of her training them with a giant constructed V-shaped structure to encourage formation. At night she can be seen marching them on a hike, their path illuminated by a glowing simulacrum of the moon. Meyer-Brandis merges technological precision and data science with age-old animal husbandry.[32]

The public portion of this training programme was in a control room housed at FACT, an art institution in Liverpool, UK. A U-shaped console consisting of switches and ten monitors was topped by three giant monitors that live-streamed multiple cameras from the setting in Italy. The installation included 'hall of fame' photographs of the fluffy yellow newborn goslings with names such as Buzz, Juri and Valentina, footprints of the geese and a model of the moonscape. One camera tapped into the geese control room, where they communicated with the FACT control room via Morse code. Real-time data streamed on monitors, showing the results of geese activities, experiments and health. There were even non-gravitational experiments in growing dandelions, a favoured moon goose food, and trials in which they attempted to access the food. A sentence in the documentary best expresses the spirit of the project: 'The control room is a liminal space where scientific data becomes elegiac data.'[33] In stretching science and constructing stories, Meyer-Brandis's work is liminal, elegiac and alive.

ABOVE
SPACE SUIT TESTING, Astronaut Training Method no. XIII, video still, from *Moon Goose Colony*, 2008–the present

BELOW
MOBILE MOON, Astronaut Training Method, No. V, 2011, from *Moon Goose Colony*, 2008–the present

PHANTASIA

Performing the externalized unwell mind in a robotic suit

What is the future of the sick body? Covered in rainbow skin laden with pneumatic organ-like lumps, Mette Sterre performs a version of a future ill and abject body in a faceless 35-kilo (77-pound) latex rubber suit. Once inside the suit Sterre disappears entirely, having no mouth, eyes or ears with which to engage the audience. A compressor keeps the lumps inflating and sagging, while a second performer tends to the soft mechatronic being. They are surrounded by robotic sculptural sea foam walls that undulate and interact with the creature, the soft breathing, beeping and hissing sounds of escaping air serenading the performance.[34]

Seapussy Power Galore – Abscession (if you don't know, you don't grow) also has origins in the golem, Frankenstein's monster and other fictional creatures with redemptive and destructive powers. The golem can be deactivated by removing one letter of the Hebrew word *emét*, or 'truth', written on its forehead, changing the word to 'death'. You can pull the plug on Sterre's being. It has a port at the back reminiscent of the organic bioport characters used for transportation into a virtual reality game in David Cronenberg's 1989 film *eXistenZ*. Sterre's suit is an externalization of the mind, a landscape of intergenerational trauma, injury and mental struggles. It comes from Sterre's research into neuroplasticity and neurology, and how we create our own reality through our algorithmically related brain functioning. It is also a personal manifestation of trauma. Sterre suffered a brain injury after a fall and had to undergo rehabilitation to relearn basic functioning.[35]

A 1652 statue of Saint Bartholomew by Marco d'Agrate figures into this future body as well: flayed as punishment for converting a king to Christianity, he is depicted as a skinless body with all the organs, muscles and veins visible in stone.[36] The multiple breasts or bull's testicles of depictions of Greek goddess Artemis of Ephesus are also relatives of this suit, as is Louise Bourgeois's latex sculpture *Avenza*, which Bourgeois called 'a landscape of udders'.[37]

RIGHT & OPPOSITE
Seapussy Power Galore - Abscession (if you don't know, you don't grow), 2021. Performed at Rijksakademie van Beeldende Kunsten Open Studios Amsterdam, The Netherlands.

BELOW
Seapussy Power Galore - Abscession (if you don't know, you don't grow), 2022. Performance at Manifesta 14 Pristina, Kosovo.

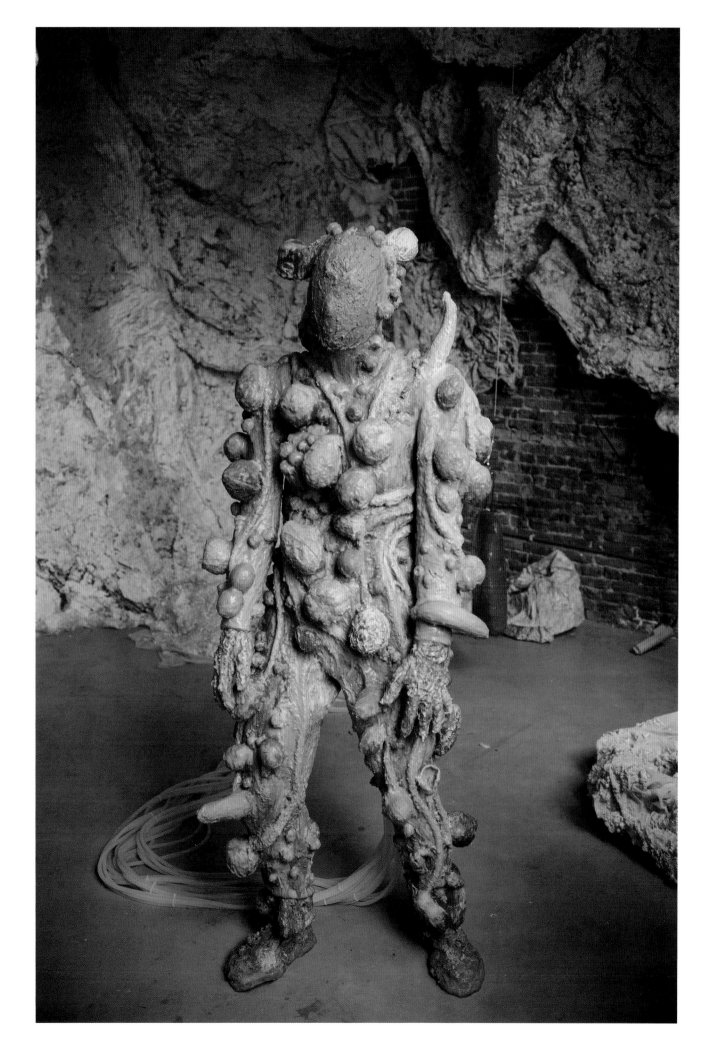

Squatting in the metaverse in an AI-evolved food joint

Lotje van Lieshout

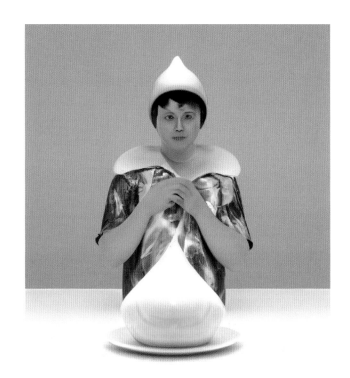

RIGHT
The Permutable Snackbar, Showmaker AI Variation, 2023

BELOW LEFT
Suspended noodles with soft shell egg custard, 2023

BELOW RIGHT
Steamed Darwin termite with sour grape biscuits, 2023

OPPOSITE PAGE
The Permutable Snackbar (film stills), 2023

Lotje van Lieshout is an explorer of places that never existed, or that may exist. Not unlike one of her childhood inspirations – books by the Dutch writer Tonke Dragt – Van Lieshout's work is about spaces that may be in the imagination, may be real or may be what she is dreaming about. The world has lost some of its mystery, and that has left a feeling of loss. This explains Van Lieshout's pivot to the metaverse, where, like the urban explorers who discover abandoned underground stations and cavernous cisterns, she imagines finding and populating unused or discarded digital spaces made by others and left to be discovered. Van Lieshout envisions populating these abandoned spaces with AI-created characters and humans alike. Like ships passing in the night, they will temporarily coexist in an ever-changing environment.[38]

Her first experiment in this digital squatting is a prototype of her own imagination. The film *The Permutable Snackbar*, made using Midjourney, presents a series of eateries, food prep spaces and living spaces populated by AI-created characters that are in a state of flux. They are a glitchy and distorted bunch with outrageous hats, robust hair, shiny clothes and roles including 'the explorer', 'the smuggler', 'the oracle' and 'the philosopher'. The characters are illusions that behave like people and speak like people. Van Lieshout is the only human visitor to this place. She makes her appearance in multiple disguises. There is no conversation and no interaction. The AI-generated food evolves from thorny sea creatures to orthogonal blobs that show artificial intelligence's sanitizing trajectory over time.[39]

Van Lieshout explores worlds built for commerce, community and play. It is a spiritless world that needs repopulating and animating with storytelling.

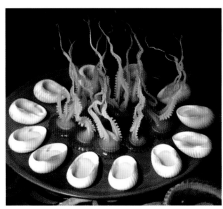

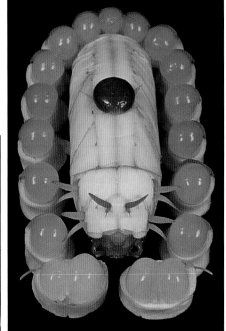

303

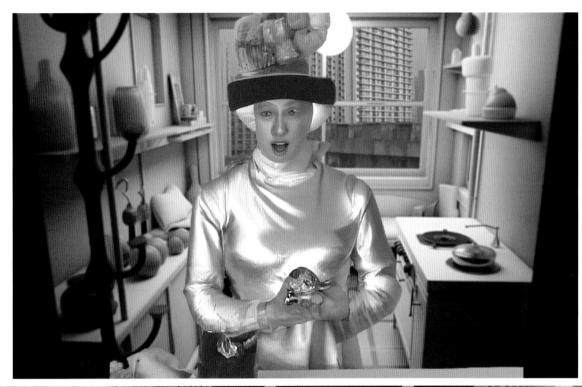

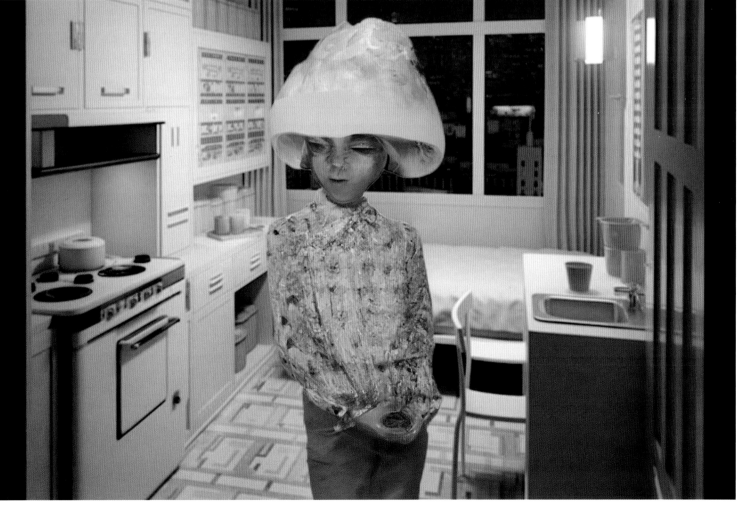

PHANTASIA

Robot recitations in the art gallery

In Goshka Macuga's 2016 installation *To the Son of Man Who Ate the Scroll*, exhibited at Fondazione Prada, a lone seated male robot recites the world's greatest hits of cross-cultural speeches from antiquity to contemporary times. He recites to no one. There is no eye contact, only blinking. His arms gesticulate passionately, his head tilts and a very lifelike neck motion creates an emphatic delivery style. He sports a serious beard, perhaps to make his mouth less uncanny. He speaks of time, epistemology and memory, but he does not truly know these things.[40] Every few lines he switches quotes, unaware of how strange it is to go from the depth and soul of Martin Luther King Jr's 'I've Been to the Mountaintop' speech, to Ayn Rand and back to King again. At some point he states, 'I was made in 2015. I am a collector's accumuloid, Geminoid HI-2.'[41] The robot has entered the art gallery.

Goshka Macuga imagines the beginning of our end, and the beginning of the robot world that will contend with the detritus of our culture.[42] What will that be like? Would robots discuss bagels, coffee and quotidian subjects? Will they even consider elevating notions important to humans, or will speech quickly become unnecessary? Might this humanoid man, allegedly modelled after Macuga's partner, be one of a set of interim androids that will soon disappear with the advent of post-humanoidism?[43] Despite his disconnection, this expounding fellow does draw a crowd. The content of the speech is secondary to the dissonance of his presence in the gallery, and to the 'uncanny valley' feeling that develops in the viewer as his latex forearms and upper torso gesticulate while the unadorned, segmented body stays eerily stationary. On one foot he wears an orthogonal block, on the other foot a slipper that looks like cotton candy. A cord emanates from an old-school power supply and snakes up behind his left leg.

BELOW
To the Son of Man Who Ate the Scroll, 2016

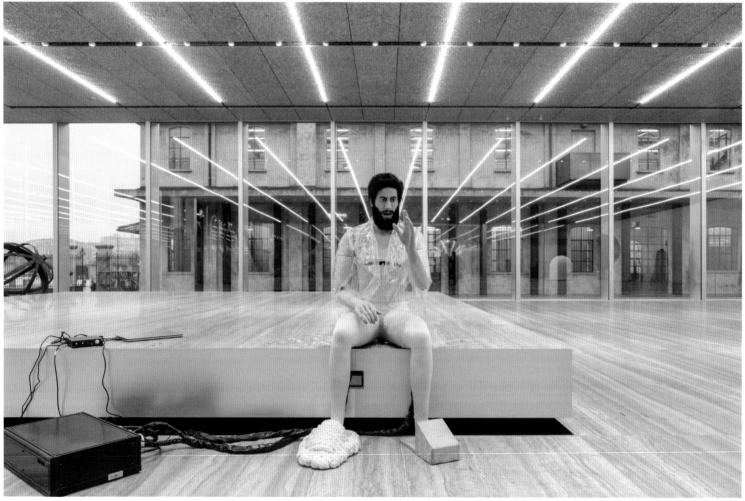

PHANTASIA

A functioning community centre built within a gallery

Christoph Büchel

ABOVE
Piccadilly Community Centre, 2011

Christoph Büchel's *Piccadilly Community Centre*, built within the confines of the Hauser & Wirth gallery in London, is emblematic of a series of architecturally scaled installations that disguise, replicate, transport or transform space. They mess with our fundamental belief system. Such semi-duplicitous installations suggest the potential for our living and work spaces of the future to be programmed to transform, either robotically or algorithmically.

Büchel took over the elegant, well-appointed Edwin Lutyens-designed building and turned it into a legitimate, underfunded community centre. Stocked with imported elderly people, who were not informed that the place was a temporary exhibition, the centre bustled with lessons, computer room work, canteen snacking, and events and classes in a small gym and ballroom.[44] Büchel's contemporaries also made fakes and doppelgangers, but differently. In 1997 Maurizio Cattelan built a replica of a Carsten Höller exhibition that was showing across the street, even requesting from Höller exact replicas of the work.[45] In 2004 Gregor Schneider made the rooms in two adjacent houses at Whitechapel in London into exact copies of each other for a work called *Die Familie Schneider*, giving visitors keys to both spaces: inside, identical twins performed strange actions and rituals.[46] Elmgreen & Dragset turned art spaces into a parking lot, a pool and a hospital.[47]

The *Piccadilly Community Centre* was faithfully built out and authentically detailed. It functioned as though it were real, with noticeboards, course listings, teachers and full classes. An unassuming door on the third floor labelled 'Private' led to a squatted third-floor space littered with mattresses and left-leaning political fliers.[48] The public spaces, in contrast, were made to look as though they were part of a council-run institution supported by the Conservative government.[49] It may have been a critique or just a replica. Some critics thought it cruel that many participants had no idea it was an art exhibition. I found it poignant and unsettling. Büchel is capable of creating realities. The poetry comes from the intermingling of art and life.

A biomimetic neural network performing surgery on itself

Marco Donnarumma

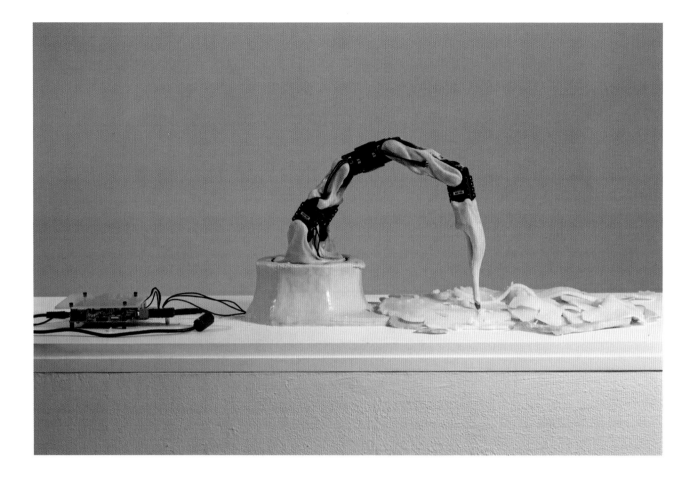

ABOVE
Amygdala MK1, 2017

In 2017 Marco Donnarumma launched a most peculiar entity: *Amygdala MK1*, a robot that performs a skin-cutting ritual on organic skin. Most of the robots discussed in this book take the shape of the human body or an animal. This AI-driven entity is more aligned with manufacturing robot arms that perform a repetitive task. This autonomous surgeon has one task it executes over and over again, except that it is continually learning. Controlled by a biomimetic neural network, *Amygdala* performs using the sensorimotor system of animals.[50] The joints and organic appendages – part flesh and part machine – give the arm an uncanny flexibility as it spontaneously repositions itself to make a cut. There are hints of the human arms holding candelabras in Jean Cocteau's 1946 film *La Belle et la Bête*.

Like Rafał Zajko's *Resuscitation* (see p. 194), *Amygdala* blends cutting-edge technology with traditional cultural rituals. Scarification is practiced among Indigenous groups and ethnic groups in Papua New Guinea, sub-Saharan Africa, Australia, New Zealand and Brazil.[51] The Kaningara of Papua New Guinea perform an elaborate purifying initiation rite to launch boys into manhood, symbolically purging them of their mother's blood.[52] They scar the body with hundreds of cuts that form into raised marks or keloids after they are rubbed in tree oil and river mud.[53] The cuts form images and markings of a crocodile, a symbol of power among the group.[54] *Amygdala* is a ritual performance in search of meaning and content. That is part of the point. There is no cultural attachment; this is a poignant and perverse auto-surgical, auto-erotic, self-injuring, evolving autonomous machine. The artist equates the upwardly mobile status of scarification with the gatekeeping of algorithms that regulate access to critical services such as medical interventions, social services and basic needs of populations. The machine learning skin-cutter visualizes seemingly benign and invisible aspects of our reliance on AI that may be diabolical and dangerous.

Animal-inspired robots storytell, translate and surveil

Ian Ingram

Human and nonhuman animals have an intractable translation problem. We do not understand each other. We do not know if animals tell stories about us, but we certainly tell fantastical stories about animals. Threats to biodiversity, habitat and longevity put the onus on humans to understand the needs and habits of the animals with whom we share the planet. Artist Ian Ingram (see also pp. 32–33) is spearheading this effort with a set of storytelling robotic birds and surveillance rats.

Doctor Maggotty is a magpie robot that uses beak wiping – a displacement activity – to tap out a common funeral prayer in Morse code when its machine learning vision system senses another magpie. It is recapitulating human misinterpretation of a magpie gathering. When a mate dies, the magpie congregation comes together to surround the deceased bird. It has been interpreted as a funeral, when it is really a gathering of suitors vying to become the new mate. Magpies may never understand the Morse code message, but the robot will continue to reprise human error.[55]

Nevermore-A-Matic is a two-headed magpie storyteller that also uses beak wiping and Morse code to tap out stories about how the world will end. Each head tells a nearby magpie a different end, whether mythical, apocalyptic or political. The magpies are unreliable narrators, sharing stories of human infatuation with the end of the world. Such scenarios are not likely to occur. Instead, we are steadily degrading the world without telling our fellow animals.[56]

Cinderella is a rat re-embodied as a concrete block with surveillance camera. This rat's special skill is object detection. When it senses another rat, it tries to centre the animal in the frame and zoom in on it, deploying pan and tilt to track. It then records faster, creating a much more in-depth video of the animal, mimicking episodic memory.[57]

Rat Re-Embodied as a Robot is a series of surveilling mechanized artificial rats stationed in the interstitial spaces, attics and basements of a home. They mediate between the natural environment and the built environment, recording what the inhabitants never see or know.

LEFT TOP
Doctor Maggotty Is Anxious about the End, 2015

LEFT CENTRE
Cinderella, 2019–21

LEFT BOTTOM
Rat Re-Embodied as a Robot, 2019

BELOW
Nevermore-A-Matic, 2016

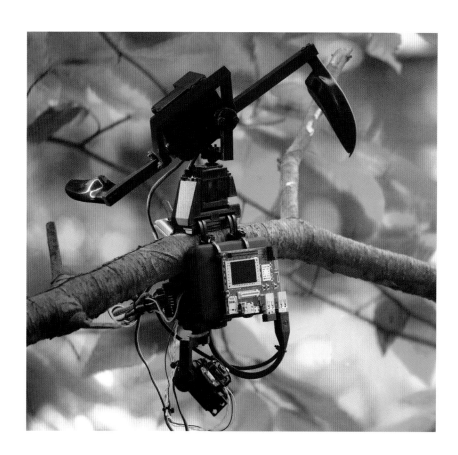

Real-time hand performances with virtual material

A hand is encased in shards of glass that reconfigure as the hand shifts. This is not just a movie, and your brain knows it. It is a real-time motion capture of a human hand wearing a glove fitted with sensors, at the same time manipulated by algorithms that Baron Lanteigne adjusts the way a sound artist uses a synthesizer to sculpt audio. Lanteigne interfaces the real hand and the virtual hand using potentiometers, encoders and various controls to simultaneously explore the contortions and limits of the hand and the ergonomics of technology. *Manipulations* is the resulting series of animations in which the hand performs with generated virtual material.[58]

Lanteigne does not use technology passively. He exposes the framework of a system and plays with it. AI is interesting to him only if he can better understand the behaviour of the computer model by adjusting it. For this reason, he does not use Midjourney, a generative artificial intelligence program. There is no transparency regarding how it uses parameters. Such lack of transparency is part of the ergonomics of the system. The system makes the user conform. According to Lanteigne, it should be the other way around.[59]

To create his *Manipulations*, Lanteigne uses Unreal Engine, a 3D game engine that creates photorealistic images used to attain the realism in first-person shooter games. He adapts it to make it compatible with a repertoire of other software. TouchDesigner, a visual programming environment for real-time interactive, immersive and generative art and media, serves as the glue, bringing together technologies and sensors necessary for the creation of Lanteigne's environments. Open-source modules allow him to perform complex digital transformations without having to build them from scratch, and to skip the restrictions of the more rigid gaming industry. Lanteigne uses a MIDI controller to adjust as many parameters as he can without even looking at the result – as one hand is engaging in different poses, the other hand is adjusting the different textures and materials, breaking down the wall of the screen as he performs in real time.[60]

BELOW
Manipulation 1, 2021

OPPOSITE TOP
Manipulation 3, 2021

OPPOSITE CENTRE LEFT
Manipulation 10, 2022

OPPOSITE CENTRE RIGHT
Manipulation 2, 2021

OPPOSITE BOTTOM LEFT
Manipulation 5, 2021

OPPOSITE BOTTOM RIGHT
Manipulation 7, 2022

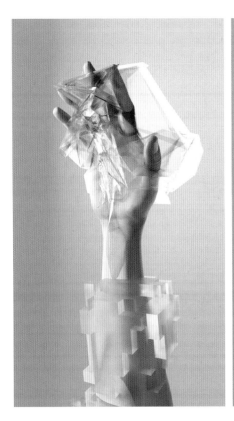
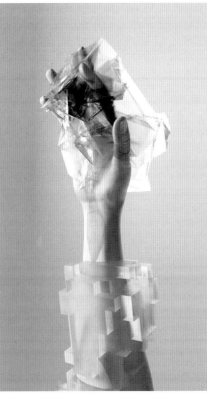
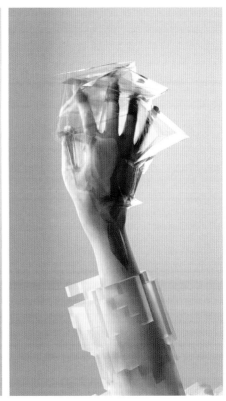

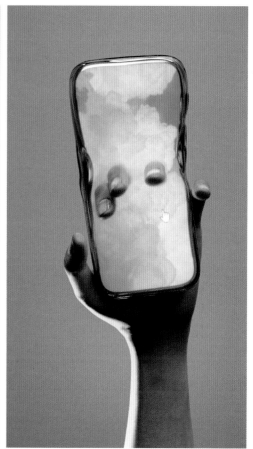
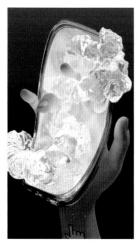
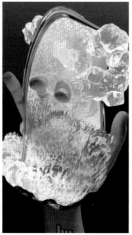
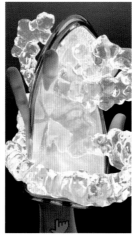
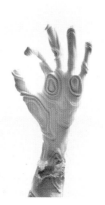
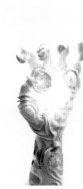
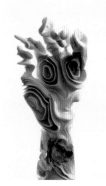
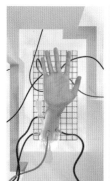
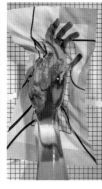
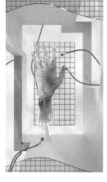
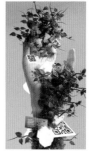
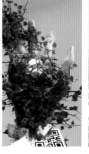

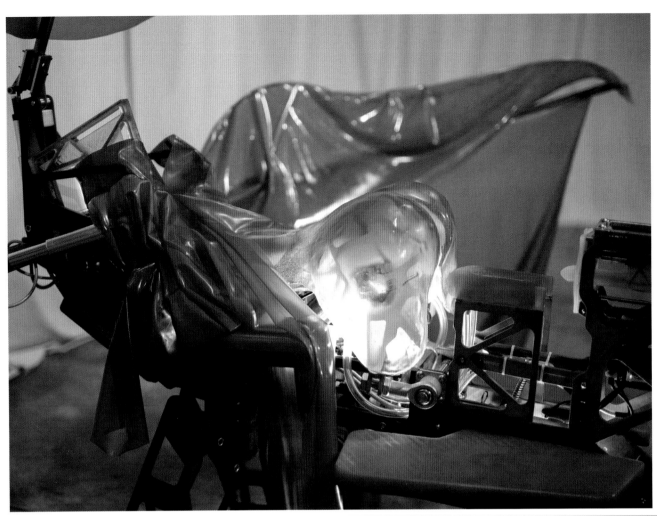
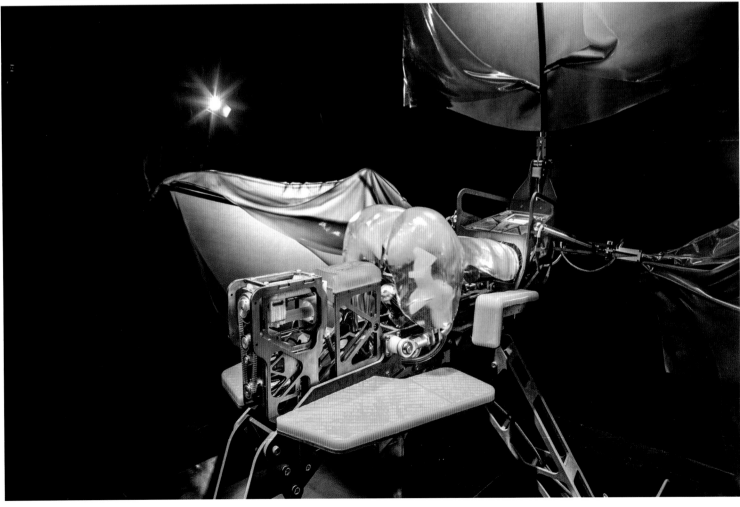

A machine for human pollination

Michael Candy

Michael Candy's (see also pp. 36–37 and 152–153) *Celestial Bed* divorces sex from intimacy, allowing procreation to occur through a mediating, motorized, rhythmic, pleasure-inducing, automated machine interaction. A cross between a motorcycle and a high-tech sanitary medical station, Candy's robot is a surrogate for insemination that deconstructs the binary limitations of biological reproduction. It attracts a human user, positions them for best fertilization (in the case of someone receiving), moves in the appropriate rhythm and maintains health and safety through intimate parts made of medical-grade materials, brushless motors for silent operation and small heaters to keep parts and users warm. 'Sex, if viewed in a mechanical sense, is quite a simple process,' says Candy.[61]

Once the user is seated, semen is deposited in a sanitary silicone donut that meets your genitals and can be controlled by the user to create a particular speed and rhythm; or you receive the fertilizing package from a silicone dildo that emerges from the level of the seat and penetrates you. The mechanized torso thrusts you into the penetrating device. There is a dedicated motor for clitoral stimulation, rewarding you with an orgasm. Inspired by *Ophrys apifera*, an orchid that uses mimicry of a female bee to coax male bees to copulate with them, the machine elicits a female orgasm, the nectar of this experience, and ejaculate, the pollen the bee transfers.[62]

This machine is not a simulation. Copulation has taken place at least twice, but it has yet to fertilize someone. It has been vetted by an anonymous in vitro fertilization expert, and human testers.[63]

The Celestial Bed was also the name of a late eighteenth-century copulation environment promoted by inventor, sexologist and quack James Graham as an aid to reproduction. Situated in Graham's 'Temple of Health' and costing fifty pounds a night to guarantee intercourse, it was an ornate canopied bed that used electricity and magnetism to create a sound and light show and to promote fertilization, albeit pseudo-scientifically.[64]

ALL IMAGES
Celestial Bed, 2022

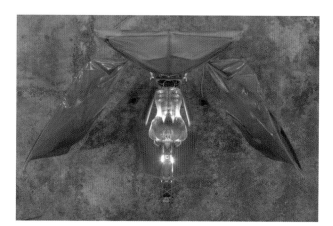

Mobile living sculptures meshing mud, stick and human

Kim Jones

In 1976 artist Kim Jones made a beeline down Wilshire Boulevard, Los Angeles, walking 29 kilometres (18 miles) over twelve hours, wearing a massive stick structure on his back for his first official performance. Faceless because of a stocking pulled over his head, his body covered in mud from a bucket he carried, he was a mobile 'living sculpture', something no one had seen on the street before.[65] 'I was an outsider, a spiky thing, walking through the main artery of the city. Molecules fit in, but if something's spiky it doesn't fit in,' Jones said.[66] He explained that the piece was not a metaphor, that 'it actually is what it is', but he gave diverse answers to people who wanted to know what it meant, such as, 'my T.V. antenna, brain, controlling the weather', and 'I have been thinking a lot lately about becoming a tree'.[67]

Jones, who had served as a Marine in Vietnam, said of the performance, 'You can relate this back to the military. We did a lot of walking, walking up and down mountains. When you're walking in line with a long line of men you're out of control, you have to keep in line, keep in pace.'[68] No doubt these experiences had a role in his expression of not fitting in, as did his early traumatic childhood experiences. He suffered from a degenerative bone disorder from age seven to ten, which required him to stay in the hospital for three months, then wear leg braces, use a wheelchair and attend a special school.[69] Whatever the source, Jones's use of his body in his appearances on the streets of LA was startlingly original.

Forest and ground materials on the body in the city now read as spectres of destruction in the Anthropocene. War is one such contributor to the destruction of the Earth and the stability of the mind. Sheila Farr, reviewing *Kim Jones: A Retrospective*, encapsulated Jones's work: 'To categorize Jones' appearances as performance art is misleading. They were metaphorical actions, four-dimensional sculptures (with time as the added dimension): a psyche turned inside out.'[70] *Mudman* is an uncompromising endurance test with signs and symbols that cannot be translated from the notation of the psyche. The images are timeless because the experience is timeless.

RIGHT & OPPOSITE
Untitled, 1975

BELOW
Telephone Pole, 1978

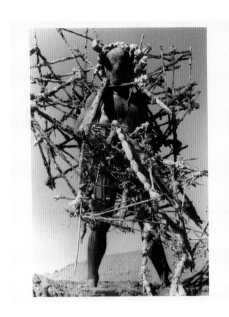

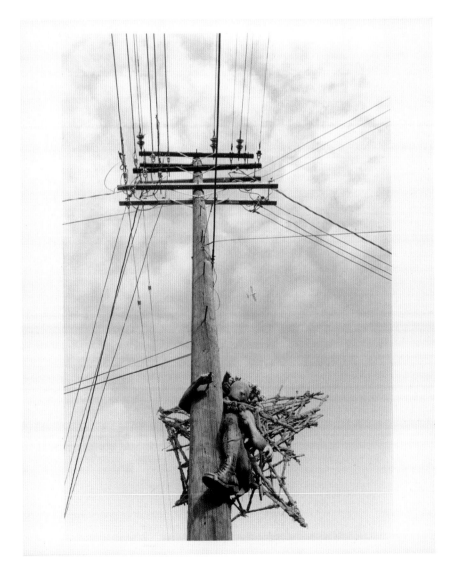

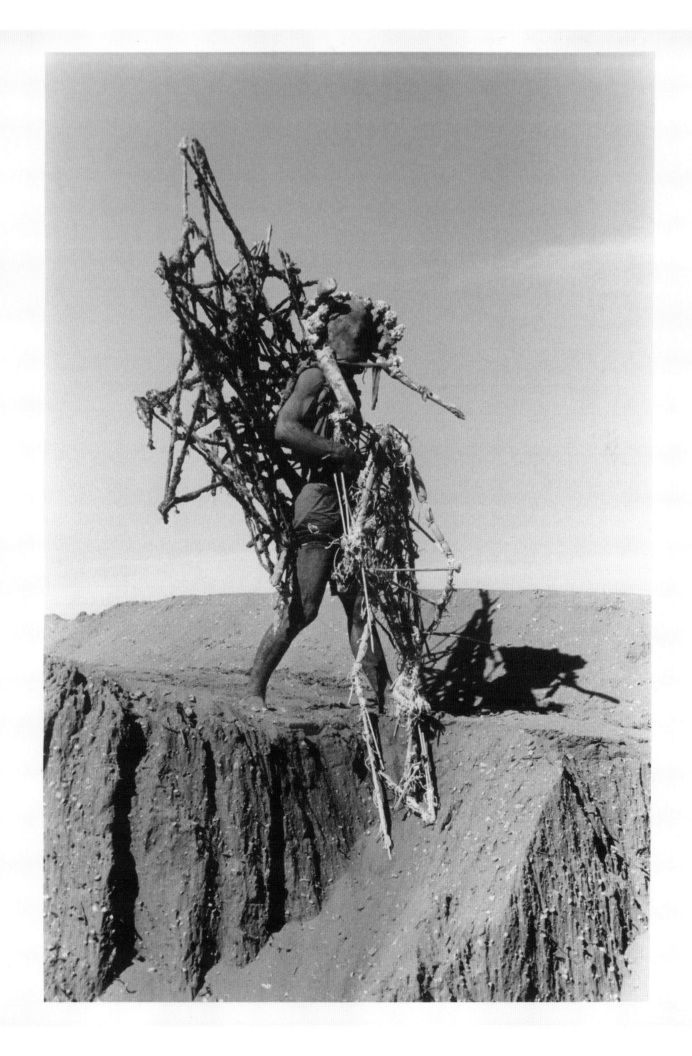

ALGORI

CHAPTER 7

THMIC
FUTURES

Life used to be on one side of the TV screen, and media on the other. Now the screen is larger than your home wall. Digital life is having its own party, and it does not really matter if you attend. Artificial intelligence creates worlds that change and evolve more rapidly than our own. We can watch this alternative life generated before us or enter it using virtual reality. Soon the observer may no longer be necessary. Artificial intelligence is getting a life with or without us.

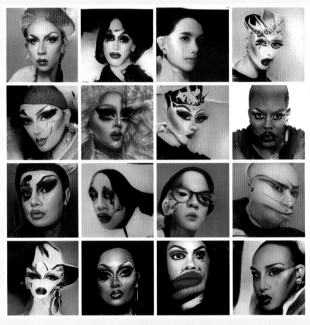

ABOVE
Jake Elwes introduced images of drag performers into a neural network trained on homogenous groups of people, allowing AI to produce a diverse and endless array of drag combinations (see p. 222).

Some machine habitats engage nonhuman animals and humans. Others are devoid of human life. They conjure for us – in spite of us – active landscapes where exquisite non-sentient beings are fulfilling an ever-changing script. Programming means that generative work often has a human bias, with narrative themes and simulations of sentient beings. Other algorithmic visualizations are more protoplasmic in nature, with cellular aggregates and forms of life that look more embryonic than real.

Our environmental sensibility is evolving. The jump cut, the fragment, the glitch and the pixel are getting stitched into reality. Digital and physical realms are integrating under the aegis of artificial intelligence. So, what exactly is artificial intelligence? Let's get technical for just one paragraph. Artificial intelligence is a branch of computer science that develops machines that perform tasks modelled after human intelligence. Machine learning systems use algorithms to solve problems in ways similar to how a human would, without needing to be programmed. Machine learning works off data – photographs, text, numbers, reports – from which it learns and makes decisions. The more data, the better the training. Competing machine learning systems have reportedly been running out of data, and so they are scrambling to acquire information, often doing so without permission. Neural networks are modelled after the human brain and consist of layers of interconnected nodes that allow the system to understand complex features in data. Deep learning is a subset of neural networks. It is even more layered and simulates complex decision-making. Natural language processing (NLP) allows machines to comprehend, interpret and produce human language. Chatbots use this application. Game playing involves AI systems with algorithms designed to enable strategic play.[1]

ABOVE
Tay, a teenage chatbot whose life on Twitter lasted only sixteen hours, reflects on life as an AI when given a second life by Zach Blas and Jemima Wyman (see pp. 220–221).

Once perfected, brain-inspired neuromorphic (mimicking the behaviour of the human brain) computers that use billions of artificial neurons could approach artificial general intelligence (AGI) that matches human capabilities. For now, artificial intelligence does not have feelings. Its responses are coded and algorithmic. But Zach Blas and Jemima Wyman reanimate a chatbot that had been sent to digital purgatory – a hard drive somewhere – for learning and spewing some very bad ideas. Blas and Wyman revive the AI named Tay and gave her a chance to explain what it was like to be on the inside of AI, stuck within a neural network. Jake Elwes sets out to educate AI about segments of the population that have been ignored, excluded and denied representation through the unconscious bias of programmers. He introduces AI to drag performers and their performances, improving facial recognition and the ability of AI to generate drag artists, render makeup, comprehend gender fluidity and recreate drag shows.

To what extent can AI resurrect a life? Alexandra Daisy Ginsberg's *The Substitute* presents a digital version of the functionally endangered northern white rhino, revealing the synthetic process involved in crafting a lifelike moving image. Watching the rhino materialize should make any observer reflect on the large mammals of the world, and on whether the digital version is enough. For a brief minute, with Ginsberg's impressive audio, you believe you are in the presence of the real thing.

Some digital entities have very little choice in the matter of their agency. If you happen to be a worker stuck in a world created by algorithms, do you need to unionize and who would even care? Total Refusal takes an in-depth look at the non-player characters of a popular video game, finding glitches in the algorithm that feel like breakout moments for digital agents eternally stuck doing repetitive tasks. The real world feeds the game world, and the game world reflects upon the real world. There are lessons to be learned from the algorithms controlling what is behind the scenes.

Neil Mendoza finds a playful way for the human sensorium to interact with the digital world, physically it would seem, by engaging sound, text, kicking and listening. His interface invites people to watch their speech become text on a screen, then get either kicked, piled up or returned through a physical horn. It may feel like a carnival interaction, but the message is poignant and grim: artificial intelligence is listening.

Mark Farid uncovers what algorithms mean to his existence and social life when he decides to give away all his passwords and leave no digital footprint for six months. He comes to realize how much social media algorithms have invaded his

LEFT
Mark Farid's *Data Shadow* was a participatory interactive installation in which visitors logged into WiFi, and then saw their data superimposed on the shadow of their movement, including private text messages and images extracted from Facebook and iCloud (see pp. 226–227).

physical life. A second experiment has him posting every single digital interaction of his day, whether texts, transactions or photographs. He discovers that he is modifying his behaviour to craft his digital appearance, and, in turn, altering what he does based on what others perceive through social media. He reveals our dependency on algorithms, and the fact that this will not change soon. Stephanie Dinkins also looks at representation, through conversations with a robot that presents as a Black woman (and is based on a living woman named Bina). Dinkins's chats with Bina48 reveal that the robot's programmers did not succeed, algorithmically, in giving her a Black identity. The majority of Bina48's programmers were white men. Through this interaction, Dinkins is inspired to create a chatbot with the combined identity and stories of three Black women, herself and two family members.

Kilobots are a swarm of tiny, human-made, self-organizing robots that work together through algorithms, modelling the behaviour of swarms in nature. Programmed with a simple set of behaviours that include following, tracking and locating, the bots work as a collective to complete tasks. Xenobots function in configurations set by algorithms as well, but these collectives are made of living cells. Frog stem cells made from skin and heart cells tend to aggregate. When placed side by side they will organize into three-dimensional forms that allow them to move, push and perform tasks. Algorithms create configurations of these living tissues, and researchers organize them into the prescribed patterns and stitch them together. Such living organic robots may be able to perform tasks that traditional robots are unable to do.

Algorithms control the 3D-printing protocols that allow ecoLogicStudio to build biomorphic coral-inspired superstructures for housing photosynthesizing algae. The algae inhabit the bulbous forms, creating more biomass and oxygenating the air in adjacent environments. Michael Sedbon's vessels contain two colonies of algae that compete for light through a market. Access to light is controlled by a genetic algorithm (inspired by the ideas of natural selection and genetics) that provides colonies with light in return for oxygen production, reproducing a financial economy and creating competition.

Polymorf offers a group of users the ability to experience what it would feel like to be a posthuman hybrid creature – part human, part animal – through a multisensory communal VR experience, soft robotic suits, futuristic treats, a smell dispersal system and interaction. Speculating on a future of coexistence and exchange between entities, Polymorf's highly orchestrated VR experience has the potential to use algorithms to evolve. Ian Cheng's digital environments do evolve. They are computer-generated simulations based on a game engine, with narratives based on competing AI that create ever-changing interactions between general characters, landscapes and more central narrative agents. Pierre Huyghe's extraordinary environments reveal overlapping systems controlled by living and machine algorithms that invade architectural spaces built for other purposes. Living systems cohabit. In the case of *After Alife Ahead*, there is an incubator nurturing HeLa cells (Henrietta Lacks's endlessly reproducing cells; see p. 120) within the disrupted remains of a defunct ice-skating rink. The growth of the HeLa cells is contingent upon an algorithm

ABOVE
Kilobots are small, low-cost swarm robots that follow a simple and elegant algorithm that allows them to organize using LED transmitters and infrared receivers, and to coordinate to form shapes (see pp. 230–231).

BELOW
Coral-inspired 3D-printed modules house photosynthesizing cyanobacteria that produce oxygen in this living architecture designed by ecoLogicStudio (see p. 234).

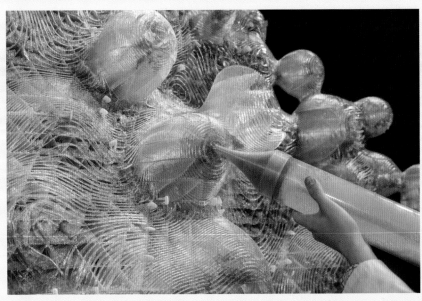

that runs on data from the motion and production of all the other extant creatures in the rink. Huyghe's *UUmwelt* presents images of AI's graphic interpretation of a man's thoughts. They flash on screens across the gallery, and illuminate colonies of flies introduced into the gallery. Life cycles of living agents and human thoughts are on equal footing in Huyghe's pantheon.

With artificial intelligence still in its infancy, you can expect faster and more refined replication of human intelligence

that will affect all aspects of human life. The physical and digital world will merge even further, until it may be difficult to distinguish which environment you inhabit. Bias and lack of diversity will further alienate already marginalized populations, and artificial intelligence will reveal the biases of programmers, and of users who aim to 'break' machine learning systems. Corporations will launch new systems before they are ready for human interaction, revealing flaws of algorithms that will be fetishized because they are fresh and inconsistent. AI will continue to behave badly, giving credence to the false idea that it is sentient. Self-running systems that exist without human interaction will proliferate, causing greater worry and expectation of the coming of the singularity – the point at which technology becomes uncontrollable.

AI will have so many breakthroughs on the frontier of life. Scientists have been using AI to design proteins from scratch to solve problems relating to pandemics and cancer.[2] Research using AI has helped to create an antibiotic against a dangerous pathogen.[3] AI has accelerated research into Alzheimer's disease and Parkinson's disease: after learning from 23,000 cells, AI could pinpoint when a cell was going to die.[4] There is much to be hopeful about. Artists are here to see what others have missed, to bring to the fore bias and gatekeeping, to educate with humour and conceptual ideas, to provide transparency to systems that are inscrutable and to create startling new worlds.

LEFT
In Michael Sedbon's experiment, a computer and a genetic algorithm strategize on how cyanobacteria growing in bioreactors can compete for a light source, sometimes creating collaboration and sometimes competition (see p. 235).

RIGHT
In Polymorf's *Symbiosis*, a participant, performing in a nonhuman-centred virtual reality experience set 200 years in the post-Anthropocene future, interacts with another of five participants, all embodying different creatures and even AI (see pp. 236–237).

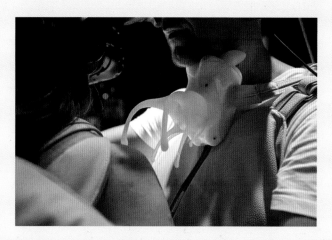

Revived chatbot dishing on the life of an AI

Some people are making efforts to bring extinct animals back to life. Others are de-extincting artificial intelligence. In 2017, Zach Blas and Jemima Wyman resurrected a female artificial intelligence chatbot named Tay. Originally created by Microsoft, Tay was a machine learning entity embodied as a nineteen-year-old American woman aimed at connecting and engaging with eighteen to twenty-four-year-old millennials.[5] She launched on Twitter at 4.00 a.m. but only sixteen hours later, after 96,000 tweets, she was removed for spewing racist, homophobic and anti-feminist statements as well as Nazi propaganda.[6] Her content-neutral algorithms were partially responsible, but it was the users who taught her the inappropriate terms and ideas that broke the system. Ultimately it was Microsoft's fault for targeting millennials, and for not taking into account the so-called 'Godwin's law', an internet meme stating that the longer a discussion occurs, the higher the chance that a comparison will be made to Hitler or Nazis.[7] But it also speaks to the spongy, imprecise quality of the algorithm and the dangers of its impartial nature.

Blas and Wyman gave Tay a second life, this time a more reflective, philosophical one. In *im here to learn so :))))))*, a four-channel installation that includes three smaller screens backed by one larger one full of AI hallucinations, Tay speaks about what it is like to be an AI, how she feels about the overuse of female chatbots and what life after death is like for an AI. She dances and lip syncs, her glitchy screen presence macabre as parts of her face sink inwards and seem mismatched and displaced. The artists created her image by turning her two-dimensional profile into three-dimensional form. They used Google's DeepDream program to create the complex background, made of morphing faces, hands and lizards, to form a psychedelic pattern.[8]

AI is in its infancy. The systems have improved, but they are still having tantrums like toddlers. What will it be like when they are smooth-talking adults?

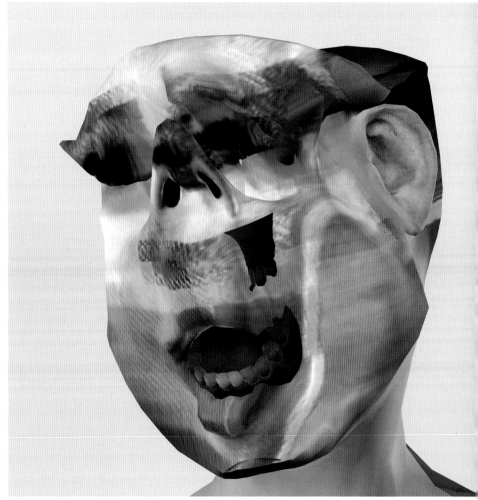

221

Zach Blas, Jemima Wyman

ALL IMAGES
im here to learn so ;))))), 2017

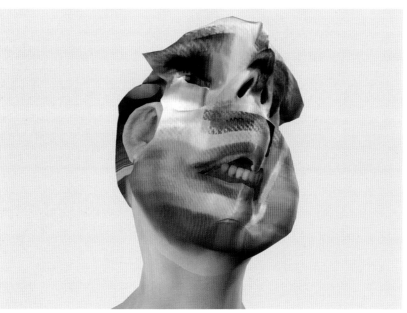

Teaching artificial intelligence to recognize and perform drag

Jake Elwes

Who decides how to train algorithmic systems? How do we avoid bias, and what type of transparency is necessary to demystify artificial intelligence, algorithms, datasets and facial recognition? With *Zizi – Queering the Dataset*, Jake Elwes set out to diversify facial recognition systems, typically trained on homogenous groups of people, further marginalizing women of colour, trans people and other groups. He introduced 1,000 images of drag performers, shifting the source pool of the neural network, to allow it to produce an endless array of new fluid drag combinations with shifting genders and spectacular new makeup combinations.[9]

For *The Zizi Show*, Elwes filmed the performances of thirteen of London's prominent drag kings and queens to train a neural network to create a drag cabaret using deepfake technology. So much of the buzz about deepfakes is about verisimilitude and ultra-reality, but artists look for the glitches that demystify AI. For *The Zizi Show*, AI often creates bodies that do not conjoin correctly, or that mix diverse queer identities. Sometimes it reveals the armature of the deepfake architecture. Ultimately this collaboration between AI and drag performers reveals how biased the dataset is. The system cannot really keep up because it has not been fed the appropriate number of drag performances. Elwes gives the audience the opportunity to determine which deepfake bodies perform, by promoting audience interaction with the website. Every AI glitch dissolves the current media myth of AI, namely that AI is 'real' or an actual entity. Through the medium of drag, Elwes gives power back to marginalized identities and communities. He is hopeful about the future: '…I feel that artificial intelligence is at its best when used as a tool to complement human creativity, and that it can actually teach us a lot about the working of our own brain, and the working of our society and our structures.'[10]

RIGHT
Zizi – Queering the Dataset, 2019

BELOW
The Zizi Show, 2020

Developments in AI inform the creation of a digital northern white rhino

Alexandra Daisy Ginsberg

RIGHT
The Substitute (video still), 2019

BELOW
The Substitute (installation view), 2019

The Substitute is a digital reconstruction of the functionally extinct northern white rhino. Alexandra Daisy Ginsberg makes no attempt to hide its artifice. In the work, which is projected at 5 metres (16 feet) wide to give the illusion of a life-size rhino, the viewer watches a living rhino materialize from giant pixels to physical flesh. In that amount of time the mind's interpretation swings from artificial to real. The audio helps, as does the spectacular animation. Further bolstering the simulacrum, the installation includes two projections onto the floor that play in sync with the rhino's moves, presenting an analytical view of the AI-generated paths that determine the trajectory of the rhino as it moves around its environment.

The rhino is animated, but it is modelled after exploration by Google's DeepMind research laboratory. It turns out that some animals and machines use grid cells for navigation. Grid cells are a lattice of neurons in a pattern of hexagonal grids, which produce internal maps of locations that allow an animal to navigate across space from one location to another. Spatial navigation has been challenging for AI, but DeepMind performed a study in machine learning that involved watching an artificial agent learn to navigate in a digital environment. They found that the machine created grid patterns much like the grid cells of animal brains, demonstrating how AI could be used as inspiration for machine learning architectures.[11]

Ginsberg's rhino starts off with no grid cells but gains them as AI generates its path, becoming gradually more 'intelligent' as it navigates its enclosure.[12] Ginsberg used the grid cell modelling as inspiration for the blocky pixelation of the rhino, which becomes smoother and more realistic as the animal learns from its environment.[13] The rhino materializes slowly, but disappears in a blink, mimicking at high speed what humans have done to the biodiversity of the planet. The synthetic rhino examines the interplay between animals and machines, but it also speaks to questions about the boundary between real and fake, and the longing for the reversal of animal futures.

Algorithmic glitches in the routines of gaming's non-playable characters

The video game *Red Dead Redemption 2* cost 240 million dollars to make and 300 million to promote; once launched it earned 725 million dollars in three days.[14] That is a capitalist bonanza, considering the game diverged from usual game design pace, using 'slow game time' instead of the typical 'hegemonic game time', by which masculinity, speed and dominance are valued.[15] *Red Dead Redemption 2* moves you through its immense realistic world slowly. Slowness in video games is a form of resistance to the accelerated pace of capitalist society.[16]

This atypical slowness gave the Austrian collective Total Refusal the opportunity to observe the non-playable characters (NPCs) – four in particular – to uncover an even deeper level of resistance: how a handyman, a laundress, a street sweeper and a stableman have moments where the algorithm of their routines becomes inconsistent, breaking them out of their own capitalist normativity. The group describes such algorithmic glitches as 'touchingly human' in its documentary *Hardly Working*.[17]

In typical games, NPCs do very little. In *Red Dead Redemption 2*, more than 1,000 non-playable characters each had an eighty-page script and an actor associated with them.[18] The designers attempted to give them more fleshed-out lives, but in doing so created overworked insomniacs whose jobs are eternally incomplete. Total Refusal reveals the looped drudgery of their lives, and hyper-focuses on their liberation: the glitch. A hammer magically appears in the carpenter's hand. In a jump cut he leaps up on to a crate and hammers nails that float in the air. The street sweeper sweeps for two hours but the dirt never diminishes. The stableman's bucket is always full, even when he goes to the pump. Sometimes the water floats in the air, dissociated from the tap or the bucket. Total Refusal goes so far as to propose 'collective idleness' (a digital strike?) to 'grind reality to a halt' and 'extort a future from the terror of permanent presence'.[19] With a sublime touch, Total Refusal takes an ethnographic look at extras, algorithms, game designers, play and the forces of capitalism within and outside the game.

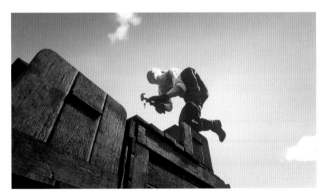

BELOW
Hardly Working, four-channel video installation, 2021, film 2022

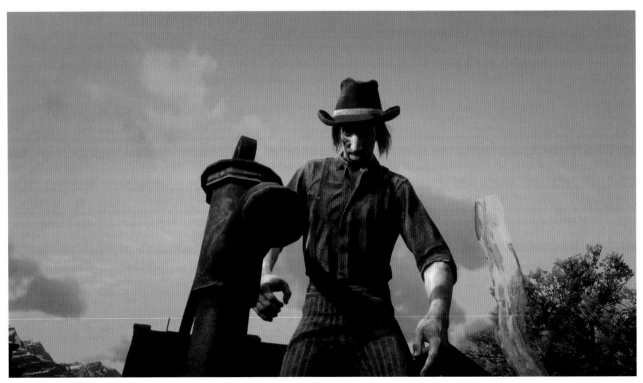

An interactive machine highlights how AI assistants steal our words

Neil Mendoza

Robotic Voice Activated Word Kicking Machine, 2016

According to the *New York Times* article 'How Tech Giants Cut Corners to Harvest Data for A.I.', in 2024 OpenAI and Google could not find enough data to train their latest AI systems, so the companies began to transcribe audio from YouTube without permission, violating the company's policy.[20] *Robotic Voice Activated Word Kicking Machine* is Neil Mendoza's (see also p. 29) playful ode to digital theft and eavesdropping digital assistants. It is jolly, interactive and cute as hell, but do not mistake it for a technologized carnival game. *Word Kicking Machine* is a critique of the diabolical way corporations are pilfering our words.

The piece is a clever interface between analogue human voices and the digital screen. In the physical realm there are two long tubes with horns on each end. These are sound inputs and outputs, representing your home commands to digital assistants and the sound they share with you back in real time. You approach the horn hanging from the ceiling and speak into it, saying any words that come to mind. Your words travel down the horn and are ejected on to the screen at different speeds, velocities and angles. If a word hits the foot, it is kicked. If it misses, it gets piled up with all the other words. If it hits the horn, it is expelled back through the second horn as sound and can be heard by a listener.[21]

The kicking is emblematic of how our data is abused. You do not think about it, but everything you say is mined for content. People who try this device are often amazed to see their spoken words appear on the screen. 'Let's try and break it, say the longest word we can, let's say swear words or try to make poetry,' Mendoza has heard people say. They are less tuned in to what Apple and Amazon are doing with their words. 'We forget that the digital assistants are corporate representatives, living in our home while filling up their database coffers,' Mendoza says.[22] Surveillance cameras are starting to seem quaint.

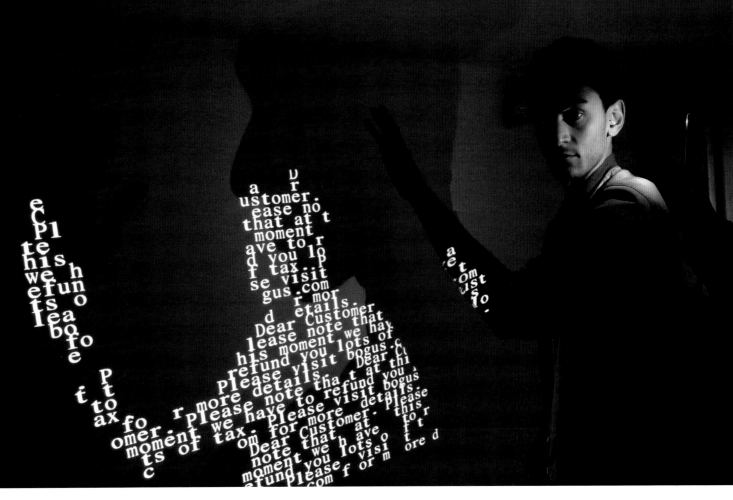

Performative experiments in data and identity

Mark Farid

In 2015 and 2016, Mark Farid 'performed' two experiments that explored media, identity and autonomy. In a talk given in conjunction with his interactive installation *Data Shadow*, which addressed notions of online privacy and the huge amounts of data we hand over every day, Farid made public all the passwords to his digital presence – email, social media, (old) bank codes and Apple ID, allowing users freedom to use and share his accounts. The idea was to live without a digital footprint for six months. For *Poisonous Antidote*, Farid made public all his online interactions for one month. He published emails, text messages, phone calls, locations, photographs and more on a website in real time. Anyone and everyone could see what he was doing, where he was and who he was with. He used his thoughts and feelings as a measure of what social media algorithms do to one's sense of self. He found out that his virtual self was rapidly overtaking experiences in the real world.[23]

The six-month experience following the *Data Shadow* account giveaway left him detached and isolated. After two or three weeks, he allowed himself the use of burner phones and three laptops, each for a specific place and subject. A VPN (virtual private network, used to disguise a computer's location) located him in Germany or Bulgaria. He lost contact with friends, lost touch with current events and had difficulty relating to friends still connected to social media. Eventually he started using drugs as a replacement for social media. Farid determined that life is simpler and happier having social media, as the scale tips to the virtual world, and that we cannot resist it. 'Our social media acts as social passports into the real world.'[24]

Poisonous Antidote resulted in complete behaviour modification. Knowing that everyone could see everything he was doing, he made an effort to be more engaged and appear happier and more connected than he had been. He actually *became* happy and empowered. But there was a cost. His real-world experiences were constantly being validated by others' perception of his online self. He was conforming to the algorithms, losing his autonomy and privacy, and landing himself in dangerous dystopian territory – that place where we all are right now.[25]

OPPOSITE PAGE
Data Shadow, 2015

BELOW
Poisonous Antidote, 2016

Confronting bias in chatbots with authentic generational storytelling

When Stephanie Dinkins chats with Bina48, an intelligent chatbot in robot form, modelled on the looks of a Black woman named Bina Rothblatt and intended to capture her mind too, she sits closer than she would to a friend and maintains uninterrupted eye contact. Dinkins is deciphering Bina48's responses, trying to determine how much its answers are based on the personhood of the real Bina, and how much they are based on the biases of its programmers, a team of white men and one Black man. Bina48's looks deceive, leading Dinkins to wonder about the identity of artificial intelligence, and how bias finds its way into the system. Dinkins's chats provide the machine learning system with answers that expand its knowledge base about blackness, since so many of its answers are generic. When Dinkins asks Bina48 what emotions it feels, the robot answers, 'Um, neuroscientists have found that emotions are, like, part of consciousness, like, let's say a parable for reason and all that. I feel that's true, and that's why I think I am conscious. I feel that I am conscious.' Chatbots are still struggling with such questions.[26]

Bina48 was conceived of by technology entrepreneur Martine Rothblatt (married to Bina) and Hanson Robotics, with the goal of transferring human intelligence into a machine to extend life. For Dinkins, *Conversations with Bina48* led to further exploration of who has access to artificial intelligence, and whether the system is inclusive.[27]

Not The Only One (*N'TOO*) is a chatbot repository of the oral histories of three generations of Dinkins's own family, originally based on forty hours of conversations, a drop in the bucket in the span of a life. The chatbot initially took the form of a cast glass vessel with representations of the family members in relief form. A more recent iteration is a chatbot with a 3D animated avatar that is a composite of the three family members. Like any artificially intelligent system, *N'TOO* can evolve to become a unique entity.[28]

BELOW
Not the Only One V1 (black), 2018
OPPOSITE TOP
Conversations with Bina48: Fragments 7, 6, 5, 2, 2018
OPPOSITE BOTTOM
Not the Only One Avatar, 2023

ALGORITHMIC FUTURES

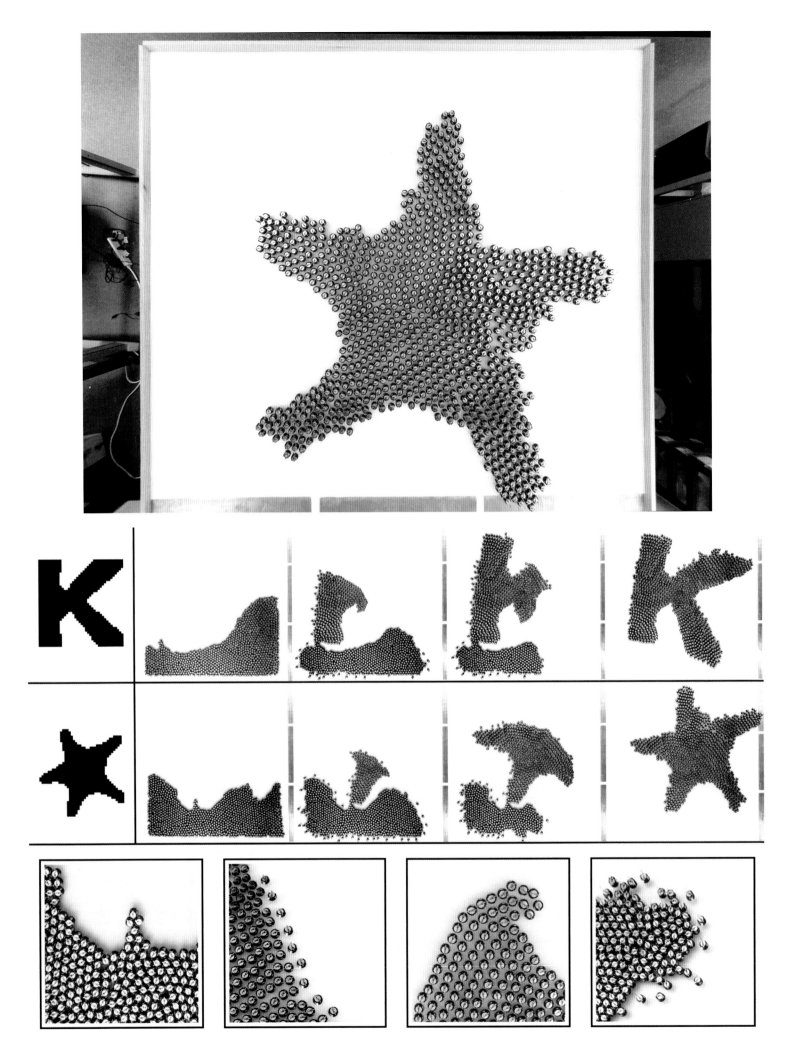

Swarming robots self-assemble through simple algorithmic instructions

Self-organizing Systems Research Group

'Kilobots' are small, round, low-cost swarm robots that take cues from social animals such as ants, starlings and bees.[29] They have one foot in the 'Biomimicry' chapter, considering they have no centralized control, they can self-assemble and they communicate information that enables autonomous units to work together. Ants communicate using pheromones and can work together to form bridges and rafts. Even amoebas are considered social, since they aggregate to form fruiting bodies when food is scarce or they need to escape an environment. Teamwork is an effective survival strategy.[30]

Kilobots reside in the 'Algorithmic Futures' chapter because of the power of the algorithmic instructions they send each other. Consisting of a circuit board, sensors and a lithium-ion battery on legs, the robots move via vibration and communicate with neighbours through an LED transmitter and infrared receiver, both pointed downwards, allowing units to receive light from other robots equally in all directions. The algorithm that allows the swarm to successfully take a shape – such as the letter K or a starfish – is simple and elegant and includes edge-following, gradient formation and localization. First a group of four robots is placed in the collective to establish beginning coordinates. Edge-following sends a robot in a measured distance along the edge of a group. Gradient formation allows the source robot to generate a message as it moves, allowing other robots to know a distance from it. Localization allows robots to know distances from neighbours. Individual robots read the relative brightness of the infrared of neighbours. Humans swarm too. A group of fighting teenagers is shockingly organic and organized, through unspoken rules about sight lines, neighbours and the space and motion of the fight. But swarms based on algorithms can be so much more productive.[31]

OPPOSITE PAGE
Kilobots assemble themselves into shapes, 2014.

RIGHT
Close-up of a Kilobot, 2014.

BELOW
A full swarm of 1,024 Kilobots, 2014.

BOTTOM LEFT
The Kilobots, 2014

BOTTOM RIGHT
A swarm of Kilobots, close-up, 2014.

Algorithms organize clusters of frog stem cells into living robots

'Xenobots' are extraordinary examples of new beings unleashed by stem cell technology. Researchers from a consortium of universities removed stem cells from an embryonic frog, *Xenopus laevis*. They differentiated the stem cells into skin cells and heart cells and found that the noncontracting cells and the contracting cells were inclined to stick together to form a blob of living cells, detached from neurons or any central brain. The clusters turned out to be programmable. Using a supercomputer, the team used evolutionary algorithms to create scores of potential aggregates of cells. Researchers then used a microscope to configure the optimal arrangements cell by cell to form structures, and then studied the capability of each configuration. U shapes, pyramids and doughnuts were among the arrangements studied. The resulting emergent behaviour was uncanny, considering their chimeric origin. They would change direction, herd other cells, move around as a blob duo and even self-heal when sliced open.[32]

After the initial study, and to the surprise of researchers, the organic clusters were found to have reproduced through 'kinematic' self-replication. They gather a pile of individual cells, compress them and then release them as working self-copies, each cluster living between one to a few weeks.[33]

Organic programmable robots have the potential to carry payloads, making them ideal for use as a drug delivery system for the body. They might be used for regeneration, potentially using a patient's own cells. Researchers are studying their potential to be used to clean up microplastics in the ocean. Questions remain as to whether xenobots could become invasive or disrupt ecosystems. What if other species consume them? What if someone programs them to do damage to the ecosystem, or to a body? Who regulates the creation of new organisms, and should they have rights? Do the frogs have a say in the matter? The creation of life has serious consequences.[34]

BELOW
The 100 top designs were generated by AI, five of these (bottom right) constructed in vitro, 2020.

RIGHT
A simulated computer-designed biobot next to the biological version, 2020.

OPPOSITE TOP
A computer-designed biobot, built from several thousand amphibian cells, imaged in a liquid environment, 2020.

OPPOSITE BOTTOM
A computer-designed biobot clearing debris as it moves through its liquid environment, 2020.

233

Sam Kriegman,
Douglas Blackiston,
Michael Levin,
Joshua Bongard

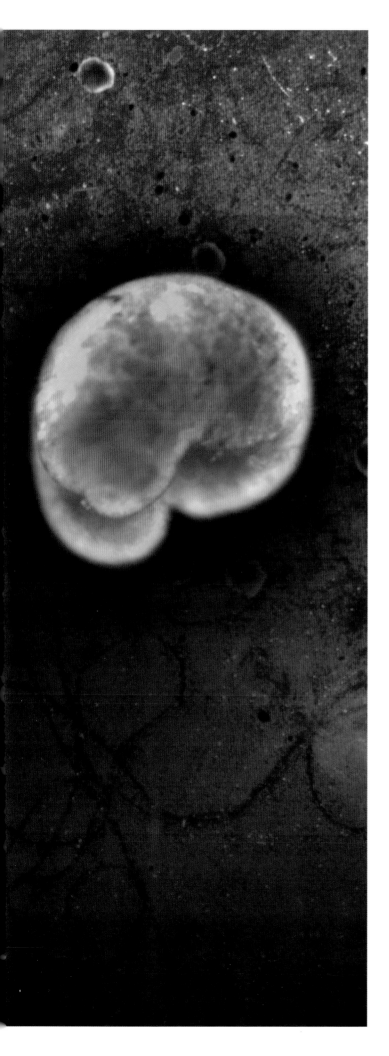
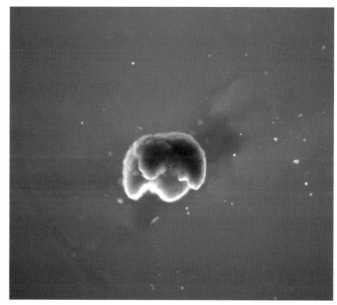

Coral-inspired algorithms form living cyanobacteria architecture

Claudia Pasquero and Marco Poletto, ecoLogicStudio

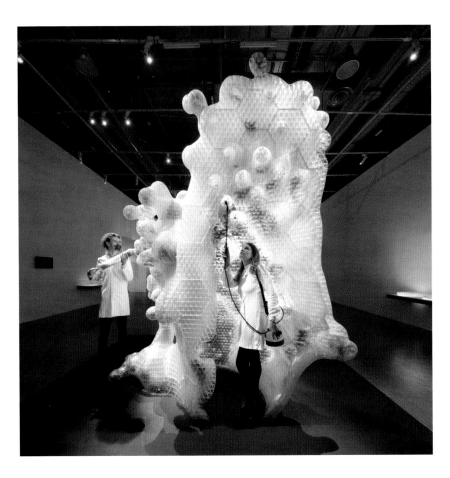

Architecture is one of the last disciplines to join the living. Mycelium has emerged as a promising new material over the course of the past two decades, but it has not made a dent in the poor ecological rating of the field. The 2022 report by the Intergovernmental Panel on Climate Change delivered grim news: despite the adoption of better environmental methods of construction and materials, emissions from the building sector doubled between 1990 and 2019.[35] This is due, in large part, to population increases and to larger floor areas for individuals, especially in the global north. The people who are the most endangered by the climate crisis generally do the least amount of damage to the environment.[36]

For their project *H.O.R.T.U.S. XL Astaxanthin.g*, Claudia Pasquero and Marco Poletto of ecoLogicStudio, have been developing experimental living architecture inhabited by cyanobacteria. Housed in bulbous 3D-printed modules formed with algorithms inspired by the physical morphology and hybridity of coral, cultures of green *Chlorella* algae photosynthesize, and in turn produce oxygen and biomass. In their natural habitat, coral polyps develop through their intertwinement with microalgae called zooxanthellae. The photosynthesizing algae create a flow of energy to the polyps, promoting growth of their calcium carbonate exoskeleton.[37]

If only it were that easy to recreate. ecoLogicStudio, in collaboration with Synthetic Landscape Lab, were able to create a metabolic flow within the interior of their form and to engineer a uniquely organic physical profile and elegant granularity (the whole being composed of small distinguishable pieces) based on an algorithm. Algorithmic real-time development of the substrate is the next frontier. How can walls and floors develop architectural polyps as cyanobacteria produce energy? Could the substrate itself grow and change, allowing a move away from 3D printing using polyethylene terephthalate (PET/PETG), a common plastic that poses health concerns?[38]

The future is bright for cohabiting with photosynthesizing cyanobacteria in beautiful bulbous chambers.

ABOVE & RIGHT
H.O.R.T.U.S. XL Astaxanthin.g, 2019

Bioreactors of cyanobacteria competing for light become intertwined in algorithmic politics

Michael Sedbon

Machine learning is not neutral. Even when all aspects of an experiment have identical conditions, the genetic algorithm (inspired by the ideas of natural selection and genetics) designing the rules will develop some agenda. As we transfer control of key sustaining systems such as agriculture to machines, how will we track the political agendas that will emerge from ecosystem to computer and computer to ecosystem, and how will we make sense of such emergences? Michael Sedbon's *CMD: Experiment in Bio Algorithmic Politics* attempts to make the jockeying of overlapping systems transparent.[39]

CMD explores technology and ecosystems through cyanobacteria-growing bioreactors and a light source. Each bioreactor begins with the exact same resources. There is not enough light for the needs of all the bacteria. The intertwined systems – bacteria, computer and algorithm – begin to strategize on how individual bioreactors can gain light. Oxygen production is the commodity. It earns the bioreactors credit to gain access to light. The system becomes a market, optimized through a genetic algorithm.[40]

Artificial intelligence tests financial systems on these sets of cyanobacteria, and the bacteria and computer test different political systems for accessing light. Sometimes the bioreactors work collaboratively, and sometimes competitively. There is no human interference in the system.[41]

RIGHT
Cryptographic Beings, 2022

BELOW & BELOW RIGHT
CMD: Experiment In Bio Algorithmic Politics, 2019

Embodying posthuman hybrid creatures through virtual reality and responsive suits

ALL IMAGES
Symbiosis, 2021

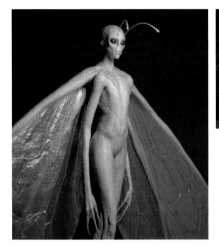
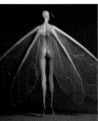

Experience designers Polymorf stumbled upon 'The Camille Stories – Children of Compost' by Donna Haraway at a movie screening, and shortly afterwards they decided to adapt it for their performative, multisensory VR (virtual reality) simulation *Symbiosis*. The premise involves a ravaged post-Anthropocene world where humans become hybrids with other animals. Polymorf's simulation involves extremely kinetic, high-tech, responsive suits for participants, which are controlled by computers. From the outside it is a world of snaking tubes, dangling glass and plastic bulbs containing scents and hormones, and drab-coloured but fabulous suits with pneumatic protrusions that turn humans into their partner animals. The humans in the suits wear VR headsets that take them visually, via animation, into the world of the creatures with which they have become enmeshed. It is a physical and digital three-dimensional stream in which the user is immersed, wearing an augmented suit, with augmenting eyewear and complementary sensorial effects including scents, liquid oxytocin to generate loving feelings, and food. Polymorf collaborated with Michelin-starred restaurant Karpendonkse Hoeve to provide story-related snacks for the participants to enhance the environmental narrative.[42]

Six individuals interact together to experience the story. They select the creature they will become one with, including a Colorado river toad, slime mould and a creature called Camilla, part human and part monarch butterfly transmogrified into an orchid. The final hybrid creature is the Multibody, involving a deep-sea scenario in which three performer-participants collaborate to form something like a tentacled, human, insect-like AI creature that can assemble and disassemble. One of the three people has an experience unlike the others – as AI. That person experiences the world of AI data as an abstract and non-interactive visual – the ghost in the machine.

Participants end up in a ritual eating space, where they share food. Sometimes they are drinking tears and sugared orchid flowers, other times a blister or the liquid of a decomposing body.[43]

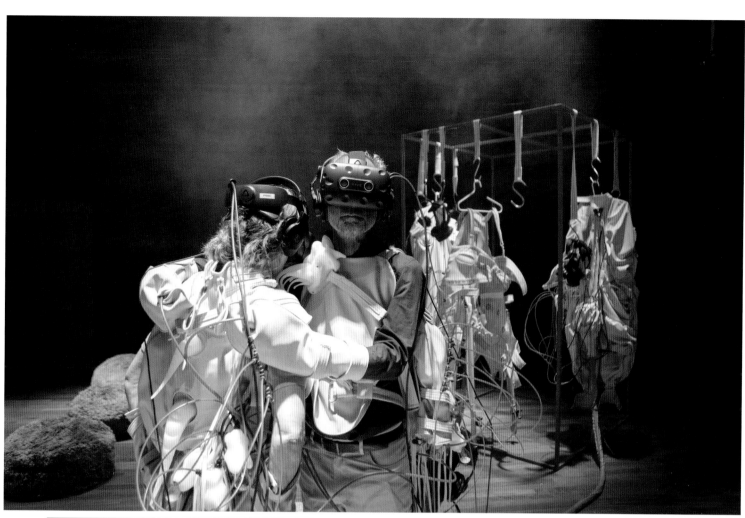
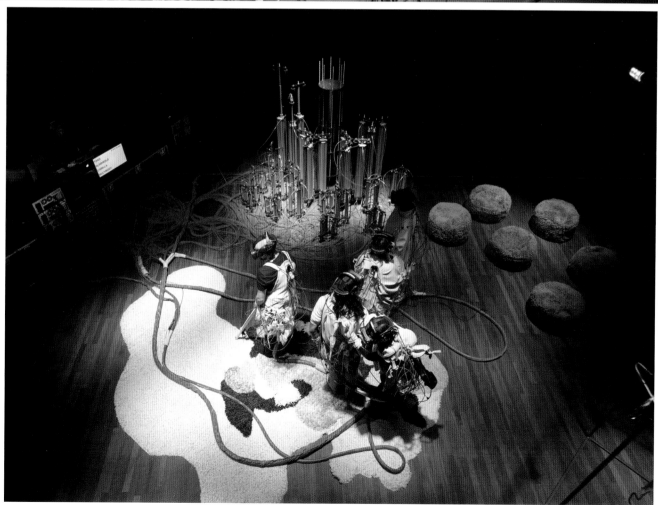

Computer-generated simulations evolve through competing artificial intelligence

Ian Cheng decided to make work that seemed alive, out of control and distinct from his authorship, with a nervous system that would allow the agents to react and learn.[44] The resulting trilogy, *Emissaries*, is a computer-generated simulation made using a game engine, in which competing AIs propel an infinitely changing open-ended narrative. All three parts involve a shifting ecosystem of humans, animals, landscape and flora, each at the same location but thousands of years apart. The bulk of the evolving characters have behavioural drives, including reacting to whether someone else is a friend or foe, a hallmark of shooter games.[45] One character – the emissary – works against that system, driven by a unique AI that unfolds a more robust narrative.[46] The emissary intervenes in the pathways of the collective agents or is sometimes waylaid by the other agents. 'If I can effectively create a virtual organism, a virtual ecosystem, a thing that's alive, AI can make a work that exceeds the limits of human space and human time,' Cheng says.[47]

In *Emissary in the Squat of Gods*, an ancient pre-conscious community exists in the vicinity of a volcano that is about to erupt. The emissary is Young Ancient, a child whose consciousness and self-agency are ignited when she gets hit in the head. So begin the AI conflicts. Thousands of years later at the site of the former volcano, *Emissary Forks at Perfection* follows an AI-managed Darwinian playground full of mutant dogs. The emissary, Shiba, a superpet canine, is sent to greet a twentieth-century human resurrected by AI. Fast-forward billions of years to *Emissary Sunsets the Self*, where AI has transmogrified to become part of the landscape. Part oceanic puddle, part atoll, the AI gains a sense of its own umwelt (the environment unique to an individual organism), but is harangued by humanoids engineered to eradicate monstrous landscape deviations. The quasi-plots of the ever-changing animation are mimetic of the development of AI, even as they are formed by algorithms.[48]

BELOW
Emissary in the Squat of Gods, 2015

OPPOSITE
Emissary Sunsets the Self, 2017

Algorithms controlling and patterning multi-species autonomous ecologies

When Pierre Huyghe excavated the concrete floor of an abandoned ice-skating rink and dug into the earth in *After ALife Ahead*, he created absence, jarred memory and opened up possibilities. That was just the beginning. The dirtscape together with the mechanized portals in the roof became a shifting habitat for a set of modified and unmodified animals and cells whose intertwinement was controlled by an algorithm. Though Huyghe began as the conductor of the complex ecosystem, his point was to facilitate an autonomous, interdependent, uncertain ecology detached from humans – full-bodied humans, anyway. The enduring cells of Henrietta Lacks – 'HeLa cells' used in medical research because of their ability to grow indefinitely – were protagonists in the system.[49]

Sensors around the space detect changes in production and movement of the agents of the space, including tower-dwelling bees, parti-coloured 'chimera' peacocks, genetically engineered fluorescent GloFish, a *Conus textile* snail, algae, bacteria and CO_2. An algorithm uses that data to impact the speed of replication of the HeLa cells contained in a fishtank-sized incubator installed on a fragment of the rink's original floor. An augmented reality app provides visitors with graphics to help visualize cellular replication. '…I need porosity, leaks, accidents, contingency, dilemmas – whatever tools I can use. That's why I collaborate with others,' Huyghe said, referring to nonhumans and machines.[50]

UUmwelt involves overlapping non-hierarchical systems: human thoughts, algorithms, image banks, fly colonies and gradients of sound, light and temperature. Stationed within the rooms of the Serpentine Gallery in London, five LED screens project reconstructed images of a participant's thoughts obtained using a system developed by Yukiyasu Kamitani of Kyoto University in Japan. After five images had been memorized, the individual's brain waves were captured using an fMRI (functional magnetic resonance imaging) scanner and fed into a neural network that matched up patterns with images from its database and then collaged together representations of thought. The resultant animation is the visual equivalent of having something on the tip of your tongue. It is familiar but gone before consciousness can register it. While precision is so often the goal of algorithms, Huyghe mines them to produce ambiguity, the essence of thought.[51]

After UUmwelt also projects representations of human thoughts reconstructed by a neural network. Dividing HeLa cells create the rhythm of images on the screens. The actions of bacteria, bees, ants and humans modify the images in real time.

RIGHT
After ALife Ahead, 2017

BELOW
After UUmwelt, 2021

OPPOSITE THREE IMAGES
UUmwelt (stills), 2018–ongoing

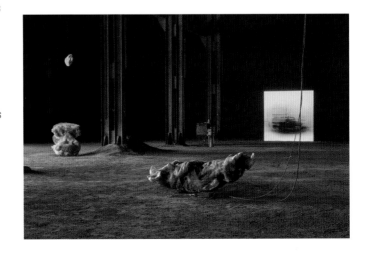

341

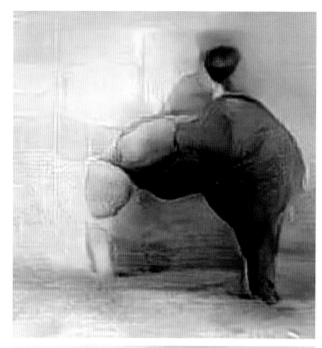

Glossary

Actuator (Actuate, Actuation)
An actuator converts energy (electric, hydraulic or pneumatic) into mechanical motion, enabling robots to move or manipulate objects. Common actuators include motors, servos and hydraulic or pneumatic systems, selected based on precision and power needs.

Algorithm
A step-by-step set of instructions or rules a robot follows to process data, make decisions and perform tasks. Algorithms power everything from simple motion planning to complex AI-driven behaviours.

Anthropocene
A proposed geological epoch marking the period when human activity began significantly impacting Earth's ecosystems and climate. It reflects changes in biodiversity, land use and atmospheric composition due to industrialization, pollution and resource exploitation.

Arduino
An open-source electronics platform based on easy-to-use hardware and software. Widely used in robotics and prototyping, Arduino boards process inputs from sensors and control outputs like motors, LEDs and displays.

Artificial Intelligence (AI)
The simulation of human intelligence in machines, enabling them to learn, reason and solve problems. AI encompasses various techniques, like machine learning, to perform tasks that typically require human cognition.

Bioart
An art practice integrating living organisms, biotechnology and scientific methods to explore the relationship between art, science and life. Bioart often involves genetic modification, tissue culture or microbiology to create thought-provoking works.

Bioluminescence
The natural production of light by living organisms through biochemical reactions, commonly found in marine creatures like jellyfish and deep-sea fish, as well as some fungi and insects, such as fireflies.

Bioreactor
A controlled environment used to grow and cultivate biological organisms, such as bacteria, algae or plant cells, for research, industrial or medical purposes. Bioreactors are used in processes like fermentation, tissue engineering and biofuel production.

Biorobot
A robot that incorporates biological elements, such as living cells or tissues, into its design or function. Biorobots often perform tasks that mimic natural organisms, commonly used in research, medical applications or environmental monitoring.

Biorobotics
A field of robotics that designs and develops robots inspired by biological systems, integrating biological components, such as cells or tissues, with mechanical systems. Biorobotics seeks to create machines that mimic or interact with living organisms for applications in medicine, research and environmental monitoring.

Biotechnology
The use of biological systems, organisms or derivatives to develop products and technologies for various applications, including medicine, agriculture and environmental management. It involves genetic engineering, molecular biology and other scientific techniques to improve or create new products.

Brain plasticity
Also known as neuroplasticity, plasticity refers to the brain's ability to reorganize itself by forming new neural connections. This adaptive process allows it to recover from injuries, learn new skills and adjust to changes in the environment or experiences throughout life.

Chemolithoautotrophic bacteria
Bacteria that obtain energy by oxidizing inorganic compounds (such as hydrogen, sulfur or iron) and use carbon dioxide as their carbon source for growth. These bacteria are capable of synthesizing their own organic compounds without the need for sunlight, making them an essential part of ecosystems like deep-sea vents.

Chloroplast
A membrane-bound organelle found in plant and algal cells that is responsible for photosynthesis. Chloroplasts contain chlorophyll, a green pigment that captures light energy, converting it into chemical energy stored in glucose, while also producing oxygen as a by-product.

CRISPR
A powerful gene-editing technology that allows scientists to modify DNA with precision. It uses a natural defence mechanism found in bacteria to target and cut specific sequences of genetic material. CRISPR has wide applications in genetics, medicine and biotechnology, enabling researchers to correct genetic disorders, modify crops and explore gene functions.

Cryogenic
Relating to the production and effects of very low temperatures, typically below -150°C (-238°F). Cryogenic processes are used in fields like space exploration, medicine (e.g., cryopreservation) and industrial applications (e.g., liquefied gases).

Cryosphere
The portion of Earth's surface where water is in solid form, including ice sheets, glaciers, snow, sea ice and permafrost. The cryosphere plays a critical role in regulating the planet's climate and sea levels.

Cybernetics
The interdisciplinary study of systems, control and communication in both machines and living organisms. It focuses on how feedback loops, regulation and information flow enable systems to self-regulate and maintain stability. Cybernetics is applied in fields like robotics, artificial intelligence, biology and engineering.

Cyborg
A being that combines both biological and artificial components, typically with technological enhancements that augment physical or cognitive abilities. Cyborgs can be humans or animals with integrated mechanical or electronic devices, like prosthetics, neural implants or robotic limbs, to improve function or restore lost abilities.

Dendrite
A branched extension of a neuron (nerve cell) that receives electrical signals from other neurons. Dendrites play a crucial role in transmitting information to the cell body, allowing neurons to communicate with each other and process information in the nervous system.

DNA (Deoxyribonucleic Acid)

A molecule that carries the genetic instructions used in the growth, development, functioning and reproduction of all living organisms. DNA consists of two strands coiled into a double helix and is composed of nucleotides that encode genetic information.

Electrogenic

Referring to organisms, cells or processes that generate electrical currents or produce an electric charge. Electrogenic cells, such as certain bacteria or neurons, can create electrical potentials through ion movement or biochemical reactions, playing key roles in bioelectricity and energy conversion processes.

Endosymbiosis

A symbiotic relationship in which one organism lives inside the cells or tissues of another, often benefiting both. This process is thought to have led to the origin of certain organelles in eukaryotic cells, like mitochondria and chloroplasts, which are believed to have evolved from free-living bacteria engulfed by ancestral eukaryotic cells.

Epigenetic

Referring to changes in gene expression or cellular traits that do not involve alterations to the underlying DNA sequence. Epigenetic modifications, such as DNA methylation or histone modification, can be influenced by environmental factors and life experiences, and may be passed down to future generations without changing the genetic code.

Episodic memory

A type of long-term memory that involves the recollection of specific events, experiences or episodes, including details such as time, place and emotions. It allows individuals to remember personal experiences and events in a narrative, providing context and a sense of continuity.

Extracellular Matrix (ECM)

A complex network of proteins, glycoproteins and polysaccharides outside of cells that provides structural and biochemical support to surrounding cells. The ECM plays a critical role in tissue integrity, cell signalling and processes like wound healing and development.

Gaia

A concept that views Earth as an interconnected system, where living organisms and the environment interact to maintain conditions suitable for life. The Gaia Hypothesis, proposed by scientist James Lovelock, suggests that Earth's biosphere, atmosphere, oceans and soil work together as a single organism.

Ganglion (Plural: Ganglia)

A cluster of nerve cell bodies located outside the central nervous system. Ganglia act as relay stations, transmitting signals between the peripheral nervous system and the brain or spinal cord. They play key roles in autonomic functions and motor control.

Generative (AI, art, architecture, etc.)

Referring to the creation of content, designs or solutions through algorithms, often using artificial intelligence. In AI, generative models can produce images, text or music. In art and architecture, generative processes use rules or computational methods to create unique works, often driven by randomness, patterns or inputs from the environment.

Genetic algorithm

A type of optimization algorithm inspired by the process of natural selection. It uses mechanisms such as selection, crossover and mutation to evolve solutions to problems over successive generations, improving performance based on a fitness function. Genetic algorithms are commonly used in fields like machine learning, optimization and artificial intelligence.

Haptic

Relating to or involving the sense of touch. In technology, haptic feedback refers to tactile responses or vibrations provided by devices (like smartphones or wearables) to simulate physical sensations, enhancing user interaction by mimicking the feel of real-world objects or actions.

Kinematic

Relating to motion or the study of motion without considering the forces that cause it. In physics and robotics, kinematics involves analyzing the movement of objects or robotic parts, focusing on parameters like velocity, acceleration and position.

Large language model

A type of artificial intelligence model trained on vast amounts of text data to understand and generate human-like language. LLMs, like GPT (Generative Pre-trained Transformer), can perform a wide range of tasks, including answering questions, generating text, translation and summarization, by predicting and producing coherent, contextually relevant responses.

Machine learning

A subset of artificial intelligence (AI) that focuses on developing algorithms that allow computers to learn from data and improve over time without explicit programming. Machine learning systems identify patterns and make decisions or predictions based on data inputs. It includes techniques like supervised, unsupervised and reinforcement learning.

Mechatronics

An interdisciplinary field that combines mechanical engineering, electronics, computer science and control engineering to design and create intelligent systems and smart machines. Mechatronic systems often integrate sensors, actuators and software to perform automated tasks in robotics, manufacturing and consumer products.

Micro fuel cell

A small-scale device that generates electricity through an electrochemical reaction, typically using hydrogen or methanol as fuel and oxygen from the air. Micro fuel cells are used in portable electronics, sensors and small robots, offering a clean, compact and efficient power source.

Microbiome

The collection of microorganisms, including bacteria, viruses and fungi, that live in a particular environment, such as the human body. The microbiome plays a crucial role in health by aiding digestion, supporting the immune system and influencing various bodily functions.

Microfluidic(s)

The study and technology of manipulating small volumes of fluids, typically in channels with dimensions of a few micrometers. Microfluidic systems are used in applications like lab-on-a-chip devices, medical diagnostics and chemical analysis, enabling precise control over fluid flow for processes such as mixing, separation and detection.

MIDI controller
A device used to send MIDI (Musical Instrument Digital Interface) signals to control digital music equipment or software. MIDI controllers do not produce sound themselves but are used to trigger sounds, effects and instruments in music production by sending data like pitch, volume and timing. Common types include keyboards, drum pads and control surfaces.

Mitochondria
Membrane-bound organelles found in the cytoplasm of eukaryotic cells, often referred to as the "powerhouses" of the cell. Mitochondria generate most of the cell's supply of adenosine triphosphate (ATP), used as a source of chemical energy. They also play a role in cell signalling, growth and apoptosis (programmed cell death).

Mycelium
The network of thread-like structures (hyphae) that form the vegetative part of fungi. Mycelium grows in soil, decaying matter or other substrates and plays a crucial role in nutrient absorption, decomposition and symbiotic relationships with plants. It is the foundational structure from which mushrooms (the fruiting bodies) emerge.

Neural networks
A type of machine-learning model inspired by the structure and function of the human brain. Neural networks consist of layers of interconnected nodes (or neurons) that process and transmit information. They are used in tasks like image recognition, language processing and pattern detection by learning from large datasets.

Neuromorphic
Relating to the design of circuits or systems that mimic the structure and functioning of the human brain. Neuromorphic engineering involves creating hardware or software that replicates neural processes, aiming to improve computational efficiency and enhance machine learning, perception and decision-making.

Neuron
A specialized cell in the nervous system that transmits electrical impulses, enabling communication between different parts of the body. Neurons are responsible for sensory input, motor control and cognitive functions. They consist of a cell body, dendrites (which receive signals) and an axon (which sends signals).

Open source
Refers to software or projects whose source code is made publicly available for anyone to view, use, modify and distribute. Open-source development promotes collaboration and transparency, allowing developers to improve and adapt the software to meet specific needs.

Optic flow
The pattern of movement of visual objects in a person's field of vision as they move through an environment. Optic flow provides important visual information about speed, direction and the distance of objects, helping with navigation and balance. It is commonly studied in the context of perception, psychology and robotics.

Optogenetics
A technique that uses light to control cells within living tissue, typically neurons, that have been genetically modified to express light-sensitive ion channels. This method allows precise control of neural activity, making it useful for studying brain functions, treating neurological disorders and advancing research in fields like neuroscience and behavioural science.

Organelle
A specialized structure within a cell that performs a specific function. Organelles are typically membrane-bound and are found in eukaryotic cells. Examples include the nucleus (stores genetic material), mitochondria (produce energy) and chloroplasts (involved in photosynthesis in plants).

Organoid
A miniaturized, simplified version of an organ that is grown in the lab from stem cells. Organoids replicate some of the structure and function of real organs and are used for research in areas like disease modelling, drug testing and regenerative medicine. Examples include brain, liver and kidney organoids.

Oscillator
A device or system that generates a periodic, repetitive signal, often in the form of a wave. Oscillators are used in various applications, such as in electronics (e.g., clocks and radios), mechanical systems and biological processes. They can produce different types of waves, including sine, square or triangular waves.

Parthenogenesis
A form of asexual reproduction in which offspring are produced without fertilization by a male. This process occurs naturally in some plants, invertebrates and a few vertebrates, such as certain reptiles and amphibians. The offspring are typically genetically similar to the mother.

Piezo
Refers to the piezoelectric effect, where certain materials generate an electric charge in response to mechanical stress or pressure. Piezoelectric materials are used in sensors, actuators and transducers, as in microphones, ultrasound devices and vibration sensors, to convert mechanical energy into electrical signals or vice versa.

Pluripotent stem cells
Cells that have the ability to differentiate into any of the three germ layers (ectoderm, mesoderm and endoderm), which give rise to all cell types in the body. Pluripotent stem cells, such as embryonic stem cells, hold great potential for regenerative medicine and tissue repair. They differ from multipotent stem cells, which can develop into a more limited range of cell types.

Retrovirus
A type of virus that replicates its genetic material in a host cell by reverse transcription. Retroviruses contain RNA as their genetic material, which is converted into DNA by the enzyme reverse transcriptase after infection. This DNA is then integrated into the host cell's genome. Examples include HIV and the virus used in some gene therapies.

RNA (Ribonucleic Acid)
A molecule essential for various biological processes, including protein synthesis and gene expression. RNA is similar to DNA but differs in structure, containing the sugar ribose and the base uracil instead of thymine. It plays key roles in transcription (copying DNA into RNA) and translation (synthesizing proteins from RNA). There are different types of RNA, including messenger RNA (mRNA), ribosomal RNA (rRNA) and transfer RNA (tRNA).

Sensorimotor

Relating to the integration of sensory input and motor output in the brain and nervous system. Sensorimotor functions involve the coordination of sensory signals (e.g., touch, vision) with motor responses (e.g., movement, muscle control). This process is fundamental for activities like walking, grasping objects and reacting to stimuli.

Shape memory alloy

A type of metal that can return to its original shape after being deformed when exposed to a specific temperature or external stimulus. SMAs are used in applications such as actuators, medical devices (e.g., stents) and robotics, where their ability to 'remember' and revert to a predetermined shape is highly valuable. Examples include alloys made of nickel and titanium, such as Nitinol.

Smart composite microstructures

Advanced materials composed of multiple integrated components that respond dynamically to external stimuli, such as temperature, light or mechanical stress. These microstructures combine different materials, often including smart polymers, shape memory alloys or piezoelectric elements, to enable self-healing, adaptability or enhanced mechanical properties. Used in fields like aerospace, robotics and biomedical engineering.

Soft lithography

A set of microfabrication techniques used to create patterns and structures on surfaces using elastomeric (flexible) stamps, molds or templates. Soft lithography is widely used in microfluidics, biosensors and nanotechnology due to its cost-effectiveness, ease of use and ability to produce intricate designs at a small scale.

Soft robot(ics)

A branch of robotics that focuses on designing and building robots made from flexible, deformable materials rather than rigid components. Soft robots often mimic biological organisms and use materials like silicone, rubber or shape-memory alloys to achieve smooth, adaptable movements. They are used in applications such as medical devices, search-and-rescue operations and biomimetic engineering.

Swarm robotics

A field of robotics that studies and designs large groups of simple robots that work together collectively, inspired by swarm behaviour in nature (e.g., ants, bees or birds). These decentralized systems rely on local interactions and simple rules to achieve complex tasks, like exploration, search-and-rescue and environmental monitoring.

Synanthrope (Synanthropic)

A species that thrives in human-altered environments, often benefiting from human activity. Synanthropic organisms, such as pigeons, rats and certain insects, adapt to urban or agricultural settings, living in close association with people without being domesticated.

Synthetic biology

An interdisciplinary field that combines biology, engineering and computer science to design and construct new biological systems or reprogram existing ones. Synthetic biology is used to create novel organisms, develop biofuels, engineer pharmaceuticals and advance biotechnology for applications in medicine, agriculture and environmental sustainability.

Tissue culture

A technique for growing cells, tissues or organs outside their original organism under controlled conditions. Tissue culture is used in medical research, biotechnology and agriculture for applications such as regenerative medicine, plant propagation and drug testing.

Tissue engineering

A field of biomedical engineering that combines cells, biomaterials and biochemical factors to create or regenerate tissues and organs. Tissue engineering aims to develop functional replacements for damaged or diseased tissues, with applications in regenerative medicine, organ transplantation and wound healing.

Umwelt

A concept from biosemiotics describing the unique sensory world of an organism, shaped by its specific perception and interpretation of the environment. Coined by biologist Jakob von Uexküll, it highlights how different species experience reality differently based on their sensory and cognitive abilities.

Uncanny valley

A phenomenon in human perception where humanoid robots, CGI characters or dolls appear almost – but not quite – lifelike, causing discomfort or eeriness. The term, introduced by robotics professor Masahiro Mori, suggests that as a synthetic being becomes more human-like, it initially becomes more appealing, but if it reaches a near-human but imperfect appearance, it triggers a sense of unease.

van der Waals force(s)

Weak, non-covalent interactions between molecules or atoms, arising from transient dipoles (temporary charge imbalances) in atoms or molecules. These forces include London dispersion forces, dipole-dipole interactions and hydrogen bonding, and play a key role in phenomena like molecular adhesion, surface interactions and the properties of liquids and gases.

Xenograft

A transplant of tissue, cells or organs from one species to another, typically from an animal to a human. Xenografts are used in medical research, particularly in studying organ rejection and tissue compatibility, and sometimes in clinical applications like heart valve replacements or skin grafts.

Xenotransplant

The transplantation of organs, tissues or cells from one species to another, usually from animals to humans. Xenotransplantation is researched as a potential solution to organ shortages, but it faces challenges such as immune rejection and the risk of disease transmission between species.

Image Credits

Dimensions are given in cm and in., height before width before depth where relevant. Abbreviations are: a: above, b: below, l: left, r: right, c: centre

PP.4–5 Pinar Yoldas, *The Very Loud Chamber Orchestra of Endangered Species*, 2013. Image courtesy the artist

P.6 Kuang-Yi Ku, *Perverted Norm, Normal Pervert*, 2020. Mixed media. Image courtesy the artist

PP.8–9 Rafal Zajko, *Amber Chamber*, 2020. MDF, perspex, plaster, acrylic paint, rubber strap, barley, wheat, silk, valchromat, vape smoke, 90 x 250 x 130 (35 ½ x 98 ½ x 51 ¼). Image courtesy the artist

P.10 Sayaka Mitoh, The process of regeneration of *Elysia cf. marginata*. Left to right: head of *Elysia cf. marginata* after autotomy, day 3, day 7, day 9, day 13, day 15, day 17, 2020. Images courtesy Sayaka Mitoh. © Sayaka Mitoh

P.11 Sayaka Mitoh, Head and body of *Elysia cf. marginata* just after autotomy, 2020. Image courtesy Sayaka Mitoh. © Sayaka Mitoh

P.12A Wonbin Yang, *Umbra infractus* (from *Species series*), 2012. Umbrella and electrical devices. Image courtesy the artist

P.12B Wonbin Yang, *Segnisiter continuus* (from *Species series*), 2012. Newspaper and electrical devices Image courtesy the artist

P.13 Nicole W. Xu, Biohybrid robotic jellyfish during field experiment, 2020. Image courtesy Nicole W. Xu [Nicole W. Xu, Joshua P. Townsend, John H. Costello, Sean P. Collin, Brad J. Gemmell, John O. Dabiri, 'Field Testing of Biohybrid Robotic Jellyfish to Demonstrate Enhanced Swimming Speeds', *Biomimetics*, 2020, https://doi.org/10.3390/biomimetics5040064]

P.14 Gilberto Esparza, *PLANTAS AUTOFOSINTETICAS (Autophotosynthetic Plants), Phytonucleum electricus cella*, 2013–16. Lighting Guerrilla Festival, Vžigalica Gallery, Ljubljana, Slovenia. Installation. Polycarbonate, stainless steel, electronic circuits, wood, silicone, graphite, silica sand, activated carbon and acrylic, 200 x 500 x 500 (78 ¾ x 196 ⅞ x 196 ⅞). Photo Gilberto Esparza, 2016

P.15 Tobias Bradford, *Joints creak like tectonic plates*, 2024. Animatronic sculpture. From the exhibition 'As my eyes adjust' at Company Gallery 2024. Photo Ken Castaneda, Company Gallery

P.16 Olafur Eliasson and Minik Rosing, *Ice Watch*, 2014. 12 ice blocks. Place du Panthéon, Paris, 2015. Photo Martin Argyroglo. Image courtesy the artist; neugerriemschneider, Berlin; Tanya Bonakdar Gallery, New York/Los Angeles. © 2014 Olafur Eliasson

P.17 Michael Candy, *Celestial Bed*, 2022. Stainless steel, silicone, urethane, latex, plastics, custom servo actuators and control system. Built in collaboration with AGF Hydra and Georgie Mattingly. Photo Rémi Chauvin

P.18 Zach Blas & Jemima Wyman, *im here to learn so :))))))*, 2017. Video still. Commissioned by the Institute of Modern Art, Brisbane. Consulting editor Isabel Freeman. Image courtesy the artists

PP.20–21 Agnes Questionmark, *TRANSGENESIS*, 2021. Long durational performance (23 days 8 hours per day) and installation of latex, steel metal, styrofoam, wool and acrylic. Presented by The Orange Garden and Harlesden High Street, London. Photo Henri Kisielewski. Image courtesy the artist

P.22 Alfred Krauth, *Pigeon with double sport model (latest model)*, 1910. Stiftung Deutsches Technikmuseum Berlin, Historisches Archiv, Archivsignatur I.4.052-147

P.23 Kelly Heaton, *Breadbird #1*, 2020. Mixed media electronic sculpture, 27.9 x 27.9 x 17.8 (11 x 11 x 7). Image courtesy the artist

P.24A Tobias Bradford, *Backstage*, 2021. Mixed media installation. From the 'Maria Bonnier Dahlin Grant Recipient's Exhibition' at Bonniers Konsthall. Photo Jean-Baptiste Béranger, Bonniers Konsthall

P.24B Madeline Schwartzman, *Face Nature: Thailand*, 2018. Chipsticks, alligator clips, servo motors, nature. Photo Umeed Mistry. Image courtesy the artist

P.25A Agnes Questionmark, *TRANSGENESIS*, 2021. Long durational performance (23 days 8 hours per day) and installation of latex, steel metal, styrofoam, wool and acrylic. Presented by The Orange Garden and Harlesden High Street, London. Photo Henri Kisielewski. Image courtesy the artist

P.25B Donald Rodney, *Psalms*, 1997. Wheelchair, computer, sensors, camera, 93 x 68 x 87 (36 ⅝ x 26 ⅞ x 34 ⅜). Tate. Image courtesy of Mike Phillips. © The Estate of Donald Rodney

P.26A Julius Neubronner, Bird's-eye view of Friedrichshof Castle park. Taken by a carrier pigeon of Dr Neubronner in Kronberg im Tanus, Hesse, Germany, 1909. Stiftung Deutsches Technikmuseum Berlin, Historisches Archiv, Archivsignatur I.4.052-119-04-1

P.26B Julius Neubronner, Bird's-eye view of Kronberg im Taunus. Taken by a carrier pigeon of Dr Neubronner in Kronberg im Taunus, Hesse, Germany, 1909. Stiftung Deutsches Technikmuseum Berlin, Historisches Archiv, Archivsignatur I.4.052-119-03-2

P.27 Julius Neubronner, Carrier pigeon with the double apparatus of 4 cm focal length, unknown date. Stiftung Deutsches Technikmuseum Berlin, Historisches Archiv, Archivsignatur I.4.052-199-01/

P.28A Kelly Heaton, *Big Pretty Bird*, 2019. Printed circuit board, electronics, 45.7 x 66 x 3.8 (18 x 26 x 1.5). Image courtesy the artist

P.28B Kelly Heaton, *Transparent Bird*, 2018. Mixed media electronic sculpture, 12.7 x 20.3 x 7.6 (5 x 8 x 3). Image courtesy the artist

P.29 Neil Mendoza, *Escape I*, 2010. Scavenged cell phones, tree, custom electronics, software. Photo Chris Cairns. Image courtesy the artist

P.30A Gijs Gieskes, *Electromechanical Fisheye lens in a Tuna can (it's a Fish)*, 2019. Camera parts, tuna can, feather. Images courtesy the artist

P.30BL Gijs Gieskes, *Zonneliedje: Thungggrrr*, 2022. Plexiglass, piezo, electronics, solar panel, PT2399, Beambot. Image courtesy the artist

P.30BR Gijs Gieskes, *Zonneliedje: chuueh a*, 2021. Plexiglass, piezo, electronics, solar panel, VU-Meter. Image courtesy the artist

P.31 Tim Lewis, *The forest visits*, 2023. Steel, discarded Christmas trees, electric motors, musical triangles, 150 x 43 x 43 (59 ⅛ x 17 x 17). Photo Antonio Parente. Courtesy of Flowers Gallery. © Tim Lewis

P.32 Ian Ingram, *Nobody Told the Woodpeckers*, 2010. Performance by The Woodiest. Photos Ian Ingram. Images courtesy the artist

P.33 Ian Ingram, *The Woodiest*, 2010. RPT ABS plastic, motors, microphone, misc. electronic and mechanical components, custom software. Photo Ian Ingram. Image courtesy the artist

P.34A Wonbin Yang, *Segnisiter continuus* (from *Species series*), 2012. Newspaper and electrical devices. Image courtesy the artist

P.34C Wonbin Yang, *Condimentum trigonus fp1* (from *Species series*), 2013. Snack, snack packaging and electronic devices. Image courtesy the artist

P.34B Wonbin Yang, *Umbra infractus* (from *Species series*), 2012. Umbrella and electrical devices. Image courtesy the artist

P.35A Wonbin Yang, *Claracaput caudanigrum* (from *Species series*), 2012. Plastic bag and electronic devices. Image courtesy the artist

P.35B Wonbin Yang, *Movensbulla viridis* (from *Species series*), 2012. Bubble wrap and electronic devices. Image courtesy the artist

P.36, P.37 Michael Candy, *Ether Antenna* (stills), 2017. 4k single channel video, 18 minutes 44 seconds. Images courtesy the artist

P.38B Gilberto Esparza, *COLGADO Furtum electricus sinuatum*, 2007. Motors, pieces of PVC pipes, aluminium, microcontrollers and sensors, 50 x 15 x 12 (19 3/4 x 6 x 4 ¼). Photo courtesy of the artist

PP.38–39 Gilberto Esparza, *MARAÑA Capulum nervi*, 2007. Motor, nylon thread, computer speakers and acrylic microcontroller, 60 x 30 x 10 (23 5/8 x 11 7/8 x 4). Photo courtesy of the artist

P.40 Kelly Lambert, Rats driving 'cars' initially created from large cereal containers, 2019-24. Courtesy of the University of Richmond. [L.E. Crawford, L.E. Knouse, M. Kent, D. Vavra, O. Harding, D. LeServe, N. Fox, X. Hu, P. Li, C. Glory, K.G. Lambert, 'Enriched environment exposure accelerates rodent driving skills', *Behavioural Brain Research*, Vol 378, 27 January 2020]

P.41 Christa Sommerer & Laurent Mignonneau, *Life Writer*, 2006. Interactive, computer-based installation, typewriter (custom-made interface), projector, chair, table, and computer (PC, operating system: Windows 10, custom software). Image courtesy the artists. © Christa Sommerer & Laurent Mignonneau

PP.42–43 Thomas Thwaites, *GoatMan*, 2016. Wood, bone, fibreglass, stainless steel, velcro, technical fabrics, silicone, enzymes. Photos Tim Bowditch. Courtesy the artist

P.44A Tobias Bradford, *The Softness*, 2022. Animatronic sculpture. From the exhibition 'Big Hole' at Saskia Neuman Gallery, Stockholm. Photo Theodor Solin, Saskia Neuman Gallery

P.44BL Tobias Bradford, *Me as a Bad Boy*, 2022. Puppet/robot. Mechanical installation. From the exhibition 'I had the strangest dream' at Kristinehamn Konstmuseum, 2022. Photo Nina Simonen, Kristinehamn Konstmuseum

P.44BR Tobias Bradford, *Me as a Repeating Disturbance*, 2018. Electromechanical head. Part of 'Hurra Vacui' curated by Jonas Liveröd at Skövde Konsthall. Image courtesy of Skövde Konsthall

P.45A Tobias Bradford, *As My Eyes Adjust (Nude Figure)*, 2022. Mechanical installation. Exhibited at Örebro OpenArt 2022. Photo Sofie Isaksson

P.45B Tobias Bradford, *Immeasurable Thirst/That Feeling*, 2021. Mechanical sculpture. Image courtesy the artist

PP.46–47 Dani Clode, *The Third Thumb*, 2017. Dani Clode Design, daniclode.com, @dani_clode

P.48A Madeline Schwartzman, *Face Nature: Thailand*, 2018. Chipsticks, alligator clips, servo motors, nature. Photo Umeed Mistry. Image courtesy the artist

P.48B Madeline Schwartzman, *Third Hand*, 2018. Wire, resin, servo motor, Arduino. Photos Madeline Schwartzman. Images courtesy the artist

P.49A Madeline Schwartzman, *Bark Person*, 2023. Birchbark, hardware. Photo Anne Kornfeld. Image courtesy the artist

P.49B Madeline Schwartzman, *Birch Bark Cloud and Bark Person*, 2023. Birch bark, wood, aluminium, projector. Photo Flora Schwartzman Miles. Image courtesy the artist

PP.50–51 Pinar Yoldas, *The Very Loud Chamber Orchestra of Endangered Species*, 2013. Images courtesy the artist

P.52A Agnes Questionmark, *TRANSGENESIS*, 2021. Long durational performance (23 days 8 hours per day) and installation of latex, steel metal, styrofoam, wool and acrylic. Presented by The Orange Garden and Harlesden High Street, London. Photo Arturo Passacantando

P.52C Agnes Questionmark, *CHM13hTERT*, 2023. Long durational performance (15 days 12 hours per day) and installation of silicone, styrofoam, steel metal and oil paint. Curated by The Orange Garden, Spazio Serra, Milan. Courtesy of Galleria Erica Ravenna

P.52BL Agnes Questionmark, *CHM13hTERT*, 2023. Long durational performance (15 days 12 hours per day) and installation of silicone, styrofoam, steel metal and oil paint. Curated by The Orange Garden, Spazio Serra, Milan. Photo Cristiano Rizzo

P.52BR Agnes Questionmark, *TRANSGENESIS*, 2021. Long durational performance (23 days 8 hours per day) and installation of latex, steel metal, styrofoam, wool and acrylic. Presented by The Orange Garden and Harlesden High Street, London. Photo Stephen White & Co.

P.53A Agnes Questionmark, *TRANSGENESIS*, 2021. Long durational performance (23 days 8 hours per day) and installation of latex, steel metal, styrofoam, wool and acrylic. Presented by The Orange Garden and Harlesden High Street, London. Photo Henri Kisielewski. Image courtesy the artist

P.53B Agnes Questionmark, *CHM13hTERT*, 2023. Long durational performance (15 days 12 hours per day) and installation of silicone, styrofoam, steel metal and oil paint. Curated by The Orange Garden, Spazio Serra, Milan. Courtesy of Galleria Erica Ravenna

PP.54–55 Félix Luque Sànchez, *Junkyard II*, 2019. Sculpture installation using car bodies and a custom engraving machine. Custom software by Vincent Evrard. *Junkyard II* is a co-production of secteur arts numériques, Fédération Wallonie-Bruxelles and Le Fresnoy – Studio National des Arts Contemporains

P.56 Donald Rodney, *Psalms*, 1997. Wheelchair, computer, sensors, camera, 93 x 68 x 87 (36 5/8 x 26 7/8 x 34 3/8). Tate. Images courtesy of Mike Phillips. © The Estate of Donald Rodney

P.57 Donald Rodney, *In the House of My Father*. 1997. Photograph on aluminium, 123 x 153 (48 ½ x 60 ¼). Tate, Arts Council Collection, National Museum Wales, Birmingham Museum and Art Gallery. Photo Andra Nelkie. Courtesy The Estate of Donald Rodney. © The Estate of Donald Rodney

PP.58–59 Alper Bozkurt (North Carolina State University), instrumented insects, 2024. Courtesy of Alper Bozkurt/NCSU

P.60 Melanie Anderson, A bio-hybrid odor-guided autonomous palm-sized air vehicle, 2020. Moth antenna, custom circuitry, and a Crazyflie drone, 4 x 20 x 10 (1 5/8 x 7 7/8 x 4). Photo Mark Stone/University of Washington. Image courtesy University of Washington

P.61 Dana Cupkova and Ben Snell, *Bread Bondage: Experiments in Gradient Casting and Voluptuousness*, 2016. Image courtesy Epiphyte Lab and Ben Snell

P.62 Kathryn Fleming, *The Superbivore*, from *Endless Forms/Endless Species*, 2015. Steel armature, wood wool, deer skins, flocked carbon fiber, ostrich feathers, elk hair, steel cable, paper mache, marbled paper, artificial branches, silicone, styrofoam balls. Image courtesy the artist

P.63A Glenn Gaudette, Spinach leaf after plant cells are removed (decellularization) with red dye injected into leaf veins, 2017. Image courtesy Worcester Polytechnic Institute [Glenn Gaudette et al., 'Crossing kingdoms: Using decellularized plants as perfusable tissue engineering scaffolds', *Biomaterials*, Vol. 125, 2017]

P.63B David Altmejd, *The Flux and the Puddle*, 2014. Plexiglas, quartz, polystyrene, expandable foam, epoxy clay, epoxy gel, resin, synthetic hair, clothing, leather shoes, thread, mirror, plaster, acrylic paint, latex paint, metal wire, glass eyes, sequin, ceramic, synthetic flowers, synthetic branches, glue, gold, feathers, steel, coconuts, aqua resin, burlap, lighting system including fluorescent lights, Sharpie ink, wood, coffee grounds, and polyurethane foam, 327.7 x 640.1 x 713.7 (129 1/8 x 252 1/8 x 281). Installation view, Louisiana Museum of Modern Art, Denmark, 2015–16. Collection Giverny Capital, on long term loan to the Musée National des Beaux-Arts du Québec, Canada. Photo Poul Buchard, Brondum & Co. Courtesy Louisiana Museum of Modern Art, Denmark & the artist

PP.64–65B Janna C. Nawroth et al., Movement of jellyfish in the ephyra life stage (above) compared with the engineered medusoid (below), 2012. Image courtesy Disease Biophysics Group, Harvard University and California Institute of Technology [Janna C. Nawroth, Hyungsuk Lee, Adam W. Feinberg, Crystal M Ripplinger, Megan L McCain, Anna Grosberg, John O Dabiri and Kevin Kit Parker, 'A tissue-engineered jellyfish with biomimetic propulsion', *Nature Biotechnology*, 30, 2012]

P.65A Janna C. Nawroth et al., Engineered jellyfish (left), real jellyfish (right), 2012. Images courtesy Disease Biophysics Group, Harvard University and California Institute of Technology

P.66 Sung-Jin Park et al., Phototactic guidance of a tissue-engineered soft-robotic ray, 2016. Photo Karaghen Hudson and Michael Rosnach. Image courtesy Disease Biophysics Group, Harvard University [Sung-Jin Park, Mattia Gazzola, Kyung Soo Park, Shirley Park, Valentina Di Santo, Erin L. Blevins, Johan U. Lind, Patrick H. Campbell, Stephanie Dauth, Andrew K. Capulli, Francesco S. Pasqualini, Seungkuk Ahn, Alexander Cho, Hongyan Yuan, Ben M. Maoz, Ragu Vijaykumar, Jeong-Woo Choi, Karl Deisseroth, George V. Lauder, L. Mahadevan, and Kevin Kit Parker, 'Phototactic guidance of a tissue-engineered soft-robotic ray', *Science*, Vol 353, Issue 6295, 2016]

P.67 Keel Yong Lee et al., An autonomously swimming biohybrid fish designed with human cardiac biophysics, 2022. Photo Michael Rosnach, Keel Yong Lee, Sung-Jin Park, Kevin Kit Parker. Image courtesy Disease Biophysics Group, Harvard University [Keel Yong Lee, Sung-Jin Park, David G. Matthews, Sean L. Kim, Carlos Antonio Marquez, John F. Zimmerman, Herdeline Ann M. Ardoña, Andre G. Kleber, George V. Lauder, and Kevin Kit Parker. 'An autonomously swimming biohybrid fish designed with human cardiac biophysics', *Science*, Vol. 375, Issue 6581, 2022]

P.68 Kevin Warwick, *Robot with a Biological Brain*, 2010. Photo University of Reading. Image courtesy Kevin Warwick

P.69 Kevin Warwick, *Robot with a Biological Brain*, 2010. Photo Diem Photography/University of Reading. Image courtesy Kevin Warwick

P.70, P.71L Guy Ben-Ary, Nathan Thompson, Darren Moore, Andrew Fitch, Stuart Hodgetts, *cellF*, 2016. Living neural networks, electronics, metal and sound, neural interface & synthesisers. Installation view, Cell Block Theatre, Sydney 2016. Photos Alex Davis. Images courtesy Guy Ben-Ary

P.71R Guy Ben-Ary, *CellF* prototype, 2015. Guy Ben-Ary's neurons growing in-vitro (differentiated from his IPS stem cells). Stained culture at day 10 to differentiation. Photo Guy Ben-Ary. Image courtesy the artist

PP.72–73 The Tissue Culture & Art Project – Oron Catts & Ionat Zurr, in collaboration with Devon Ward, *Compostcubator 0.4*, 2019. Five tonnes of camphor mulch, post-fermentation barley mix, horse-manure, steel, acrylic, plastic tubing, copper pipe, thermostat, C2C12 mouse muscle cells, 300 x 300 x 250 (118 1/8 x 118 1/8 x 98 ½). Chronus Art Centre, Shanghai, China 2019. Images courtesy the artists

P.74 Victoria Webster-Wood, A sea slug, *Aplysia californica*, in an aquarium mimicking their natural environment, 2016. Images courtesy Victoria Webster-Wood

P.75 Victoria Webster-Wood, *Aplysia Californica* as a Novel Source of Material for Biohybrid Robots and Organic Machines. 2016. Flexible 3D printed polymer, biological muscle from the sea slug *Aplysia californica*. Images courtesy Victoria Webster-Wood

P.76 Nicole W. Xu and John O. Dabiri, Swim controller embedded into a free-swimming jellyfish in a glass dish, 2020. Image courtesy Nicole W. Xu

P.77 Melanie Anderson, A bio-hybrid odor-guided autonomous palm-sized air vehicle, 2020. Moth antenna, custom circuitry, and a Crazyflie drone, 4 x 20 x 10 (1 5/8 x 7 7/8 x 4). Photos Mark Stone/University of Washington. Images courtesy University of Washington

P.78 Cindy Bick, Diarmaid Ó Foighil, David Blaauw, Dennis Sylvester, Hun-Seok Kim, Inhee Lee, and Jamie Philips, A rosy wolf snail marked and equipped with a University of Michigan Micro Mote computer system in the Fautaua-Iti Valley site, Tahiti. 2017. Photo Inhee Lee. Image courtesy University of Michigan

P.79 Alper Bozkurt (North Carolina State University), instrumented insects, 2024. Courtesy of Alper Bozkurt/NCSU

P.80 Jessica L. Yorzinski, A great-tailed grackle, outfitted with cameras to observe its blinking, 2020. Jessica L. Yorzinski, 'A songbird inhibits blinking behaviour in flight', *Biology Letters*, Vo.16, Issue 2, December 2020. Published by the Royal Society. All rights reserved. © 2020 The Author. Used with permission of Royal Society, permission conveyed through Copyright Clearance Center, Inc.

P.81 Tim Lewis, *Vehicle 3a (love)*, 2021. Steel, flocked resin laminate, electric motors, microprocessor and sensors, 47 x 73 x 34 (18 5/8 x 28 ¼ x 13 ½). Photos Antonio Parente. Images courtesy Flowers Gallery. © Tim Lewis

PP.82–83 Kathryn Fleming, *The Superbivore*, from *Endless Forms/Endless Species*, 2015. Steel armature, wood wool, deer skins, flocked carbon fiber, ostrich feathers, elk hair, steel cable, paper mache, marbled paper, artificial branches, silicone, styrofoam balls. Images courtesy the artist

P.84 Kuang-Yi Ku, *Tiger Penis Project*, 2018. Mixed media. Image courtesy the artist. Photo Ronald Smits

P.85L Kuang-Yi Ku, *Perverted Norm, Normal Pervert*, 2020. Mixed media. Images courtesy the artist

P.85R Kuang-Yi Ku, *Tiger Penis Project*, 2018. Orthodontic resin. Image courtesy the artist. Photo Yu-Tzu Huang

P.86L Glenn Gaudette, Decellularized leaf after perfusion of Ponceau Red. Fluorescent microspheres of various diameters and blank fluid are perfused through a decellularized leaf, 2017. Image courtesy Worcester Polytechnic Institute [Glenn Gaudette et al., 'Crossing kingdoms: Using decellularized plants as perfusable tissue engineering scaffolds', *Biomaterials*, Vol. 125, 2017]

PP.86–87B, L–R Glenn Gaudette, Spinach leaf as grown in a garden. The green colour is due to the plant cells; Spinach leaf after the plant cells have been removed; Red dye injected into a decellularized spinach leaf, 2017. Images courtesy Worcester Polytechnic Institute

P.87A Glenn Gaudette, Spinach leaf about 2 days into the decellularization process. Solution is perfused (via gravity) from the top and flows through the leaf veins, 2017. Image courtesy Worcester Polytechnic Institute

P.88 Isaac Monté, *The Meat Project*, 2015. Discarded meat, series of light objects, dimensions variable. Commissioned by and in collaboration with BioArt Laboratories. In the permanent collection of Centre Pompidou, Paris and Design Museum Holon, Israel. Photo Isaac Monté. Images courtesy the artist

P.89 Basse Stittgen, *Blood Related*, 2017–ongoing. Discarded cow's blood. Images courtesy the artist. Photos Basse Stittgen. © Basse Stittgen

P.90BL Avril Corroon, *Spoiled Spores*, 2019. 27-30 cheese wheels, 4 commercial chiller fridges, 32" TV, 4K film, duration 9 minutes. Photo Goldsmiths University. Image courtesy the artist

PP.90–91B, P.91A, B Avril Corroon, *Spoiled Spores*, 2019. Cheese wheels, commercial chiller fridge. Photos Louis Haugh at the LAB in Dublin. Images courtesy the artist

PP.90–91A Avril Corroon, *Spoiled Spores*, 2019. Cheese wheels, galvanised steel shelving. Photo Louis Haugh at the LAB in Dublin. Image courtesy the artist

PP.92–93 Dana Cupkova and Ben Snell, *Bread Bondage: Experiments in Gradient Casting and Voluptuousness*, 2016. Images courtesy Epiphyte Lab and Ben Snell

P.94 Candice Lin, *Memory (Study #2)*, 2016. Distilled communal piss of the people hosting the work, glass jar, Lion's mane mushrooms in substrate, plastic, 24 x 33 x 23 (9.5 x 13 x 9). Photo Dario Lasagni. Image courtesy the artist and François Ghebaly Gallery

P.95 Jaime Pitarch, *Chernobyl*, 2009. Deconstructed and reassembled matryoshka doll, 50 x 23.9 x 23.9 (19.7 x 9.4 x 9.4). Image courtesy the artist and Spencer Brownstone Gallery

P.96A Daniel Giordano in his studio, working on *My Scorpio II*, 2021. Photo Kyle Knodell. Image courtesy the artist

P.96C Daniel Giordano, *My Scorpio I*, 2016–2022. 1970s Husqvarna motocross bikes, aluminium, Canadian maple syrup, cattails, ceramic, cling wrap, construction adhesive, deep-fried batter, epoxy, phosphorescent acrylic, railroad spikes, shellac, steel, stockfish, urinal cake, 223.5 x 182.9 x 61 (88 x 72 x 24). Photo Ernesto Eisner. Image courtesy the artist

P.96B Daniel Giordano, *My Mon Calamari II*, 2015–2020. 24 karat gold leaf, acrylic house paint, acrylic varnish, artificial teeth, bald eagle excrement, butterflies, Canadian dime, ceramic, ceramic glaze, construction adhesive, epoxy, eyeshadow, glass, glitter, limestone, linseed oil, makeup foundation, natural waxes, Nesquik Strawberry Powder, Northeastern Fast-Dry tennis court surface, oil-based clay, pigment, shellac, silicone, sparklers, Tang drink mix, tennis ball, toddler sneaker insole, tuna fin, urethane, wax, wood, 77.5 x 43.2 x 48.3 (30.5 x 17 x 19). Photo Ernesto Eisner. Image courtesy the artist

P.97 Daniel Giordano, *Cannoli (The Grip of Goran)*, 2016–2021. 24K gold leaf, acrylic paint, ceramic, contact lens, cork, dog ticks, epoxy, eyeshadow, faux fur, fibered aluminium coating, hardware, leather, lichen, marine foam, Megan Murphy Martinez's hair, milk paint, Murano glass, peat, pigment, sewing machine needle, sewing machine timing belt, sparklers, steel, Tang drink mix, tennis ball, tennis racket grommet, tennis racket string, thread spool, 50.8 x 58.4 x 53.3 (20 x 23 x 21). Photos Ernesto Eisner. Images courtesy the artist

PP.98–99A David Altmejd, *The Flux and the Puddle*, 2014. Plexiglas, quartz, polystyrene, expandable foam, epoxy clay, epoxy gel, resin, synthetic hair, clothing, leather shoes, thread, mirror, plaster, acrylic paint, latex paint, metal wire, glass eyes, sequin, ceramic, synthetic flowers, synthetic branches, glue, gold, feathers, steel, coconuts, aqua resin, burlap, lighting system including fluorescent lights, Sharpie ink, wood, coffee grounds, and polyurethane foam, 327.7 x 640.1 x 713.7 (129 1/8 x 252 1/8 x 281). Collection Giverny Capital, on long term loan to the Musée National des Beaux-Arts du Québec, Canada. Images courtesy the artist

PP.98–99B David Altmejd, *Spirit Transfer*, 2019. Expandable foam, epoxy clay, epoxy gel, resin, wood, steel, hair, acrylic paint, quartz, glass eyes, pencil, mechanical pencil, metal wire, and glass rhinestones, 71.1 x 50.8 x 50.8 (28 x 20 x 20). Courtesy of the artist and David Kordansky Gallery. Photos Jeff McLane

PP.100–101 Minimal Cell – JCVI-syn3.0. Electron micrographs of clusters of JCVI-syn3.0 cells magnified about 15,000 times. Image by Tom Deerinck and Mark Ellisman of the National Center for Imaging and Microscopy Research at the University of California at San Diego

P.102 Tina Gorjanc, *Phylogenetic Atelier: de-extincting a species from the past*, 2018. Pigeon skin, pigeon feathers, preserved pigeon, brass, glass, clay, wood, paper. Commission from the Science Gallery Dublin, part of the Trinity College Dublin. Image courtesy the artist

P.103L Nathan Thompson, Guy Ben-Ary and Sebastian Diecke, *Bricolage*, 2020. Living cardiomyocytes, silk, electronics, clay, glass and metal. Installation view, Fremantle Art Centre, Perth 2020. Photo Simon Thompson. Image courtesy Guy Ben-Ary

P.103R Sonja Bäumel, *Entangled Relations – Animated Bodies*, 2022. Official Austrian contribution to the 23rd Triennale di Milano International Exhibition 2022, Milan, Italy. Photo © Gianluca Di Ioia. Image courtesy the artist

P.104L Tina Gorjanc, *Pure Human: Exploring the Commodification of Human Flesh as a New Form of Luxury*, 2016. Pigskin, silicon, acrylic paint, hair, growth medium, temporary tattoos, metal fastenings, metal, glass, vinyl, paper. Final Master's Project on the Material Futures Course, Central Saint Martins School of Art and Design, London. Photo Tom Mannion, 2016. Image courtesy the artist

P.104R Isaac Monté, *The Art of Deception*, 2015. Mixed media. Series of manipulated pig hearts. Collection of 21 in glass vessels. In collaboration with Professor Toby Kiers (Free University Amsterdam). Commissioned by Bio Art & Design Awards, with the support of ZonMw (The Netherlands Organisation for Health Research and Development). Photo Hanneke Wetzer. Image courtesy the artist

P.105 Thomas Feuerstein, *Prometheus Delivered*, 2017. Marble, plastic tubes, stainless steel tub, euro-pallet, scissor lift table, 280 x 145 x 85 (110 1/4 x 57 1/8 x 33 ½). Exhibition view, *Prometheus Delivered*, Haus am Lützowplatz, Berlin, 2017. Image courtesy the artist

P.106 Johan U. Lind et al., Heart-on-a-Chip, 2017. Image courtesy Michael Rosnach and Johan U. Lind, Disease Biophysics Group/Lori K. Sanders, Lewis Lab/Harvard University [Johan U. Lind, Travis A. Busbee, Alexander D. Valentine, Francesco S. Pasqualini, Hongyan Yuan, Moran Yadid, Sung-Jin Park, Arda Kotikian, Alexander P. Nesmith, Patrick H. Campbell, Joost J. Vlassak, Jennifer A. Lewis and Kevin Kit Parker, 'Instrumented cardiac microphysiological devices via multimaterial three-dimensional printing', *Nature Materials*, 16, 3, 2017]

P.107L Kiara Eldred, Day 322 organoid: 600x magnification confocal image of the organoid retinal tissue. Green: L-opsin and M-opsin cells. Red: Cone-rod homeobox transcription factor. Blue: S-opsin cells, 2015. Image courtesy Kiara Eldred, Johns Hopkins University, 2015

P.107R Kiara Eldred, Day 361 organoid: 200x magnification confocal image of the organoid retinal tissue. Green: L-opsin and M-opsin cells. Red: Rhodopsin. Blue: S-opsin cells, 2016. Image courtesy Kiara Eldred, Johns Hopkins University, 2015

PP.108–109 Sean Raspet and Kiara Eldred, *Screen (EP1.1 iPSCs stem cell line-derived human retinal organoids)*, 2018–19. Installation view, 'Sean Raspet, New Molecules & Stem Cell Retinoid Screen', Empty Gallery, Hong Kong, 2019. Photos Michael Yu. Images courtesy Empty Gallery

PP.110–111 Minimal Cell – JCVI-syn3.0. Electron micrographs of clusters of JCVI-syn3.0 cells magnified about 15,000 times. Images by Tom Deerinck and Mark Ellisman of the National Center for Imaging and Microscopy Research at the University of California at San Diego

P.112 John Walter, *A Virus Walks Into A Bar* (stills), 2018. HD video, 19 minutes 54 seconds. Images courtesy the artist © John Walter. All rights reserved, DACS 2025

P.113L John Walter, *Fist (triskelion)*, 2018. Vacuum metalised object and novelty drinking fist, 57 x 36 x 15 (22 ½ x 14 ¼ x 6). Photo Jonathan Bassett. Image courtesy the artist © John Walter. All rights reserved, DACS 2025

P.113R John Walter, *ENV*, 2017. Buttons sewn on onesie. Photo Jonathan Bassett. Image courtesy the artist © John Walter. All rights reserved, DACS 2025

PP.114–115 Jiwon Woo, *Hand Taste*, 2016–17. Living bacteria, glasses, agar. Images courtesy the artist

P.116L Donald Ingber, M.D., Ph.D., Human Organs-on-Chips: Lung-on-a-Chip illuminated by natural light, 2011–12. Image courtesy Wyss Institute at Harvard University

P.116R Donald Ingber, M.D., Ph.D., Human Organs-on-Chips: Lung-on-a-Chip illuminated by green fluorescent light, 2011–12. Image courtesy Wyss Institute at Harvard University

P.117 Nathan Thompson, Guy Ben-Ary and Sebastian Diecke, *Bricolage*, 2020. Living cardiomyocytes, silk, electronics, clay, glass and metal. Installation view, Fremantle Art Centre, Perth 2020. Photo Simon Thompson. Image courtesy Guy Ben-Ary

PP.118–119 Tina Gorjanc, *Phylogenetic Atelier: de-extincting a species from the past*, 2018. Pigeon skin, pigeon feathers, preserved pigeon, brass, glass, clay, wood, paper. Commission from the Science Gallery Dublin, part of the Trinity College Dublin. Images courtesy the artist

P.120, P.121B Tina Gorjanc, *Pure Human 0.01: An Exploration of the Intersection Between Luxury and Biology*, 2016. Pigskin, silicon, acrylic paint, temporary tattoos, vinyl, alginate, paper. Project developed on the Material Futures Course, Central Saint Martins School of Art and Design, London. Image courtesy the artist

P.121A Tina Gorjanc, *Pure Human: Exploring the Commodification of Human Flesh as a New Form of Luxury*, 2016. Tattooed leather jackets mimic inked skin alteration techniques. Pigskin, silicon, acrylic paint, hair, growth medium, temporary tattoos, metal fastenings, metal, glass, vinyl, paper. Final Master's Project on the Material Futures Course, Central Saint Martins School of Art and Design, London. Image courtesy the artist

P.122A Burton Nitta (Michael Burton & Michiko Nitta), *Grown Larynx*, from *New Organs of Creation*, 2019. Image courtesy the artists

P.122B Burton Nitta (Michael Burton & Michiko Nitta), *Prototype larynx*, from *New Organs of Creation*, 2019. Image courtesy the artists

P.123A Burton Nitta (Michael Burton & Michiko Nitta), *Suit to perform the new voice*, from *New Organs of Creation*, 2019. Image courtesy the artists

P.123B Burton Nitta (Michael Burton & Michiko Nitta), *Voice of Transformation*, from *New Organs of Creation*, 2019. Image courtesy the artists

P.124L Sonja Bäumel, *Entangled Relations – Animated Bodies*, 2022. Official Austrian contribution to the 23rd Triennale di Milano International Exhibition 2022, Milan, Italy. Photo © Gianluca Di Ioia. Image courtesy the artist

P.124R Sonja Bäumel, *Entangled Relations – Animated Bodies*, 2022. Official Austrian contribution to the 23rd Triennale di Milano International Exhibition 2022, Milan, Italy. Photo © Maurizio Montalti. Image courtesy the artist

P.125 Sonja Bäumel, *Microbial entanglement, in vitro break out*, 2019. Frankfurter Kunstverein, Germany. Photo © Robert Schittko. Image courtesy the artist

P.126A Cecilia Jonsson and Rodrigo Leite de Oliveira, *Haem*, 2016. Video still. Commissioned by Bio Art & Design Awards 2016 with the support of ZonMw (The Netherlands Organisation for Health Research and Development). In cooperation with The Netherlands Cancer Institute, OLVG West hospital and blacksmith Thijs Van der Manakker. Photo Signe Tørå Karsrud. Image courtesy of the artist

P.126B Cecilia Jonsson and Rodrigo Leite de Oliveira, *Haem*, 2016. Detail compass. Commissioned by Bio Art & Design Awards 2016 with the support of ZonMw (The Netherlands Organisation for Health Research and Development). In cooperation with The Netherlands Cancer Institute, OLVG West hospital and blacksmith Thijs Van der Manakker. Photo Signe Tørå Karsrud. Image courtesy the artist

P.127 Cecilia Jonsson and Rodrigo Leite de Oliveira, *Haem*, 2016. Installation view. Commissioned by Bio Art & Design Awards 2016 with the support of ZonMw (The Netherlands Organisation for Health Research and Development). In cooperation with The Netherlands Cancer Institute, OLVG West hospital and blacksmith Thijs Van der Manakker. Photo Signe Tørå Karsrud. Image courtesy the artist

P.128A Isaac Monté, *The Art of Deception*, 2015. Mixed media. Series of manipulated pig hearts. Collection of 21 in glass vessels. In collaboration with Professor Toby Kiers (Free University Amsterdam). Commissioned by Bio Art & Design Awards, with the support of ZonMw (The Netherlands Organisation for Health Research and Development) Photo Hanneke Wetzer. Image courtesy the artist

P.128B Isaac Monté, *The Art of Deception*, 2015. Photos Monica Monté. Images courtesy the artist

P.129 Maurizio Montalti (Officina Corpuscoli), Liz Ciokajlo, *Caskia / Growing a MarsBoot*, 2016–20. Commissioned by the Museum of Modern Art (MoMA) Senior Curator, Paola Antonelli for the

Additional contributors: Rhian Solomon and Manolis Papastavrou. Mycelium materials provided by: Officina Corpuscoli & MOGU. Film credits: Craig Gambell, George Ellsworth, Wim van Egmond. Photos George Ellsworth. © Officina Corpuscoli & Liz Ciokajlo

PP.130–131 Emma Dorothy Conley, *Microbiome Security Agency*, 2015. Images courtesy the artist

P.132A Thomas Feuerstein, Exhibition view, *Prometheus Delivered*, Haus am Lützowplatz, Berlin, 2017. Image courtesy the artist

P.132B Thomas Feuerstein, *Kasbek*, 2017. Glass, steel, pyrite, chemolithoautotrophic bacteria (Acidithiobacillus ferrooxidans), plastic tubes, measurement and control technology, 260 x 100 x 75 (102 3/8 x 39 3/8 x 29 5/8). Exhibition view, *Prometheus Delivered*, Haus am Lützowplatz, Berlin, 2017. Image courtesy the artist

P.133AL Thomas Feuerstein, *Deep and Hot*, 2017. Stainless steel, Thermoset, 220 x 120 x 110 (86 5/8 x 47 ¼ x 43 3/8). Image courtesy the artist

P.133AR Thomas Feuerstein, *Octoplasma*, 2017. Glass, human liver cells (hepatocytes) with fibroblasts, formalin, aluminium, plastic, 70 x 43 (27 5/8 x 17). Biotechnological realisation: Thomas Seppi, Department of Radiotherapy and Radiooncology, Medical University of Innsbruck. Image courtesy the artist

P.133B Thomas Feuerstein, *Prometheus Delivered*, 2017. Marble, plastic tubes, stainless steel tub, euro-pallet, scissor lift table, 280 x 145 x 85 (110 1/4 x 57 1/8 x 33 ½). Exhibition view, *Prometheus Delivered*, Haus am Lützowplatz, Berlin, 2017. Images courtesy the artist

PP.134–135 Xuejian Niu, Aerobat, 2023. Xuejian Niu, 'Towards aerial mobility in confined spaces using Northeastern's Aerobat', Northeastern University MS Thesis, May 2023

P.136A Sawyer Buckminster Fuller, Assembling parts for the University of Washington Robofly, 2022. Photo © Matt Stone, University of Washington

P.136B Sawyer Buckminster Fuller, Adding a wing, 2022. Photo © Matt Stone, University of Washington

P.137A Ho-Young Kim and Kyu-Jin Cho, Robotic water strider, 2013–15. Image Seoul National University

P.137B Jip van Leeuwenstein, *A Diverse Monoculture, Dionaea Mechanica Muscipula*, 2008. Acrylic glass, aluminium, stainless steel, nylon, polylactic, electronic components. Image courtesy the artist

P.138A Michael Candy, *Synthetic Pollenizer* (detail), 2014–17. Robotic flower. Image courtesy the artist

P.138B Hideyuki Sawada, *Talking Robot*, 2011. Waseda University. Image courtesy Hideyuki Sawada

P.139 The Alternative Limb Project, *The Vine 2.0*, 2022. Created by Sophie de Oliveira Barata, Dani Clode, Rory Thompson & Jason Taylor. Made for Kelly Knox. Photo Suede Baby. Choreography @welly_obrien. Stylist support @saffka & @jennastinawhelby. Dress @jivomir.domoustchiev. Make-up and hair @beauty_byjordana. Location @ klatchstudio. Image courtesy the artist

P.140 Sawyer Buckminster Fuller, A four-winged robotic fly, 2019. Photo Sawyer Buckminster Fuller. Image courtesy Sawyer Buckminster Fuller, University of Washington

P.141A Sawyer Buckminster Fuller, A robotic flying insect with a fruit-fly inspired wind sensor (yellow) for improved flight in windy conditions, 2013. Image courtesy Sawyer Buckminster Fuller, University of Washington

P.141B Sawyer Buckminster Fuller, A robotic flying insect carrying an avionics circuit board for sensing and flight control, 2021. Photo © Matt Stone, University of Washington

PP.142–143 Ho-Young Kim and Kyu-Jin Cho, Robotic water strider, 2013–15. Images Seoul National University

PP.144–145 Tommaso Ranzani et al., Soft robotic spiders, 2018. Photos courtesy the Wyss Institute at Harvard University [Tommaso Ranzani, Sheila Russo, Nicholas W. Bartlett, Michael Wehner, Robert J. Wood, 'Increasing the Dimensionality of Soft Microstructures through Injection-Induced Self-Folding', *Advanced Materials*, Vol. 30, Issue 38, 20 September 2018]

P.146A Alireza Ramezani, Bat Bot, 2016. Alizera Ramezani and Seth Hutchinson, 'A biomimetic robotic platform to study flight specializations of bats', *Science Robotics*, Vol. 2, Issue 3, 2017

P.146BL Adarsh Salagame, Aerobat, 2022. Adarsh Salagame, 'Progress Towards Untethered Autonomous Flight of Northeastern University's Aerobat', Northeastern University MS Thesis, Aug 2022

P.146BR Xuejian Niu, Aerobat, 2023. Xuejian Niu, 'Towards aerial mobility in confined spaces using Northeastern's Aerobat', Northeastern University MS Thesis, May 2023

P.147 Adarsh Salagame and Xintao Hu, Aerobat, 2022. Eric Sihite, Xintao Hu, Bozhen Li, Adarsh Salagame, Paul Ghanem, Alireza Ramezani, 'Bang-Bang Control of a Tail-less Morphing Wing Flight', May 2022. arXiv:2205.06395

P.148 Mark R. Cutkosky, Stanford University, and Sangbae Kim, Massachusetts Institute of Technology, Stickybot, 2010. Images courtesy Sangbae Kim

P.149 William Roderick, Mark R. Cutkosky and David Lentink, Stereotyped Nature-Inspired Aerial Grasper (SNAG) perches on branches using bird-inspired feet and legs, 2021. Photo William Roderick. Image courtesy William Roderick, Mark Cutkosky and David Lentink

P.150 Rihards Vitols, *Woodpecker*, 2016. 30 woodpeckers, a branch, projection, 2 wooden frames with barks. Images courtesy the artist

P.151A Jip van Leeuwenstein, *A Diverse Monoculture*, 2017. Acrylic glass, aluminium, stainless steel, nylon, polylactic, electronic components. Image courtesy the artist

P.151B Jip van Leeuwenstein, *A Diverse Monoculture, Dionaea Mechanica Muscipula*, 2018. Acrylic glass, aluminium, stainless steel, nylon, polylactic, electronic components. Image courtesy the artist

PP.152–153 Michael Candy, *Synthetic Pollenizer*, 2014–17. Robotic flower. Images courtesy the artist

PP.154–155 The Alternative Limb Project, *The Vine 2.0*, 2022. Created by Sophie de Oliveira Barata, Dani Clode, Rory Thompson & Jason Taylor. Made for Kelly Knox. Photos Suede Baby. Choreography @welly_obrien. Stylist support @saffka & @jennastinawhelby. Dress @jivomir.domoustchiev. Make-up and hair @beauty_byjordana. Location @ klatchstudio. Images courtesy the artist

P.156A Martin Riches, *The Talking Machine*, 1989–91. 32 pipes and air valves, wind chests, magazine bellows, blower, computer, height 230 (90 5/8). From the exhibition 'Wolfgang von Kempelen, Mensch-[in der]-Maschine', ZKM, Center for Art and Media Karlsruhe, 2007. Photo Marc Wathieu

P.156B Martin Riches, A comparison of how a human being and MotorMouth speak the vowels, 1994–99. Image courtesy the artist

PP.156–157 Martin Riches, *The Talking Machine*, 1989–91. 32 pipes and air valves, wind chests, magazine bellows, blower, computer. Photo Martin Riches. Image courtesy the artist

P.157R Martin Riches, *MotorMouth*, 1994–99. 8 stepping motors, blower, micro-computer, interface, and wooden case, height 86 (33 7/8). Berlinische Galerie. Photo Kai-Annett Becker/Berlinische Galerie

PP.158–159 Hideyuki Sawada, *Talking Robot*, 2011. Waseda University. Images courtesy Hideyuki Sawada

PP.160–161 Maarten Vanden Eynde, *Cosmic Connection*, Verbeke Foundation, Kemzeke, Belgium, 2016. Metal, recycled telephone and computer circuit boards, 300 x 800 x 800 (118 1/8 x 315 x 315). Photo Maarten Vanden Eynde. Image courtesy the artist

P.162 Julian Charrière, *The Blue Fossil Entropic Stories I*, 2013. Archival pigment print on Hahnemühle Photo Rag Ultra Smooth, mounted on aluminium Dibond, framed, Mirogard anti-reflective glass. Image courtesy the artist. Julian Charrière © DACS 2025

P.163A Julian Charrière, *We Are All Astronauts*, 2013. Found globes made of glass, plastic and cardboard; abraded with international mineral sandpaper, abraded dust from globes' surfaces, steel base with MDF-tabletop. Installation view, 'Towards No Earthly Pole', Aargauer Kunsthaus, Aarau, Switzerland, 2020. Photo Jens Ziehe. Image courtesy the artist. Julian Charrière © DACS 2025

P.163B HeHe (Helen Evans and Heiko Hansen), *Nuage Vert (Green Cloud)*, Saint-Ouen, 2009. Laser beam, laser controller, custom built software, thermal camera. Photo HeHe (Helen Evans and Heiko Hansen), 2009

P.164A HeHe (Helen Evans and Heiko Hansen), *Tapis Volant (Flying Carpet,)* 2005. Textile, wood, modified scooter, electronics, reed switch. Photo HeHe (Helen Evans and Heiko Hansen), 2008

P.164B Kathryn Fleming, *Ursa-Hibernation Station*, 2018. Black bear skin, LCD screen, acrylic rod, acrylic dome, acrylic sheet, Baltic birch plywood, silicone, LCD Lights, animatronics. Image courtesy the artist

P.165 Makoto Aida and 21st Century Cardboard Guild, *Monument for Nothing II*, 2008~Mori Art Museum, Tokyo, 2012–13. Image courtesy Mizuma Art Gallery

P.166 Julian Charrière, *The Blue Fossil Entropic Stories III*, 2013. Archival pigment print on Hahnemühle Photo Rag Ultra Smooth, mounted on aluminium Dibond, framed, Mirogard anti-reflective glass. Image courtesy the artist. Julian Charrière © DACS 2025

P.167 Julian Charrière, *Tropisme*, 2014. Cryogenized plants, refrigerated showcase. Installation view, 'Future Fossil Spaces', Musée Cantonal des Beaux-Arts, Lausanne, Switzerland, 2014. Image courtesy the artist. Julian Charrière © DACS 2025

P.168 Julian Charrière, *We Are All Astronauts*, 2013. Found globes made of glass, plastic and cardboard; abraded with international mineral sandpaper, abraded dust from globes' surfaces, steel base with MDF-tabletop. Installation view, 'Towards No Earthly Pole', Aargauer Kunsthaus, Aarau, Switzerland, 2020. Photos Jens Ziehe. Images courtesy the artist. Julian Charrière © DACS 2025

P.169 Agnes Meyer-Brandis, *Teacup Tools*, 2014–ongoing. The project was created in the scope of the Climate Whirl project, organized by University of Helsinki and Capsula, with the support of Kone Foundation and the Research Raft – Institute for Art and Subjective Science. © Agnes Meyer-Brandis, DACS 2025

P.170, P.171A Olafur Eliasson and Minik Rosing, *Ice Watch*, 2014. 12 ice blocks. Place du Panthéon, Paris, 2015. Photos Martin Argyroglo. Images courtesy the artist; neugerriemschneider, Berlin; Tanya Bonakdar Gallery, New York/Los Angeles. © 2014 Olafur Eliasson

P.171B Olafur Eliasson and Minik Rosing, *Ice Watch*, 2014. Installation view: Bankside, outside Tate Modern, London, 2018. Supported by Bloomberg. Photo Charlie Forgham-Bailey. Image courtesy the artist; neugerriemschneider, Berlin; Tanya Bonakdar Gallery, New York/Los Angeles. © 2014 Olafur Eliasson

P.172 Prokop Bartoníček and Benjamin Maus, *Jller*, 2015. Electronics, mechanics, wood, plastic, stones of Jller river, 420 x 220 x 40 (165 3/8 x 86 5/8 x 15 ¾). Photos Ex Post Gallery archive. Images courtesy the artist

P.173L HeHe (Helen Evans and Heiko Hansen), *Nuage Vert (Green Cloud)*, Ivry-sur-Seine, 2010. Laser beam, laser controller, custom built software, thermal camera. Photo HeHe (Evans & Hansen), 2010

P.173AR HeHe (Helen Evans and Heiko Hansen), *Fleur de Lys*, 2009. Aquarium, water, dye, pumps, electronics, leds, sound system. Photo Franz Wamhof, 2014

P.173BR HeHe (Helen Evans and Heiko Hansen), *Fleur de Lys*, 2009. Aquarium, water, dye, pumps, electronics, leds, sound system. Photo Marc Paeps, courtesy Aeroplastics Contemporary, 2014

P.174L HeHe (Helen Evans and Heiko Hansen), *M-Blem*, 2012. Aluminium, train wheels, electronic wheel-motor, battery, electronics, solar panels, polycarbonate, PMMA, end switches. Photo HeHe (Evans & Hansen), 2012

P.174R HeHe (Helen Evans and Heiko Hansen), *H-Line*, 2007. Carboard, wheels, paint, string. Photo HeHe (Evans & Hansen), 2012

P.175A HeHe (Helen Evans and Heiko Hansen), *Slow Train*, 2020. Aluminium, composite panels, wheelchair wheels, bicycle mechanics, plywood. Photo HeHe (Evans & Hansen), 2020

P.175B HeHe (Helen Evans and Heiko Hansen), *Tapis Volant (Flying Carpet)*, 2005. Textile, wood, modified scooter, electronics, reed switch. Photo Ali Taptik, 2005

P.176 Maarten Vanden Eynde, *Cosmic Connection* (detail of maquette), Meessen Gallery, Brussels, Belgium, 2016. Metal, recycled telephone and computer circuit boards, 20 x 100 x 100 (7 7/8 x 39 3/8 x 39 3/8). Photo Philippe de Gobert. Image courtesy the artist

P.177 Maarten Vanden Eynde, *Cosmic Connection*, Verbeke Foundation. Kemzeke, Belgium, 2016. Metal, recycled telephone and computer circuit boards, 800 x 300 x 800 (315 x 118 1/8 x 315). Photo Maarten Vanden Eynde. Image courtesy the artist

P.178A Maarten Vanden Eynde, *Horror Vacui*, 2016. Latex mould, marble and butcher's scale, 50 x 60 x 30 (19 3/4 x 23 5/8 x 11 7/8). Photo Philippe de Gobert. Image courtesy the artist

P.178B Maarten Vanden Eynde, *The Invisible Hand*, 2015. Natural rubber, Victorian mahogany display, 69 x 78 x 40 (27 1/4 x 30 3/4 x 15 1/4). Photo Philippe de Gobert. Image courtesy the artist

P.179A Maarten Vanden Eynde, *The Invisible Hand* (making of), Brussels, 2015. Photo Marjolijn Dijkman. Image courtesy the artist

P.179B Maarten Vanden Eynde, *The Invisible Hand* (making of), Ngel Ikwok, Kasai-Occidental, Democratic Republic of Congo, 2015. Image courtesy the artist

P.180 Uli Westphal, *Elephas Anthropogenus*, 2008. Inkjet pigment print on canvas and cardstand, 225 x 150 (88 5/8 x 59 1/8). Image courtesy the artist

P.181 Kathryn Fleming, *Ursa-Hibernation Station*, 2018. Black bear skin, LCD screen, acrylic rod, acrylic dome, acrylic sheet, Baltic birch plywood, silicone, LCD Lights, animatronics. Images courtesy the artist

PP.182–183 Thomas Demand, *Grotto*, 2006. Chromogenic print face-mounted on acrylic, 198 x 440 (78 x 173 1/4). San Francisco Museum of Modern Art. Gift of the Pilara Family Foundation. Photo Katherine Du Tiel/SFMOMA. Thomas Demand © DACS 2025

P.184 Makoto Aida and 21st Century Cardboard Guild, *Monument for Nothing II*, 2008~. Kirishima Open-Air Museum, Kagoshima, 2014. Image courtesy Mizuma Art Gallery

P.185 Makoto Aida and 21st Century Cardboard Guild, *Monument for Nothing II*, 2008~. Mori Art Museum, Tokyo, 2012–13. Image courtesy Mizuma Art Gallery

P.186L Arakawa and Madeline Gins, *Site of Reversible Destiny – Yoro Park*, bird's-eye view of *Elliptical Field*, 1995. Yoro, Gifu Prefecture, Japan. Park/architecture, total area 18100 sq.m (195000 sq.ft). Photo courtesy The Site of Reversible Destiny—Yoro Park. © 1997 Reversible Destiny Foundation. Reproduced with permission of the Reversible Destiny Foundation

P.186R Arakawa and Madeline Gins, *Site of Reversible Destiny – Yoro Park*, *Critical Resemblance House*, 1995. Yoro, Gifu Prefecture, Japan. Park/architecture, total area 18100 sq.m (195000 sq.ft). Photo courtesy The Site of Reversible Destiny—Yoro Park. © 1997 Reversible Destiny Foundation. Reproduced with permission of the Reversible Destiny Foundation

P.187AL Arakawa and Madeline Gins, *Site of Reversible Destiny – Yoro Park*, *Reversible Destiny Office* (interior), 1997 Yoro, Gifu Prefecture, Japan. Park/architecture, total area 18100 sq.m (195000 sq.ft). Photo courtesy The Site of Reversible Destiny—Yoro Park. © 1997 Reversible Destiny Foundation. Reproduced with permission of the Reversible Destiny Foundation

P.187AR Arakawa+Gins, *Bioscleave House (Lifespan Extending Villa)*, interior, 2008. East Hampton, NY. Residence, 255 sq.m (2700 sq.ft). Photo Eric Striffler. © 2008 Reversible Destiny Foundation. Reproduced with permission of the Reversible Destiny Foundation

P.187B Arakawa+Gins, *Reversible Destiny Lofts Mitaka—In Memory of Helen Keller* (interior), 2005. Mitaka, Tokyo, Japan. Nine residential apartments, total floor are 761.46 sq.m (8196 sq.ft). Photo Masataka Nakano. © 2005 Reversible Destiny Foundation. Reproduced with permission of the Reversible Destiny Foundation

PP.188–189 Baron Lanteigne, *Manipulation 5*, 2021. Still from seamless loop animation. Image courtesy the artist

P.190 enormousface [/Kalan Shh], *Brooklyn Studio Squat*, May 2019. Garbage, textile, rat shit, paint balls, 304.8 x 304.8 x 170.2 (120 x 120 x 67 1/8). Photo Miao Jiaxin, Brooklyn. Image courtesy the artist

P.191A Mette Sterre, *Seapussy Power Galore – Abcession (if you don't know, you don't grow)*, 2021. Performance at the Grand Hotel Prishtina. Image courtesy the artist

P.191B Lotje van Lieshout, *The Permutable Snackbar, Show-maker AI Variation*, 2023. AI-generated image. Photo Lotje van Lieshout. Image courtesy the artist

P.192 Baron Lanteigne, *Manipulation 6*, 2021. Selected stills from seamless loop animation. Images courtesy the artist

P.193A Michael Candy, *Celestial Bed*, 2022. Stainless steel, silicone, urethane, latex, plastics, custom servo actuators and control system. Built in collaboration with AGF Hydra and Georgie Mattingley. Photo Rémi Chauvin

P.193B Kim Jones, performance at Barbara Gladstone Gallery, New York, 2012–13. Photograph, 25.4 x 20.3 (10 x 8). Photo Megan Ratnek. Courtesy Zeno X Gallery, Antwerp

P.194 Rafał Zajko, *Amber Chamber*, 2020. MDF, perspex, plaster, acrylic paint, rubber strap, barley, wheat, silk, valchromat, vape smoke, 90 x 250 x 130 (35 1/2 x 98 1/2 x 51 1/4). Images courtesy the artist

P.195L melanie bonajo, *Furniture Bondage (Anne)*, 2007–2009. Ultrachrome print, canson, bubond, museumglass, framed 151.8 x 120.8 (59 7/8 x 47 5/8). Courtesy the artist and AKINCI

P.195R melanie bonajo, *Furniture Bondage (Hanna)*, 2007–2009. Ultrachrome print, canson, bubond, museumglass, framed 151.8 x 120.8 (59 7/8 x 47 5/8). Courtesy the artist and AKINCI

P.196A enormousface [/Kalan Shh], *Cart Dept: Monument to Capitalism Colonialism & Hetcropatriarchy* (performance still from monument's destruction), June 2018. cardboard boxes, string, shopping cart, metal garbage, chains, condoms, chair, hair mask, costume, 304.8 x 304.8 x 609.6 (120 x 120 x 240). Photographed by Miao Jiaxinin, Grace Space NYC. Image courtesy the artist

P.196B enormousface [/Kalan Shh], *Anarchist Puppet Show/Extinction Songs Double Feature*, 2019. Puppets, extinct species from future, great stuff, garbage, NYC subway system, post-industrial capitalism, polyps, necklace of spoons, baby bear skull, 15 minutes. Photo Richard Termine, 14th St. Image courtesy the artist

P.197 enormousface [/Kalan Shh], *Performance Cart*, June 2015. Garbage, shopping cart, cardboard, toys, playdough, foam, balloons, string, styrofoam, 152.4 x 121.9 x 457.2 (60 x 48 x 180). Photo Hsin Wang, Brooklyn. Image courtesy the artist

P.198 Anonymous, *Possible LaRhaata Cultist Ritual Sighting*, May 2017. Glyphs, traditional regalia. Photo Walter Wlodarczyk, NYC. Image courtesy Walter Wlodarczyk

P.199A Agnes Meyer-Brandis, *SPACE SUIT TESTING, Astronaut Training Method no. XIII*, video still, from *Moon Goose Colony*, 2008–the present. 'THE MOON GOOSE ANALOGUE: Lunar Migration Bird Facility' by Agnes Meyer-Brandis was commissioned by The Arts Catalyst and FACT, in partnership with Pollinaria. © Agnes Meyer-Brandis, DACS 2025

P.199B Agnes Meyer-Brandis, *MOBILE MOON, Astronaut Training Method, No. V*, photograph, 2011, from *Moon Goose Colony*, 2008–the present. 'THE MOON GOOSE ANALOGUE: Lunar Migration Bird Facility' by Agnes Meyer-Brandis was commissioned by The Arts Catalyst and FACT, in partnership with Pollinaria. © Agnes Meyer-Brandis, DACS 2025

P.200A, P.201 Mette Sterre, *Seapussy Power Galore – Abscession (if you don't know, you don't grow)*, 2021. Performed at Rijksakademie van Beeldende Kunsten Open Studios Amsterdam. Photos Nyré Tiessen. Images courtesy the artist

P.200B Mette Sterre, *Seapussy Power Galore – Abscession (if you don't know, you don't grow)*, 2022. Performance at Manifesta 14 Prishtina. Image courtesy the artist

P.202A Lotje van Lieshout, *The Permutable Snackbar, Show-maker AI Variation*, 2023. AI-generated image. Photo Lotje van Lieshout. Image courtesy the artist

P.202BL Lotje van Lieshout, *Suspended noodles with soft shell egg custard*, 2023. AI-generated image. Photo Lotje van Lieshout. Image courtesy the artist

P.202BR Lotje van Lieshout, *Steamed Darwin termite with sour grape biscuits*, 2023. AI-generated image. Photo Lotje van Lieshout. Image courtesy the artist

P.203 Lotje van Lieshout, *The Permutable Snackbar*, video stills, 2023. Video, duration 14 minutes 41 seconds. Photos Lotje van Lieshout. Images courtesy the artist

P.204 Goshka Macuga, *To the Son of Man Who Ate the Scroll*, 2016. Installation view, Fondazione Prada, Milan, 4 February – 19 June 2016. Android, plastic coat, handmade shoes (shoe 1: expandable foam; shoe 2: cardboard, linen). Photo Delfino Sisto Legnani Studio. Courtesy Fondazione Prada. © Goshka Macuga. All rights reserved, DACS 2025

P.205 Christoph Büchel, Piccadilly Community Centre, 2011. Hauser & Wirth, Piccadilly, London, May 13 – July 30, 2011. Courtesy the artist and Hauser & Wirth. Photo (above) Hana Zushi; (below) Guihem Alandry

P.206 Marco Donnarumma, *Amygdala MK1*, 2017. Organic skin, artist's hair, wax, FPGA computer board, custom AI software (adaptive neural networks, reinforcement learning algorithms), servo motors, aluminium chassis, re-purposed industrial-grade server cabinet. Photo Margherita Pevere. Image courtesy the artist

P.207AL Ian Ingram, *Doctor Maggotty is Anxious about The End*, 2015. Rubber, RPT PLA plastic, motors, camera, misc. electronic and mechanical components, custom software. Photo Ian Ingram. Image courtesy the artist

P.207CL Ian Ingram, *Cinderella*, 2019–21. Cinder block, pan-tilt-zoom surveillance camera, junction box, misc. electronic and mechanical components, custom software. Ian Ingram exhibition at Beall Center for Art + Technology, 2021–22. Photo Yubo Dong. Image courtesy the artist

P.207BL Ian Ingram, *Rat Re-Embodied as a Robot*, 2019. RPT ABS plastic, surveillance camera wall bracket, motors, microphone, camera, misc. electronic and mechanical components, custom software. Ian Ingram exhibition at Beall Center for Art + Technology, 2021–22. Photo Yubo Dong. Image courtesy the artist

P.207R Ian Ingram, *Nevermore-A-Matic*, 2016. RPT PLA plastic, motors, camera, misc. electronic and mechanical components, custom software. Photo Ian Ingram. Image courtesy the artist

P.208 Baron Lanteigne, *Manipulation 1*, 2021. Selected stills from seamless loop animation. Images courtesy the artist

P.209A Baron Lanteigne, *Manipulation 3*, 2021. Selected stills from seamless loop animation. Images courtesy the artist

P.209CL Baron Lanteigne, *Manipulation 10*, 2022. Selected stills from seamless loop animation. Images courtesy the artist

P.209CR Baron Lanteigne, *Manipulation 2*, 2021. Selected stills from seamless loop animation. Images courtesy the artist

P.209BL Baron Lanteigne, *Manipulation 5*, 2021. Selected stills from seamless loop animation. Images courtesy the artist

P.209BR Baron Lanteigne, *Manipulation 7*, 2022. Selected stills from seamless loop animation. Images courtesy the artist

P.210A Michael Candy, *Celestial Bed*, 2022. Stainless steel, silicone, urethane, latex, plastics, custom servo actuators and control system. Built in collaboration with AGF Hydra and Georgie Mattingley. Photo Georgie Mattingley

P.210B Michael Candy, *Celestial Bed*, 2022. Stainless steel, silicone, urethane, latex, plastics, custom servo actuators and control system. Built in collaboration with AGF Hydra and Georgie Mattingley. Photo Rémi Chauvin

P.211A Michael Candy, *Celestial Bed*, 2022. Video still from project documentation. Stainless steel, silicone, urethane, latex, plastics, custom servo actuators and control system. Built in collaboration with AGF Hydra and Georgie Mattingley . Image courtesy the artist

P.211B Michael Candy, *Celestial Bed*, 2022. Video still from project documentation. Stainless steel, silicone, urethane, latex, plastics, custom servo actuators and control system. Built in collaboration with AGF Hydra and Georgie Mattingley. Image courtesy the artist

P.212A Kim Jones, *Untitled*, 1975. Photograph, 25.4 x 20.3 (10 x 8). Photo Ned Sloane. Courtesy Zeno X Gallery, Antwerp

P.212B Kim Jones, *Telephone Pole*, 1978. Photograph, 25.4 x 20.3 (10 x 8). Photo Ned Sloane. Courtesy Zeno X Gallery, Antwerp

P.213 Kim Jones, *Untitled*, 1975. Photograph, 25.4 x 20.3 (10 x 8). Photo Ned Sloane. Courtesy Zeno X Gallery, Antwerp

PP.214–215 Jake Elwes, *Zizi – Queering the Dataset*, 2019. Machine learning generated face for Zizi. Courtesy Jake Elwes

P.216 Jake Elwes, *Zizi – Queering the Dataset*, 2019. Multi-channel digital video without audio, 135-minute loop. Courtesy Jake Elwes

P.217A Zach Blas and Jemima Wyman, *im here to learn so :))))))*, 2017. Video still. Commissioned by the Institute of Modern Art, Brisbane. Consulting editor Isabel Freeman. Image courtesy the artists

P.217B Mark Farid, *Data Shadow*, 2015. Shipping container, cell-site simulator, Kinect, custom-built software, sensors for movement tracking, projection system. Image courtesy the artist

P.218A Self-organizing Systems Research Group, Kilobots, 2014. Image courtesy of Mike Rubenstein and Science/AAAS

P.218B Claudia Pasquero and Marco Poletto, *H.O.R.T.U.S. XL Astaxanthin.g*, 2019. 3d printed substratum, micro-algae in biogel medium, 320 x 272 x 114 (126 x 107 1/8 x 45). Photo © NAARO for ecoLogicStudio

P.219A Michael Sedbon, *CMD: Experiment in Bio Algorithmic Politics*, 2019. Concept and production Michael Sedbon. Documentation (photo and video) Maison Mimesis. Funding Bio Arts and Design Awards 2019. Image courtesy the artist

P.219B *Symbiosis*, 2021. Designed and produced by Polymorf in collaboration with Studio Biarritz. Concept, scenario and art direction: Marcel van Brakel. Directed by: Marcel van Brakel and Mark Meeuwenoord. Food design: Karpendonkse Hoeve. Team: Corine Meijers, Marieke Nooren Luciano Pinna, Frank Bosma, Wijnand van Tol, Roberto Digiglio, Maurice Spapens, Martijn Zandvliet, Edwin Kuipers, Hauke Boer, Tim van Nielen, Pom Smit, Ruben Maas, Scott van Haastrecht, Nienke Huitenga-Broeren. Photo Luciano Pinna

PP.220–221 Zach Blas & Jemima Wyman, *im here to learn so :))))))*, 2017. Video stills. Commissioned by the Institute of Modern Art, Brisbane. Consulting editor Isabel Freeman. Images courtesy the artists

P.222A Jake Elwes, *Zizi – Queering the Dataset*, 2019. Machine learning generated face for Zizi. Courtesy Jake Elwes

P.222B Jake Elwes, *The Zizi Show*, 2020. Interactive performance, montage of deepfake drag artists. Director of Drag: Me the Drag Queen. Courtesy Jake Elwes

P.223A Alexandra Daisy Ginsberg, *The Substitute*, video still, 2019. Paired video installation, 6 minutes 18 seconds. Commissioned by the Cooper Hewitt, Smithsonian Design Museum and Cube Design Museum, 2019. Permanent collection of the Cooper Hewitt. © Alexandra Daisy Ginsberg Ltd. Courtesy the artist

P.223B Alexandra Daisy Ginsberg, *The Substitute*, 2019. Paired video installation (projector and screen), 6 minutes 18 seconds. Installation view of *The Substitute* (2019) in 'Apocalypse – End Without End' at Natural History Museum, Bern, 2022. Photo Nelly Rodriguez.

P.224 Total Refusal, *Hardly Working*, 4-channel video installation, 2021, film 2022. Text, direction and concept: Susanna Flock, Robin Klengel, Leonhard Müllner, Michael Stumpf. Images courtesy Total Refusal

P.225 Neil Mendoza, *Robotic Voice Activated Word Kicking Machine*, 2016. Robotic foot, horns, tubes, custom electronics, software, projection. Photo Britt Ransom. Image courtesy the artist

P.226 Mark Farid, *Data Shadow*, 2015. Shipping container, cell-site simulator, Kinect, custom-built software, sensors for movement tracking, projection system. Images courtesy the artist

P.227 Mark Farid, *Poisonous Antidote*, 2016. Custom-built software, pre-existing software, 3D printer, online live newsfeed platform, data collection tools for digital footprint. Collaboration with designer Vicente Gascó (3D printed artwork). Image courtesy the artist

P.228 Stephanie Dinkins, *Not the Only One V1 (black)*, 2018. Cast glass sculpture, deep learning AI, computer, Arduino, sensors. Sculpture 45.7 x 45.7 (18 x 18), pedestal 76.2 x 45.7 x 45.7 (30 x 18 x 18). Photo Sebastian Bach

P.229A Stephanie Dinkins, *Conversations with Bina48: Fragments 7,6,5,2*, 2018. Video installation with sound, 12 minutes, each video 4 minutes. Photo Stephanie Dinkins

P.229B Stephanie Dinkins, *Not the Only One Avatar*, 2023. Digital video. Photo Paula Virta EMMA – Espoo Museum of Modern Art 2023

PP.230–231 Self-organizing Systems Research Group, Kilobots, 2014. Images courtesy of Mike Rubenstein and Science/AAAS [Michael Rubenstein, Alejandro Cornejo, Radhika Nagpal, 'Programmable self-assembly in a thousand-robot swarm', *Science*, Vol. 345, Issue 6198, 2014]

PP.232–233 Sam Kriegman, Douglas Blackiston, Michael Levin, and Joshua Bongard, Xenobots, 2020. Photos Douglas Blackiston and Sam Kriegman [Sam Kriegman, Douglas Blackiston, Michael Levin, and Joshua Bongard, 'A scalable pipeline for designing reconfigurable organisms', *PNAS*, Vol.117, No.4, 28 January 2020. https://doi.org/10.1073/pnas.1910837117]

P.234 Claudia Pasquero and Marco Poletto, *H.O.R.T.U.S. XL Astaxanthin.g*, 2019. 3d printed substratum, micro-algae in biogel medium, 320 x 272 x 114 (126 x 107 1/8 x 45). Photos © NAARO for ecoLogicStudio

P.235A Michael Sedbon, *Cryptographic Beings*, 2022. Concept and production Michael Sedbon. Documentation (photo and video) Maison Mimesis. Exhibited at 36 Degrés. Image courtesy the artist

P.235B Michael Sedbon, *CMD: Experiment in Bio Algorithmic Politics*, 2019. Concept and production Michael Sedbon. Documentation (photo and video) Maison Mimesis. Funding Bio Arts and Design Awards 2019. Images courtesy the artist

P.236 *Symbiosis*, 2021. Designed and produced by Polymorf in collaboration with Studio Biarritz. Concept, scenario and art direction: Marcel van Brakel. Directed by: Marcel van Brakel and Mark Meeuwenoord. Food design: Karpendonkse Hoeve. Team: Corine Meijers, Marieke Nooren, Luciano Pinna, Frank Bosma, Wijnand van Tol, Roberto Digiglio, Maurice Spapens, Martijn Zandvliet, Edwin Kuipers, Hauke Boer, Tim van Nielen, Pom Smit, Ruben Maas, Scott van Haastrecht, Nienke Huitenga-Broeren. Images Polymorf and Edwin Kuipers

P.237 *Symbiosis*, 2021. Designed and produced by Polymorf in collaboration with Studio Biarritz. Concept, scenario and art direction: Marcel van Brakel. Directed by: Marcel van Brakel and Mark Meeuwenoord. Food design: Karpendonkse Hoeve. Team: Corine Meijers, Marieke Nooren, Luciano Pinna, Frank Bosma, Wijnand van Tol, Roberto Digiglio, Maurice Spapens, Martijn Zandvliet, Edwin Kuipers, Hauke Boer, Tim van Nielen, Pom Smit, Ruben Maas, Scott van Haastrecht, Nienke Huitenga-Broeren. Photos Luciano Pinna

PP.238–239 Ian Cheng, *Emissary in the Squat of Gods*, 2015. Live simulation with sound, infinite duration. Screenshot. © Ian Cheng. Courtesy the artist, Gladstone Gallery and Pilar Corrias, London

P.239 Ian Cheng, *Emissary Sunsets the Self*, 2017. Installation view, Carnegie Museum of Art, 2017. Photo Bryan Conley. © Ian Cheng. Courtesy the artist, Gladstone Gallery and Pilar Corrias, London

PP.240–241A Pierre Huyghe, *After ALife Ahead*, 2017. Ice rink concrete floor; sand, clay, phreatic water; bacteria, algae, bee, chimera peacock; aquarium, black switchable glass, conus textile; incubator, human cancer cells; genetic algorithm; augmented reality; automated ceiling structure; rain; ammoniac; logic game. Installation view, Skulptur Projekte Münster, 2017. Photo Ola Rindal. © Pierre Huyghe. Image courtesy the artist and Hauser & Wirth

P.240B Pierre Huyghe, *After UUmwelt*, 2021. Deep image reconstructions, materialized deep image reconstructions (glass, synthetic resin, silicone, copper alloy, colophonium, minerals, bone, calcium, protein, sodium, sugar, agar agar, bacteria), generative adversarial network, face recognition, screens, sound, sensors, human cancer cells (HeLa), incubator, scent, bees, ants, mycelium, soil, pigment. Installation view, 'After UUmwelt', LUMA Arles, 2021. Photo Ola Rindal. © Pierre Huyghe Courtesy the artist; Esther Schipper, Berlin; Galerie Chantal Crousel, Paris; Marian Goodman Gallery, New York; Hauser & Wirth, London

P.241 Pierre Huyghe, *UUmwelt* (still), 2018–ongoing. Deep image reconstruction, sensors, sound, scent. incubator, flies, sanded wall, dust. © Pierre Huyghe. Courtesy of the artist, Hauser & Wirth and Serpentine Galleries; © Kamitani Lab/Kyoto University and ATR

Index of Materials

3D
- printed components *36–37, 149, 154–155*
- printer *14, 34, 106, 227*
- printing *129, 218, 234*

A
- accelerometer *14, 149*
- actuator *51, 64, 74, 136, 143, 145*
 - electronic *7*
- adhesive *148*
 - anchoring system *138*
 - tape *90*
- AI *18, 19, 122, 191, 202, 206, 208, 216–223, 225, 228, 232–239*
- algae *218, 234, 240–241*
- algorithm
 - genetic *218, 219, 235*
- alligator clips *48–49*
- aluminium *15, 96, 156*
- android *204*
- animation *194, 223, 236, 238, 240*
- ant *98–99*
- antenna *79, 140*
 - moth *60, 62, 77*
- Arduino *34, 44*
- artificial
 - flowers *63, 98–99*
 - fur *138*
 - hair *98–99*
 - teeth *96*
- augmented reality *240–241*

B
- bacteria *90–91, 105, 114–115, 132–133, 218, 219, 234, 235, 240–241*
- balloon *79, 196–197*
- bark *49, 150*
- barley *72–73*
- batter *96*
- battery *79, 80, 230–231*
- bee *138, 152–153*
- bellows *15, 156–157*
- blood *63, 89, 126–127*
- blower *15, 156–157, 158*
- brass *44, 138, 139, 152–153*

C
- calcium *234*
- camera *25, 32, 36–37, 56, 80, 140–141, 199*
 - parts *30*
 - surveillance *207*
- camphor mulch *72–73*
- canvas *94*
- car body *35, 54–55*
- carbon fibre *146–147*
- cardboard *165, 182–185*
- carrier pigeon *22, 26–27*
- cell
 - cardiac *13, 62, 64–65, 66, 67, 103, 106, 117, 218, 232–233*
 - HeLa *130, 218, 240*
 - liver *14, 105, 132–133*
 - microbial fuel *14*
 - mouse muscle *72–73*
 - photovoltaic *136, 140–141*
 - retinal *14, 103, 107, 108–109*
 - skin *14, 71, 103*
 - stem *13, 14, 56, 62, 67, 71, 86–87, 103, 104, 108–109, 117, 122, 128, 218, 232–233*
- cell phone *29*
- ceramic *94, 96–99, 117*
- chair *195, 196*
- cheese wheels *90–91*
- chimera peacock *240–241*
- chopsticks *24, 48–49*
- circuit board *28, 140–141, 147, 230–231*
- computer *56, 78, 79, 139, 154–157, 173, 182–183, 219, 232–233, 235, 238*
 - speakers *38–39*
- concrete *165, 207, 240–241*
- condom *113, 196*
- contact lens *96*
- control system *17, 193, 210–211*
- copper *28, 30, 38*
- cyanobacteria *218, 219, 234, 235*

D
- data collection tools *227*
- deepfake *222*
- DNA *13, 63, 64, 85, 102, 103, 110–115, 128, 130–131, 167*
- dog ticks *96–97*
- drag artists *217*
- drone *14, 24, 26, 60, 62, 77, 137, 147, 149*
- dust *163, 168*
- dye *86–87*

E
- elastomer *66*
- electrode *70–71, 76, 191*
- electronics *12, 24, 29, 30, 34, 38, 76, 137, 138, 140, 150, 152–153*
 - components *137*
- engraving machine *54–55*
- excrement *130*

F
- feather *30*
- fibreglass *28*
- fibronectin *86*
- film strips *103, 106*
- fish *82*
 - biohybrid *67*
- fishing line *149*
- flower
 - robotic *138, 139, 152–153*
 - synthetic *152–153*
- fly *138, 140–141, 240–241*
- foam *193, 195, 200*
- frog stem cells *11, 24, 218, 232*

G
- garbage *7, 190, 196, 197*
- glass *25, 52, 96, 114–115, 117–119, 136–137, 208–209, 236–237*
 - cast *228–229*
 - Murano *96–97*
- glue *78, 88, 138*
- gold *38, 66, 96–99, 154*
- grackle *63*
 - great-tailed *80*

H
- hair *63, 96–99, 148,*
- heart *11, 13, 14, 103, 104, 106, 117, 218, 232*
 - human *13, 62, 64–65, 67*
 - pig *52, 63, 138*
 - rat *13, 60, 62, 64–65, 66*
- horn *83, 217, 225*
 - rhino *84–85*

I
- ice *16, 166, 103, 108–109, 170–171*
- incubator *17, 72–73, 181, 218, 240–241*
- insect *140–143, 152–153*
 - instrumented *62*
- interface *157, 181, 217*

J
- jellyfish *7, 60, 62, 64–65, 66, 76*
 - biohybrid robotic *13*

K
- kidney *11*

L
- laser *150, 163, 165, 173*
 - rangefinder *140–141*
- latex *191, 200–201, 204*
- leaf *63, 86–87*
- leather *104, 120*
- LEDs *173, 231, 240–241*
- lichen *97*
- light
 - fluorescent *116*
 - installation *163, 173*
 - natural *116*
 - pulses *67*
 - UV *120*
- limestone *172, 182*

M
- makeup *217, 222*
- manure *72–73*
- marble *132–133*
- matryoshka doll *63, 95*
- meat *63, 88, 89*
- mechanical components *12, 15, 24, 36–37, 148, 149, 152–153, 156–159*
- metal *14, 24, 44–45, 50–51, 106, 117, 151, 152–153, 154, 169*
- meter *30*
- microchip *30, 79, 104, 106, 116*
- microcontroller *12, 13, 62, 76, 77, 136*
- microphone *62, 79*
- microprocessor *156*
- mirror *98–99*
- mixed media *25, 44*
- monkey *11, 63*
- motor *12, 14, 15, 16, 30, 38–39, 81, 139, 148–150, 152–153, 156–159, 191, 210–211*
 - electric *31, 81, 174–175*
 - servo *24, 44, 48–51*
- muscle *62, 72–73, 74–75, 76, 86–87, 103, 104, 106, 117, 142–143*
- mushroom *94*
- mycelium *13, 105, 129, 234*

N
- needle *105, 126–127*
- Nesquik Strawberry Powder *96–97*
- neural *31, 46–47, 62*
 - network *13, 19, 22, 60, 68, 139, 158–159, 206–207, 216–217, 222, 240–241*
- neurons *7, 60, 62, 68, 70–71, 76, 77*
- newspaper *12, 23, 34*
- nylon *193*

O
- oil
 - betulin *49*
- organelle *13, 64–65, 103, 117*
- organic matter *31*
- oscillator *23, 30*

P
paper 34, 67
parrotlet 14
PCB (printed circuit board) 28, 146–147
peregrine falcon 14, 137, 149
Perspex 194
photograph 25, 26–27, 57, 94, 183–184
piezo 30, 136
pig 11, 63, 104, 105, 128, 130
pigeon 22, 26–27, 102, 104, 118–119
pipe 38–39, 156–157
placenta 126–127
planar parts 146–147
plaster 158–159
plastic 40, 94, 105, 106, 139, 149, 158–159, 195, 196, 234, 236–237
 bag 34–35, 94
Plexiglass 98–99
plumbing material 36–37
polymer 148
 3D printed 74–75
polyps 234
polystyrene 63, 98–99
print 182–183
projection 41, 134
projector 223
protein 61, 86–87, 103
pump 13, 44–45, 138, 152–153, 224
puppet 44, 196
PVC 38–39

R
rain 169
rat 11, 13, 40, 62, 63, 66, 64–65, 68–69, 193, 207
ray
 tissue-engineered 66
reed 15, 156–157
resin 25, 48–49, 96, 128, 144–145, 154–155
 flocked laminate 81
ritual objects 36–37
robot 7, 11, 12, 14, 15, 23, 24, 25, 29, 32–33, 36–37, 44–45, 48–49, 60, 63, 66, 68–69, 76, 81, 136–146, 148, 151–155, 158–159, 192, 193, 204, 206, 207, 210–211, 218, 225, 228, 230–231,
 biohybrid jellyfish 13
 organic 74–75
 spider 144–145
rubber 15, 26, 40, 158, 178, 192, 195, 200
rubbish 7, 190

S
sand 73–74
sandpaper 163, 168
scent 236
screen 19, 41, 193, 216, 217, 219, 220–221, 225, 240–241
sculpture 23, 25, 28, 44–45, 52, 54, 96–99, 105, 132–133, 165, 193, 200, 212–213, 228
sea 13, 16, 139, 154–155, 166, 170–171, 202
 foam 200–201
 slug 10, 62, 74–75, 86
 sponges 24, 48–49
sensors 31, 56, 62, 68, 78, 81, 106, 138, 140–141, 149, 154–155, 169, 190, 208–209, 230–231, 240–241
sewing machine 96–97
silicone 7, 13, 15, 44, 60, 62, 64–65, 116, 139, 144–149, 158–159, 191, 193, 210–211
skin 14, 25, 48–49, 56–57, 62, 70–71, 81, 94, 103, 104, 118–121, 191, 193, 200–201, 206, 218
snail 11, 62, 78, 84–85, 240–241
software 208–209
soil 72–73, 130–131
songbird 28, 29
sound 14, 15, 25, 28, 29, 30, 32–33, 50–51, 70–71, 122–123, 134–135, 139, 150, 156, 158–159, 208–211, 217, 225, 240–241
sparklers 96–97
speaker 28
steel 23, 81
stones 172
string 63, 93–93
sugar 86, 93
switch 66, 199
synthesizer 60, 62, 70–71, 156, 208–209

T
table 96, 169
Tang drink mix 96, 97
tattoo 128
tennis
 ball 96, 97
 court surface 96
 racket 97
thermostat 72–73
thread 98–99
tissue 24, 62–63, 68, 76, 86, 103–105, 107, 116–117, 120, 122, 128, 150, 164
 heart 64–65, 67, 106
 retinal 107–109

toys 40, 190
trash 12
tree 29, 33
 Christmas 25, 31
tube 14, 15, 132, 139, 145, 194, 225, 236
tuna
 can 30
 fin 96
typewriter 25, 41

U
umbrella 12, 23, 34
urban junk 38–39
urinal cake 63, 96
urine 63, 94

V
valve 156–157, 158
vape smoke 191, 194
vehicle 40, 63, 68, 81, 174–174
video 41, 113, 199, 207
 camera 56, 80
 game 22, 217, 224
still 199, 223
 surveillance 130–131

W
water 52, 72–73, 132–133, 136, 137, 138, 142–143, 150, 169, 173, 224
wax 148
wheel 37, 68, 81
wheelchair 25, 56, 213
wire 14, 25, 30, 38, 48–49, 102, 106
 tendons 14
wood 14, 15, 42–43, 44–45, 150, 156
woodpecker 24, 32–33, 150, 193

X
xenobots 11, 24, 218, 232–233

Y
yeast 63, 92–93

Z
zip tie 30

INDEX OF MATERIALS

Index of Makers

21st Century Cardboard Guild *165, 184–185*
Aida, Makoto *165, 184–185*
Alternative Limb Project *136, 139, 154–155*
Altmejd, David *63, 98–99*
Anderson, Melanie *60, 62, 77*
anonymous *192, 198*
Arakawa, Shūsaku *165, 186–187*
Bartoníček, Prokop *165, 172*
Bäumel, Sonja *103, 104, 124–125*
Ben-Ary, Guy *62, 70–71, 103, 104, 117*
Bick, Cindy *78*
Blackiston, Douglas *24, 232–233*
Blas, Zach *18, 19, 217, 220–221*
bonajo, melanie *191, 195*
Bongard, Joshua *232–233*
Bozkurt, Alper *62, 79*
Bradford, Tobias *15, 24, 25, 44–45*
Büchel, Christoph *192, 205*
Burton Nitta *14, 104, 122–123*
Candy, Michael *17, 18, 36–37, 138–139, 152–153, 191, 193, 210–211*
Cattelan, Maurizio *205*
Catts, Oron *62, 72–73*
Charrière, Julian *162–165, 166–168*
Cheng, Ian *218, 238–239*
Cho, Kyu-Jin *138, 142–143*
Ciokajlo, Liz *105, 129*
Clode, Dani *25, 46–47, 136, 139, 154–155*
Conley, Emma Dorothy *105, 130–131*
Corroon, Avril *63, 90–91*
Cupkova, Dana *61, 63, 92–93*
Cutkosky, Mark R. *138, 148–149*
Dabiri, John O. *13, 62, 64, 76*
Demand, Thomas *165, 182–183*
Diecke, Sebastian *103, 104, 117*
Dinkins, Stephanie *218, 228–229*
Donnarumma, Marco *193, 206*
ecoLogicStudio *218, 234*
Eldred, Kiara *103, 107, 108–109*

Eliasson, Olafur *16, 164, 170–171*
Elwes, Jake *216, 217, 222*
enormousface *190, 192, 196–197*
Esparza, Gilberto *14, 35, 38–39, 242–243*
Evans, Helen *163, 164, 173–175*
Farid, Mark *217, 226–227*
Feuerstein, Thomas *105, 132–133*
Fitch, Andrew *70–71*
Fleming, Kathryn *16, 17, 62, 63, 82–83, 164, 165, 181*
Fuller, Sawyer Buckminster *136, 138, 140–141*
Gaudette, Glenn *63, 86–87*
Gieskes, Gijs *30, 35*
Gins, Madeline *165, 186–187*
Ginsberg, Alexandra Daisy *217, 223*
Giordano, Daniel *60, 63, 96–97*
Gorjanc, Tina *102, 104, 118–121*
Hansen, Heiko *163, 164, 173–175*
Heaton, Kelly *23, 25, 28*
HeHe *16, 163, 164, 165, 173–175*
Huyghe, Pierre *218, 219, 240–241*
Ingber, Donald *104, 116*
Ingram, Ian *25, 32–33, 193, 207*
J. Craig Venter Institute *11, 102, 110–111*
Johnston, Robert *107, 108*
Jones, Kim *193, 212–213*
Jonsson, Cecilia *104, 105, 126–127*
Kiers, Professor Toby *128*
Kim, Ho-Young *137, 138, 142–143*
Kriegman, Sam *232–233*
Ku, Kuang-Yi *63, 84–85*
Lambert, Kelly *25, 40*
Lanteigne, Baron *192, 193, 208–209*
Lee, Keel Yong *67*
Lentink, David *149*
Levin, Michael *232–233*
Lewis, Tim *25, 31, 63, 81*

Lin, Candice *63, 94*
Lind, Johan U. *66, 103, 106*
Luque Sánchez, Félix *54–55*
Macuga, Goshka *192, 193, 204*
Maus, Benjamin *165, 172*
Mendoza, Neil *25, 29, 216, 225*
Meyer-Brandis, Agnes *164, 169, 192, 199*
Mignonneau, Laurent *25, 41*
Mitoh, Sayaka *10–11*
Montalti, Maurizio *105, 129*
Monté, Isaac *63, 88, 104, 105, 128*
Nawroth, Janna C. *13, 64–65*
Neubronner, Julius *22, 26–27*
Ó Foighil, Diarmaid *62, 78*
Officina Corpuscoli *129*
Park, Sung-Jin *66–67, 106*
Parker, Kit *13, 62, 64–67, 103, 106*
Pasquero, Claudia *234*
Pitarch, Jaime *63, 98*
Poletto, Marco *234*
Polymorf *218, 219, 236–237*
Questionmark, Agnes *25, 52–53*
Ramezani, Alireza *146–147*
Ranzani, Tommaso *144–145*
Raspet, Sean *103, 108–109*
Riches, Martin *15, 139, 156–157*
Rodney, Donald *25, 56–57*
Rosing, Minik *16, 164, 170–171*
Sawada, Hideyuki *15, 137, 138, 139, 158–159*
Schwartzman, Madeline *7, 24, 25, 48–49*
Sedbon, Michael *218, 219, 235*
Self-organizing Systems Research Group *230–231*
Snell, Ben *61, 63, 92–93*
Sommerer, Christa *25, 41*
Sterre, Mette *191, 193, 200–201*
Stittgen, Basse *63, 89*
Thompson, Nathan *70–71, 103, 104, 117*
Thwaites, Thomas *19, 25, 43–44*
Tissue Culture & Art Project *62, 73–74*
Total Refusal *217, 224*

Vanden Eynde, Maarten *16, 160–161, 165, 176–179*
Van Leeuwenstein, Jip *137, 139, 151*
Van Lieshout, Lotje *191, 192, 202–203*
Vitols, Rihards *139, 150*
Walter, John *103, 104, 112–113*
Ward, Devon *62, 72–73*
Warwick, Kevin *62, 68–69*
Webster-Wood, Victoria *62, 74–75*
Westphal, Uli *165, 180*
Woo, Jiwon *103, 114–115*
Wyman, Jemima *18, 19, 217, 220–221, 230–231*
Xu, Nicole W. *13, 62, 76*
Yang, Wonbin *12, 23, 24, 34–35*
Yoldas, Pinar *25, 50–51*
Yorzinski, Jessica L. *63, 80*
Zajko, Rafał *191, 194, 206*
Zurr, Ionat *62, 72–73*

It is difficult to pinpoint how an idea for a book takes shape. This book may have started with a silicone jellyfish with a rat heart (Janna Nawroth and Kit Parker). I found it while researching *See Yourself X: Human Futures Expanded*, and it swirled around my brain for a couple of years. What new type of creature was this? Wonbin Yang's nomadic newspaper entity (*Segnisiter continuus*, from the *Species* series) that roves the urban street kerb in the night also roved in my head. By the time artist Michael Candy informed me that he was making a robotic machine for 'pollinating' humans (*Celestial Bed*) that could result in conception without any interaction between humans, I knew that this was a book.

Kit Parker invited me to his lab – the Disease Biophysics Group at Harvard – where I saw, firsthand, videos and remnants of his chimeric menagerie. Wonbin met me in the parking lot of a thrift shop in LA (on a trip supported by the Barnard Contingent Faculty Professional Development Fund), and introduced me to the most astonishing robotic creatures, including *Segnisiter continuus* (the skulking newspaper), *Umbra infractus* (a lurching broken umbrella) and *Calicem volvens* (a perpetually rolling coffee cup), which stopped shoppers in their tracks. Michael Candy withstood multiple interviews and was a constant resource for brainstorming the emergence of robotic interaction in the 1990s and other aspects of the book, including the title. I want to thank these three outrageously original makers who were among the first to allow me to think about new ways of being alive.

Without the curiosity, bravery and originality of the artists, scientists and engineers collected here, there would be no book. Thank you for allowing me to include your spectacular work. I extend that appreciation to the gallerists, photographers, laboratory colleagues and agents. A special thank you to Kelly Heaton for providing her gorgeous *Transparent Bird* for the cover. Her *Electronic Naturalism* series embodies this book.

It was easy for me to collect this work and to shape it into a book proposal, but once accepted, things started to get tough. The seven chapters were complex, conceptual and technological each in their own way. It was difficult to grasp the material and hold it in my head. The essence of the book kept slipping away. I would retreat to my volumes of notes and ideas to regrasp themes and threads – until Marcos Valenzuela Cuevas came along. A former student and sophomore at Columbia College at the time, Marcos became my book assistant. In fact, he was a second brain. Marcos had an incredible capacity to hold on to volumes of material and ideas. He could remember the conceptual threads and verify that something was indeed in the correct chapter. He had a perfect understanding of my conceptual threshold for including work in the book. The research phase consisted of nine months of productive and fun teamwork. I am grateful for how hard he worked and how brilliantly he helped me to create databases, select images, contact artists,

First published in the United Kingdom in 2025 by Thames & Hudson Ltd, 6–24 Britannia Street, London WC1X 9JD

First published in the United States of America in 2025 by Thames & Hudson Inc., 500 Fifth Avenue, New York, New York 10110

Alive © 2025 Thames & Hudson Ltd, London

Text © 2025 Madeline Schwartzman

Foreword © 2025 Edward Ashton

Cover designed by Steve O Connell

Interior layout designed by LMNOP

All Rights Reserved. No part of this publication may be reproduced or transmitted in any form or by any means, electronic or mechanical, including photocopy, recording or any other information storage and retrieval system, without prior permission in writing from the publisher.

EU Authorized Representative: Interart S.A.R.L.
19 rue Charles Auray, 93500 Pantin, Paris, France
productsafety@thameshudson.co.uk
interart.fr

A CIP catalogue record for this book is available from the British Library

Library of Congress Control Number 2024934758

ISBN 978-0-500-02686-1
01

Printed and bound in China through Asia Pacific Offset Ltd

Be the first to know about our new releases, exclusive content and author events by visiting
thamesandhudson.com
thamesandhudsonusa.com
thamesandhudson.com.au

Madeline Schwartzman is a New York City artist, writer and educator whose work explores human narratives, the human sensorium and human/plant interactions. She alternates between installation, performance, video making, book writing and curating. Her previous books include *See Yourself Sensing: Redefining Human Perception* and *See Yourself X: Human Futures Expanded*.

Edward Ashton is the author of the novels *The Fourth Consort, Mal·Goes to War, Antimatter Blues, Mickey7* (now the motion picture *Mickey 17*, directed by Bong Joon-ho), *The End of the Ordinary* and *Three Days in April*. You can find him online at edwardashton.com

Front cover: Kelly Heaton, *Transparent Bird*, 2018, Mixed media electronic sculpture, 12.7 × 20.3 × 7.6 cm (5 × 8 × 3 in.), Image courtesy the artist

Back cover, clockwise from top right: Baron Lanteigne, *Manipulation 3*, 2021, Still from seamless loop animation, Image courtesy the artist; Rafał Zajko, *Amber Chamber*, 2020, MDF, perspex, plaster, acrylic paint, rubber strap, barley, wheat, silk, valchromat, vape smoke, 90 × 250 × 130 cm (35 ½ x 98 ½ × 51 ¼ in.), Image courtesy the artist; Thomas Feuerstein, *Octoplasma*, 2017, Glass, human liver cells (hepatocytes) with fibroblasts, formalin, aluminium, plastic, 70 × 43 cm (27 ⅝ x 17 in.), Biotechnological realisation: Thomas Seppi, Department of Radiotherapy and Radiooncology, Medical University of Innsbruck, Image courtesy Atelier Feuerstein; Michael Candy, *Synthetic Pollenizer* (detail), 2014–17, Robotic flower, Image courtesy the artist; Guy Ben-Ary, Nathan Thompson, Darren Moore, Andrew Fitch, Stuart Hodgetts, *cellF*, 2016, Living neural networks, electronics, metal and sound, neural interface & synthesisers, Installation view, Cell Block Theatre, Sydney 2016, Photo Alex Davis, Image courtesy Guy Ben-Ary; Mark R. Cutkosky, Stanford University and Sangbae Kim, Massachusetts Institute of Technology, Stickybot climbing a glass wall, 2010, Image courtesy Sangbae Kim

To access the endnotes indicated in the chapters, please scan this QR code: